Political Catchphrases and Contemporary History

Political Catchphrases and Contemporary History

A Critique of New Normals

SUMAN GUPTA

OXFORD
UNIVERSITY PRESS

Great Clarendon Street, Oxford, OX2 6DP,
United Kingdom

Oxford University Press is a department of the University of Oxford.
It furthers the University's objective of excellence in research, scholarship,
and education by publishing worldwide. Oxford is a registered trade mark of
Oxford University Press in the UK and in certain other countries

Published in the United States of America by Oxford University Press
198 Madison Avenue, New York, NY 10016, United States of America

British Library Cataloguing in Publication Data

Data available

Library of Congress Control Number: 2022933191

ISBN 978–0–19–286369–0

DOI: 10.1093/oso/9780192863690.001.0001

Printed and bound by
CPI Group (UK) Ltd, Croydon, CR0 4YY

To

Amit Kumar Gupta (1936–2021)

Acknowledgements

Conversations with Richard Allen, Ayan-Yue Gupta, Milena Katsarska, Sebastian Schuller, John Seed, Peter H. Tu, and Cheng Xiao have sharpened various arguments in this study. The Open University's School of Arts and Humanities has allowed me congenial and encouraging working conditions. I am grateful to Dominic Byatt for commissioning this project, and to two anonymous reviewers for their helpful guidance.

Shortcomings in the following pages are entirely my responsibility.

Contents

1. Introduction: Parts and Whole 1

2. 'New Normal', 2001–2019 11

3. 'New Normal', 2020 46

4. The Concept of Normality 78

5. Policy Catchwords: 'Austerity' and 'Resilience' 105

6. Anti-Establishment Catchphrases: 'We Are The 99%' 134

7. Conclusion: Loose Ends 157

Bibliography 182
Index 204

1

Introduction

Parts and Whole

Preliminaries

If the career of a particularly popular and widely used political catchphrase
were tracked over a period of time, with its shifting nuances and applications
contextualized, a historical account of that period would be obtained. Such
a historical account would be akin to 'material history', which traces social
processes surrounding objects, or the 'history of ideas', which is anchored to
abstractions. And yet, the history woven around a catchphrase would be dis-
tinctive. Along with conveying a picture of the period, it would clarify how
catchphrases work. The rationales underpinning their circulations and effects
would be exposed to some degree. Light would be thrown on the links between
various and even disparate preoccupations in social life, and, more broadly, on
the fluid processes of knowledge construction and dissemination. A project of
this sort would have a special interest if the period in question were a recent
or ongoing one, structured as 'contemporary history'. Using a catchphrase as
a linchpin for selecting and connecting areas seems particularly meaningful
at present, in the age of digital communications, social networks, and global
publicity strategies.

That is the core idea of this book. In subsequent chapters I concentrate on a
few familiar and widely used phrases and words to give an account of the pe-
riod 2001–2020, principally from British and American sources. These are my
case studies of political catchphrases in contemporary history. Readers who
are particular about definitions and methods would have paused on my open-
ing observations with interest; they might well be asking what is meant by
'political catchphrase' and by 'contemporary history'. Considered responses
to such questions will appear in the final chapter, with the case studies behind
them. The view taken here is that readers would have reasonable preconcep-
tions about those terms already, which would be sharpened by noting how
they are used and exemplified in the case studies. Conceptual observations in

Political Catchphrases and Contemporary History. Suman Gupta, Oxford University Press.
© Suman Gupta (2022). DOI: 10.1093/oso/9780192863690.003.0001

the final chapter bring both the practical and theoretical dimensions of this study together and suggest ways forward for further research in this direction.

Having said that, it nevertheless seems prudent to immediately put some minimum markers on those two key structuring notions: 'political catchphrase' and 'contemporary history'. That is to say, some little pragmatic and explicit refining of these notions is necessary for the study to progress coherently, for readers and author to be on the same page even if they disagree about the arguments on that page.

Accordingly, at this stage it seems to me that William Safire's impressionistic description of 'catchword' and 'catchphrase' in his 'dictionary of catchwords, slogans, and political usage' (1968) is all that is needed for kick off: 'a word [or phrase] that crystallizes an issue, sparks a response [...]. At their best, catch phrases used as slogans summarize and dramatize a genuine appeal' (68). In fact, in the spirit of the current study, Safire then chose to present the distinctions between catchwords, catchphrases, and slogans by illustration rather than definitions, and, as it happens, the illustration he chose bears directly upon the catchphrase which occupies much of this study. With reference to Republican campaign statements by Warren G. Harding in the US presidential election of 1920, the first after World War I, Safire pointed out that:

> 'Normalcy' [an unusual term compared to 'normality'] was a *catchword*; 'not nostrums but normalcy' [a much quoted phrase from a speech] a *catch phrase*; 'back to normalcy' a *slogan* [adopted for and headlining the Republican campaign].
>
> (68, emphasis in original)

According to Safire, the aural qualities and play on meanings of such words and phrases largely explain their catchiness: such as, the slight awkwardness of 'normalcy', the alliteration of 'normalcy' and 'nostrums', the counterpoint of taking doubtful new measures ('nostrums') as opposed to restoring what was ('back to normalcy'). At the same time, these words and phrases only catch on if they seem particularly apt for the context in which they appear. Such aptness is perceived by audiences, who then take up the resonant words or phrases so that they become catchwords or catchphrases. Aptness may also be actively suggested to audiences by some formation, such as a party in a political campaign. In that case, these phrases catch on in a designed way, as slogans. The context of Harding's 1920 campaign is discussed further in the next chapter, and Safire's approach elaborated in the final chapter. At present, that quotation offers a sufficient initial account of the distinctions to get on with.

The emphasis here on the *political* is worth underlining straightaway; this study does focus particularly on *political* catchphrases and words. They are differentiated from the most common source of catchphrases and slogans: commercial promotion. Though an equivalence between the use of catchphrases in political publicity and commercial promotion is often taken for granted, here the differences are germane. The similarities and crossovers are not disregarded in this study but considered to be conditional to the differences.

1. 'Political catchphrases' do not foreground a financial transactional rationale. Rather, they tend to obscure such rationales where they exist or can be attributed. 'Commercial catchphrases' work explicitly through and with transactional rationales, and are meant to promote a commodity transfer. In other words, commercial catchphrases are designed to highlight a commodity and in the first instance court those who would pay for that commodity so as to possess/consume it. Political catchphrases address collective interests which are usually not tied to commodities and court those who share those collective interests.

2. Commercial catchphrases themselves originate as commodities from commercial firms. These are therefore planned and disseminated in deliberate ways, and the processes are generally well defined (e.g. 'brands', 'slogans', and 'logos' are clearly defined and demarcated by advertisers), and lend themselves to formalization and predictable application (as 'tactics' or 'strategies'). They are invariably produced, so to speak, 'from above'. Those characteristics of commercial catchphrases are sometimes imported wholesale for political publicity and advocacy. However, it is usually allowed that political catchphrases might appear without such clarity of planning and process, with unpredictable effect—in protests, for instance, or for exhortations and summons which relate to an unforeseen eventuality. To be pat, political catchphrases sometimes appear in response to unanticipated or immediate situations, 'spontaneously' or 'organically' or 'from below' or, at least, inconveniently from an institutional or establishment perspective.

3. Somewhat different normative attitudes towards the two kinds of catchphrases are found among the political and commercial cognoscenti. By and large, commercial catchphrases are regarded positively among those who are interested in marketing. Catchphrases are regarded as being creative, value-enhancing, and necessary. Among those interested in

politics, catchphrases are often considered an unavoidable distraction from serious issues and debates, as being trivializing and misleading. Much political scholarship refers to catchphrases and slogans in disparaging terms.

4. With regard to 'contemporary history', the view taken here is an entirely pragmatic one: the description of a very recent period, the concerns of and developments in which are regarded as not having reached closure— or being done with—but as continuing to unfold. Arguably, this is the case for any historical account, even those which cover distant periods and practices. Benedetto Croce (1921) had persuasively argued that 'every true history is contemporary history': 'if contemporary history springs straight from life, so too does that history which is called non-contemporary, for it is evident that it is only an interest in the life of the present can move one to investigate past fact' (12–13). Nevertheless, there are pragmatic considerations which differentiate my way of engaging with 'contemporary history' from those of historians looking to what Croce dubs 'non-contemporary history'. To some degree, this has to do with readers' expectations. Readers of contemporary history approach the narrative in terms of being of the present, or, as G.W.F. Hegel put it in his lectures on the philosophy of history, '*the last stage in History, our world, our own time*' (1956: 442, a much discussed formulation). A part is also played by readers' need to come to terms with their immediate experiences, especially where the present seems transformed by some upheaval—or, as Henry Rousso (2016 [2012]) had it, contemporary history is understood in terms of the 'last catastrophe'. Crises, if not quite catastrophes, have a structuring impetus for the catchphrases tracked in this book. Beyond that, the specific nuances of contemporariness that arise in contemplating political catchphrases are taken up in the final chapter. Those are gradually crystallized through the case studies.

Of more immediate interest, for the historian there is a practical challenge in engaging with contemporary history. It involves weaving a narrative to describe a period from informing sources which are not themselves designed for that purpose. The informing sources may be texts of particular junctures within the period, which are meant to report news, serve legal proceedings, bolster commercial activity, maintain accounts, declare policies, inform initiatives, undertake advocacy, entertain, etc. Naturally, at any given time there would be a great surfeit of such informing sources. Within this excess, the contemporary historian looks for connections and patterns, rationales for

disregarding some material and highlighting some, which enables a narrative to emerge that, effectively, describes the period and offers a coherent perspective on it. In doing this, it is most helpful for a historian if there are already other such narratives—other contemporary histories—to refer to, which can then be expanded, contested, or complemented. But the contemporary historian seldom has the facility of an existing narrative to bounce off. That is a disadvantage of being so up-close to the period in question. The contemporary historian then generally chooses some conventional methods, tried and tested in histories of other periods already, to help the enterprise. Fixing a period is itself such a convention. Further, the historian may choose to delimit the description in terms of a region, a specific activity or object, an ideological interest, a focal point such as a personage or a community, etc. This helps to curtail the surfeit of informing sources and make the relevant material manageable, and to offer some preconceived connections and patterns to look for. For this study, I choose a somewhat unusual device of this sort for a contemporary history of the period 2001–2020: namely, focusing on political catchphrases. While this device does not offer preconceived historicist connections and patterns, this is in itself a connecting and pattern-generating device. Connections and patterns emanate from the very take up, repetitive and sustained usage, and demise of catchphrases.

I will return, as promised, to the relevant notions of 'political catchphrase' and 'contemporary history' in the final chapter. These preliminary notes suffice for me to plunge into the meat of the study, the case studies of certain political catchphrases of our world, our own time.

Approaches

This study has two related purposes: one, to map some of the contours of social practices and ideologies in our time; and two, to track how those practices are structured and ideologies embedded through political catchphrases and catchwords. This study, in brief, presents a distinctive approach to contemporary history and builds upon a theory of political catchphrases.

Introduced thus, readers may expect to find abstract precepts and concepts stated at the beginning, logical inferences made, and plausible hypotheses developed subsequently, which are eventually tested with observations and data. Despite quite strong conceptual investments, that is not the path followed for this study. The distinctive understanding of contemporary history and the theory of political catchphrases developed here are stated in general terms only in

the final chapter. Those generalizations are fairly swiftly made and are, to be honest, inconclusive. They surface gradually from the main body of this study, which consists of a series of case studies. These case studies are foregrounded and are the substance of this book. The theoretical issues are addressed in the interstices of the case studies, in intermittent reflections, and formulated after they are done. The case studies are not meant to substantiate preconceived formulations; theoretical formulations are crystallized through the case studies. Each case study has a definite focus. At the same time, the case studies are joined up through recurring motifs and a coherent analytical approach.

Readers may consequently approach this book in different ways, according to their interests. Some may choose to concentrate on specific chapters and disregard the overall project. Most chapters could be read as making self-contained arguments, and the questions that arise immediately are seldom left unanswered—at least, not to any insupportable extent. Each of the main chapters is given to particular catchphrases/words. Chapters 2 and 3 are both devoted to the extraordinarily adaptable catchphrase 'new normal', the former covering the period 2001–2019 and the latter focusing on 2020. Though Chapter 3 is informed by and follows up on patterns discerned in Chapter 2, each can be read independently of the other. Chapter 4 reflects on the discussion of 'new normal' in Chapters 2 and 3 by digging back into the career of the term 'normal', which drifted from specialist registers into popular usage. Chapter 5 explores two catchwords at specific junctures in political and bureaucratic discourse: 'austerity' and 'resilience'. Chapter 6 discusses the 2011 Occupy Wall Street slogan 'We are the 99%' and the catchphrases 'the 1%' and 'the 99%'. Each of these chapters bears upon and speaks to others in numerous ways, and yet each can also be read independently, with a narrow focus on particular catchphrases and their contexts.

More profitably, the book could be read in its entirety as developing a sustained argument through interwoven themes across the case studies. These lead towards the theoretical generalizations of the final chapter, with potential for further case studies and honing of methods and concepts. Approached thus, the chapters slot together much like pieces of a jigsaw. Chapters 2 and 3, as observed already, are both about the catchphrase 'new normal', respectively for the period 2001–2019 and over the year 2020. Between these, the career of a single catchphrase is tracked in some detail, across both specialist and everyday usage, culminating in a climactic juncture for the catchphrase. Chapter 4 then gives an account of the emergence of the catchphrase from the earlier travels of the term 'normal' and concepts of normality. The term 'normal' emerged from specialist discourse into popular usage; shades from both

accrued in the concept of normality, which was renegotiated in the usage of 'new normal'. Between Chapters 2 and 4, thus, the provenance, shifting nuances, and growing purchase of catchphrases like 'new normal' are conveyed, along with a multidimensional sense of the period 2001–2020. Chapters 5 and 6 focus, somewhat like a magnifying glass, on catchwords and catchphrases at specific conjunctures within that period. These have a definite bearing on certain underpinnings of the 'new normal', and had been noted in passing within the broader canvas of Chapters 2–4. Chapter 5 explores the catchwords 'austerity' and 'resilience', both of which became commonplace in political and bureaucratic circles around 2010. As against such catchwords, drawn from establishment sources, Chapter 6 pulls in the direction of anti-establishment protests by discussing the concurrent Occupy Wall Street protest slogan 'We are the 99%' and the catchphrases 'the 99%' and 'the 1%'. Chapters 5 and 6 thus complement each other. Together they present reasonably substantial accounts of, respectively, establishment and anti-establishment positions within the period covered in Chapters 2–4. With these case studies in mind, Chapter 7 makes some generalizations about the kind of contemporary history undertaken here and proposes a theory of political catchphrases which coheres with the case studies.

The fit of the chapters in relation to each other gives only a partial account of the design of this study as a whole. Its coherence ultimately derives from the numerous fine-grained details which are repeatedly echoed or nudged in different directions, through analogous rationales and direct connections across the case studies.

For instance, a significant argument in Chapter 2 on the catchphrase 'new normal' through 2001–2019 is that it was introduced in the service of top-down management and governance strategies, and its persistent catchiness marked the effectiveness of those strategies. The catchphrase's deployment amidst political and economic upheavals bears this out; indeed 'new normal' became and carried on being a catchphrase because of various crises. It first caught on, as discussed in this chapter, after the terrorist bombings of 9/11 and the consequent legislative measures and restrictions that were introduced in the USA and, soon, worldwide. The catchphrase was used and compliantly received as a way of engineering consensus on a regime which might have seemed contrary to fundamental political and legal principles before that. With slight shifts, the catchphrase was then used to similar effect by investment gurus after the dot-com crash of 2002, by political pundits and ministers after the financial crisis from 2007–2008 in the USA and EU countries, and, with a

distinctive turn, in China. It worked to ground austerity policies in many countries, and interestingly it also came to be used with critical verve against those policies. Between, in the main, pushing top-down manoeuvres and, occasionally, putting an ironic or bitter cast on those manoeuvres, the catchphrase was also used, among other issues, for promoting flexible working practices and to sharpen awareness of climate change.

Chapter 3 takes up the catchphrase amidst the Covid-19 outbreak. In many ways the catchphrase 'new normal' defined the dramatic consequences of the pandemic. Again, it worked to embed some degree of consensus on the social restrictions that were imposed to control the outbreak. More interestingly, as the chapter shows, this process was variously inflected by resonances from every stage of the catchphrase's career from 2001. There were echoes of post-9/11 securitization, of investor rethinking after the dot-com crash, of austerity strategies and their consequences after the 2007–2008 financial crisis, of the drive to ground flexible online working, and of populist crises of democracy, particularly in the USA and EU states. In the period of its most intensive and extensive usage, the catchphrase carried shades of its negotiations through crises of the preceding two decades. Political nuances seemed to have sedimented within it to engage the overwhelming pandemic-driven upheavals of 2020. In some respects, its management and governance thrust appeared to become opaque and ironic even as the catchphrase seemed to reach a saturation point of catchiness.

With Chapters 2 and 3 in view, Chapter 4 asks what the rise of the catchphrase 'new normal' means for concepts of normality and the term 'normal'. The term has traced complex accruals from specialist to everyday usage, and from top-down strategies to bottom-up negotiations. The chapter examines existing histories of the 'normal', following its development from, in particular, medical and statistical scholarship to its gradual association with institutional (normalizing) moves and advent into habitual usage. The appearance of 'new normal' as a catchphrase, it is argued, marks a further step in the process of conceiving normality by, paradoxically, undermining its received connotations while retaining something of its meaning. That has usually occurred when powerful parties in various areas of social life have found it expedient to dislocate habitual expectations and norms.

Chapter 5 pays close attention to the use of catchwords by and within political and bureaucratic formations to implement their strategies. One of these catchwords, 'austerity', was strongly tagged to the 'new normal' that followed the 2007–2008 financial crisis, discussed in both Chapters 2 and 3.

The other catchword, 'resilience', has been particularly popular within bureaucratic circles, that is, among those tasked with implementing 'austerity' measures. The part played by these catchwords in political and bureaucratic machinations is best discerned at close quarters. Therefore, unlike the broad sweep of Chapters 2–4, Chapter 5 concentrates on quite specific junctures and contexts in Britain: New Labour and Conservative political discourse around 2010 for 'austerity', and Arts Council England's cultural policies after 2010 for 'resilience'. In these contexts, it is observed that the catchwords have had somewhat contrary passages. Though 'austerity' was promoted by the political class in the first instance, it soon took on a life of its own in discourses critical of governmental policies—'austerity' became a pejorative term. 'Resilience', however, mainly caught on within bureaucratic circles, seemed to stay associated with positive norms, and served to implement 'austerity' measures. The histories of both catchwords prior to these junctures are also considered.

To a significant extent (though that is not all of the argument) Chapters 2–5 thus track the governance and management strategies that have been grounded through catchphrases. Chapter 6 is devoted to a slogan and catchphrases which were designed to express disaffection with those strategies and challenge prevailing dominant interests. The slogan of the Occupy Wall Street movement of 2011, 'We are the 99%', and the catchphrases, 'the 99%' and 'the 1%', also offer an opportunity to consider statistical figures in political rhetoric. The slogan and catchphrases used statistical figures in a metaphoric way, it is argued here, but also referred to systematic statistical investigations. A close examination of these catchphrases reveals much about the use of statistics to undergird ideological commitments and to both support and question policy drives.

As far as this study is concerned, the case studies of Chapters 2–6 do not lead up to a general gauging of the present. No particular distemper is foregrounded and nor is any problem solved by the end. That does not mean that such objectives as diagnosing the prevailing social condition and recommending solutions for problems are considered wanting—not at all. This study simply leaves it to the reader to make any final diagnosis, having taken the pulse of the present zeitgeist and noted various symptoms. The case studies in themselves do offer some evaluations of specific issues and contexts. The latter variously reverberate with other issues and contexts across the case studies. The view taken here is that criss-crossing connections between the case studies suggest a dominant disposition of the present, which may be analysed in a number of ways. The contemporary social condition, glimpsed here from principally American and British perspectives, may be grasped via the rubric

of neoliberalism, global capitalism, resurgent nationalisms and identity politics, post- or neocolonial power relations, class and generational divides, and different modes of developing and contesting knowledge. It seems to me that the relevance of such conceptual frames to the case studies is self-evident to some extent; a more considered elaboration of those can be left to readers or deferred as an unfolding project. Though the book is complete, I am unable to draw a line under this project here.

Instead of prognoses and ways into the future from the present of history, the final Chapter 7 attempts to make good on earlier promises in this introduction. It sets out some of the concepts which had motivated this study. Those concepts were grasped searchingly to begin with, and seemed to gain in clarity as investigations progressed. Accordingly, a distinctive approach to contemporary history is outlined and a theory of political catchphrases proposed in the final chapter. Three arguments are presented, admittedly sketchily and tentatively. The first considers what 'contemporary' means in contemporary history, and suggests that it has to do with a prevailing idiom. The second asks what is 'political' in political catchphrases, and considers responses with various dictionaries of political expressions in mind. And the third gives an account of the catchiness of catchphrases by unpacking how 'keywords' work—not, as might be expected, in Raymond Williams' (1976) sense, but as a device for organizing and searching texts.

These concluding arguments in Chapter 7 are obviously unequal to the complexity of the case studies which precede it. They do nevertheless set the ground for further such case studies and sharpening of concepts and methods.

2

'New Normal', 2001–2019

Sentences

The phrase 'new normal' caught on in 2001 and has proved extraordinarily popular and adaptable since. As a catchphrase, it offers a nice rhetorical way of summing up a situation and rounding off observations. However, its conceptual implications are rather more considerable than its rhetorical advantages. The phrase encapsulates a new concept of normality itself. Its purchase as a catchphrase has served to normalize that new concept of normality. This and the following two chapters flesh out these points, first by considering the career of the catchphrase and then by examining its relation to the concept of normality.

When I set about writing this chapter, the phrase was powerfully associated with social conditions following the Covid-19 outbreak. In fact, it evinced a remarkable escalation of usage after the World Health Organization declared the outbreak a pandemic on 11 March 2020. A Google search with the keyword 'new normal' in mid-October 2020 came up with 90.5 million results (45.2 million in the news category and 13.3 million in the video category), itself an indication of the scale of its usage. A search with 'new normal' <and> 'Covid-19' accounted for 88.1 million results (37.9 million news and 7.71 million videos). Similarly impressive numbers were obtained when joined with 'coronavirus' (49.7 million) and with 'pandemic' (47.4 million), at least some of which did not overlap with each other. The social conditions following the outbreak had evidently hardened as the immediate ground for the catchphrase, but not entirely. It has appeared with growing frequency for a couple of decades already, and even in the midst of the pandemic it was occasionally evoked for other contexts. But the Covid-19 social condition is the obvious juncture to begin from, before tracking its earlier career.

Making a beginning is a daunting task for this study. It makes sense to begin by noting some of the characteristic ways in which the catchphrase 'new normal' was used in the pandemic context. To do that meaningfully, some illustrative examples of usage are needed. But the areas of usage were

Political Catchphrases and Contemporary History. Suman Gupta, Oxford University Press.
© Suman Gupta (2022). DOI: 10.1093/oso/9780192863690.003.0002

extraordinarily various. The phrase appeared thus (often prominently, as titles, mottos, or leitmotifs) in governmental documents, academic publications, industry reports, information pamphlets, campaign posters, commercials, documentaries, movies, television series, songs, fictional texts, artworks, tweets, blogs, internet profiles, etc. The registers, modes, and contexts of usage were dauntingly numerous. Nevertheless, some effort at clarifying its connotations before tracking its career seems expedient, and news reports provide a reasonable if limited resource. As the Google search numbers show, news reports accounted for nearly half the results of usage. Such reports usually cover diverse areas of social life (politics, economy, culture, sports, crime, education, fashion, celebrity, etc.) at various levels (city, regional, national, international). Taken together, news reports are amongst the most widely read and most regularly produced texts. They usually maintain a direct address, are circumspect about both specialist vocabulary and colloquialisms, and eschew convoluted constructions while courting rhetorical appeals. Linguistic usage in news reports, I suspect, slips continuously into everyday conversations. For the purposes of these observations, news reports are texts that are likely to be found by a news aggregator like Google's.

So, I searched for sentences using 'new normal' in the reports of two British national dailies, *The Guardian* and *The Telegraph*, for the period 25 July–25 September 2020. In this period the initial shock of the Covid-19 outbreak and immediate lockdowns were done with. The consequent changes in social arrangements still seemed strange but were nevertheless routine; a mixture of sulky trepidation and grudging acceptance prevailed. The outbreak continued with rises and falls in numbers. Reports in these British dailies were not very different from English-language reports from other countries: the USA, Canada, Australia, India, South Africa, etc. In a similar vein, 'the new normal' had found its way translated into other languages—for instance, into German (*neue Normalität*), Portuguese (*novo normal*), Spanish (*nuevo normal*) news, as far as I am aware. My collection of sentences, sieving out obviously like constructions, follows. The newspaper, date of appearance, and general theme are marked for each; the specific authorship and context are not. The emphasis here is on phrase usage in a general way rather than with individual quirks. The list is divided into four sections, three to do with the pandemic and the fourth to do with other issues. Some of the distinctive rhetorical features of sentences are also noted parenthetically. The sentences are numbered for easy reference, there are 54 altogether.

1. The Covid-19 'new normal' as an unfamiliar prevailing situation

1.01: 'In five-inch heels and a lace pencil skirt, Milan is taking baby steps into *the new normal*' (*The Guardian*, 24 Sept.) [theme: fashion; metaphors: baby steps]

1.02: 'Pubs have been adapting to *the "new normal"* over the past few months and will continue to do so, but pubs were struggling to break even before today and these latest restrictions may push some to breaking point' (*The Guardian*, 22 Sept. 2020) [theme: pubs; metaphors: adapt/breaking point]

1.03: 'Welby writes that *the "new normal* of living with Covid-19 will only be sustainable–or even endurable—if we challenge our addiction to centralisation and go back to an age-old principle: only do centrally what must be done centrally"' (*The Guardian*, 15 Sept. 2020) [theme: religion; metaphors: sustainable—endurable]

1.04: 'Children in Scotland went back to school in August, so Vincent-Smith has had "a head start" on *the new normal*, adjusting to staggered school runs, adding masks, wipes and hand sanitiser to backpacks, and working out how the family can reacclimatise' (*The Guardian,* 5 Sept. 2020) [theme: schools; metaphor: reacclimatise/head start]

1.05: 'As much of the rest of the country starts to try and live *a new normal*, vulnerable groups like the senior citizens risk being left behind—as fears of the virus remain for them' (*The Guardian*, 3 Sept. 2020) [theme: the elderly; metaphor: left behind]

1.06: 'The *new normal* needs a new politics' (*The Guardian*, 26 July 2020) [theme: politics; repetition: new]

1.07: 'The *new normal* is beginning to be felt' (*The Guardian* 25 July 2020) [theme: business; metaphor: feeling]

1.08: 'The economy now needs to be free to adjust to *the "new normal"*, whatever that may be, and losing some jobs while creating others is a necessary part of that process' (*The Telegraph*, 24 Sept. 2020) [theme: economy; metaphor: free to adjust; note hedge]

1.09: 'It's the *new normal*. Or the new abnormal' (*The Telegraph*, 24 Sept. 2020) [theme: culture/films; antonym: abnormal]

1.10: 'As we settle in for what might be a long haul through the autumn and winter, time devoted to picking high-quality stocks

that can adapt to a challenging new normal will repay the investment' (*The Telegraph* 31 Aug. 2020) [theme: economy; metaphor: adapt/challenging]

1.11: 'Indeed, a number of new companies will make their money out of this so-called "*new normal*"' (*The Telegraph*, 29 Aug. 2020) [theme: economy; hedge]

1.12: 'The *new normal* may mean staff coming in for a couple of days a week—just don't expect your own space' [*The Telegraph*, 28 Aug. 2020) [theme: work; hedge]

1.13: 'Lockdown meant a move away from uncomfortable underwires and itchy lace—but what now in the "*new normal*"? (*The Telegraph*, 11 Aug. 2020) [theme: fashion; question]

1.14: 'One face mask is not enough if you are easing into a *new normal*, it's time to get one for every occasion' (*The Telegraph*, 4 Aug. 2020) [theme: fashion; metaphor: easing into]

1.15: 'A ban on backstroke, weightlifting "pods" and some extreme HIIT shelved. Lucy Dunn gets the low-down on the "*new normal*" for gyms' (*The Telegraph*, 26 July 2020) [theme: fitness; metaphor: low-down]

2. The Covid-19 new normal as a settled situation

2.01: 'The usually warm connection between artists and audience at the end of a show is lost in the chill of *the new normal*' (*The Guardian*, 20 Sept. 2020) [theme: art; metaphor: chill]

2.02: '*That's not necessarily at all sustainable, it's not where we want* the new normal *to be, but it does suggest more flexibility of how we run our key operations*' [*The Guardian*, 1 Sept. 2020) [theme: business; metaphor: place-where to be/ sustainable]

2.03: 'For many in Papua New Guinea, Covid-19's "*Niupela Pasin*"— *new normal*—is a return to the old ways' (*The Guardian*, 20 Aug. 2020) [theme: economy; metaphor: place-return to]

2.04: 'The first must-have look of the "*new normal*" doesn't have a designer label, or a hefty price tag' (*The Guardian*, 11 Aug. 2020) [theme: fashion; metaphor: look]

2.05: 'People sleeping rough and living on the streets doesn't have to be part of *the new normal*' (*The Guardian*, 11 Aug. 2020) [theme: homelessness; metaphor: place: to be part]

2.06: 'My summer romance with *the new normal* is consciously uncoupling—goodbye summer and goodbye freedom, it was nice while it lasted' (*The Telegraph*, 21 Sept. 2020) [theme: new measures; metaphor: romance]

2.07: 'Nevertheless, there are a glut of chic and clever jewellery launches to bring a little sparkle to the *new normal*' (*The Telegraph*, 14 Sept. 2020) [theme: fashion; metaphor: sparkle]

2.08: 'In a post-Covid world, you can rely on Singapore Airlines as it adjusts its award-winning services to accommodate the "*new normal*"' (*The Telegraph*, 10 Sept. 2020) [theme; metaphor: accommodate]

2.09: 'In Switzerland, the atmosphere was as normal as I have experienced since lockdown began—not *new normal*, but normal normal' (*The Telegraph*, 8 Sept. 2020) [theme: travel; repetition and antonym]

2.10: 'The "*new normal*" means my school run has never been so chilled' (*The Telegraph*, 6 Sept. 2020) [theme: daily life; metaphor: chilled]

2.11: 'Forms and bureaucracy dictate our *new normal*, leaving us more infantilised than ever before' (*The Telegraph*, 29 Aug. 2020) [theme: measures; metaphor: infantilised]

2.12: '*This* "*new normal*" is really quite depressing, and I fear the queues, the masks, and the virtue-signalling (our youngest was told off by one disapproving lady for daring to touch a box of fudge in a gift shop) are going to last for years' (*The Telegraph*, 28 Aug. 2020) [theme: daily life; categorical/note article 'this']

2.13: 'Britain's appetite for the *new normal* will leave us all with a stomach ache' (*The Telegraph*, 15 Aug. 2020) [theme: food; metaphor: appetite]

2.14: 'But, in general, the "*new normal*" was increasingly hard to distinguish from the old one' (*The Telegraph*, 12 Aug. 2020) [theme: New Zealand measures; metaphor: distinguish]

2.15: 'Face masks become *new normal* as figures show almost everyone wearing one outside the home' [*The Telegraph*, 6 Aug. 2020) [theme: measures; categorical change]

2.16: 'Fitness firms struggle to shape up for the *new normal*' (*The Telegraph*, 2 Aug. 2020) [theme: business; metaphor: shape up]

2.17: 'The carefree mixture of casual and formal is *the new normal*' (*The Telegraph*, 1 Aug. 2020) [theme: fashion; categorical]

2.18: 'Stringent rules have kept infection rates low in the Canary Islands where tourists have been returning to the *new normal* of holidays' (*The Telegraph*, 27 July 2020) [theme: travel; metaphor: returning-place]

2.19: 'In a turbulent world, giving workers the chance to plan ahead will make the hideous "*new normal*" more bearable' (*The Telegraph*, 27 July 2020) [theme: work; metaphor: hideous/bearable]

2.20: 'After such a long period of time working from home, many of us have developed new ways of working and fallen into new routines, and while lots of workers are looking forward to getting "back to normal", many feel like *the* "*new normal*" will never be the same as it once was' (*The Telegraph*, 27 July 2020) [theme: work; metaphor: back to]

3. The Covid-19 new normal as an imminent situation

3.01: 'The sources of our economic growth and the kinds of jobs we create will adapt and evolve to *the new normal*' (*The Guardian*, 24 Sept. 2020) [theme: economy; metaphors: evolve and adapt]

3.02: [About Revenge Porn Helpline cases] 'But while the number of cases has dropped slightly since April, they remain higher than in any previous year, prompting campaigners to warn of a "*new normal*" post lockdown' (*The Guardian*, 15 Sept. 2020) [theme: sex; metaphor: warn-danger]

3.03: 'The door is open for more public investment in climate mitigation and adaptation, and there is a growing chorus demanding that *the new normal* be "green"' (*The Guardian*, 15 Sept. 2020) [theme: climate change; metaphor: chorus-demanding]

3.04: 'He expects *the new normal* to herald "a resurgence of the fan as a sort of face mask", complete with old-age flirting techniques' (*The Guardian*, 3 Sept. 2020) [theme: fashion; metaphor: herald]

3.05: 'With optimism and proactivity at its core, our back-to-school pro-gramme of thoughtful, practical Guardian Masterclasses throws a golden autumnal light on what the "*new normal*" truly means: a chance to reach for something better than the ordinary' (*The*

Guardian, 31 August 2020) [theme: education; metaphor: golden autumnal light]

3.06: 'Or maybe not: maybe as the new world becomes *the new normal* we'll want to hurry forward, away from our first intuitions of change, shedding them behind us because nothing's so stale as the news from last week' (*The Guardian*, 1 Aug. 2020) [theme: books; metaphor: place-hurry forward/shedding/stale]

3.07: 'And now, with measures easing, it is becoming clear how our pandemic-inflected sense of style may translate into life in the "new normal"' (*The Guardian*, 26 July 2020) [theme: fashion; metaphor: translate]

3.08: 'It is, of course, not that simple, and there are many variations which will involve a mix of control measures as well as vaccines, but at least there will (hopefully) be more options and opportunities on the road towards *a "new normal"* if we already start preparing the ground, and build constituencies and public confidence towards a new future' (*The Telegraph*, 13 Sept. 2020) [theme: vaccines; metaphor: road/ground/build]

3.09: 'Mitchell and his wife Flo escaped London for his mother-in-law's home in Hampshire as they planned for their *new normal*' (*The Telegraph*, 22 Sept. 2020) (theme: sports; metaphor: plan; note possessive 'their']

3.10: 'It is time to move to what will become our *new normal* for as long as the coronavirus is with us' (*The Telegraph*, 16 Sept. 2020) [theme: measures; personalization of coronavirus]

3.11: 'As pandemic restrictions ease, three experts explain how we can best transition to the *new normal*' (*The Telegraph*, 25 July 2020) [theme: mental health; metaphor: transition]

4. Other new normals

4.01: 'Extreme weather is *the new normal*' (*The Guardian*, 16 Aug. 2020) [theme: climate change; categorical]

4.02: '*The new normal* is abnormal in the extreme, a city where library books have been pulled from the shelves and a protest song banned in schools' (*The Guardian*, 1 Aug.) [theme: Hong Kong security law; antonym: abnormal]

4.03: 'In the UK, overweight is *the new normal*' (*The Guardian*, 26 July 2020) [theme: health; categorical]

4.04: 'Russian influence in the UK is "*the new normal*"' (*The Guardian*, 20 July 2020) [theme: politics; categorical]

4.05: 'Such preoccupations are absolutely typical of *the new normal*, in which a propagandistic diversity agenda is not only touted as basic fact but also as the basis on which we must all work, think and teach' (*The Telegraph*, 27 Sept. 2020) [theme: politics/diversity training; synonym: typical/normal]

4.06: 'It is now widely believed that depressed aggregate demand, accompanied by ultra-low inflation and near-zero interest rates, is *the new normal*' (*The Telegraph*, 20 Sept. 2020) [theme: politics; categorical]

4.07: 'Dutch-style roundabouts prioritising cyclists could become the *new normal* after more planning applications submitted' (*The Telegraph*, 19 Aug. 2020) [theme: transport; categorical/tentative]

4.08: 'Air conditioning could become "*new normal*" as Brits endure unseasonably hot nights' (*The Telegraph*, 12 Aug. 2020) [theme: weather; categorical tentative]

With those sentences in view, some general inferences can be made. These concern the denotative usage of the catchphrase, and the substantive association of the catchphrase with the pandemic context.

Denotation

Repeated usage is the defining characteristic of a catchphrase like 'new normal', as it is for slogans, proverbs, aphorisms, dictums, etc. Frequent repetition has not made this catchphrase passé—it is not a cliché yet. Those Google search figures indicate that the density and frequency of its repetition in relation to the Covid-19 context over at least seven months were remarkable. In this respect, the sentences suggest three observations.

First, a particular consanguinity was perceived between the Covid-19 context and the expression 'new normal'. So long as the former prevailed, the latter was associated with it. In fact, over the period covered in the examples, and indeed earlier and since, the 'new normal' became substitutable for the Covid-19 context. In many of the sentences, 'new normal' simply refers immediately to the Covid-19 context (starting with 1.01, 1.02, 1.04, 1.06, 1.14, and onwards).

The 'new normal' had come to denote this context and was often used as if to name it.

Second, using the 'new normal' thus was convenient because it allowed for constant adaptation to different themes, seemingly giving a distinctive turn to the catchphrase and a distinctive angle on the theme. In other words, it immediately foregrounded the common denominator arising from the Covid-19 context across quite disparate areas. The sentences cover almost every area of news reporting: politics (1.06, 2.11, 2.14, 3.03), economy (1.10, 1.11, 3.01), and business/work (1.02, 1.07, 1.12, 2.02, 2.19, 2.20), fashion (1.01, 1.13, 2.04, 2.07, 2.17, 3.04, 3.07), education (1.04, 2.10, 3.05), culture and arts (2.01, 2.13, 3.02, 3.06), travel (2.08, 2.09, 2.18), sport and fitness (1.15, 2.16, 3.09, 3.11), etc. For every theme there was a precedent situation and an obtaining situation arising from the outbreak, and for every theme the phrase 'new normal' worked as shorthand to indicate that that was the connection. At the same time, the catchphrase also showed that this shift was not specific to any given theme but cut across others at the same time.

Third, denotative usage and its peculiar convenience did not mean that the catchphrase became exclusively attached to the Covid-19 context. The 'new normal' was already a burgeoning catchphrase before the outbreak of the pandemic (much of its earlier career is discussed further on in the chapter). It may be surmised that some remnant or accrual from past contexts was available, however unobtrusively, in its usage within the Covid-19 context (an argument which occupies the next chapter). Within the period covered by the sentences given in the previous section, the catchphrase continued to be used for other contexts (as in the sentences in section 4). In fact, a kind of hierarchy of usage developed. In itself, the catchphrase was predominantly and emphatically attached to the Covid-19 context. When featuring elsewhere, its usage appeared as a deliberate labelling, a new recruitment to the precincts of the catchphrase. Thus, the sentences in section 4 are mainly categorical statements, of the form such-and-such *is* or could *be* the new normal: 'Extreme weather *is* the new normal (4.01); 'overweight *is* the new normal' (4.03); 'Russian influence ... *is* the new normal' (4.04); 'Air conditioning ... could *become* the new normal' (4.08). In brief, there was a core usage of the moment and a range of other usages around the core. This has, in fact, been a feature of the catchphrase's career from 2001 onwards.

Substance

As already observed, those sentences suggest that in some way the catchphrase 'new normal' was just *right* for the situation faced after the Covid-19 outbreak.

No doubt repetition played a part here. Repeated usage was probably set up by initial categorical statements, such as 'Living with Covid-19 *is* the new normal'; 'Living with the pandemic will *become* the new normal'. With incessant repetition the categorical could be dropped and the phrase became denotative for a while. This is much like naming or renaming. If Dick decided to start calling Jack 'Slug' and many others followed Dick's cue, then poor Jack would be in some danger of becoming better known as 'Slug'.

But there was more than mere repetition to the strong association of the catchphrase with the pandemic. It was a meaningful association. The experience of the pandemic context had a substantive bearing on the ordinary-language concept of normality. I mean 'ordinary' as opposed to 'specialist' concepts of normality, which are examined at some length in Chapter 4. The relevant ordinary-language dictionary definition of 'normality', appears under General Uses I.1.a in the Oxford English Dictionary (2020): 'Constituting or conforming to a type or standard; regular, usual, typical; ordinary, conventional. (The usual sense.)' With that in mind, the examples given offer some insight into how this definition was given a distinctive turn by the catchphrase.

First, my division of the sentences related to Covid-19 into three parts is already based on a conceptual consideration. That the 'new normal' can be conceived as, at the same time, describing a settled situation, an unfamiliar prevailing situation, and an imminent situation gives a curiously abstract construction to the ordinary concept of normality. Some of the sentences suggest an oxymoron or contradiction in the catchphrase, and I pick those up further on, but that is not quite my immediate point. It is not the defamiliarization or subversion of normality that these sentences principally suggest, but rather the normality of the 'new normal'. The point seems to be that the *concept* of normality in the Covid-19 context is as standard, typical, usual, regular, conventional, etc. as it ordinarily is; it is just that *realities* are yet to conform or are only occasionally conforming with this concept. It is as if the *concept* of normal life has been somewhat dissociated from the *reality* of living, and moreover the *concept* is more real than the *reality* and it is up to *reality* to catch up with the *concept*. The concept seems to have overtaken the reality. This is an odd if unobtrusive turn given by the catchphrase. It contrasts with the dictionary definition, which suggests that the concept is a description of reality: what is normal is such because the realities of living (behaviours, activities, etc.) make it so. We may say that the 'new normal' suggests a dissociated sensibility towards normality rather than a contradiction or paradox. The concept of normality assumes precedence over the reality. This is obvious in the construction of sentences/clauses such as: 'The new normal needs a new politics' (1.06); 'The new normal is beginning to be felt' (1.07); 'it's not where we want

the new normal to be' (2.02); 'to accommodate the new normal' (2.08); 'shape up for the new normal' (2.16), and the like. The concept of such normality already obtains as normal, these suggest, but such that the all-comprehending realities of politics, feeling, fitting, being, living are somewhat off norm.

Second, the curious notion that the living reality is off norm from the current Covid-19 'new normal' is conveyed in those sentences without grammatical infelicity or obvious incoherence. The sentences seem, so to speak, quite normal. They do not jar. It appears to me that the frequent use of metaphors serves to gloss over any possible awkwardness in syntax or meaning. Consider metaphors like these in relation to the 'new normal' of the Covid-19 context: [1] 'taking baby steps' (1.01), 'infantilised' (2.11); [2] 'adapt' (1.02, 1.10, 3.01), 'evolve' (3.01); [3] 'sustainable' (1.03, 2.02), 'adjust' (1.08), 'reacclimatize' (1.04); [4] being 'left behind' (1.08), 'return' (2.03, 2.18, 2.20), 'road towards' (3.08), 'hurry forward' (3.06), 'herald' (3.04); [5] 'translate' (3.07), 'transition' (3.11); [6] 'easing into' (1.14), 'be part of' (2.05), 'accommodate' (2.08), 'shape up' (2.16); [7] 'chill' (2.01, 2.10), 'appetite' (2.13), 'hideous' (2.19), 'golden autumnal light' (3.05). These quietly and with piecemeal effect associate the *concept* of the normality in 'new normal' to *real* experiences and processes. They are likely to evoke memories and images of, respectively: [1] childhood, [2] natural changes, [3] environments or habitats, [4] locations and directions of travel, [5] state changes, [6] shapes and spaces, [7] sensations. The awkwardness of the concept of new *normality* overtaking the reality of habituated or familiar *normal* life is rendered unexceptional—is normalized— by these metaphors. Put another way, the habituated and familiar normal life evoked by the metaphors serve to ground the concept of the *new* normal. As a figure of speech, metaphors often render the abstract tangible and hold ambivalences together. However, the catchphrase 'new normal' is not in itself obviously metaphorical. With specific associations, of course, it could be: if the 'normal' were visualized in the geometric and original sense of 'perpendicular', or in terms of a statistical graph, it may well operate as a metaphor in itself. By and large though, in everyday communications, apart from mathematicians and statisticians few take that turn. Despite its relatively recent advent into everyday vocabulary (in the course of the nineteenth century), 'normal' is now firmly established as almost a pre-conceptual abstraction (Chapter 4 dwells on this process). It is simply taken as making sense without referring straightforwardly to anything. But the phrase 'new normal' might, if one were to pause on it, disturb the way in which 'normal' simply makes sense. That is where the metaphors come in, to smooth away such disturbance. The

catchphrase seems to invite metaphors and constitutes its relevance through metaphors.

Third, simply by being used so frequently, catchphrases attached to specific contexts do loose some of their glib transparency at times and seem opaque. That is to say, they are then not just used to say something, they draw attention to themselves and to how that something is being said. With time, most catchphrases, unless adapted to other contexts and of-the-moment issues, tend to be regarded as clichés. This quality of flickering opacity in catchphrases is apt to lead to wordplay in their usage, or tentative or conditional usage. And that kind of wordplay or tentativeness could imply a reconsideration of the issue to which the catchphrase refers. That is to say, the substantive bearing of the catchphrase on the context is brought to attention as a mutual modification. Pausing and paying attention to the catchphrase could mean reconsidering the issue it is applied to. This kind of tentative usage and wordplay on 'new normal' is variously found in the sentences. Tentativeness is indicated often by putting 'new normal' in quotation marks: around a third of the sentences do this (1.02, 1.08, 1.13, 1.15, 2.03, 2.04, 2.08, 2.10, 2.12, 2.14, 2.19, 2.20, 3.05, 3.07, 3.08, 4.04, 4.08); in sentence 1.11, 'this so-called "new normal"' is doubly tentative. Tentativeness in this form could be by way of partially disowning the catchphrase while taking recourse to it, as if it were a reported phrase. That may be one way in which awareness of the catchphrase being a catchphrase is registered (i.e. this is in quotation marks because it is a catchphrase). Tentativeness could also be a way of doubting the aptness of the phrase or the reality of the Covid-19 situation itself. Wordplay around the 'new normal' in these sentences seems to underline the inadequacy of the catchphrase, or perhaps the irony of using it at this juncture. The counterpoint or antonym is used in this vein: 'It's the new normal. Or the new abnormal' (1.09—and yes, that is two sentences); 'not new normal, but normal normal' (2.09); 'the "new normal" was increasingly hard to distinguish from the old one' (2.14); 'The new normal is abnormal in the extreme' (4.02—not a Covid-19 instance). Despite these nuances, the main effect of such tentativeness or wordplay is to foreground the catchphraseness of the catchphrase, so to speak.

With these initial observations on the connotations of the catchphrase 'new normal' in media usage, I turn to its career from 2001 onwards, in the form of a contemporary historical narrative. In the remainder of this chapter, I focus on the period 2001–2019; in the next, I concentrate on 2020 alone, where the pandemic context is discussed in more detail.

9/11

The catchphrase 'new normal' has, I have noted already, an older provenance than the Covid-19 context. The Google n-gram of the phrase 'the new normal', tracking frequency of usage over time (by year) in a corpus of 8 million printed books from 1800 to the present is shown in Figure 2.1.

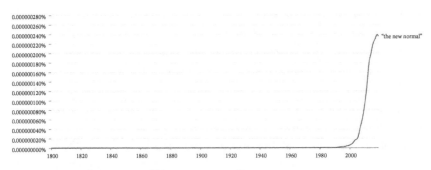

Fig. 2.1 Google n-gram of 'the new normal'.

Published books are not the obvious medium of catchphrase circulation; nevertheless, this is an indicative graph. Neither 'new' nor 'normal' are recently introduced words, but the phrase combining them appears from only just before 2000 and really took off shortly afterwards. This kind of Google n-gram graph is relatively rare, and seems to be obtained mainly with catchphrases and slogans: similar results, for instance, can be elicited with 'black is beautiful' or 'just do it'.

Prior to 2001, the phrase only had a limited purchase in financial accounting and business reportage. A *Time* magazine article of 1 August 1949 entitled, in tentative tones, 'New Normal?', reported on decreasing inflation and the health of stock values since World War 2, and noted General Electric's performance as 'possibly a bellwether of how good "normal" might be'. The title worked here at two levels. At one, it gestured towards the comprehensive social shift, across all areas, which resulted from the war. Tacitly, before the war life was normal; the war itself was presumably not normal; and the prevailing condition after it is possibly a 'new normal?'. At a more restricted level, for its immediate readership, the article pointed to the statistical normals (means and deviations) which describe the economic condition ... for stocks, for trading, for inflation, for interest rates, etc. That, in this instance, the phrase had a relatively specialist and a general import at the same time hints at its potential as a catchphrase. But, in fact, it did not become one over the next five

decades. It remained confined to business and accounting circles in the in-
terim, and that rarely too, and mostly fortuitously. In financial accounting
and forecasting, normals often have to be adjusted, not merely in response to
economic performance but in anticipation of extraneous factors which would
predictably impinge upon performance. That could include regime changes:
for instance, in taxation, regulation, institutional redefinition (such as, privati-
zation of public-sector companies), and criminalization or decriminalization
of trading practices. Under such circumstances, accountants would naturally
prepare forecasts according to a 'new normal' as against the prevailing or prior
normal. Such anticipated change in normal indicators would bear upon in-
vestor behaviours. The Google n-gram in Figure 2.1 shows some pick-up of
the phrase from the mid-1990s. Those generally take in the fortuitous or well-
defined use of the phrase in technical areas—mathematics and logic, data
science, finance, computing, geology, meteorology, etc.

The phrase became a catchphrase after the terrorist attacks in the USA of 9
September 2001 ('9/11' as it came to be known), repeatedly and increasingly
frequently used thereafter in media reports and programmes, speeches, policy
reports, academic papers, and so on. Its first significant use is attributed to Dick
Cheney, then vice president under President George W. Bush. In his remarks
to the Republican Governors Association of 25 October, he had observed:

> Homeland security is not a temporary measure just to meet one crisis. Many
> of the steps we have now been forced to take will become permanent in Amer-
> ican life. They represent an understanding of the world as it is, and dangers
> we must guard against perhaps for decades to come. I think of it as the new
> normalcy.

What that meant was described thus:

> To date, nearly 1,000 individuals have been arrested or detained here in
> our country during the course of this investigation. We're cutting terrorists
> off from their sources of funding by freezing millions of dollars in assets.
> Congress has passed important new legislation giving us modern methods to
> pursue the war on terror, while safeguarding the rights of law-abiding citizens.
> Tomorrow at the White House, President Bush will sign it into law.
>
> (Cheney 2001)

The phrase 'new normalcy' was numerously quoted in newspaper reports over
the following months. Before long it became 'new normal' rather than 'new

normalcy', and remained associated with Dick Cheney's announcement while becoming a general appellation—or coming to denote—the post 9/11 social condition. But let's pause on Cheney's 'new normalcy' before carrying on with the 'new normal'.

Cheney may have been well versed in the history of Republican election campaigns or, more likely, not—in any case, his choice of words came with an apposite echo from there. The first presidential elections after World War 1 in 1920 featured 'back to normalcy' as the campaign slogan of Republican candidate, and eventual victor, Warren G. Harding. A political slogan usually represents or is associated with the agenda of a government, institution, political party, movement, formation, or alignment, whereas a political catchphrase or catchword is more fluidly and repeatedly employed by various users in different and emerging contexts. 'Back to normalcy' became Harding's 1920 Republican slogan, and 'normalcy' caught on in a larger way. As William Safire (1968) observed in his compendium of political slogans and catchphrases: '"Normalcy" was a *catchword*; "not nostrums but normalcy" a *catchphrase*; "back to normalcy" a *slogan*'—all originating from Harding and taking a life of their own. The awkwardness of the word 'normalcy' gave it a distinctive and therefore memorable ring: 'Harding's use of the word might have been a mistake; some say the word was written "normality" and fluffed, but if true the mistake was fortuitous: the word caught on to symbolize not only a campaign but an era' (Safire 1968: 291). The era in question, thus symbolized, was robustly characterized by Karl Shriftgiesser (1948: 37) a decade or so after it ended: 'return to normalcy, to use the gauche word of Warren Harding's that became the destructive shibboleth by which the American public was led over the peak and down the hill into the valley of the Great Depression'. At the optimistic campaigning juncture in 1920, 'back to normalcy' was meant to counter the post-war weariness that gripped the American public—it suggested a restoration or return of some sort. In that sense, its echo in Cheney's 'new normalcy' was ironic: after 9/11, for Cheney and more widely, it suggested quite the opposite of any restoration or return—it was an announcement of no-return. It exhorted the American public to 'buckle down and get used to a new regime'. And yet, perhaps the irony is not as pointed as it might seem. In 1920, 'back to normalcy' was less straightforward than it sounded. It did not, in fact, suggest a return to or restoration of pre-war conditions, or to pre-Wilson Republicanism. In a detailed account of the 1920 campaign historian Wesley Bagby (1962: 158) says:

That Harding sensed this popular feeling was proved by his famous phrases: 'What America needs is not heroics but healing, not surgery but serenity, not nostrums but normalcy'. The world needed, he said, to steady down 'once more to regularity'. It was time for change.

In this reading there's no return or restoration in going 'back to normalcy' then, but rather it answered to a desire for change from the condition of war. 'Normalcy' was used here in the loosely medical sense of being healthy, as a counterpoint of abnormal. It was associated with healing, serenity, good medicine (rather than nostrums), and regularity. And in that sense too, its echo in Cheney's 'new normalcy' still rang as ironic: it went, after all, hand in hand with George W. Bush's declaration of a war, a 'war on terror'. That a 'war on terror' established a 'new normalcy' sounded like an indefinite deferral of healing, serenity, regularity—bidding goodbye to all that.

Cheney's Hardingesque turn and its ironies petered out as 'new normalcy' was replaced by the more pat 'new normal', but the thrust of his announcement remained with this phrase. Why, we may ask, the 'new normal' rather than the more grammatically natural 'new normality'? 'Normality' is the noun form of the adjective sense of 'normal', suggesting a condition; using 'normal' as noun gives the word a technical or specialist air—as if the term is defined as a thing or object in itself. But in the catchphrase it is obviously not that. Nevertheless, the technical or specialist turn is a nuance of the catchphrase, and perhaps the advantages of that nuance become apparent in the contexts of its usage. Alternatively, the 'normal' in 'new normal' possibly rings as a dangling adjective, inviting a noun to be added after it according to context. In terms of context, after Cheney's 'new normalcy', through the period of the invasion of Iraq to Barack Obama's election as president in 2008, the 'new normal' predominantly referred to the post-9/11 condition. That is, it was associated with the various adjustments in political and social life which *resulted* from the terrorist attacks—especially in the USA, and gradually across the Anglophone sphere and further. As such, the suggestiveness of the phrase, anchored to 9/11, seemed to spread from context to context, area to area.

Thus, quite soon after Cheney's 'new normalcy', on 14 November 2001, the popular National Public Radio's (NPR) science and health programme *The Infinite Mind*, created by Bill Lichtenstein and hosted by psychiatrist Fred Goodwin, broadcast an episode entitled *The New Normal?* This addressed mental health problems following the terrorist attack. Goodwin introduced the programme thus:

This show is about the new normal, but to address that question in the current context is quite complex. Generally, in mental health, we differentiate normal from illness by how long the symptoms continue after a stress or trauma. For example, the full range of depressive symptoms is normal in a grief reaction, but if they go on month after month, grief has slipped into clinical depression. But how can you distinguish normal from disorder when the precipitating stresses continue; when week after week, there's another stressing event and we're told by officials that such events are likely to continue? There's a real challenge here for the mental health community to separate normal reactions to world events from the clinical symptoms of a disorder requiring intervention and treatment.

(NPR Programme Transcript: 2)

Thus, a conceptualization of the normal other than in statistical or accounting terms, in terms of health and illness, was recruited into the 'new normal'. The argument was: where departure from normal behaviour is usually gauged in relation to a specific stressing event, for an ongoing and continuous appearance of stressing events a different approach is needed. Having constant cause for stress needs to be conceived of as the 'new normal'. In a way, the distinction between health (normality) and illness is blurred in this new normal, wherein possible distemper due to ongoing stress is the normality. Importantly, for this 'new normal' the battleground is the mind. The *normal* mental-health situation is given as the mind being interfered with by local stresses, like a bereavement, and being restored where necessary by watchful psychiatrists. In the *new normal*, however, the mind is under constant attack from stressful 'world events', and the psychiatrists are fighting a continuous barrage of stresses by their interventions. The mind seems to become a general space where world events and psychiatrists battle to maintain a balance that is the 'new normal'.

Taking a different direction, but more predictably from Cheney's 'new normalcy', in August 2003 the NGO Lawyers Committee for Human Rights (now called Human Rights First) published a report entitled *Assessing the New Normal: Liberty and Security for the Post-September 11 United States*. By this time the 'war on terror' had morphed into the invasion of Iraq, which began in March 2003. The various deceptions and mendacities which the George W. Bush administration in the USA and the Tony Blair government in the UK had pushed to justify the invasion were beginning to seem unjustifiable. There were suspicions of human rights abuses and atrocities being committed by military and private security companies commissioned by the government (the Abu

Ghraib torture photographs would appear not long afterwards). The growing count of civilian casualties in Iraq grated, albeit less than the relatively small numbers of casualties among US military personnel. Though not directed specifically to the Iraq-invasion context, this report was evidently grounded in this troubled time. Its thrust is best conveyed briefly in its Executive Summary:

> *Assessing the New Normal*, the third in a series of reports, documents the continuing erosion of basic human rights protections under U.S. law and policy since September 11. Today, two years after the attacks, it is no longer possible to view these changes as aberrant parts of an emergency response. Rather, the expansion of executive power and abandonment of established civil and criminal procedures have become part of a 'new normal' in American life. The new normal, defined in part by the loss of particular freedoms for some, is as troubling for its detachment from the rule of law as a whole. The U.S. government can no longer promise that individuals will be governed by known principles of conduct, applied equally in all cases, and administered by independent courts. As this report shows, in a growing number of cases, legal safeguards are now observed only insofar as they are consistent with the chosen ends of power.
>
> (Lawyers Committee for Human Rights 2003: vii)

The areas where 'rule of law' had been compromised, according to the report, included uneven access to courts and extra-judicial proceedings where legal recourse should be guaranteed; infringement of privacy protections and un-regulated covert operations by government agencies; weaponizing the civil immigration system and undermining established procedure; and, especially, extending infringements of 'rule of law' in the international domain. Much has been written about these developments since. The question that arises here is: what did the particular phrase 'new normal' convey here? The point the report emphasized was that a 'detachment from the rule of law as a whole' had settled in permanently and could no longer be regarded as pertaining to a temporary emergency—a state of exception. That seems to place adherence to the 'rule of law' as the 'normal' condition; and correspondingly, departure from 'rule of law' was pegged as the 'new normal'. As with the psychiatric 'new normal' of the *Infinite Mind* episode noted earlier, the phrase makes sense as a departure from an erstwhile idea of what's 'normal'. The normality of 'rule of law' is a somewhat complicated matter. Let's say, as a rule of thumb, that 'rule of law' is understood as the consistent and coherent application of some

fundamental principles of liberal jurisprudence for all proceedings within a given state jurisdiction (taking the formal or thin description of 'rule of law' in Tamanaha 2004). The normal legal condition according to 'rule of law' may then be understood in two somewhat different ways: one, a condition where comprehensive application of those principles is maintained in *practice* (i.e. normal-in-practice); or two, a condition where there's consensus on a conceptual system based on those principles to which practice should adhere (i.e. normal-in-concept). This distinction is not quite nit-picking. It is difficult to feel convinced that 'rule of law' has ever really been consistently normal-in-practice anywhere, including in the USA; it is easier to maintain that 'rule of law' as normal-in-concept has been consensually held in formally liberal states with variable effects on practice. In this sense, the normal is not quite an ideal and nor is it quite a reality; this is normal in the sense that some system of 'rule of law' is held as normative. This report made the argument that both consensus on the concept and adherence to the practice of 'rule of law' had been undermined—hence, 'detachment from the rule of law as a whole'. In this sense, the 'new normal' was not so much a departure from or an alternative to but a negation of the 'normal'.

By 2005, the 'new normal' seemed well grounded as a catchphrase referring to—almost denoting—the post-9/11 social condition. But from that core a broader set of connotations were extended to the phrase, as if its implications were being generalized and could be delinked from the post-9/11 social condition. This was only possible, of course, given that it was considered as linked in the first instance. In an interesting way, an encyclopaedia-like description of the phrase in a 2005 academic paper showed precisely how this linking and delinking works:

The new normal was a term that emerged in public discourse following the 9/11 terrorist attacks. It came to signify both a broader public understanding of new risks, and specific organizational responses to that risk, such as risk-avoidance processes and procedures. The new normal, for example, was often used to describe heightened airline safety, including more rigorous inspections of passengers. It is applied to new antiterrorism laws by civil liberty advocates and to the artistic, literary, and musical tributes to the 9/11 victims. Observers have noted that new normal involves the public stockpiling of antibiotics and gas masks, heightened anxiety and stress-related illness, and acts of civility and selflessness that emerged following the 9/11 attacks.

New normal, then, represents a broadly reconstituted order that incorporates new understandings and interpretations of a crisis into a revised status quo.

(Sellnow et al. 2005: 169)

That last sentence is an enactment of delinking: it's a generalization which deliberately decontextualizes the phrase from its 9/11 moorings and attaches it to abstract concepts of 'order' and 'crisis'. Quite naturally, the next paragraph then moves to a systems-theory description of these concepts, and effectively recruits the phrase away from the 9/11 context to more fluid application to organizations, groups, etc. But the 9/11 context was still firmly attached to it as a dominant core of its associations, around which other considerations of normality and norms could be visualized as a diaphanous penumbra, linked and yet liberated or at least delinkable. Indicatively, on the fourth anniversary of 9/11, CNN/ *USA Today*/GALLUP released an attitude survey that found that:

most Americans feel that neither the country nor their own lives have fully returned to normal since terrorists killed nearly 3,000 people on Sept. 11, 2001. [...] Americans appear a bit more pessimistic now than they were then about the likelihood that normalcy will ever be fully restored to the country or to their own lives.

(Saad 2005)

While that dominant sense remained attached, opportunistic employment of the catchphrase appeared in a range of relatively momentary or marginal debates in this period—not less important debates, but receiving less sustained attention then. Reports on climate change took recourse to it at times, as did those on health concerns (especially increased incidence of obesity), and on growing habituation to digital applications. An art exhibition entitled *The New Normal*, curated by Michael Connor, was put together in 2008 and then toured in various galleries in the USA, Canada, and Spain till 2010. Connor's essay on the theme in the attendant book (Connor et al. 2008) began with Cheney's speech and the post-9/11 context and then broadened the discussion, via chosen artworks, to everyday life. Connor (and putatively the artworks) paused, on the one hand, on life under continuous surveillance, and, on the other hand, voluntary and involuntary data-sharing by individuals using new digital technologies. The essay observed optimistically that 'disclosure is a game with its own rules and aesthetic codes' (15) and recommended the exhibition as an investigation of these rules and codes. So, the trace of the catchphrase from

Dick Cheney's 9/11 pronouncement remained, and yet, also seemed diluted by 2008.

Financial crisis 2007–2008

However, the catchphrase's occasional appearance in business and accounting circles prior to 9/11, which had receded into the background for a while, made a decisive return. It reappeared in financial circles with reference to and yet drawing away from post-9/11 associations, and gradually congealed around the 2007–2008 financial crisis. Gradually, its denotative significance shifted from 9/11 to the financial crisis. By 2009–2010, the 'new normal' immediately signified the financial crisis and regimes of perpetual austerity rather than post-9/11 and war-on-terror regimes.

This shift took place most indicatively in the relentlessly motivated realms of financial speculation, and started well before the financial crisis of 2007–2008. It appeared, in fact, with the slump following the terrorist attacks and, more importantly, the bursting of the dot-com bubble between 2000 and 2002. After dizzying growth in the share values of new technology start-ups through the 1990s, they plummeted quickly within two years. Online companies either went out of business or had to find ways around having their valuations slashed savagely (accounts of the time include Perkins and Perkins 2001; Cellan-Jones 2001; and Malmsten et al. 2002). In the April 2003 issue of the finance magazine *Fast Company*, technology investor Roger McNamee announced the 'New Normal' following the dot-com crash (capitalized: it was the theme of that issue). This referred to an investment environment in which profits could be secured again from the sector, given its emerging and promising character. The thrust of this upbeat announcement depended on McNamee's own successful portfolio as an investor on behalf of various companies, especially through Integral Capital Partners, which he had co-founded. In an interview in that *Fast Company* issue, he spoke of an 'old normal' in the 1980s and 1990s when the new dot-com companies provided an exciting and relatively unregulated field of adventurous investing with quick fortunes being made, which led to that precipitate crash. In the emerging New Normal from 2003, McNamee observed, the technology sector promised robust, regulated, and long-term growth, and offered propitious prospects for investors—as his own portfolio proved. 'The '90s *were not normal*,' he announced. 'The thing I am most certain of in this world is that the technology universe will not see that '90s type of growth explosion again—not in our lifetime. This is the New Normal, and

it's about the rest of your life' (McNamee and Labarre 2003). By 2004, he had elaborated his theme into a book, where he summarized the New Normal thus:

- The power of the individual is rising rapidly.
- The world offers more choices than ever, but it also requires us to make more decisions.
- Technology and globalization are facts of life; they rule our economy and they aren't going away.
- None of us has enough time, so making the most of the time we have is essential. (McNamee 2004: xix)

The book was a heady elaboration of these seemingly world-embracing tenets, a celebration of the successful investor's clarity of vision, zeitgeist knowledge of the 'facts of life', individual heroism, bolstered by the author's own proven record. The New Normal became a kind of motivational chant, appearing on almost every page of the book, often several times.

By 2008, financial gurus were feeling troubled again as a big crash unfolded. Some of the largest financial-sector corporations in North America and Western Europe teetered on the brink of bankruptcy in 2007 and 2008, calling for gigantic state-interventions or bailouts. Among the many factors which led to the crisis were the introduction of subprime mortgages and a consequent housing bubble, deregulation of and normalized corruption in transactions (such as price-fixing and predatory lending), complex packaging of risk in products for large-scale speculation, and a credit crunch. The government bailouts enabled most of those big corporations to survive relatively unscathed (barring a few notorious cases of liquidation, like Lehman Brothers and Ameriquest). They became de facto nationalized, though not *de jure*. Their executives retired in disgraceful luxury or continued their activities, while large numbers of middle- to lower-rung workers became unemployed. Some temporary and mild regulatory measures were introduced—often reintroduced having been rescinded earlier—to signify de facto nationalization. More importantly, the governments in question thrust the cost of the bailouts given from the public purse upon the citizens who had filled that public purse to begin with. This strategy was captured by the righteous-sounding catchword 'austerity' (of which more later, especially in Chapter 5), underpinned by the portentously measured imminence or reality of recession. Public spending on all sectors (health, education, culture, social care, housing, etc.) were brutally cut; for the great majority, savings stopped growing and pensions became permanently insecure; small- and medium-sized businesses and jobs disappeared

while unemployment benefits shrank. Government executives drew public attention away from the financial sector by articulating the crisis in terms of a 'sovereign debt crisis', with collective responsibility laid on citizens as the collectively indebted. Catchphrase-laden exhortations from political leaders and government bureaucrats to 'do more with less' and demonstrate 'resilience' and 'sustainability' became de rigueur. On the campaign trail towards becoming UK prime minister in 2009, David Cameron announced an 'age of austerity', and spoke of the need to get out of 'the debt crisis' by 'doing more for less'. The 'new normal' found its way into the political and bureaucratic repertoire of these catchphrases too, striking by turn downbeat and upbeat notes. Elected in 2009 as the financial crisis hit, in a 2010 interview US President Barack Obama was able to note an improvement in the economic outlook. But, he observed, an undesirable 'new normal' might be in the offing:

> What is a danger is that we stay stuck in a new normal where unemployment rates stay high. People who have jobs see their incomes go up. Businesses make big profits. But they've learned to do more with less. And so they don't hire. And as a consequence, we keep on seeing growth that is just too slow to bring back the eight million jobs that were lost. That is a danger. So that's something that I've spent a lot of time thinking about.
>
> (Obama with Kroft 2010)

Around the same time though, like so many other leaders, his secretary of education, Arne Duncan, was enthusiastically propagating the 'new normal' gospel with all the rhetorical flair of a parrot:

> I am here to talk today about what has been called the New Normal. For the next several years, preschool, K-12, and postsecondary educators are likely to face the challenge of doing more with less.
>
> My message is that this challenge can, and should be, embraced as an opportunity to make dramatic improvements.
>
> (Duncan 2010)

In political and bureaucratic circles, the catchphrase had found an ambiguous but steady anchoring to the financial crisis. However, in the world of speculation and investment, where the crisis seemed centred, the phrase managed to recover its motivational drive à la McNamee somewhat sooner, within 2009.

In March 2009, for instance, a *McKinsey Quarterly* strategy article entitled with the phrase gauged opportunities for investors to make hay—albeit comparatively moderate amounts of hay—in this crisis environment because 'it is

no less rich in possibilities for those who are prepared' (Davis 2009). It argued that investors mainly have to factor in the changes that have resulted and calculate accordingly. In brief, the changes involve less leveraged businesses and greater government regulation, the latter a good thing in some respects (more transparent) and bad in others (more protectionist). That distribution of what's good or bad marked the investor's normative (normal) horizons; for others, of course, highly leveraged businesses with little regulation and access to unprotected monies had proved disastrous—that was the crisis. More or less in keeping with McNamee's insights, the article pointed investors to the technology sector and to Asia, where the crisis was not felt as keenly then. The 'new normal' anchored to the crisis, the article promised, will persist even when the crisis is over. Investment managers who had waded into this 'new normal' and, again like McNamee, claimed to know what's what and how to strike gold were also keen on the relentlessly motivational cadences of the catchphrase. Bond traders William H. Gross and Mohamed El-Erian of Pacific Investment Management Company (PIMCO) were the McNamees of the 2007–2008 financial-crisis 'new normal', and set about a publicity campaign to colonize the catchphrase. Their success in doing so among the financial cognoscenti was down to their own performance, especially through the PIMCO Total Return fund (see Forbes 2010), though that 'new normal' success was a bit frayed a few years down the line (Goldberg 2013). In any case, by turn, El-Erian and Gross produced a series of lectures, blogs, and interviews in the course of 2009, claiming to have 'coined' the phrase 'new normal'. A chatty article on this 'new normal' by Gross (2009) made much the same assessment and recommendations as the *McKinsey Quarterly* article, with golfing and child–adult metaphors thrown in and a PIMCO stamp put on them. Delivering the Per Jacobsson Foundation lecture on that theme the following year, El-Erian said:

> We coined the term 'new normal' at PIMCO in early 2009 in the context of cautioning against the prevailing (and dominant) market and policy view that post-crisis industrial economies would revert to their most recent means. Instead, our research suggested that economic (as opposed to financial) normalization would be much more complex and uncertain—thus the two-part analogy of an uneven journey and a new destination.
>
> (El-Erian 2010: 12)

The claim that El-Erian and Gross 'coined' the catchphrase was bold, but it was made confidently and was repeated often by them and others. The journey–destination metaphor was well taken, and captured the speculative intent in

deploying the catchphrase, not just at this juncture but also earlier. Just as Cheney's 2001 'new normalcy' had put anything like a 1920 Harding notion of 'back to normalcy' to rest, it now seemed evident that no journey can take an even path and reach a familiar destination. There would be no return from the post-9/11 security and legal regime and no return from austerity. In financial investment and speculation, it seemed, returns are not so much impossible as not to be contemplated—only new destinations could be reached, and, despite the challenges, they all offer investors opportunities. History has no lessons here.

While the 'new normal' of the 2007–2008 financial crisis was being registered in this vein, there were two sorts of specialist recourse to the catchphrase. On the one hand, some got down to fleshing out the practicalities of 'doing more with less' and being 'resilient' in various sectors of governance. A multitude of government and corporate reports, scholarly papers and books, journal special issues, etc. followed along those lines. On the other hand, and more interestingly, some picked up the upbeat tone of the investors against their grain, and started anticipating a wholesale social and cultural transformation for the good—a caring and humane capitalism, a thrifty but contented lifestyle for ham and eggers (happily austere). A paper by Amitai Etzioni (2011), simply entitled 'The New Normal', went through various measurements (data) of consumption, social relations, beliefs, and lifestyles during the recession in the USA to raise the prospect of general moral improvement:

> The Great Recession has forced a much larger number of Americans to face the question of whether they can adapt to a more austere life and whether they can find other sources of contentment. Data show that this is possible but there seems no way to predict which course Americans will follow, unless these data are much more widely available and the social forces that promote consumerism are restrained.
>
> (Etzioni 2011: 788)

For Martin Walker (2009), the force that could restrain the forces that promote consumerism was already at large, and it was precisely the one which investors contemplated with trepidation: Big Government. Or, in his words: 'Thrift is becoming the new normal for the American consumer [...]. But lavish spending is becoming the new normal for the federal government [...]' (66). He felt Big Government might engineer a transformation to get past what had been an unsustainable model of rapacious consumerism. Soon, however, the crisis was declared as done—by 2012, or 2014, or 2016, depending where one

was. Having taken possession of the catchphrase, El-Erian wondered whether it wasn't time to declare 'the end of the new normal' in 2016. However, to many it already seemed that not much had changed for financial investors and speculators. Somehow, this 'new normal' was no more than a bit of varnish on old furniture, merely accentuating the old patina (as Crouch 2011; Mirowski 2013; Dardot and Laval 2019 [2016], among others, observed discontentedly). In short: government remained small, regulation remained ineffective (the effects of the main instrument in the USA, the Dodd-Frank Act 2010, was uncertain), highly leveraged business practices rebooted quickly, and de facto nationalizations of banks soon became loss-making re-privatizations.

2012–2019

By 2012, the energies of the 'new normal' as a catchphrase anchored to the financial crisis were already seeping away in the USA and Europe, though they did so slowly. Its encouraging cadences in investment circles made it a useful brand name for various consultancy firms, and it persisted mainly as such in those circles. In 2011, Paul Hodges of International EChem and John Richardson of the Asia section of ICIS (Independent Commodity Intelligence Services) authored an e-book entitled with the catchphrase in the spirit of McNamee and Gross and El-Erian; and Hodges set up a consultancy operation entitled New Normal Consulting. By 2020, the UK Companies House had twenty incorporated companies listed bearing the name New Normal. However, if soon after 2012 the catchphrase had moved on from the financial crisis in business circles, it remained firmly with its fallout on the ground: austerity policies. These consisted in governmental regimes of doing 'more with less', cutting public expenditure, moving publicly financed services to private players and deregulating accordingly, cutting taxes, and downgrading employment security. Various studies thereafter observed that this had become a permanent regime of government, irrespective of the financial crisis. In the 'new normal', it seemed austerity had been 'constitutionalized' (McBride 2016), become grounded in citiscapes (Hinkley 2018), diluted human rights protections (Lusiani and Chapparo 2018), and exacerbated inequality (Wysong and Perrucci 2018)—to name some researches tagged to the catchphrase. In 2019, Isabel Ortiz and Matthew Cummins published *Austerity: The New Normal* based on 161 IMF country reports for 2018–2019. This observed that following a brief period of increased governmental spending during the financial crisis in 2008–2009, from 2010 onwards—and by their projections, continuing till at

least 2024—reduced spending had become the norm across the world, with severe consequences:

> Overall, austerity has become a 'new normal', with the majority of countries in the world contracting public expenditures in the period 2010-24. The incidence and depth of fiscal austerity varies across regions and income groups. In terms of regions, for 2020 onwards, the Middle East and North Africa has the highest proportion of countries contracting expenditure during the three shocks (15 out of 20, on average), which is also the region that undergoes the most severe cuts (3.2 per cent of GDP, on average) [...]. For country income groups, 45 per cent of countries classified as low-income experience budget cuts during the three shocks, on average, which increases to 62 per cent of lower middle-income countries, 66 per cent of upper middle-income countries and 69 per cent of high-income countries. However, the deepest contractions occur in middle-income countries. This includes 2.1 and 2.5 per cent of GDP for lower and upper middle-income countries, respectively, on average during the three shocks, compared to 1.8 and 1.3 per cent of GDP for low- and high-income countries, respectively.
>
> (Ortiz and Cummins 2019: 11)

Austerity had become one of the stable references for the catchphrase in circles which felt concerned about it. But austerity was itself a 'catchword' with a shifting purchase, on which more in Chapter 5.

Meanwhile, as a catchphrase, 'new normal' was cropping up for other contexts in all kinds of media, for issues from the trivial to the serious, of little or great public interest. An NBC American sitcom entitled *The New Normal*, aired in late 2012 and early 2013, for instance, had neither a whiff of the financial crisis and austerity about it, nor the scent of investment opportunities. Set in middle-class Los Angeles, it featured a gay couple employing a single mother as surrogate for their baby, and taking her and her daughter into their home. The 'new normal', in this instance, was in presenting same-sex relationships and single motherhood within the precincts of family life in a way that would be palatable for mainstream US television viewers. The series wore its attempts to court that audience on its sleeve, with a thick layering of fairly conservative family values delivered with light-hearted nods to conventional prejudices. Notably, it was possibly the first to employ the catchphrase in popular culture circuits with a gay political agenda, perhaps inspired by critical discussion of 'normality' of longer provenance than the catchphrase itself—especially, 1990s' queer theory (of which more in Chapter 4). As it happened, if the idea was to

bring about a 'new normal' of family life by performing it on screen, even this gentle effort was received with hostility by religious groups and broadcasters (Goldberg 2012; Pierce 2012). 'New normal' was then recruited by Evangelist ideologues to campaign against LGBTQ politics in various articles (and at book length with the catchphrase as title in Nolland et al. 2018). In this regard, cheery optimism and ominous censoriousness confronted each other across a chasm in the same words.

Another significant uptake of the phrase, carrying the shadow of the financial crisis and something of the spirit of investor optimism (with individualism shorn off), took place outside the USA and Europe—in the People's Republic of China. It appeared here less as a catchphrase and more as a political slogan. A catchphrase is used to characterize a prevailing or emerging condition or phenomenon (or commercially, a product or service) and is adaptable to numerous contexts. A political slogan refers squarely to the objectives and strategies (the agenda) of a political alignment—a government, institution, party, association, movement, etc. Such slogans appear where the alignment and its objectives are represented to a relevant audience or seek public attention: such as, a government promoting certain policies and ideological principles, an institution presenting its purpose, a party making an election bid, or an activist group announcing its oppositional position. Shortly after becoming president in 2013, Xi Jinping started using the phrase (新常态 *xin changtai*). Notably, in May 2014 news reports quoted him as observing: 'We must boost our confidence, adapt to the new normal condition based on the characteristics of China's economic growth in the current phase and stay cool-minded' (Reuters 2014). His speech at the opening of the APEC (Asia-Pacific Economic Cooperation) summit on 9 November 2014 dwelt on the phrase at some length. In relation to the relatively slower growth rate of just over 7 per cent that year after a prolonged period of growth rates over or hovering at double digits till 2011, Xi observed that this was a 'new normal' which offered new development opportunities. In his words: 'First, despite slower growth under the new normal, China's economy is still growing at a considerable rate'; 'Second, under the new normal, China's economic growth is more stable and has more diverse drivers'; 'Third, under the new normal, China's economic structure has been improved and upgraded, providing more stable development prospects'; 'Fourth, under the new normal, the Chinese government has vigorously streamlined administration and delegated powers, further unleashing market vitality' (Xi 2014). In these points, in fact, the 'new normal' was not used by way of labelling an agenda or policy framework—so, not quite as a political slogan in the sense I have delineated. The first two points

pegged the 'new normal' as describing an economic condition which China had not engineered but found itself in. The third and fourth points marked the government's responses to that 'new normal'—thus, a consequent process of engineering rather than measures that create a 'new normal'. In Xi's three-volume selection of speeches and writings *The Governance of China*, effectively a sanctioned account of his policy thinking, the 'new normal' appeared in the second volume (Xi 2017). This did not carry the APEC 2014 speech, but had a section entitled 'The New Normal of Economic Development', with speeches and writings from December 2014 to July 2017. One of these, 'What Is the New Normal in China's Economic Development?', from a speech to the CPC Central Committee on 18 January 2016, interestingly put the phrase in 'a historical and practical perspective' (268) and detailed his view of the effect of the financial crisis of 2008 in Western economies on PR China (271–72).

Though Xi's use of the 'new normal' was circumspect, it soon gathered a life of its own in PR China and internationally. It seemed to become a slogan denoting the Xi-government's economic programme itself, rather than referring to a situation to which that programme responded. It is doubtful whether Xi intended the phrase to become a slogan for his own economic policies, but that occurred nevertheless. In fact, his position in PR China and his rhetorical facility meant that, on the one hand, almost every speech or text he produced offered numerous memorable and quotable phrases, and, on the other hand, bureaucrats and academics inside and outside China endowed such phrases with superlative significance. Xi's 'new normal', with the catchphrase baggage it already had, became conveniently available as an overarching slogan for China's economic policy particularly and Xi's governmental regime generally. Within China, a concerted effort was made by economists and policy experts to make the slogan cohere with numerous initiatives, sector by sector, issue by issue, and phase by phase (e.g. Tong and Wan, eds. 2017; Cai, ed. 2020; Wan and Li 2020). Effectively, the slogan seemed to become a title for a coherent policy direction. Outside China, the phrase was given a wider purchase that made economic policy drives coterminous with modes of social control, so that it appeared to become a slogan for Xi's general principles of government (the Noesselt, ed. 2017 special issue of the *Journal of Chinese Political Science* is a good example).

As the second decade of the twenty-first century wound down, the catch-phrase kept expanding its range to a bewilderingly large number of issues. Woven through the financial crisis and austerity, a distinctive strand had to do with conditions of work, especially with regard to working time and workspace. The desirability of 'flexible', 'agile', 'nimble' working

practices—especially in the 'gig economy' of temporary or short-term employment—emerged into business vocabulary in the 1980s. This referred to a shift from fixed hours (the traditional 9-to-5 job) and a fixed space (the office desk) towards more opportunistic use of time and space. The aspiration to free up time and space for work converged with the emergence of the 'digital workplace' in the 1990s. On the one hand, this became a brand name for commercial products integrating office facilities (maintaining records, replicating documents, communications, etc.) through internet portals. On the other hand, the 'digital workplace' emerged as a concept whereby paid work could be shifted from being done in material spaces to internet precincts. The latter was a possibility that interested companies and governments keeping tabs on— and encouraging—the gradual increase of persons working on computers, and often working seamlessly from both offices and homes. Influentially, the US government's NCIA (National Communication and Information Administration) and Economics and Statistics Administration published a report, *A Nation Online* (2002), based on large-scale surveying, which tracked trends in this regard. This suggested that a gradual elimination of material workspaces in favour of digital workspaces could take place. Correspondingly, the division of work and leisure in the working day could then be reconsidered. This kind of 'flexibility' in work was already the subject of considerable upbeat research, especially under the Alfred P. Sloane Foundation's programmes; in 2003, the Foundation turned this focus predominantly on the issue of space and launched the National Workplace Flexibility Initiative (see Christensen 2013). These drives began to anticipate an imminent 'new normal' with the onset of the financial crisis of 2007–2008. Sponsored by the Foundation, Georgetown University Law Centre's (2009) report *Public Policy Platform on Flexible Work Arrangements* (FWA) appeared conveniently at this juncture, with a recommended national campaign backed by a policy and legal framework to 'make FWAs the "new normal" in the American workplace' (12 and *passim*). As the financial crisis and perpetual austerity settled, the opportunistic, individualist spirit which was celebrated as the 'new normal' for investors was transposed on the 'new normal' of the 'high performing', 'innovative' worker. This was elaborated in elegiac tones, for instance, by John Putzier (2004), in a book with the indicative title *Weirdos in the Workplace: The New Normal ... Thriving in the Age of the Individual* (Ch. 4 extolled the virtues of flexible working and digital workspace). A great density of news articles, documentary films, corporate reports, academic papers, and commercials have tracked the imminence, and then the gathering pace and unmistakable appearance of this 'new normal' since. On the eve of the Covid-19 outbreak, this 'new normal' seemed

to be of the present, at least for some sectors of white-collar workers (Taylor and Luckman, ed. 2018 offered case studies accordingly).

To an overwhelming degree, reports and studies of the 'new normal' of 'flexible work' in the 'digital workplace' have had a starry-eyed, gushing tenor. The following points have been stressed. Workers want it because it makes for sound 'work–life balance', makes caring and nurturing while working easier, cuts the costs of commutes, allows for greater self-determination in the distribution of leisure—and working time. Employers want it because it makes for happier and more productive workers (or, at the least, as productive as always) and increases speed and efficiency. Countless attitude surveys and 'evidence-led research' have been devoted to bolstering these arguments, attended by how-to-make-work-flexible guidebooks. Some concern has occasionally been expressed for the mental health of isolated homeworkers, but generally it would seem that all who are invested in the issue have been looking out for workers' interests. Relatively less discussed (save in narrowly focused academic papers and some abstract generalizations in, for example, Lazzarato 2017 [2009] and Bloom 2017), have been the obvious downsides for workers. It was not for nothing that this 'new normal' really came together during the financial crisis of 2007–2008, amidst cutbacks. Flexible working decimated legal protections for workers and strictures about employers' responsibility towards workers, which were carefully instituted through much of the twentieth century. In terms of time, flexible work meant the erasure of the relationship between working time and pay. That remained, especially in the public sector, an accounting process *de jure*, but completely dissociated from the de facto practices of work. It also erased erstwhile notions of right to leisure/holidays and overtime pay. It normalized casual and temporary working contracts or made the 'gig economy' mainstream. Pension and other benefits and protections of employment began accordingly to be pared down or to disappear. In terms of space, it has tended to give increasing access to employers into workers' homes. That usually takes the form of invasive surveillance and diktats, sometimes in the name of looking out for the worker's 'health and safety'. The distinction between private/personal and public space has gradually been dissolved for workers beyond some formal platitudes. Ironically, the effects of these changes have perhaps been most keenly felt by workers whose work has not been—or cannot be—flexibilized: manual, menial, and shop-floor workers. Unmistakably, the principal benefit of flexible working in these terms have been for employers' account books, to buck up the performance measures of managers and the returns-on-investment of shareholders. Savings have appeared in terms of estates costs, infrastructure costs, insurance costs,

pension contributions—without eating into output and turnovers. At the same time, new investment opportunities in technology industries and services have opened up. Flexible working has made sense of 'doing more with less'.

By way of drawing towards a conclusion for this chapter, the growing association of the catchphrase with climate change through this period is likely to be regarded as the most momentous in retrospect. With growing frequency from around 2010 onwards, the catchphrase was being used to headline reports on global warming/climate change in news media and scientific bulletins: such as, 'The New Normal?: Average Global Temperatures Continue to Rise' (Biello 2010); 'Get used to "extreme" weather, it's the new normal' (Hedegaard 2012); 'Extreme heatwaves are predicted as the new normal for British summers by 2040' (Bawden 2013); 'Climate: the new abnormal' (Stover 2014); 'Study sees a "new normal" for how climate change is affecting weather extremes' (Mooney 2015). Headlines give a glimpse of but the tip of the iceberg in catchphrase usage in news media. 'New normal' featured with growing frequency in reference to specific weather events and general reportage on climate change research and policy. In being used thus, the prior familiarity of the catchphrase was called upon to emphasize the issue, and, at the same time, the significance of the issue imbued the catchphrase with a distinctive significance. In the main, however, such usage is a rhetorical ploy in newspeak. More interestingly, from 2015 onwards, the catchphrase was given a more rigorous and measured turn, in tune with the scientific advocacy that raised climate change as an urgent public and policy issue. In this direction, a paper in 2015 (Trenberth et al. 2015—the subject of the newspaper report just mentioned, Mooney 2015) objected to the tendency in reportage to infer a 'new normality' from singular extreme weather events. It proposed instead that specific weather events should, in the first instance, be examined as if they are not caused by human-induced climate change. Thereby the extent to which such events can be explained by cumulative factors can be determined, which would then give a robust and graded sense of the contribution of long-term climate change. The paper concluded:

> The climate is changing: we have a new normal. The environment in which all weather events occur is not what it used to be. All storms, without exception, are different. Even if most of them look just like the ones we used to have, they are not the same. But we cannot sort out these questions of degree without a large ensemble of model simulations, particularly for events as rare as the Boulder floods, and the kinds of models that can be run in such a way are often incapable of simulating the event in question and thus lack

physical credibility. We argue that under such conditions it is better for event attribution to focus not on the synoptic event, but rather on the influences of the changed large-scale thermodynamic environment on the extremes and temperatures and moisture associated with the event.

(Trenberth et al. 2015: 729)

A couple of years later, another paper (Lewis et al. 2017) took possession of the catchphrase itself, recruiting it away from its catchphrase-like fluidity and conferring it with a quantifiable rigour. The argument suggested that the catchphrase could be more than a rhetorical device and designate a method of measuring climate change. That would be by setting a reference point of extreme weather (a kind of current norm of extremity) and then statistically tracking changes before and after to establish the time taken for a 'new normal' to emerge:

The time of emergence of a new normal [ToENN] is defined here as having occurred when more than 50% of future anomalies exceed a reference event in magnitude or intensity. This definition can be applied broadly to a diversity of events. We begin by applying this general ToENN framework using the record-breaking global average 2015 temperatures as a reference event. When will years as hot as 2015 become the norm? We focus on annual- and seasonal-scale events, rather than short-duration, high-impact extremes such as heat waves, as such large-scale observed record-breaking events have been widely discussed in the public domain using a new normal framing. However, our proposed methodology is intended to be applied to investigating events across spatial and temporal scales.

(Lewis et al. 2017: 1141–42)

A couple of years later, another paper (Moore et al. 2019) offered a different take on the idea of the 'new normal' in relation to climate change. This focused on the relationship between the objectively measurable phenomenon and subjective perceptions thereof. Drawing upon a large corpus of Twitter posts (between 2014 and 2016) to gauge the latter, the paper concluded that evidence of climate change in objective terms did not have a corresponding impact on perceptions. Perceptions tend to normalize the obtaining situation quickly and in an ongoing way, or, in other words, do not register the change as long-term change. In a *New Scientist* report on the study, one of the authors, Frances Moore (2019) asked, 'Is there a risk that these exceptional events [such as, record-breaking temperatures] just become part of the "new

normal"?', and answered, 'But temperatures quickly became unremarkable: after just a couple of years of strange temperatures, people stopped tweeting about them. Our best estimate is that people base their idea of normal weather on what happened in just the past two to eight years.' In relation to climate change, the catchphrase thus not only grounded itself in the rhetorical ploys of news reportage but also took a step into specialist purposes. That is to say, its purchase as a catchphrase inspired attempts to give it a measurable reference— attaching it to gauges for empirical process and perceptual processing—which, in turn, could give it added weight as a catchphrase. In a way, the phrase 'new normal' in relation to climate change has served as one of the fulcrums of science-based public advocacy.

In policy circles, the importance of science-based public advocacy apropos of climate change has intermittently been referred to a somewhat different turn on the 'normal', through the phrase 'post-normal science'. Its resonance has mostly been limited to science and technology policy circles, wherein it appears as a policy-academic catchphrase. It was introduced and elaborated in an influential paper by Silvio Funtowicz and Jerome Ravetz (1993), which focused on areas where scientific knowledge is uncertain or contested and yet the social stakes in that knowledge are high. This means that, despite ambiguities in the knowledge, policy decisions based upon it cannot wait for more conclusive findings and full consensus. This situation puts a particular pressure upon scientists and policymakers who have to act upon the available scientific evidence and inferences. Both cannot wait for scientific knowledge to follow its normal, generally gradual, course towards garnering consensus, but have to act jointly to advocate for an appropriate path forward. They then engage in 'post-normal science', where '[t]he model for scientific argument is not a formalized deduction but an interactive dialogue' (740) which would involve 'public engagement and participation' (751), in the spirit of bringing in 'extended peer communities' (753). All this is redolent with the good intentions of governing elites, or perhaps with their desire to indemnify themselves against liability or minimize responsibility. The relationship between the catchphrase-at-large 'new normal' and this policy–academic catchphrase 'post-normal science' is not immediately evident—an interesting issue to which I return in Chapter 4.

Towards 2020

In 2020, the core application of the catchphrase 'new normal' shifted again: this time, as observed at the beginning, in view of circumstances following the

Covid-19 outbreak. These circumstances and their relation to the catchphrase call for a considered pause, to which the next chapter is devoted.

Notably, the career of the catchphrase outlined in this chapter involved no cancellation of an existing nuance with the appearance of a new one. The 'new normal' following the 9/11 terrorist attack remained the 'new normal' thereafter and is still a 'new normal' as this is written. But it was given an additional dimension with the 'new normal' for investing in the technology sector following the dot-com crash announced by McNamee. That was not overtaken by the 'new normal' set by the 2007–2008 financial crisis and consequent austerity policies: the complex of the catchphrase's ambit extended further, and that too remains an aspect of the 'new normal' as this is written. Positive and negative normative takes from 9/11 and the financial crashes did not quite oppose, let alone negate, each other; rather, they appeared to be the flipsides of the same coin. The advent of the 'new normal' as a political slogan in PR China tagged an institutional agenda to the fluid circuits of the catchphrase, without eschewing or dislodging its catchphrase purchase. Every circumstantial recruitment of an issue to the 'new normal' added to the catchphrase without subtractions, from the truly global crisis (like climate change) to the relatively trivial (like eating habits or fashion tastes). The 'new normal' of gender and sexual relations, whether seen through liberal light or illiberal murk, was and is not a separate area from any of the above issues. The catchphrase makes it a piece within the whole. Flexible working as a 'new normal' too became but another and continuing surface in the prism of the catchphrase. The measured turn given to the phrase with reference to climate-change research sharpened its connotations without dispelling its catchphrase fluidity. In the process, the catchphrase refracts so many issues pertaining to the contemporary world or reorients and grounds so many of them by its suggestiveness that it acquires a constitutive power. That is to say, it seems to effect something that is greater than its many contexts of usage, as if the very persistence of the usage of the 'new normal' brings about an adjustment in the concept of normality itself and materializes a state of normality. This turn seemed all the more entrenched as the Covid-19 pandemic unsettled the world in 2020.

3

'New Normal', 2020

Eve of the pandemic

By mid-2020 the catchphrase 'new normal' referred first and foremost to conditions following the Covid-19 outbreak. Though the contagion was quietly taking root already, in early January 2020 few would have known about it and fewer would have anticipated its global impact. Nevertheless, 2020 began with apprehensions and events for which the catchphrase was frequently used, following issues outlined in the previous chapter. The explosive spread of the pandemic, so that it quickly became *the* 'new normal' did not mean that the prior resonances of the phrase were erased and replaced. As in earlier phases of the catchphrase's career, each nuance and resonance accrued with earlier ones, enriching its connotations and extending its reach. But there was something different about the emphatic way in which the 'new normal' became attached to the pandemic, with denotative effect. This meant that though the earlier resonances and nuances were very far from dispelled, they all seemed to become, so to speak, aligned with this forceful association. The 'new normal' of the Covid-19 condition became, to use a metaphor, like a magnetic pole of the catchphrase with regard to which its many usages now formed a pattern much like iron filings. The other usages appeared to be apropos of its reference to the pandemic hereafter, in various degrees turned towards or away from the latter. In the process, the catchphrase itself seemed to become opaque at times, drawing attention to its own catchphraseness and its limitations. This chapter outlines how this process unfolded.

In English, news headlines featuring the catchphrase appeared from the beginning of the year, well before the pandemic became *the* news. On 1 January, the English version of a feature by Serge Halimi in *Le Monde diplomatique* declared 'From Santiago to Paris to Beirut, Protest is the New Normal' (Halimi 2020). The French version was entitled '*De Santiago à Paris, les peuples dans la rue*'. In French, the equivalent '*nouvelle normale*' had been relatively rarely used and could barely be considered a catchphrase, though the word *normal(e)* has both an older provenance and more frequent everyday usage. However, as the pandemic expanded, the use of '*nouvelle normale*' increased

Political Catchphrases and Contemporary History. Suman Gupta, Oxford University Press.
© Suman Gupta (2022). DOI: 10.1093/oso/9780192863690.003.0003

in French reportage. Halimi's article pointed to the extraordinary proliferation of a particular form of protest around the world: by crowding in public spaces. As the year opened, large-scale crowd protests were under way in Hong Kong, Iraq, Iran, Lebanon, Canada, Mexico, Chile, Brazil, Columbia, France, Italy, Poland, Algeria, and Liberia, to name a few countries. These variously challenged austerity measures, neoliberal policies, inequality and discrimination, corruption, and authoritarian governments. The protests, as Halimi observed, mostly sought something larger than redressal of specific grievances: they demanded regime change. Concurrently, as it happened, through December 2019 and January 2020, particularly intense bushfires raged in various regions of Australia, regarded as the latest disaster connected to climate change. On 2 January, an op-ed piece by Paul Krugman (2020) in *The New York Times*, headlined 'Apocalypse Becomes the New Normal', suggested that the Australian bushfires and other such catastrophes over the previous year were 'all related to climate change': 'Apocalypse will become the new normal – and that's happening right in front of our eyes'. The tense change between the headline and the in-text warning took advantage of the fluidity of the catch-phrase; a new normality calls for attention by its evidence in the present as it shifts towards another, more disastrous, new normality. It seems both evident and imminent. In this connection, building upon a series of protest actions, the Extinction Rebellion group called for gatherings outside Australian Embassies in various countries from early January. The Fridays for Future movement also continued calling upon school students to take strike action in various countries from 3 January onwards. Amidst burgeoning expressions of anti-establishment dissent and discontent, the establishments in question often seemed fractured along ideological lines and increasingly defensive. The UK-based consultancy company Verisk Maplecroft, which offers global risk assessments which insurers take seriously, released its report *Political Risk Outlook 2020* in mid-January. It observed:

> The pent-up rage that has boiled over into street protests over the past year has caught most governments by surprise. Policymakers across the globe have mostly reacted with limited concessions and a clampdown by security forces, but without addressing the underlying causes. However, even if tackled immediately, most of the grievances are deeply entrenched and would take years to address. With this in mind, 2019 is unlikely to be a flash in the pan. The next 12 months are likely to yield more of the same, and companies and investors will have to learn to adapt and live with this 'new normal'. (11)

The year seemed set for a tumultuous 'new normal'.

Within two months 2020 turned out to be very much more tumultuous than anticipated, and the catchphrase became a sort of discursive site for mediating and negotiating paths through the tumult by echoing the recent past, and at times becoming opaque itself.

The shadow of 9/11

'New normal' had taken off as a catchphrase after 9/11 and President George W. Bush's declaration of a 'war on terror' on 20 September 2001 (Bush 2001). On 11 September 2001 acts of extraordinary violence in the USA by a fanatical religious alignment were witnessed, which then became an expanding and continuing cycle of bloodletting, with proliferating extremist brutality and state aggression by turn. The impetus was, of course, all at the hands of human agencies, and indeed that has been the case for renewed usages of the catchphrase thereafter, whether due to the 2007–2008 financial crisis, austerity, identity politics, climate change, working from home, or crowd protests. In that respect, it might seem that the 'new normal' that appeared after the Covid-19 outbreak had a different push: it was an act of nature, a legal *force majeuere*. However, the various turns of the Covid-19 'new normal' in 2020 often recalled—or variously chimed with—the 9/11 'new normal' of 2001. Evidently, despite the differences, the consequent sense of shifting normality at multiple levels of social organization and everyday life appeared to be of similar scales. In both instances the causes of the 'new normal' were articulated so as to constitute the experience of the 'new normal' in analogous ways. For instance, both evoked, very quickly and naturally, metaphors of war. The experience was to be of prolonged warfare and emergency measures but without promising the closure of peace and restoration of established custom. The 9/11 and Covid-19 'new normals' chimed particularly in being similarly fraught: an imperative and sudden departure from a given normality with no promise of return—towards a militarized order on constant war-footing, forcefully imposed rather than consensually directed. In this precipitate and anxiogenic tenor, the 9/11 'new normal' seemed to be echoed in the Covid-19 'new normal'. The war metaphors were particularly emphatic in both because the force of states was invoked and unleashed. No state had, however, taken warlike stances for the 2007–2008 financial crisis. In that instance, the culpable financial sector had to be protected and citizens made to pay by the state. That financial-crisis 'new normal' moved from the impetus of normalized corruption in the financial sector straight to a *post-war* evocation of 'austerity' instead, with the warlike juncture skipped (see Chapter 5). However, the echo

of the 9/11 'new normal' in the Covid-19 'new normal' seemed expedient and similarly warlike.

It might be argued that the terrorist attacks of 9/11 were more meaningfully—were actually—acts of war compared to the appearance of a contagious virus. In fact, both were similarly within metaphorical territory insofar as social responses went. The moves following the 9/11 attacks were presented as being very much larger than reprisal for those specific attacks. They seemed to engage with a clash of ideologies, civilizations, ways of life, East and West/North and South. Though economic interests and political expediency motivated on-the-ground strategies, the conflicts were presented in abstract and polarized normative terms. These resonated both with a swathe of liberal thinking (influentially, for instance, Rawls 1999 and Huntington 1996), and with popular sentiment in formally democratic states (often crystallized in catchphrases and slogans). Bush's phrase 'war on terror', for instance, came to designate legislative changes and political–economic strategies which cut across domestic and international domains, and took in every area of governmental, commercial, and civil activity and, indeed, the domain of convictions and emotions, the mind itself. 'War on terror' became as persistent and pervasive a catchphrase as 'new normal' thereafter. The 'war' in question was seemingly directed against the experience of 'terror' itself and anything that could cause that experience could be dubbed 'terrorist'—except, of course, actions by the Bush administration and its allies. Effectively, this 'war' could draw in any *other* organization, state, set of attitudes, beliefs, habits, cultural practices, etc., according to the needs of those calling the 'war'. It was, as I had noted at the time, really a metaphoric 'war' against abstractions which could materialize as actual conflict, or at least as tangible coercion, whenever needed. It was a speech-act courting acceptance of a 'new normal':

> A war against an abstraction that seems to include different experiences and tangible effects and contexts is one that causes little demur. This is a war that can be easily condoned because of its very fuzziness, because it is not clear what such a war consists in – what its means are, what exactly the specific targets are, etc. In a sense such a war is glibly accepted largely because one cannot possibly be sure in what sense this is a war; a war against an abstraction has all the metaphoric power and yet all the sense of underlying security that a loose use of the word 'war' with regard to abstractions (such as 'war against crime', 'war on unemployment', 'information war', 'gender war', etc.) has instilled in a period of relative stability.
>
> (Gupta 2002: 27)

In the event, as observed in the previous chapter, the 'war on terror' after 9/11 sucked in many dimensions of civil life: mental health, transport, surveillance, civil rights, art, and so on. All became accordingly facets of the 9/11 'new normal', which is to say, the 'new normal' that was also the 'war on terror'.

Inevitably, war metaphors greeted the Covid-19 outbreak and immediately resonated with the metaphoric 9/11 'war on terror'. In fact, war metaphors have been endemic to science and policy language concerning epidemics for long. With writings about epidemics in mind, Susan Sontag (1990) had observed that in capitalist societies:

> War-making is one of the few activities that people are not supposed to view 'realistically'; that is, with an eye to expense and practical outcome. In all-out war, expenditure is all-out, imprudent – war being defined as an emergency in which no sacrifice is excessive. But the wars against diseases are not just calls for more zeal, and more money to be spent on research. The metaphor implements the way particularly dreaded diseases are envisaged as an alien 'other', as enemies are in modern war; and the move from the demonization of the illness to the attribution of fault to the patient is an inevitable one, no matter if the patients are thought of as victims. Victims suggest innocence. And innocence, by an inexorable logic that governs all relational terms, suggests guilt. (99)

Of course, Sontag's reservations about the political resonances of metaphors for epidemics, especially war metaphors, could be regarded as too sweeping. In a comprehensive history of writings by epidemiologists, Charles De Paolo (2006) justifiably objected to Sontag's censorious tone towards them. Scientists trying to convey their findings to general readers necessarily take recourse to metaphor, and where epidemiologists have called upon war metaphors those are often valid in scientific terms. The point, De Paolo suggested, is 'that a careful balance must always be maintained between the edifying use of language and the factual integrity of the science' (208). Nevertheless, Sontag's point remains pertinent. Those metaphors may make scientific sense for epidemiologists for the benefit of general readers, but when an outbreak occurs they are also instrumentalized by politicians, bureaucrats, and businesses for ends which are not simply about conveying truths. In fact, war metaphors for the Covid-19 outbreak were repeatedly used by political leaders in the first instance by, to name a few, Donald Trump (USA), Narendra Modi (India), Xi Jinping (PR China), Emmanuel Macron (France), Boris Johnson (UK), Viktor Orban (Hungary), and Cyril Ramaphosa (South Africa). In Iran, interestingly,

the messaging of measures against the outbreak echoed slogans and images from actual wars, especially the Iran–Iraq War, 1980–1988 (Schwartz and Gölz 2020). War metaphors circulated at various levels: in instructional material from various authorities, in public notices, in media reportage, and in social networks. So imperative was their appearance in relation to the pandemic that, with unusual expedition, a significant number of scholarly analyses of these appeared within months of the outbreak (e.g. Caso 2020; Frizelle 2020; Craig 2020; Semino 2020; Gillis 2020). More numerously, news features and editorials noted such metaphors often, not only to deploy them but also to consider what deploying them implies, assuming a kind of metadiscursive stance. Unease was evident throughout. Some weighed the pros and cons of such metaphors for effective communication, others struck accusatory or defensive attitudes. Unsurprisingly, in reflecting upon the metaphoric 'war' against Covid-19 the shadow of the metaphoric 'war on terror' following 9/11 came up frequently.

The 'new normal' of post-9/11 legal adjustments in, to begin with, the USA and thereafter in numerous states, which had seemed to undermine fundamental principles of jurisprudence, cast a long shadow on the pandemic world. The Covid-19 outbreak called for lockdowns and social distancing and other restrictive measures which bore upon legal tenets. Recourse to existing emergency frameworks within the law or legislation of new frameworks were needed wherever the contagion caught on globally. By 22 July, WHO set up a Covid-19 Law Lab to 'gather and share legal documents from over 190 countries across the world to help states establish and implement strong legal frameworks to manage the pandemic' (WHO 2020[1]); in December the Lex-Atlas Project was set up to compile sixty to eighty country-wise reports of these responses (Lex-Atlas 2021). Such widespread legal management of restrictions naturally recalled the post-9/11 legal adjustments. For those interested in and involved with legal frameworks, the possibility that the already widely apprehended Covid-19 'new normal' might follow the legal direction of the 9/11 'new normal' was a matter of concern. Most obviously, enlisting contact-tracing methods to manage the spread of the contagion, enhanced policing, and strong enforcement of restrictions suggested an upgrading of the perpetual surveillance regimes after 9/11. A posting by the human rights organization Amnesty International on 3 July raised this concern:

Lessons learnt from recent history tell us that there is a real danger surveillance measures become permanent fixtures. In the wake of the attacks of

11 September 2001 (9/11), government surveillance apparatus expanded
significantly. Once these capabilities and infrastructure are in place, govern-
ments seldom have the political will to roll them back.

(Amnesty International 2020)

As legal provisions were made in various countries to accommodate such
measures, the 9/11 changes were numerously and anxiously recalled in news
media and, more carefully, in academic publications (Lazarus ed. 2020: 3;
Ram and Gray 2020: 16; Sharon 2020; van Kolfschooten and de Ruijter 2020:
485–86). Each of these insisted that unlike the post-9/11 'new normal' of per-
petually enhanced surveillance and policing, the Covid-19 measures had to
be planned as temporary, with clear mechanisms for being withdrawn when
unnecessary. In a larger way, these concerns echoed those of legal experts
contemplating the post-9/11 regime: that is, such measures are undesirable
because they undermine some of the fundamental principles of rule of law in
liberal jurisprudence.

These fears and anticipations found, in this instance, more sympathetic re-
ception due to one significant difference from the post-9/11 situation. For the
latter, responding to terrorist attacks, and indeed interpreting what 'terrorism'
means in legislative terms, was almost entirely at the behest of ruling political
agencies within states. International coordination was generally after the fact
of national-level legislation. Though these adjustments were of similar scale
in the pandemic context, the impetus for legislation was actually not solely in
the hands of ruling political agencies. In fact, the Donald Trump administra-
tion in the USA and the Jair Bolsonaro administration in Brazil often found
that their policy drives were thwarted; to lesser degrees, in numerous states
such agencies found their own choices unexpectedly floundered or proved to
be misdirected. From the beginning of the outbreak, the pandemic had to, by
definition, cohere with established medical guidance instead of political will,
and with constant attention to developments in the international domain. As
it happened, the importance of limiting enhanced surveillance and policing
and maintaining rule of law was, in this instance, underlined by intergov-
ernmental organizations. The Organization for Economic Co-operation and
Development issued a policy brief on 4 May (OECD 2020) charting ways of
ending restrictions when they became unnecessary, also recalling 9/11. The
International Development Law Organization (IDLO) issued a statement on
27 March (Beagle 2020), emphasizing the importance of adherence to rule of
law in Covid-19 responses, and followed it up with a policy brief in Septem-
ber (IDLO 2020). Unquestionably, the World Health Organization (WHO)

came to the forefront as the most important international body for issuing guidance on medical matters and organizing global responses to health crises. Though, for entirely specious reasons, Trump formally moved to take the USA out of the WHO (Hinshaw and Armour 2020) and Bolsonaro threatened to do so too (Elliott and Robinson 2020), the centrality of the WHO in the midst of the pandemic remained unshaken. As already noted, on the front of legal responses the WHO had set up the Covid-19 Law Lab in July; in October, as a second wave of growing Covid-19 cases and mortalities were reported across a number of countries, WHO had the following advice for governments:

> One key lesson learned from this pandemic is that clear, caring, inclusive and regular communication from authorities contributes to public trust in the government's response, which leads to improved understanding of individual responsibility and, subsequently, a greater willingness to adopt infection prevention practices as part of 'the new normal'. Embedding these practices as part of our 'new normal' can be a stepping stone to a 'new future', with benefits for other health issues, far beyond the response to COVID-19.
>
> (WHO 2020[2])

Perhaps there was a tacit nod to the post-9/11 'new normal' there. At any rate, this 'new normal' clearly had a contrary thrust, no longer heralding a perpetual condition but a 'stepping stone' and underlining a soft role for governments. The formulation 'new future' was a bit clumsy (can the future be characterized as old or new?), but it did convey that the 'new normal' should be temporary and the future should be a departure from this and previous 'new normals'. The awkward play with the catchphrase revealed a sceptical attitude towards it in much the way that war metaphors aroused doubts.

As discussed in the previous chapter, one of the areas where the catchphrase had an early purchase after 9/11 concerned the consequent mental health crisis. Amidst the Covid-19 outbreak, mental health guidance anchored to the catchphrase was numerously issued in professional bulletins and newsletters, newspapers and magazines, posters and leaflets. The catchphrase had become so squarely denotative for the pandemic condition that it also appeared more or less unthinkingly in all sorts of research publications, including on psychiatry. Unsurprisingly, some of these went back to lessons learned from the mental health crisis after 9/11 to inform managing that after the pandemic outbreak (Polizzi et al. 2020; DePierro et al. 2020; Andoh 2020).

Business and investing

The distinctive turn given to the catchphrase in financial circles after the 2002 dot-com crash and, particularly, the 2007–2008 financial crisis also flowed into the Covid-19 context, but with circumspection. The 2007–2008 financial crisis marked a horizon for changes, the settling of a 'new normal' for businesses and investors, which were still very much out there as the pandemic struck. However, after the dot-com crash and the financial crisis it was an upbeat outlook that was imbued in the catchphrase; in the Covid-19 context, an upbeat outlook, however habitual in these circles, could not be assumed without circumspection—or rather, could not be assumed with confidence. Upbeatness became a more future-gazing attitude. The overall economic outlook amidst the pandemic was succinctly captured when the United Nations found it necessary to update its January *World Economic Situation and Prospects 2020* report in May under the title *World Economic Situation and Prospects as of mid-2020*. The subtitles under which it presented the available data at the time give a reasonable sense of the devastating impact of the pandemic: 'Pandemic destroying jobs'; 'Trade in goods and services ("Economic pain spreading through global trade networks", "A sudden drop in global tourism and travel")'; 'Commodity prices in a free fall'; 'Developing countries face mounting financial constraints'; 'Rapid, bold but uneven policy responses'; 'Rising poverty and inequality'; 'Globalization facing an existential threat'. Online services were the only obvious growth area. Asking whether after the Covid-19 outbreak the prospect would be 'back to normal or a new normal?', the report observed:

> The longer the uncertainties persist, the harder it gets for an economy to return to its normal, pre-crisis trajectory. [...] If uncertainties about vaccine, testing and treatment persist, people will return to work with a high degree of caution and risk aversion, which will depress both consumption and investment. People will get used to a new lifestyle, leading to a permanent shift in demand for certain goods and services. Demand for restaurant meals, sporting events, movie theatres, live entertainment and tourism will likely remain low, while demand for existing and new online services will continue to rise dramatically. Social distancing can become the new normal, entrenching and possibly reinforcing fear, mistrust and prejudice among people, communities, societies and countries. Countries may seek to reduce interdependence, and shorten supply chains, as many may consider the potential costs of a

crippling pandemic too high relative to the benefits they receive from eco-
nomic integration and interdependence. The fight against the pandemic—if
it continues for too long and its economic price becomes too high—will
fundamentally reshape trade and globalization.

(UN 2020: 12)

This bleak prospect, interestingly, confined the 'new normal' to a limited
purchase—for social distancing—while confirming that 'back to normal' is
unlikely. The tinge of optimism which the presentism of 'new normal' of-
ten evokes seemed inappropriate. But, like the WHO's 'new future', a largely
despairing report did move towards recommendations on a hopeful note to
'recover better':

The crisis presents an opportunity to 'recover better', strengthening public
health systems, improving prevention and access to treatment and vaccina-
tions, and building capacities to withstand future shocks. [...] Recovering
better will require building resilience with fiscal buffers and automatic sta-
bilizers to withstand economic shocks, and robust social protection systems
to protect the well-being of households. Fiscal stimulus packages rolled out
to fight the economic crisis can be targeted to facilitate the transition to a
green economy, bridge the digital divide both within and between countries,
accelerate structural transformation and promote sustainable development.

(UN 2020: 16)

Though the catchphrase had never been more intensively used before the
pandemic, in considered usage most found it unequal to the unfolding crisis.

Nevertheless, some of the heroic investors of the 2007–2008 financial crisis
who had taken possession of the 'new normal' catchphrase still found use for
it. Mohamed El-Erian, now chief economic advisor at Allianz, observed that
the prevailing 'new normal 1.0' was characterized by 'frustratingly low eco-
nomic growth, increasing inequality – not just in income and wealth, but in
income, wealth, and opportunity, and central banks becoming more and more
held hostage by the marketplace' (El-Erian and Carver 2020), to a coming
post-pandemic 'new normal 2.0' of even gloomier prospects. His July article
entitled with the futuristic turn of this 'new normal 2.0' saw it as 'a world of
even lower growth, even higher inequality, even more tenuous financial sta-
bility, and greater pressures on institutional integrity and bipartisan politics'
(El Erian 2020: 1). El-Erian's advice for dealing with this 'new normal 2.0' of-
fered little scope for profits due to investor acumen and heroism in reading

shaky markets. Rather, he suggested that governmental policy which supports investors by propping up businesses and controlling markets would be the panacea—not through crisis-struck bailouts but by ongoing policy support. Effectively, this advice banked on the public purse propping up private businesses continuously so that investors were not left out of pocket. Serializing the catchphrase thus shifted the ground from salutary investor-insight in difficult times to beleaguered investor-dependence on states in even more difficult times. In fact, in business circles the catchphrase, serialized or not, was itself beginning to grate. It had lost much of its optimistic varnish now. A *Forbes* magazine article of April mulled the troubled juncture for the catchphrase, less in its argument and more in its title, 'COVID-19 And The Corporate Cliché: Why We Need To Stop Talking About "The New Normal"' (Cox 2020). Its author wondered somewhat indecisively whether the catchphrase was meaningful any longer and how it was misused. More articulately, the title pointed to the nub of the matter: that in a specific domain—corporate speak—the catchphrase was going out of vogue and sounding tired—becoming a cliché. Becoming a cliché is a rather more serious problem in that domain than simply being meaningless at times or frequently misused. The point was: the catchphrase had been overused, its gloss had worn off, it was not cutting it in the way it used to. For this domain, some other catchphrase was needed to do something like the work that the 'new normal' did since the 2007–2008 financial crisis, something that would sound encouraging for investors and businesses in a different way, and, at the same time, be properly circumspect amidst unpromising circumstances.

For the 2007–2008 financial crisis, it was a McKinsey strategy article (Davis 2009, see previous chapter) which influentially introduced the catchphrase to lay out encouraging prospects for investors and businesses. In fact, this article used the catchphrase for that context somewhat earlier than PIMCO's El-Erian and Gross. In a similar vein, in March 2020, McKinsey's Kevin Sneader and Shubham Singhal introduced the updated catchphrase 'next normal'. This was done in a deliberate manner. They recalled the 2009 article written eleven years earlier, and observed:

> It is increasingly clear our era will be defined by a fundamental schism: the period before COVID-19 and the new normal that will emerge in the post-viral era: the 'next normal'. In this unprecedented new reality, we will witness a dramatic restructuring of the economic and social order in which business and society have traditionally operated. And in the near future, we will see the beginning of discussion and debate about what the next normal could entail

and how sharply its contours will diverge from those that previously shaped our lives.

<div align="right">(Sneader and Singhal 2020[1]: 2)</div>

Evidently, the 'next normal' was proposed simply as a phrase replacing 'the new normal that will emerge', both overlapping with and differentiated from the 'new normal'. It had just the right balance of familiar upbeatness and necessary circumspection. In that sense the phrase did not do much more than El-Erian's 'new normal 2.0', or, for that matter, WHO's 'new future' or UN's 'recover better'. Where the 2007–2008 financial-crisis 'new normal', and earlier the 2003 dot-com-crash 'new normal', marked investment opportunities that had already arisen and could be capitalized, McKinsey's Covid-19 'next normal', like El-Erian's Covid-19 'new normal 2.0', put opportunities more tentatively in the indefinite future. The opportunities and optimism of the 'new normal' were deferred to the 'next normal'. What Sneader and Singhal presented as portending the 'next normal' included, fairly obviously, observations such as the pandemic has given a decisive fillip to online work and digital facilities; automation is thereby more easily grounded; Big Government and higher public spending are back; consumer behaviour has changed and favours caution; and companies that plan ahead and bide their time will have advantages (be 'resilient'). Such observations did not take a great deal of research and knowhow to produce, and indeed numerous features and reports in the media had already said as much, as did the UN report and El-Erian's article cited earlier. Arguably, McKinsey's edge as a consultancy firm has always depended upon being able to package such observations for maximum publicity. That is, their talent lies in being able to restate the obvious such that it seems fresh and becomes memorable and repeatable. Producing the apt catchphrase is a significant element in such packaging. Just as McKinsey had successfully associated the 'new normal' with the 2008–2009 financial crisis in investment and business circles (before El-Erian claimed it with such determination), the similar alliterative ring and assonance of the 'next normal' was McKinsey's most significant contribution to analysing prospects amidst the pandemic. Naturally, hitting upon the apt catchphrase needed to be bolstered by frequent repetition, and in subsequent months these points, anchored to the catchphrase, were repeated whenever possible (Sneader and Singhal 2020[2] and 2020[3]).

The 'next normal' caught on quickly in corporate circles. Within months, numerous firms produced their own reports, headlining their very similar visions with the 'next normal': the professional services firm Deloitte, the facilities services firm ISS, the market research firms IRI and Mintel, the law firm

Reed Smith, the technology conglomerate Cisco, and the multinational conglomerate Hitachi, to name but a few. These reports, converging on the 'next normal' catchphrase, became a way of announcing their continuing optimism in the face of adversity, of claiming their place in the business club, and of publicizing their intent for their clientele and investors. When UNESCO (The United Nations Educational, Scientific and Cultural Organization) took up the phrase in July 2020 to label its 'global campaign challenging our perception of normality', the 'next normal' began to make inroads beyond the corporate domain in a markedly corporate spirit. The short video that was released by way of launching the campaign made an interesting move (UNESCO 2020[1]). (See Table 3.1.) It picked statements pertinent to the pre-pandemic context which were labelled 'normal', then juxtaposed those with statements pertaining to the pandemic context of lockdowns and restrictions labelled 'not normal', and left it to the viewer to consider what the 'next normal' should be. In every instance, the pre-pandemic 'normal' statement referred to an undesirable trend, the pandemic 'not normal' suggested an improvement for that trend, and the 'next normal' pointed towards continuation of the 'not normal' pandemic trend beyond the pandemic with the motto 'Now is our chance to build a better normal'. Some of the statements in question were as follows:

Table 3.1 Examples of the pre-pandemic 'normal' and the pandemic-period 'not normal' from the UNESCO 2020 video

Normal (pre-pandemic)	Not normal (during the pandemic)
Air pollution causes 8.8 million early deaths a year.	During Covid-19, Himalayan peaks became visible for the first time in 30 years.
One child dies of pneumonia every 39 seconds, 43 years after the vaccine was found.	Coronavirus leads scientists and tech companies to open-source their patients.
One child out of 5 doesn't go to school.	During Covid-19, mobile operators grant free online access to educational resources in Africa.
Thirty world heritage sites have been destroyed by wars in the last 20 years.	After lockdown started, 11 conflict-affected countries have declared ceasefires.

Source: UNESCO July 2020 https://en.unesco.org/news/unescos-next-normal-campaign

The 'next normal' campaign presented a set of minimally stated propositions, therefore, of things-to-feel-cheerful-about-during-the-pandemic. Thus minimally stated, they seemed more like advertisement logos for tech companies, mobile operators, political agencies, and the like. They gelled perfectly

with the many corporate 'next-normal' reports that appeared very soon after the McKinsey report.

Work and education

In some areas associated with the catchphrase, its reiteration in the Covid-19 context appeared to mark a leap towards fulfilment or purification, a precipitate settling-in of the 'new normal' which was anticipated or had been emerging through a gradual process. In a way, the denotative weight of the 'new normal' for the pandemic appeared coterminous with the unarguable fulfilment of a 'new normal' in these areas. The most obvious of these had to do with the drive towards 'flexible working' in 'digital workspaces' discussed in the previous chapter.

When the Covid-19 outbreak appeared, the first and only preventive response was to impose lockdowns and social distancing measures while strategies for treating the infected were explored and research towards developing vaccinations initiated. Alongside policing of public spaces, minimizing contact between persons involved the closure or dramatic reduction of numbers in shared working spaces: offices, shops, classrooms, factories, warehouses, ports, etc. To keep economic activity and productive life alive, it was necessary to move as much of formal work online as possible. The technological infrastructure to enable such a move had become more advanced than at any other comparable juncture in the past. Indeed, even without such a crisis, moves towards 'flexible working' and 'digital workspaces' were energetically under way over the previous two decades, as noted earlier. That direction had been mooted as a 'new normal' for a decade already; a vast policy drive and infrastructural shift was already being implemented to maximize working-from-home across amenable employment sectors (since, at least, Georgetown University Law Centre 2009). In the most immediate sense, the 'new normal' of the pandemic was seen as a fulfilment of the long anticipated 'new normal' of working-from-home in digital workspaces. This seemed such a natural convergence of a prior sense of the catchphrase with its particular resonance in the Covid-19 context, that it was, in fact, the first direction from which the catchphrase was linked to the context. That occurred before the WHO declared the outbreak a pandemic, that is, when the epidemic was principally centred in China, a country where the catchphrase has had a slogan-like purchase.

In China, in fact, 'flexible working' and working from home had not been as forcefully pushed, with as much bright-eyed optimism, as in the USA,

Western Europe, and other liberal capitalist countries. The rationale for making working from home the 'new normal' had rested, principally, in reducing investments while increasing production and profits in the private sector, and indeed in public-sector organizations which had come to be modelled like their private-sector counterparts. This rationale was powerfully propelled by the 'doing more with less' slogan raised during the 2007–2008 financial crisis in, particularly, North America and Western Europe, and persisted in bureaucratic and management circles thereafter. PR China's response to that crisis, under the slogan 'new normal', had been focused less on cutting costs and more on strategic and focused investments. 'Doing more with less' was not a publicly declared and publicized impetus there—if anything, the spirit of the policy was simply doing more and scaling up—and, correspondingly, 'flexible working' did not seem such a wonderful idea or quite so imperative. However, PR China's quick move towards lockdowns in January–February 2020 in hotspots for the contagion, naturally brought working from home firmly into the foreground and merged it with its own prevailing 'new normal' slogan.

On 11 February, the data-mining and consultancy firm iiMedia Research released figures for the growing use of online working resources in China amidst lockdowns: 'during the Spring Festival of 2020, there are more than 300 million remote office workers in China, and the number of companies using teleworking exceeds 18 million'. However, the firm was careful about the long-term prospects:

> iiMedia Consulting analysts believe that the penetration rate of remote office in China is relatively low, and there is a large developmental space in teleworking industry. Catalyzed by the epidemic, the demand for remote offices surged in the short term, and cloud office concept stocks have been trending strongly in the secondary market during the Spring Festival of 2020. However, the habits of remote office users in China have not yet been established. After the epidemic, more attention should be paid to cultivating user habits, ensuring information security, highlighting the advantages of collaborative office, and increasing user stickiness.
>
> (iiMedia 2020)

English-language reports in Chinese newspapers were quick to declare the emergence of a 'new normal' from these figures, such as in the *Global Times* (GT 2020) and the *China Daily* (Ma Chi 2020). As lockdowns were announced in numerous countries around the world, the Covid-19 'new normal' of working from home in China became a global necessity. A McKinsey article of 23

March offered lessons from China for implementing remote working in global businesses (Bick et al. 2020). Every significant government agency and commercial firm published guidance on working from home, mostly in the form of sector-specific 'how-to' pamphlets. News media carried hundreds of articles declaring that working from home was a necessary 'new normal' from which there would be no return. 'Next normal' reports of the sort cited above eyed the investment opportunities in working-from-home products and services. Books started appearing in a general 'how-to' tenor (starting with Mangia 2020). This was no longer a matter of strategizing how to make working from home a 'new normal' as it was prior to the Covid-19 outbreak, as in fact it had been for the previous couple of decades (see Chapter 2). This 'new normal' of working from home couldn't be regarded as emerging or to be achieved. Caught in the larger 'new normal' that was the Covid-19 context itself, working from home had already become the 'new normal', an inseparable element of this larger Covid-19 'new normal'. Its pros and cons did not need to be considered and researched; rather, the pros had to be maximized and the cons minimized after the fact. The issue now was how to make it function adequately and for good.

A distinctive aspect of working from home amidst the pandemic related to education: that is, teaching and learning from home for students in schools and tertiary education institutions. Lockdowns meant that educational activity that occurred in built environments had to be moved expeditiously, insofar as possible, to digital environments: from offices, classrooms, lecture theatres, libraries, laboratories, sports grounds, campuses, etc. to their digital equivalents online. In-person exchanges had to move to technology-mediated exchanges. This proved to be a particularly anxiogenic move for schools (primary and secondary), where the provision for remote teaching and learning had not been pushed forcefully. It has generally been held that in the initial stages of education, developing interpersonal relationships is essential and even digital education resources should largely be delivered in a hands-on way. The Covid-19 'new normal' of remote learning at school level seemed really quite new. Contributions to Doug Lemov ed. (2020) gave a helpful account of how teachers coped, with a beleaguered and compulsory optimism: 'Since this New Normal began, we've witnessed plenty of challenges in the classroom [...] but we have seen even more of a can-do attitude, a problem-solving embrace of situations outside our control' (Lemov and Woolway 2020: 3–4). In any case, governments in various countries made decisive and perceivably risky moves to reopen schools as quickly as possible after the first spate of national lockdowns (eyeing the reopening of schools in the UK, Beaumont 2020 and Penna

2020 reported on the experience in France, Poland, Belgium, Germany, South Korea, Denmark, Israel, Kenya, China, Taiwan, Spain, and Italy). For the tertiary sector, especially universities, the experience of this 'new normal' was somewhat different. Here this situation seemed to bring to a culmination the 'new normal' of remote teaching and learning that had already been jogging along and gathering pace for a couple of decades. Though universities were also reopened soon after the schools in many countries, remote learning was regarded as permanently ensconced, at least to some degree, across the sector. And this was regarded as being more in line with a chronicle foretold than in a spirit of uncontrollable and temporary necessity.

The drive towards the organized delivery of higher education by digital means had started in the late 1990s, around the time digital workspaces were being constructed. The idea was to push for a convergence of the frontline of technological innovation and the frontline of knowledge dissemination. The ways in which digital technologies may be incorporated in, particularly, higher education were already reasonably defined in the Enhancing Education Through Technology Act of 2001 in the USA; its updated 2015 version gave an itemized list of 'tools and practices' which covers the current ground well:

(A) interactive learning resources that engage students in academic content; (B) access to online databases and other primary source documents; (C) the use of data, data analytics, and information to personalize learning and provide targeted supplementary instruction; (D) student collaboration with content experts and peers; (E) online and computer-based assessments; (F) digital content, adaptive, and simulation software or courseware; (G) online courses, online instruction, or digital learning platforms; (H) mobile and wireless technologies for learning in school and at home; (I) learning environments that allow for rich collaboration and communication; (J) authentic audiences for learning in a relevant, real world experience; (K) teacher participation in virtual professional communities of practice; (L) hybrid or blended learning, which occurs under direct instructor supervision at a school or other location away from home and, at least in part, through online delivery of instruction with some element of student control over time, place, path, or pace; and (M) access to online course opportunities for students in rural or remote areas. (Section 2403, Definitions)

Evidently, the thrust of these 'practices and tools' are to enable remote teaching and learning in increasing degrees and possibly to a complete extent. Over this period from 2001 to 2015, a slew of direct and indirectly relevant legislation in various countries facilitated the embedding of such tools and

practices in, particularly, higher education. The advantages of these have been prolifically publicized: enhanced access to learning material (through open-access publishing, open-source codes, open training data, publicly accessible digital repositories, etc.); increasing student choices and independence; transparency of procedure; overcoming disadvantages due to location or means, or border restrictions; enabling new kinds of professional skills; accessing education while being employed; and reducing the carbon footprint of education institutions. The principal driver for the embedding of these tools and practices were, however, economic rather than progressive considerations. Those considerations were woven through the catchphrase.

Roughly from the 1940s to the 1990s, in most countries the state was the main regulator of the higher education sector and often the main source of funding, with private business interests, where active, playing a relatively covert or seemingly altruistic part. Within education delivery, the intervention of business interests was not considered de rigueur. A notion of 'academic autonomy' seemed to guard against the interference of those interests, guaranteed in law, ergo by the state as protector of public interests. But that was always questionable: who is to say that the state would not choose to promote business rather than public interests, or the private desires of the powerful few rather than of the inclusive all? Nevertheless, at least in principle, business interests were kept at arm's length. The process of embedding technological tools and practices in higher education, which enabled steps from largely on-site or contact-based learning towards increasing degrees of remote and flexible learning, were effectively a gradual reduction of the state's public-interest role and a constant expansion of the profit-making role of businesses with the state's support. This was because the technological tools and practices were produced, disseminated, and operated very largely by private-sector companies. Such business-driven remote-learning tools and practices were put in place energetically on two grounds. On the one hand, government spending on education could be reduced by rationalizing the use of built infrastructures, on-site employees, and measured working time. On the other hand, universities could at the same time become arenas for profitable business activity, with students as consumers of universities' services and universities as consumers for technology services. Technologically facilitated higher education could, then, from this perspective, be regarded as a mechanism for sieving a combination of students' monies and such direct public monies as universities continued to receive for business to prosper. Meanwhile, universities could also produce low-cost research for technological innovation for businesses to capitalize on. Indeed, early reflections on the advent of digital tools

and practices and remote learning in higher education were troubled by the entry of private business interests in what had been considered a protected public-interest sphere. David Noble (1998: 118), contemplating the advent of 'private vendors of instructional hardware, software, and content looking for subsidized product development and a potentially lucrative market for their wares', observed that 'campus commercialization [...] has now shifted to the core instructional function, the heart and soul of academia'.

Through the following two decades technologically facilitated remote learning in universities veered between transforming itself into a 'new normal' and becoming caught up in a larger 'new normal' with a constant consolidation of growing business interests. Through this period, to begin with, 'blended learning' became an inner-circle catchphrase. This referred to a mixture of contact (face-to-face) and remote (through online means) learning, or, more precisely, the gradual reduction of contact learning in favour of a gradual increase in remote learning. Numerous academic papers, reports, and guidebooks appeared in a steady stream through the 2000s prophesying, and heartily embracing, a 'new normal' of education, and before long it was considered as having become a 'new normal'. As a case in point, Charles Dziuban, Patsy Moscal, Anders Norberg, and their colleagues at the University of Central Florida, produced a series of reports and papers on blended learning starting from 2004 (Dziuban et al. 2004), and were firmly able to declare that it has become the 'new normal' by 2018 (Dziuban et al. 2018)—a 'new normal' of education. After the 2007–2009 financial crisis, the larger 'new normal' of cuts in public funding interestingly gelled with that direction: the 'new normal' *of* education merged into education *in* this 'new normal'. In the previous chapter, US Secretary of Education Arne Duncan's (2010) enthusiastic call for 'doing more with less' in education in the 'new normal' was quoted; shortly before that the US Department of Education (2010) had released a paper with advice on how 'policymakers, educators, and other stakeholders [can] work together to utilize "The New Normal" to improve student learning and accelerate reform'. The only substantive advice there had to do with 'smart use of technology' which would allow 'each person to be more successful by reducing wasted time, energy, and money'. The financial logic of this kind of education policy in the 'new normal' caused some unease, but not much (e.g. Bruininks et al. 2010; Goldstein et al. 2011). From around 2012 onwards, the new buzzword, or buzz-acronym, was MOOCs (massive open online courses): online platforms delivering, initially, courses and, later, whole degree programmes for contact-free remote learning. That effectively moved from a blended to a 'pure' model, with an air of preferring pure malt to blended Scotch whisky. Some of

these platforms were set up by private firms, some by universities (like Coursera, EdX, FutureLearn), where the latter had become increasingly dependent upon being entrepreneurial as state support dwindled. Numerous news media and education-service-provider firms published reports on MOOCs as opening up another 'new normal' *of* education. By 2019, almost all universities globally had in-house blended learning tools and practices in place, and many had partnered in or set up their own platforms to make some of their offerings fully online.

When the Covid-19 outbreak appeared in 2020, it seemed to be but a final push for remote learning in universities as a 'new normal' *of* education merging into the needs of education *in* this larger 'new normal'. It was considered that universities can only be resilient if they can capitalize on remote learning, and such resilience is the future of universities as a sector. That, at any rate, was the foregone conclusion in more considered academic and policy publications on this 'new normal' education in general (such as Xin Xie et al. 2020; Pacheco 2020; d'Orville 2020; Quilter-Pinner and Ambrose 2020; World Bank 2020) and the innumerable such publications about higher education in specific disciplines and regions. The gist of such publications was that the Covid-19 'new normal' had made the remote-learning 'new normal' a fait accompli, and all that remained was for a few little creases to be smoothed out: such as, digital divides among students, variable infrastructure in regions and institutions, perceived alienation in the learning process, and resistant attitudes among some stakeholders. Relatively little attention was given to what had been the main driver of remote learning throughout: the embedding of private interests working through technology providers in the education process. But the situation in this regard could be gauged in a tangential way. The largest coordinated response for education to the Covid-19 context was launched by UNESCO in March 2020, the Global Education Coalition, to, mainly: 'Help countries in mobilizing resources and implementing innovative and context-appropriate solutions to provide education remotely, leveraging hi-tech, low-tech and no-tech approaches' (UNESCO 2020[2]). The coalition consisted of 140 partners from 'international organizations, civil society and the private sector'. The partner listings were instructive (UNESCO 2020[3]). The only way in which governments featured there was through transnational organizations which act as global 'third sector' bodies (promoting 'social enterprise' and private–public partnerships), usually receiving governmental contributions. The majority were private-sector firms and foundations (presenting public-spirited agendas of generating benefits-with-profits). Evidently, the Covid-19 'new normal' had enabled a consolidation of business interests as

the bedrock of education globally, with states taking well-mediated back seats. At the same time, there was growing concern that sustained dependence upon, ultimately, privately sourced online education provision was steadily exacerbating digital divides, in both affluent and less affluent countries (UNICEF and ITU 2020; Shackleton and Mann 2021; Coleman 2021).

Polarized politics

There was obviously a deep irony in the various modes of denoting the Covid-19 social condition as the 'new normal'. At the heart of the catchphrase was a familiar medical counterpoint: between medical normality (good health) and pathology (disease). The next chapter considers this and other counterpoints in some detail. No particular medical knowledge was needed, however, for this counterpoint to play in usage of the catchphrase. All sorts of consequences of the contagion could be seen as a 'new normal': fear of infection, constraints in everyday life and work, dramatic policy moves, economic hardships, and even the continuing incidence of the disease. But all that was on the understanding that the pathology itself, the infection-ridden bodies, the real encounter with morbidities and mortalities, could not be understood as normal under any kind of circumstance. By definition, the pathology itself is not normal, though all the ways of reckoning with and addressing it may be normalized. The pathology that was the pandemic was the absolutely unnegotiable core in counterpoint to which all kinds of 'new normal' situations may be understood as such.

Where, prior to the pandemic, the catchphrase was applied bitterly to some areas of social injustice and dysfunction, that now seemed inappropriate even as a despairing rhetorical ploy. The year before, as noted in the previous chapter, Isabel Ortiz and Matthew Cummins (2019) had declared austerity as a 'new normal' with a global overview. The idea was that policies around the world (reports on 161 countries were surveyed) of cutting support for public services and privatizing them, and deregulating commercial activity, with consequent exacerbation of social inequality and precarity had become so pervasive and persistent since the 2007–2008 financial crisis that they had ceased to trouble. Such policies and their consequences had become normalized, a 'new normal'. In fact, so widespread had austerity measures become that they were accepted even by those who suffered their deleterious consequences, and were taken simply as the-way-things-are. As morbidities and mortalities from the pandemic grew inexorably, however, it now appeared that austerity was

an aspect of the pathology itself. In a way, austerity has emerged from a pervasive and imperceptible spread, normalized, to combining with the infectious virus and becoming a joint cause of explosive morbidities and mortalities—therefore (re)pathologized. Instead of austerity as 'new normal' and Covid-19 as disease, now Covid-19+austerity seemed to be the disease. As a synecdoche for austerity at large, the struggles of public health services, stripped bare by cutbacks and the interference of profit-making practices, against the pandemic could not but trouble now. Their struggles were felt particularly by those in financially straitened circumstances, since the latter rely predominantly on public health provision. Thus, in a single equation, the pandemic magnified the effects of austerity and sharp inequalities in terms of morbidity and mortality figures. Public health officials, medical bodies and associations, epidemiologists and health-policymakers pointed to the obvious relationship between austerity and the deadliness of the disease more or less unanimously. Media reportage on the issue proliferated. Broad-based studies of the relationship between public health provision, inequality, and the effects of the virus presented very similar patterns across regions and countries (e.g. Shadmi et al. 2020 reporting on thirteen countries in different continents; Bambra et al. 2020 drawing upon data for USA, UK, and other high-income countries; a *Dialogues in Human Geography* special issue with commentaries from forty-two contributors from different countries, introduced in Rose-Redwood et al. 2020). If the 'new normal' came up here at all, it was with a shudder at the prospect of an enhanced version of the pre-pandemic 'new normal' of austerity:

> The COVID-19 pandemic has created a global crisis in which the 'normal' conditions and structures of societies have been upended. Much of the rhetoric [...] is about returning to 'normality', but it is clear that whatever happens we will be entering a 'new normal', whether that be altered social practices, truncated mobility, reconfigured labor relations, increased precarity, deepened inequalities, or more cooperative, communal, caring arrangements. There are also increasing concerns that governmental attempts to deal with the pandemic without further disrupting the market may ultimately lead to the emergence of a new neoliberal authoritarianism.
>
> (Rose-Redwood et al. 2020 104)

When the IMF seemed to make its pandemic lending and recovery packages conditional on the worn privatization and deregulation model, 308 organizations from around the world signed an open letter demanding that those

conditions be removed in October 2020 (Eurodad 2020): 'Ahead of the 2020 IMF Annual Meetings, we call on the IMF to turn away from the mistakes of the past and finally close the dark chapter on IMF-conditioned austerity for good'. The intergovernmental United Nations Conference on Trade and Development's *Trade and Development Report 2020* (UNCTAD 2020) unambiguously denounced a 'lost decade' of fiscal austerity and corrosive inequality. It was, in fact, extraordinarily forthright about the disastrous consequences of global austerity policies since the 2007–2008 financial crisis, and the need to withdraw them after the pandemic. But even amidst these confirmations of the pathological nature of austerity, an upgraded version of austerity as the imminent 'new normal' featured implicitly in government policy documents, and offered hope for the 'next normal' in various corporate strategy reports.

Movements which were more optimistically declared 'new normal' prior to the pandemic also developed a more troubled association with the catchphrase, or, to put that another way, troubled the catchphrase. In relation to these, the catchphrase seemed to flicker between optimistic and pessimistic cadences or become dissociated from its referents. The rousing announcement, 'Protest is the New Normal', with which *Le Monde diplomatique* had greeted the new year is a case in point. The kind of crowd protests in various countries this referred to—against austerity measures, neoliberal policies, inequality and discrimination, corruption and authoritarian governments, and climate change—hit a wall as lockdowns and restrictions were implemented following the outbreak (see Gupta et al. 2020: Ch. 5). The very authorities that these were directed against found an unquestionable reason to shut them down in February and March, with only weak resistance. Within a month, such crowd protests started again, either continuing after an imposed hiatus (e.g. Hong Kong, Lebanon, Chile, Algeria, and Iraq) or picking up long-drawn grievances with renewed impetus (e.g. Nigeria, Cameroon, Belarus, Bulgaria, Poland, Hungary, Mexico, and Thailand). Naturally, all crowd protests now went against the grain of measures to contain the spread of the contagion. The very elemental form of protesting as a crowd in a public space was out of synch with the 'new normal' that was the Covid-19 context. The reappearance of such crowds after being precipitately stopped with the first round of lockdowns was riven with new anxieties.

The most explosive impetus to crowd protests of this period indubitably came from the USA, following the public murder of George Floyd, an African American man, by a White police officer in Minneapolis on 26 May. This was a spark that reignited a powerful anti-racism protest, principally under the banner of the Black Lives Matter (BLM) movement (and slogan), which

assumed unprecedented scales across the USA, and spread to the UK, Brazil, Germany, and other countries. BLM had been formed after the acquittal in 2013 of the man who had shot Trayvon Martin (February 2012) in Sanford FL, and following the regular occurrence of such killings. Despite increasingly desperate protests since, African Americans dying at the hands of the police had continued with grinding regularity. With the victory of Donald Trump in the presidential elections of 2016, white-supremacist nationalist alignments received a decisive fillip. Confrontations between such groups and antifascist formations (notably in Charlottesville VA in August 2017) became repeated occurrences thereafter. The George Floyd BLM protests were a sustained outburst of the gradually growing rage at racial injustice in the USA and elsewhere. However, in the context of the pandemic, such protests could no longer be dubbed as expressing or auguring an optimistic 'new normal'. Rather, racial injustice, in line with austerity-induced inequality, could now only be regarded as a social pathology of which these despairing protests were a consequence and symptom. As with austerity and inequality, in fact, the Covid-19 contagion seemed to reflect racial schisms, as if the schism itself magnified the contagion and was contributing to the pathology. In the USA and UK particularly, numerous research papers and reports noted the heightened effect of the contagion on particularly Black and ethnic minority constituencies (such as Millett et al. 2020; Pareek et al. 2020; Kirby 2020; Hacque et al. 2020). In the USA and UK, government strategies were developed to address this unevenness (CDC USA 2020; Race Disparity Unit UK 2020). Those observations gelled with the global picture of higher Covid-19 deaths among vulnerable populations, including 'older adults, people living in densely populated areas, people with lower socioeconomic status, migrants and minorities' (Shadmi et al. 2020:1). The magnification of Covid-19 morbidity and mortality along the lines of racial inequality in the USA, UK, and elsewhere merged with the immediate causes of the BLM protests: racial injustice appeared now to be not just an endemic pathology but one assuming pandemic proportions in synch with the Covid-19 contagion itself. The only optimistic 'new normal' that could be mentioned here seemed to lie in the distant future. Former US president Barack Obama evoked it three days after Floyd's death in an Instagram post:

It will fall mainly on the officials of Minnesota to ensure that the circumstances surrounding George Floyd's death are investigated thoroughly and that justice is ultimately done. But it falls on all of us, regardless of our race or station – including the majority of men and women in law enforcement

who take pride in doing their tough job the right way, every day – to work together to create a 'new normal' in which the legacy of bigotry and unequal treatment no longer infects our institutions or our hearts.

(Quoted in Danner 2020)

The use of the word 'infects' was of its time. Apart from Obama's statements, the catchphrase understandably did not come up in this connection. But other social forces which had, for a while, been associated with the catchphrase, were beginning to congeal alongside and against such protests: exclusionary nationalist forces.

Those had also manifested themselves in the form of crowd protests, but by associating themselves with protests against the governments' Covid-19 lockdowns and restrictions. Anti-lockdown demonstrations appeared in spates in, among other countries, Israel, Serbia, Germany, the UK, Ireland, Italy, Spain, the Netherlands, Argentina, Australia and, particularly, the USA. In the main, their initial appearance had little to do with exclusionary nationalist alignments. These were, in some measure, inevitable surges from below. Covid-19 restrictions exacerbated long records of austerity policies and growing inequality, with the effects being felt particularly adversely among small businesses and those in straitened circumstances. Not only did the contagion have a markedly virulent effect on the latter, the lockdowns and restrictions themselves put small businesses at risk, unemployment went up sharply, and the marginalized seemed to become more disposable than ever. Understandably, protests against long-term austerity policies, corruption, and growing inequality were accentuated by the Covid-19 lockdowns and restrictions, and often took issue with the latter. But these were different from the exclusionary nationalist kind of crowd protest against lockdowns and restrictions, which were less about their consequences and more about claiming the prerogative to speak for the nation. The focal point of such protests was in the USA and Western Europe, and they seemed to form an ideological front against the BLM and anti-austerity protests. Typically, along with strident exclusionary nationalism, these fostered absurd conspiracy theories and took political positions now familiarly dubbed 'rightwing populist'. Those included notions such as that the pandemic was a fiction put out by a shrouded global elite to consolidate its murky control of populations and wealth, and vaccinations were a means of achieving such consolidation of power. Some popular nationalist leaders (particularly Donald Trump in the USA and Jair Bolsonaro in Brazil) were heroically pitted against that deeply embedded global elite: the latter were promoting multiculturalism, movements of peoples, and globalization where the call of the moment was for defending national sovereignty and purity

(understood in ethnic and racial terms) and economic protectionism. These notions coalesced into a distinctive set of mass demonstrations against Covid-19 restrictions and lockdowns. The latter provided the superficial reason to piggyback on calls for defining nationality in dominant ethnic terms, dismantling liberal institutions, disinvesting from transnational commitments, and championing authoritarian nationalist leaders.

Crowd protests in the Covid-19 context, then, appeared sharply polarized between inclusive and exclusive, marginalized and dominant, representative democratic and majoritarian democratic, deliberative and authoritarian, and transnationalist and nationalist political prerogatives. A concomitant of polarization was that in some respects the boundaries between the polarities were blurred, or convictions on one side seemed like mirror images of the other at times. For instance, reductive concepts of race and ethnicity were, in fact, propounded on all sides; an entrenched global elite was discerned as the ultimate adversary on all sides; and articles of faith were preferred over reasonable arguments at times on all sides. Also, somehow the rationales of austerity policies—widely understood as derived from global neoliberal and technocratic capitalism—played an ambiguous part on all sides. Austerity policies appeared to be, at the same time, props for majoritarian nationalist regimes and the bulwark of a democratic transnational order.

This polarization was, obviously, not of the Covid-19 context. It had been exacerbating worldwide for a considerable period, at different levels across numerous political territories. The pandemic had merely materialized this effervescent trend, again. In fact, at various stages the key factors that fed into such polarization had been noted, explored, and declared, with growing unease, as dangerous 'new normals'.

Of particular moment in that polarization was the concerted global rise of exclusionary nationalism and 'right-wing populism' of the sort just outlined, mainly within the decade after 2010. That meant the rise of aggressively nationalist parties and leaders in state politics, aligned with or giving coherence to conservative majoritarian forces, hostile to transnational and national liberal arrangements and even more so to what remained of socialist subscriptions therein. This seemed new, at any rate, within states with formally democratic processes, that is, with arrangements for multiparty elections with universal suffrage to appoint governments, alongside institutions designed to protect minorities and maintain parity between different interest groups. The tendency of these nationalist parties and leaders to undermine formally democratic institutions within and across states presaged a momentous and widespread ideological conflict. There was, thus, a significant rightward turn in politics

across EU member states, threatening the integrity of the transnational forma-
tion itself (see Wodak et al. 2013; Lazaridis and Campani, eds. 2017; Gupta and
Virdee, eds. 2019; Massetti et al. 2020). In the four years preceding the Covid-
19 outbreak, various elections seemed to confirm the powerful emergence of
exclusionary nationalism against the grain of formal democratic principles as
a global trend. Those included, notably, Trump's 2016 election as president in
the USA, Bolsonaro's in 2018 as president in Brazil, Modi's as prime minis-
ter for a second term in India in 2019, Johnson's as prime minister in 2019
promising a culmination to UK's secession from the EU, and Erdoğan's as
president of Turkey in 2019 following the 2017 constitutional reform which
established a presidential system there. A shift in the normality of mainstream
politics in formal democracies was, unsurprisingly, mooted—in fact, a 'new
normal'. Since what seemed new was the growing popularity of right-wing
forces among electorates in formal democracies, the 'normalization' of those
worldviews where they had previously been eschewed or marginalized was
much discussed in academic and policy circles. These studies covered a range
from the larger structures of ideological alignment to the minutiae of everyday
communications (e.g. Wodak 2015; Sa'adah 2017; Schuhmann 2018; Free-
den 2019; the special issue of *Social Semiotics*, Krzyżanowski, ed. 2020). The
pandemic 'new normal' seemed to challenge and, because of that, raise the
stakes of the normalization of right-wing populism. On the one hand, aggres-
sively nationalist parties and leaders often did an indifferent job of coming
to grips with the pandemic (Katsampekis and Stavrakakis, eds. 2020); on the
other hand, right-wing populist formations managed to become strongly as-
sociated with anti-lockdown/restrictions protests (what Vieten 2020 called
'anti-hygiene mobilization'), to the extent of using that as a front against anti-
austerity and inequality protests. With the pandemic 'new normal' squarely in
view, the 'new normal' of right-wing populism seemed set to mould a larger
'new normal' in transnational arrangements themselves—most cogently, in the
most formalized transnational formation of the time, the EU:

> [Even] after emerging strengthened from the political, economic and fiscal
> threats of the Covid-19 pandemic, the EU is facing more fundamental chal-
> lenges in the coming decade. The rise of populism in Europe (and elsewhere),
> the growing contestation of expertise and the demise of liberal trade all im-
> ply that the EU has to adapt to a new normal. These developments are linked,
> and they have in common the erosion of the system of rules and norms on
> which the EU has based not only its actions, but indeed its legitimacy.
>
> (Christiansen 2020: 23)

At least three senses of the catchphrase seemed to converge in such anxious observations.

Folded in within the 'new normal' of right-wing populism and of sharply polarized politics, was the wider 'new normal' of the digital mediascape. There were four main developments to reckon with here. First, the internet had gradually become the main source of news and social commentary for consumers, shouldering (gradually shouldering aside) older mainstream print and broadcast channels. Now mainstream channels had to vie for attention with each other and with a range of alternative and variously unregulated news sources. In this relatively inexpensive environment, instead of news providers presenting a consolidated set of reportage and commentary, consumers could cherry pick or scan offerings from a range of sources according to their interests. Second, technological capacities had been developed by, in the main, internet service providers to customize and target news according to the pre-existing interests of segments of consumers (or even individual consumers). This meant that internet service providers (and third parties with suitable access to the technology) could feed consumers only that which complied with their pre-existing interests. Consumers could thus be exposed only to news and commentary which bolstered their biases and prejudices. Third, internet service providers also developed capacities which allowed consumers to form social networks according to their pre-existing interests and share information easily with each other. Thus, consumers could easily dispose themselves into well-connected segments with shared interests and attitudes. They could form, so to speak, bubbles of confirmatory—and mutually confirming—consumption. Fourth, the presence of unregulated and alternative news sources, as well as of third parties (like internet service providers themselves), allowed such a mediascape to become a system for variously manipulating consumers. A much-discussed kind of manipulation has been the deliberate dissemination of disinformation or 'fake news', which is fed to those who are inclined to absorb it and to share it in their bubbles of like-minded segments. Technological tools to misleadingly enhance the appearance of consumer response to reportage and commentary (such as, trolling using bots) play a tractable part in manipulation.

The gradual grounding of this mediascape has been understood, prolifically in reportage and scholarship over the previous two decades, as opening up a 'new normal' with wide-ranging effects. This digital media system is regarded as having transformed commercial and political campaigning, enhanced the organization and effectiveness of protests (including crowd protests), disrupted democratic practices and procedures (like elections),

restructured interpersonal and group interactions at all levels, and, particularly importantly, reshaped modes of developing social awareness and worldviews—often captured by the phrase 'post-truth era/age'. At times, this digital mediascape has in itself been considered responsible for the polarized politics described here. Polarization, it is often argued, is corollary to forming self-confirmatory bubbles of consumption which are cut off from each other. Of the polarities, the right-wing populist agencies are regarded as being particularly savvy in using digital manipulation tools, and the consumers of right-wing populism especially vulnerable to being manipulated and buying into outlandish conspiracy theories. Insofar as the latter played amidst protests against lockdown and restrictions during the pandemic, observers of the digital mediascape usually confirmed these much discussed trends (see, for instance, Sturm and Albrecht 2020; Duplaga 2020; Shahsavari et al. 2020; Vieten 2020).

In the upper echelons of politics, as 2020 waned, the most hyped event was the US presidential elections in November. Incumbent Republican Party candidate Donald Trump had associated himself firmly with anti-lockdown and anti-restriction positions since the Covid-19 outbreak, and with the least palatable aspects of right-wing populism throughout his tenure. He was regarded as a factory of 'fake news' while he denounced all critical reportage of being such. A personality cult had formed around him peopled by conspiracy theorists and exclusionary nationalists. His much-trumpeted economic policies had widened inequalities and weakened public support systems and, in any case, their seeming benefits had crumbled during the pandemic. Contender Democratic Party candidate Joe Biden, who had appeared as a compromise at the expense of more progressive options, had all progressive and establishment expectations antithetical to Trump pinned on him. The competing candidates appeared to embody the political polarizations of the time. The flickering shades of the catchphrase 'new normal' played in the interstices of their corrosive campaign, amidst the constantly spiralling mortality and morbidity rates in the USA, and came with an ironic ring. The 'new normal' that was the Covid-19 context in the USA had itself split along party lines or candidate lines, in terms of racial fissures, the fault-line of states that are controlled by the Democratic Party or the Republican Party, and the visible split of who wears face coverings and who does not. In some instances, a hopeful future 'new normal' was prophesied as possible from the ravages of the Covid-10 'new normal', naturally from the Democratic Party side. Having declared one of the strictest lockdowns in the country, the Governor of New York State, Andrew Cuomo, for instance, observed in April:

Let's say that where we're going it's not a reopening, in that we are going to reopen what was. We are going to a different place, and we should go to a different place, and we should go to a better place. If we don't learn the lessons from this situation, then all of this will have been in vain. [...] So we're going to a different place, which is a new normal. We talk about the new normal. We've been talking about the new normal for years. We are going to have a new normal in public health. By the way, the way we have a new normal in an environment, the new normal in economics, a new normal in civil rights, a new normal and social justice, right? This is the way of the world now.

(quoted in Arter 2020)

Cuomo's was a studiedly deliberate use of the catchphrase. In fact, more than using it Cuomo reflected upon its current denotative thrust and it manifold past associations as a catchphrase. He seemed to embrace what it stood for at the time, signifying a context of lockdowns and restrictions. But he did so with an ironical awareness of its overused catchphraseness. At the same time he extended its multiple resonances to give his message an optimistic turn. That is to say, he used the phrase while talking about how the phrase has been used; he owned it and yet he put the onus of owning it more on 'the way the world is now' than on himself.

With regard to the presidential candidates themselves, the phrase seemed even more awkwardly placed. In July, a *Wall Street Journal* article observed:

In the age of coronavirus there is a lot of talk of a 'new normal' emerging. Yet in the presidential campaign of 2020, both President Trump and former Vice President Joe Biden actually are promising a return to an old normal – albeit in dramatically different, almost diametrically opposed, ways.

(Seib 2020)

Trump, the article said, was campaigning for a return to normality when 'the nation's Founding Fathers were honored as visionaries rather than villains' and those anti-racism and anti-austerity protests had not tarnished their vision. Biden was looking for a return to the normality before Trump's presidency, but with some signs of a forward-looking agenda building upon Obama's legacy. Apropos of the pandemic, Trump had already rejected the phrase in favour of a premature 'Opening Up America Again' campaign to end the first lockdown, as an article in the conservative *New Republic* magazine observed (Smith 2020). Insofar as the ambiguities of Biden's backward/forward looking campaign went, those too were noted with the catchphrase in mind in an essay in the libertarian *Reason* magazine in February, before the pandemic had squarely hit New York:

Biden is running a markedly conservative campaign in the literal sense of the word: He wants to go back, to conserve what we had under Obama. The contrast is stark with the socialists and progressives otherwise dominating the Democratic hold. What if, the Biden campaign seductively asks, we could simply pretend the 45th presidency never happened? The idea of a 'return to normalcy' has worked before. Warren G. Harding ran for president under that banner exactly a century ago.

<div align="right">(Mangu-Ward 2020)</div>

The essay went on to argue, however, that 'when it comes to politics, normal is terrible', and Biden's promise to return to normalcy à la Harding may fare no better than it did in Harding's tenure.

As it happened, the Biden campaign stayed well away from referring to a 'normal'—whether 'new', 'next', or to 'return to'. Instead, it chose a slogan which accurately reflected the forward-looking conservatism that was evident: the similarly alliterative 'build back better'. Biden's 9 July speech laying out an economic recovery plan had it labelled as 'build back better' (see Goldmacher and Tankersley 2020), and it became one of his campaign slogans thereafter, alongside 'battle for the soul of the nation'. 'Build back better' had exactly the conservative thrust of building *back* with a little concession to looking *forward*. It had the staid and yet upbeat establishment conservatism that appeared in the UN's 'recover better'. Indeed 'build back better' proved to be an apt slogan for Conservative Prime Minister Johnson in the UK too, and was tagged to his economic recovery plans from August. An article in the British newspaper *The Independent* in November wondered who had touted the slogan first, Biden or Johnson, and unsurprisingly settled for Johnson (Forrest 2020). In synch with that, the slogan was also taken up in Britain by a coalition of Third Sector organizations in a spirit of charitable liberalism, including, among others, Green New Deal UK, Greenpeace, Friends of the Earth, Quakers in Britain, and New Economics Foundation. The slogan itself had a chequered past, recalling Bill Clinton's aid package after the Haiti earthquake in 2009, and the UN's Disaster Risk Reduction framework of 2015 (see UNISDR 2017). But that's a different story from the one followed here. In any case, the slogan contributed to Biden's victory in the presidential elections at the end of 2020; which is to say, Trump lost the elections as gracelessly as possible.

A conceptual shift

Even as the use of the catchphrase 'new normal' reached an unprecedented frequency of usage in referring to the Covid-19 context, its glib deployment began

to flounder in 2020. In some respects, while continuously denoting the pandemic condition, it seemed to reach a kind of self-fulfilment or culmination of applicability (with regard to work and education); in others, it appeared to have run its course of catchiness (business and investment); and in yet others, it flickered indecisively and gratingly between optimism and pessimism (in polarized protests); and further, it was considered as having become ironic and redundant (mainstream politics). Nevertheless, the catchphrase continued to carry all the accrued and complex resonances it had acquired through its career from 2001, which fed into its more nuanced or interrogative uses in 2020. When alternatives or replacements were taken up—from 'next normal' to 'build back better'—those were nevertheless threaded through the received associations of the 'new normal'.

The history of the catchphrase, woven through contemporary times, says much about how catchphrases work amidst social ideas and forces. The fluid semiotics of the catchphrase reflect the structures and processes of social systems. Through the in-process relationship between semiotics and systems, a general conceptual shift of some importance may be discerned via the catchphrase 'new normal'. Underpinning the catchphrase is a well-established concept of considerable complexity, to do with 'normality' or 'the normal'. It is a concept of critical importance across a wide range of discourses, powerfully centred in various areas of contemporary intellection and practice, and indeed a fulcrum of modern knowledge formation. The sustained usage and wide reach of the 'new normal' over two decades bear upon the idea of the 'normal' itself. The next chapter explores what the rich connotations of the catchphrase 'new normal' imply for the seminal concept of normality.

4

The Concept of Normality

'Normal'

Constant and wide usage of the catchphrase 'new normal' has a bearing on
the idea of normality—on received connotations of the term 'normal'—even
if that idea is undefined and rarely considered explicitly. In the 'new normal',
the implicit idea of normality rests on the cusp of contradiction, which is a
productive circumstance for a catchphrase and may well be responsible for its
memorable quality and convenient adaptability. On the one hand, within the
catchphrase, the 'normal' is associated with whatever seems to be a dominant
arrangement or perception at a given juncture. There is a relativized presen-
tism there: that was 'normal' then, this is 'normal' now. On the other hand, the
'normal' in the catchphrase suggests its continuous cancellation: the 'normal'
is done with, this is the 'new normal'. In the latter sense, the 'normal' is not
relativized but fixed and relegated at the same time, put firmly in the past. Be-
tween relativization and fixity, the term 'normal' in the catchphrase seems to
pull awkwardly in different directions. None of its received connotations are
lost but all seem somewhat displaced. Every enunciation of the 'new normal'
places a question mark by the idea of the 'normal' and tacitly puts its received
meanings in doubt. As it happens, the connotations of 'normal' are extraordi-
narily rich and multifarious. The usage of 'normal' was first grounded firmly in
various areas of rigorous knowledge formation, specialist and academic, and
then dispersed across popular and everyday language usage. Thus, when the
catchphrase casts an interrogative pall over 'normal', however thoughtlessly,
a whole structure of knowledge and ordinary communication is put under
pressure. Arguably, thereby a significant shift in general human understand-
ing takes place, most likely in keeping with the ruling interests and purposes
of our times.

Ultimately, to understand the effect of the catchphrase 'new normal' it is
necessary to come to grips with the term 'normal'. This chapter is devoted to
doing so.

The term 'normal' has an unusual career, with shifting and accruing con-
notations; it is the site of wide-ranging debates. As just observed, its nuances

Political Catchphrases and Contemporary History. Suman Gupta, Oxford University Press.
© Suman Gupta (2022). DOI: 10.1093/oso/9780192863690.003.0004

developed within specialist domains (particularly biological and health sciences and statistics), primarily in the nineteenth century, before gradually becoming embedded in everyday communication in the course of the twentieth century. The term's career is therefore relatively short, and its scientific origins render the variable nuances and dispersals substantially traceable in texts. The scientific origins also make it a useful anchor for tracking knowledge development across several disciplines. Further, its gradual percolation into ordinary-language contexts throws light on the relationship between specialist and general knowledge, or between rigorous methods and customary practices. In short, the term 'normal' brings modern knowledge construction and social organization together. As such, the career of the term has been the subject of influential histories of ideas, especially from Georges Canguilhem's *The Normal and the Pathological* (1989 [first published in 1966]) to Peter Cryle and Elizabeth Stephens's *Normality: A Critical Genealogy* (2017). Where, from Canguilhem onwards, such histories have usually addressed the concept of normality, Cryle and Stephens were also particularly attentive to the specific nuances of the term 'normal'. In their words:

> Certain terms, we will suppose, become by their emergence markers of conceptual change. As might be expected then, our history of normality will pay close attention to shifting uses of the word 'normal', making the assumption that the thing we now know as normality has been molded by discursive usage. (25)

Such an assumption obviously underpins my tracking of the catchphrase 'new normal' in the previous chapters. Cryle and Stephens's book was the most careful and comprehensive tracing of the intellectual contexts of the term available when I embarked on the present study. My understanding of the 'normal' and approach to the 'new normal' lean quite heavily on it, and could be regarded as complementing it: that is, starting where it ended, and drawing upon and away from precepts it examined. Cryle and Stevens had, in fact, just about touched on the catchphrase 'new normal' right at the end of their book: 'Current usage of the phrase "the new normal" provides one testimony to the contemporary endurance of the term ["normal"] in popular culture, despite half a century of skepticism and critique' (358). A later article by the one of the co-authors, Stevens (2020), reflecting on the currency of phrases like 'return to normal' and 'new normal' in the Covid-19 context, lamented that the term 'normal' had received too little considered attention of late. This chapter moves in that direction, but not in the way Cryle and/or Stephens might have done. I do

not foreground continuing scepticism and critique of the term 'normal' but the distinctive rationale of the catchphrase 'new normal'. For this, naturally, the other histories of normality are also immensely helpful, and Canguilhem's and Michel Foucault's formulations in particular are of critical interest for my argument.

Tracking the history of the term 'normal' has involved working through specialist domains and texts as it gradually gained a popular purchase. There's a direction there, from well-defined and considered usage to loosely described and habitual usage, or from scientific knowledge to everyday common sense. Such tracking has mainly focused intensively on the specialist manoeuvres, in relation to which the term's gradual dispersal into popular and everyday usage is more or less impressionistically apprehended. The everyday usage is accounted, then, as a withdrawal from scientific rationality, accepting fuzziness where clarity used to be sought. A catchphrase like the 'new normal', as the previous chapters argue, was born within and amidst popular and everyday communication: in political address, public advocacy, news reportage, advertisement, popular writing and performance, and the like. The catchphrase has occasionally appeared in academic texts, and indeed many of the references in the previous chapters are of scholarly papers using the phrase. Even there though, it is usually used deliberately as a catchphrase. That might be the reason why the nuances of the term 'normal' seem not to have particularly helped in pegging the 'new normal'. There isn't a continuous line from the usage of 'normal' to that of 'new normal' to be drawn. The line wobbles and slips away. But, with some reconsideration, it can be drawn reasonably firmly. Doing so calls, unusually, for an approach to the term 'normal' against the thrust of the usual historicist approach: with the rationale of popular and everyday usage squarely foregrounded, and its scientific and statistical career deliberately defocused.

The various scientific connotations of 'normal' that were tracked by Cryle and Stevens (2017) may be summarized as follows. The usage of 'normal' has developed largely, but not exclusively, either in contradistinction from certain terms—such as, 'anomalous', 'abnormal', 'pathological', 'deviant', 'monstrous', 'minority', 'skewed', 'unstable', 'disabled'—or in consonance with certain terms—such as, 'standard', 'healthy', 'average', 'natural', 'common', 'ordinary', 'ideal', 'usual', 'regular', 'dominant', 'stable'. In some, but not all instances a specific contradistinctive term also suggests a consonant term: for example, where 'normal' is contradistinctive from 'pathological', 'normal' is also consonant with 'healthy'. In some instances, a contradistinctive term may suggest several consonant terms and vice versa. It is evident that the contradistinctive

terms named here are not synonymous with each other and nor is that the case for the named consonant terms. In fact, a consonant term like 'ideal' may well be regarded as the antonym of another consonant term like 'ordinary'. Though the term 'normal' and its contradistinctive term 'abnormal' appear to be adjectival forms of the noun 'norm', they do not have a necessarily antonymous relationship in usage. That is to say, 'abnormal' is not necessarily the dominant contradistinctive term. 'Normal' may also be used as a noun in some contexts.

In specialist usage, 'normal' is given a definitive (i.e. direct and explicit) relationship with one (usually, or a limited number of) specific contradistinctive and/or consonant terms. The precise definition of the relationship depends upon the context of usage, that is, for which area of knowledge or academic discipline and with what purpose. Thus, for making anatomical and physiological classifications, marking degrees/distinctions of pathology, identifying law/rule-abiding phenomena, describing populations and groups, gauging incidence or frequency, setting standards of sexual/moral behaviour, etc. there are respectively specific and separate contradistinctive and/or consonant terms to define 'normal'. These definitions then enable classification, measurement, prediction, standardization, modelling, and engineering to proceed accordingly. In the main, studies of the career of the term 'normal' from Canguilhem to Cryle and Stevens elaborate this process of defining. They pay close attention to pioneering and seminal disciplinary texts with clearly articulated purposes (descriptive, remedial, or standard/rule-setting) at particular historical junctures. The result of such a historicist approach to 'normal' across disciplines is a broad account of rational knowledge development. One of the findings of such accounts is that well-defined usages of 'normal' seem to speak to each other across disciplines and areas, and cohere or diverge to convey a broad history of ideas (or science or social progress). The term 'normal' becomes a site for negotiating diverse rationales and purposes within the sphere of specialist discourse. That is analogous to the catchphrase 'new normal' being presented as a site for negotiating diverse rationales and areas within the sphere of everyday and popular discourse in the previous chapters.

The historicist accounts of the scientific 'normal' reach towards the inevitable encounter with the everyday and popular usage of 'normal'. Though usually such accounts then offer impressionistic and inconclusive observations on the latter, much of value for this study is found there. From such observations some general principles underpinning the everyday and popular usage of 'normal' can be discerned, which are useful for considering the term 'normal' in the catchphrase 'new normal'. I turn now to such general principles

for ordinary and popular usage, before moving to their bearing upon the catchphrase.

For Cryle and Stevens (2020), an important moment in the term's drift from scientific towards popular usage occurred when it began to be used as if its meaning was known already and did not need definition, that is, when it began to be taken for granted. They associated this juncture particularly with the work of criminal anthropologist Cesare Lombroso and the Italian school of anthropometry. By this argument, such undefined usage helped the popular appeal of Lombroso's texts though he was not particularly courting popularity:

> It would be misleading to see Lombroso and his colleagues as mere vulgariz-ers. They did not just build fame by simplifying and popularizing physical anthropology, or even by extending its reach while maintaining its meth-ods. They shared certain premises with the anthropologists associated with the Parisian Société that had built physical anthropology as an influential discipline but made sense of those premises in different ways. While the So-ciété d'Anthropologie de Paris had been preoccupied with the study of race as hereditary normality, the Italian *scuola positiva* tended to take the concept of normality for granted. Whether or not that was done purposely, the fact of taking the normal for granted is itself worthy of a place in our history be-cause that became standard practice in the twentieth century. It may well be, in fact, that the normal continues to be most comfortably influential precisely insofar as it remains unanalyzed. (180)

Cryle and Stevens teased out some of the specific nuances of 'normal' in Lom-broso's work, especially in his attempts to clarify the term by illustration rather than by definition. Irrespective of these details, the significance they saw in taking 'normal' for granted—without definition—is a generalizable matter. Where, as already noted, rigorous scientific usage gives 'normal' a definitive relationship with one or a few contradistinctive and/or consonant terms ac-cording to purpose, taking it for granted involves *not* doing so. For Lombroso's methodologically less rigorous texts, taking 'normal' for granted meant leav-ing it to readers to infer what the relevant contradistinctive and/or consonant terms should be according to disciplinary preconceptions. In more 'simplify-ing and popularizing' or 'vulgarizing' texts, the disciplinary address would be watered down further. Then users would employ and receive the term 'normal' not according to shared academic preconceptions and purposes, but accord-ing to experience and cognitive factors that govern everyday communication. That is to say, if undefined, the term 'normal' would be used as if it were an

aggregate of all the contradistinctive and consonant terms it has become associated with through specialist usages, and depend upon the user's experience and cognitive context to indicate which of those serve best to make immediate sense, or which of those seem most relevant. This fluid and more or less unthinking process of relevance-determination from a range of possible contradistinctive and consonant terms is obviously different from foregrounding definitive contradistinctive and consonant terms. To summarize, *for everyday and popular usage, the term 'normal' comes with a diversity of received connotations and associations of which users may be more or less aware. When the term is used without definition in a statement, from the known connotations and associations users tacitly imply or pick those which seem most immediately relevant and serve to make the best sense of the statement.* This is not a considered process. As is characteristic of relevance-determination in all everyday communication, the process is largely habitual and unconsidered. Arguably, using terms thus enable them to circulate more fluidly and adaptably than using terms in rigorously defined ways.

It seems likely that the term 'normal' has been particularly amenable to popular and everyday usage because of its prior passages through specialist usage. Specialist definitions and associations preceded everyday relevance in this instance, and seemed to accrue in the term as it passed into everyday and popular usage. Even if those definitions and associations were not clearly processed in everyday usage, they played tacitly in the rich adaptability of the term. Possibly, the ground for this amenability for everyday and popular usage developed through phases of specialist usage. In Cryle and Stevens's account, before Lombroso's undefined usage, 'normal' was occasionally used interchangeably with several consonant terms and against several contradistinctive terms even in scientific tracts, and not always consistently. After Lombroso and the Italian criminal anthropologists, the earlier split between biomedical usage and statistical usage of 'normal' gave way to several conflations. The two thrusts were sometimes laboriously united, from anthropometrician Francis Galton's effective reinvention of the term to sexologist Alfred Kinsey's putting the term into an interrogative and sceptical perspective. Various earlier distinctions in normality, Cryle and Stevens noted, were conflated in studies of human sexuality to conceive a 'whole person' (264), markedly in Richard von Krafft-Ebing's and Sigmund Freud's different mappings of psychological types. A kind of cultural 'normal' individual, balancing the physiological and psychological concepts, was thereby invented. Then normality came to be promoted as a matter of self-management, as if the term had passed out of scientific hands and been given to everyday and popular possession. Further such moves in specialist

usage were analysed by Cryle and Stevens. In each move, the term 'normal' extended its flexible and fuzzy everyday and popular possibilities by drawing upon and concurrently away from scientific usage.

Conceived thus, 'normal' seems to have a fairly clear direction from well-defined towards undefined usage, and accordingly from scientific and specialist towards popular and everyday usage. Of course, through much of the term's career both kinds of usage overlapped, and still do. In fact, perhaps the sweep of that direction has been overstated. In some respects, specialist usage made concessions to its own limitations while conceptualizing the 'normal', so that the term's everyday potential was already prefigured within the specialist context. That is to say: *even rigorous scientific definition has been corollary to or at least dependent upon rule-of-thumb descriptions and non-specialist determinations in ways that already tended to place the term 'normal' awkwardly in scientific domains and within the reach of everyday domains.*

For the practice of medicine, in particular, a degree of subjectivity or rule-of-thumb estimation in understanding what is 'normal' has been unavoidable. In this regard, Canguilhem's (1989) distinction, made in his earlier reflections in 1943, between a patient's and a physician's view of 'normal' health, are worth recalling:

> In the final analysis it is the patients who most often decide – and from very different points of view – whether they are no longer normal or whether they have returned to normality. For a man whose future is almost always imagined starting from past experience, becoming normal again means taking up an interrupted activity or at least an activity deemed equivalent by individual tastes or the social values of the milieu. Even if this activity is reduced, even if the possible behaviors are less varied, less supple than before, the individual is not always so particular as all that. The important thing is to be raised from an abyss of impotence or suffering where the sick man *almost died*; the essential thing is to *have had a narrow escape*. (119)

From the patient's point of view, then, feeling healthy is relative to the experience of illness and the 'normal' is a gauging of subsequent relative experiences. For the physician, however, the considerations are objectively grounded:

> What interests physicians is diagnosis and cure. In principle, curing means restoring a function or an organism to the norm from which it has deviated. The physician usually takes the norm from his knowledge of physiology –

called the science of the normal man – from his actual experience of or-
ganic functions, and from the common representation of the norm in a social
milieu at a given moment. (122)

Nevertheless, the physician's efforts are initiated by the patient's sense of not
feeling 'normal', and those efforts do not end till the patient admits some sense
of feeling 'normal', even if relative to the interim suffering. In that sense, illness
and normality are first and last grounded in the patient's condition and ex-
perience of that condition. A refined reiteration of this argument is found in
Elisabeth Lloyd's (2008) interrogation of medical claims based on the Human
Genome Project (HGP). The HGP brought what Canguilhem had dubbed the
physician's 'science of the normal man' to a high pitch of fine-grained descrip-
tion: a molecular description of a complete 'normal' human individual. With
such a fine-grained template at hand, it was claimed that diseases can be clas-
sified, analysed, and treated at the molecular level, and possibly alleviated for
good. While admitting that HGP is a step change in medical science, Lloyd
raised several objections to such claims. She cited evidence showing that what
might seem abnormal compared to the normal at a molecular level may not
be manifested as a disease at the level of the physiological functions of the
organism. Further, much that is categorized as pathological is dependent on
social attitudes: for example, at times homosexuality has been considered ab-
normal and is now accepted as normal. Moreover, in terms of populations,
how disease is manifested and understood cannot necessarily be inferred from
having a 'normal' model, but from the interactions of different types of genes,
phenotypes, and environments. In brief, Lloyd concluded:

> In the genome project, certain genes are labeled as abnormal, and the deci-
> sion to do so is made by using as a comparison the DNA sequence of a gene
> that appears in an accepted model ['normal'] of the biomedical causal chain.
> What is abnormal under the biochemical model is not necessarily abnormal
> under a medical model. (143)

Thus, there are vagaries which interfere with the objective description of
human biology when it comes to determining what is 'normal' or 'abnor-
mal'/'pathological'.

For Canguilhem then, there are vagaries in a patient's experience of his/her
condition which may not always gel with the physician's analysis in terms of
the 'science of the normal man', and which the physician nevertheless needs
to take into account for the purpose of treatment. Similarly, for Lloyd, there

are vagaries in an organism's functioning in specific contexts which may not gel with the geneticist's analysis in terms of the 'accepted model' of molecular description for humans, which the geneticist also needs to take into account for the purpose of treatment. What is perceived as 'functional' by individuals or according to social conventions is the overlapping point between them, and therein the fluidities of everyday language shoulder rigorous definitions of the 'normal'.

Evidently, everyday and popular usage of the term 'normal' has to be factored into scientific usage when it concerns professional practice involving direct contact with populations at large, as the physician's medical practice does. Contact is a two-way process, and at the heart of the physician's practice there's the conventional space of consultation. Otherwise, professional practices which bear indirectly upon populations at large are apt to work with well-defined concepts and measurements of the 'normal' which then also pass into everyday language, but in a loosened and flexible way. In everyday language, those well-defined concepts are expanded by undefined usage. That is to say, the term 'normal' in various specialist usages is recognized as having a significant bearing on everyday life but is now interpreted through relevance-determination, as described earlier. In histories of the term, it is generally accepted that this is the principal mode for its transfer from specialist towards everyday and popular usage. Such histories have usually been particularly interested in the role played by institutions in this process. *Governmental and commercial professional practices, usually institutionally structured (for health, housing, education, entertainment, consumption, trade, etc.), have been analysed as the principal pathway for the popularization and democratization of the term 'normal'.* Thus, the term's growing everyday purchase is not so much imposed by specific policies and strategies as instilled through a range of policies and strategies that have been gradually introduced, familiarized, and disseminated. The top-down thrust of policies and strategies, variously structured around concepts of the 'normal', is dispersed and becomes pervasive in everyday life, seeping down to the minutiae of habits, expectations, attitudes, anticipations, transactions, and decisions ... the very grain of living as individuals within collectives. Thus, the 'normal' in everyday usage has come to signify as unquestioning social adaptation at ground level and, simultaneously, as questionable control from above, but not such that particular agents are easily pinned down. By this line of argument, institutions are regarded as the *via media*. They operate in networks of organizations and authorities which form

a coherent system, and which then extend across areas of knowledge and begin to structure knowledge, and so bear upon populations at large. The term 'normal', pushed out like a bagatelle ball from specialist usage, rolls through the institutionalized centre of the board, knocking left and right against policy and strategy pins, and settles at the everyday base of the board. But that passage, it has usually been held, could only be tracked with a fine-tuned political awareness.

In his later reflections (1963–1966), Canguilhem (1989) marked the following nuances of everyday and popular usage:

> It is possible for the normal to be a category of popular judgment because their social situation is keenly, though confusedly, felt by the people as not being in line, not 'right' (*droite*). But the very term normal has passed into popular language and has been naturalized there starting from the specific vocabularies of two institutions, the pedagogical institution and the hospitals. (237)

For Canguilhem, what appears from those institutions are demands from below, which may well be manifested, at the same time, as 'the absence of an act of awareness [*prise de conscience*] on the part of individuals, in a given historical society' (237). Apprehending a disjunction from *droite* in the 'normal', with different levels of and even without exercising *prise de conscience*, allows for a range within everyday and popular usage of the term. Where a particular instance of usage may be located within this range depends upon the relevance-determination of contradistinctive and consonant terms, as described earlier. The complexities of the context, the prevailing social contestations and flexibilities in the public sphere, might be decisive. The catchiness of the term 'normal' in popular usage follows accordingly, nodding towards what is not-quite-right or towards what-should be.

Historians of the 'normal' have often felt that the political work of the term should not be left to popular circumstance. Most historians of the 'normal' have therefore taken it upon themselves to actively fill in the orientation of the 'normal' by doing history. That is to say, doing history becomes then a project that crystallizes subsequent and manifold contexts of usage, whereby the 'normal' is substantiated as not-quite-right with full cognizance of what-should-be. That was evidently the sort of project through which Michel Foucault developed his concept of 'normalization' from *The Birth of the Clinic* (1973[1963]) onwards. He didn't foreground fixed definitions of the 'normal', with reference to which the institutions 'above' act upon the populace 'below'. Instead,

he set about tracking the 'normal-in-process', so to speak, whereby the 'above' and 'below' mutually constitute each other. His 1974–1975 Collège de France lectures on the 'abnormal' offered a succinct summary on this conception of 'normalization' and his historical project:

> I would like to try to study this appearance, this emergence of techniques of normalization and the powers linked to them by taking as a principle, as an initial hypothesis [...], that these techniques of normalization, and the process of normalization linked to them, are not simply the effect of the combination of medical knowledge and judicial power, of their composition or the plugging of each into the other, but that a certain type of power – distinct from both medical and judicial power – has in fact colonized and forced back both medical and judicial power throughout modern society. It is a type of power that finally ends up in the courtroom, by finding support, of course, in judicial and medical institutions, but which, in itself, has its own rules and autonomy.
> (Foucault 2003: 25–6)

This summary of the project led into an examination of how medical and judicial power have been 'forced back' by normalization, starting with expert testimony in criminal cases. The point of interest for Foucault was that normalization, while still operating from and traceable through institutional texts, had released itself from those institutions and had become a locus of power in itself. By this account, normalization is per se the process of power irrespective of and yet sieved through institutions and grounded pervasively in everyday life. Recognizing its autonomy, as Foucault put it, is tantamount to foregrounding the not-quite-right quality of its everyday acceptance among those in the grip of power. Thus, the disjuncture from *droite* was pulled out and foregrounded by the historian Foucault's efforts. But the historicist foregrounding was only possible because an incipient apprehension of disjuncture from *droite* was already there in everyday usage, even if without *prise de conscience*. Foucault's historicizing of normalization assumed a historiographical burden because it recognized the content of everyday and popular usages of the 'normal', and perceived the need to exteriorize their incipient *prise de conscience*, to highlight their potential for political awareness. As such, Foucault's was an academic project apropos of everyday and popular usage and not merely an accounting of subsequent and different usages of the term 'normal'. 'Normalization', in fact, is itself a term with little popular or everyday currency.

Nevertheless, Foucault's project proved helpful for later accounts of how the everyday and popular currency of the term 'normal' has come about. Insofar as

historians of the 'normal' have tracked the term's career thereafter, with close attention to the word itself, that historiographical burden has usually been taken forward. That is to say, the project of historicizing the term 'normal' has generally been undertaken with the suspicion that at its heart is something not-quite-right, and that this not-quite-rightness is embedded in its popular and everyday contexts. In other words, it is suspected that the balance of contradistinctive and consonant terms which have accrued behind everyday and popular usages somehow consolidate iniquitous and coercive power. The institutionally structured drive in twentieth-century United States to ground normality as a social principle, and to idealize the average person, has been accounted accordingly (Igo 2007; Creadick 2010). The circulations of the term 'normal' in the history of sexuality (Sullivan 1995; Warner 1999), disability (Davis 1995), and race (Carter 2007) have appeared with an unmistakable commitment to Foucault's historiographical burden—I return to these later. Of histories, Cryle and Stevens's (2017) genealogy of the term seems the least committed to assuming that burden. Nevertheless, in their final analysis of the popular and everyday currency of the term there is a move along those lines. They do not pin that idea on normalization from above or assimilation from below, but on the systemic disposition of capitalist consumerism:

> The origins of the contemporary idea of the normal as it is used in everyday speech can be traced not to nineteenth-century disciplinary institutions, as Foucault has famously argued, but to the beginning of what is now called the data society, in which anthropometric measurements were increasingly used for commercial purposes such as the production of mass-produced consumer objects or the collection of information about subjective experiences or opinions. The commercial use of anthropometric data was driven by very different interests from the ones that guided scientific or governmental projects: in a commercial context the aim was not to normalize bodies, but rather to design objects that better suited the average or typical human body. In other words, anthropometrics enabled objects to be standardized in ways that were responsive to the dimensions of the average body; they did not simply impose normative standards upon those bodies. (354)

This describes, then, a mutually negotiated and transactive process between production (producers) and consumption (consumers) instead of an exercise of power from above and its dispersal below. As such, Foucault's historiographical burden is explicitly disavowed. Despite the disavowal, however, it may be argued that the operations of commercial purposes through data analysis are

themselves institutionally grounded. Commercial corporations and firms are powerful organizations, and their structuring of data to serve consumption and profit making are, as is oft argued, now largely in partnership with capitalist governmental power. A critique of neoliberal 'governmentality', as Foucault put it, seems not far behind Cryle and Stevens's observation, and could well be tracked through popular and everyday circulations of the term 'normal'. But Cryle and Stevens did not go there.

With these observations on the sphere of ordinary and everyday circulations of the term 'normal', I now turn to its place in the catchphrase 'new normal' and return to some of its contexts in the previous chapters.

'New normal'

This chapter began by noting the contrary pulls of 'normal' in the catchphrase 'new normal': on the one hand, 'normal' seems to designate successive phases of normality relative to each other; on the other hand, a 'new normal' seems to countermand a preceding and fixed 'normal'. Between the relativized and fixed senses that are now at play within the catchphrase, the term's erstwhile relationship with contradistinctive and consonant terms appears to be readjusted—quite possibly rendered redundant—at least within the sphere of popular and ordinary language communication. No doubt, in specialist and professional circles those contradistinctive and consonant distinctions, closely woven through the development of knowledge and practice, continue to be used. It is the case that health researchers, medical practitioners, and psychiatrists continue to use the contradistinctive terms 'abnormal', 'pathological', 'morbid', 'irregular', etc. and the consonant terms 'healthy', 'functional', 'regular', 'usual', etc. to define the 'normal' for specific areas. Statisticians similarly continue to use consonant terms like 'average', 'standard', 'mean', etc. and contradistinctive terms like 'divergent', 'nonnormal', 'skewed', etc. to sharpen definitions of 'normal' according to context. So do educationists, economists, and the like. But outside the area of rigorously defined usage of 'normal', or where the term is used without explicit definition or taken for granted, it seems likely that the catchphrase 'new normal' has reoriented how 'normal' is understood.

In popular and everyday usage, the undefined term 'normal' presents a range of possible contradistinctive and consonant terms which are tacitly chosen from and honed down to determine the immediate relevance. When the catchphrase 'new normal' comes up, as it has with burgeoning frequency since 2001,

the push to sharpen the relevant sense of the 'normal' therein is diluted. In its relativized sense, 'normal' in the 'new normal' appears to be consonant with itself, with its past usages—seemingly twice removed, rather like Plato's notion of the form in ordinary perception. There is a shadowy prior 'normal' which is consonant with the 'normal' of the 'new normal', and that being so it is unnecessary to dig back into deeper consonant terms to determine the relevance of the already irrelevant prior 'normal'. In this sense, *'normal' in the 'new normal' is consonant with itself in the first instance.* At the same time, in its fixed sense, the 'normal' in 'new normal' also appears to be contradistinctive to the prior 'normal', and it seems supererogatory to sieve through deeper contradistinctive terms to sharpen the relevance of the already irrelevant prior 'normal'. Put otherwise, *'normal' in the 'new normal' appears immediately to be contradistinctive against itself.* The catchphrase, then, empties 'normal' of distinctions, making the term not only undefined but disinviting relevance-determination in popular and everyday usage.

Where the term 'normal' had passed from academic and specialist usage into popular and everyday usage, the catchphrase 'new normal' appeared and has stayed predominantly within the latter area of usage. I explore some of the catchphrase's peculiar academic turns further on. Within the everyday domain where catchphrases overwhelmingly circulate, it is evident from the previous chapters that the 'new normal' has, so to speak, percolated from above. This is not from above in the sense of originating in specialist knowledge but in the sense of being initially promoted for bureaucratic and management purposes by political and commercial authorities and by media pundits—a contemporary political and cultural elite. To be precise, rather than being expressive of elite purposes, the catchphrase has served as a means of moderating the relationship between elites and citizens, leaders and followers, managers and the managed, sellers and buyers, employers and employees, governors and the governed. In each such relationship, the 'new normal' has rendered the former's interests ostensibly obvious and acceptable to the latter. The catchphrase has largely worked as a management tactic in itself, to reassure or to announce optimistic prospects. To this extent, its grounding in everyday and popular discourse is as driven by institutional imperatives as the term 'normal' had been, but in this instance with a different impetus—managerial rather than specialist. From Dick Cheney's announcement of a 'new normalcy' in security and legal regimes in the USA after 9/11 and through the continuing 'war on terror', the catchphrase was deployed to reset expectations in a tone of reassurance. Similarly, after the dot-com crash of 2002, and particularly with the 2007–2008 financial crisis, the catchphrase was taken up by

investment gurus to recommend new investment opportunities, and by politicians and bureaucrats to make 'doing more with less' an inevitable process of disinvestments and privatizations. The 'new normal' of 'flexible working' was meant to rationalize employment regimes acceptably against the grain of existing laws and contracts. And, of course, during the 2020 Covid-19 outbreak the 'new normal' was understood as an inescapable accommodation of necessary restrictions on movement and contact. Insofar as the primary impetus for announcing a 'new normal' is for management ends, in an upbeat or reassuring spirit, the catchphrase's implicit dissociation of the 'normal' from both consonant and contradistinctive terms is useful. A particular casualty of such usage has been the contradistinctive associations of 'normal'. Since 'normal' in the catchphrase is, as I noted, its own contradistinctive term, it suggests more a continuity in contradistinction within itself rather than suggesting a point from which critical gauging of departures from normality is possible. For Canguilhem (1989), the norm that is raised in popular uses of the 'normal' were necessarily in contradistinction from the 'abnormal': 'The reason for the polemical final purpose and usage of the concept of norm must be sought [...] in the essence of the normal-abnormal relationship' (239). For the 'normal' in the 'new normal' there is no such contrary position, no essence to pin down or refer to. The sphere of popular and everyday communication instead focalizes the catchphrase 'new normal' by way of habitually accepting a continuum of relative positions without perceptible normative boundaries (or without a value locus), either wholly absorbed into a present without prospection or retrospection, or finding an ethos of continuous progress (a normalized teleology). The advantages for authority and management in these implicit nuances of the catchphrase are easily grasped. But, of course, the rhetorical designs of management and authority are only successful insofar as the contradictions and inequities of the present do not become intrinsically unmanageable, so that disaffection co-opts the 'new normal'.

However, the co-optation of the catchphrase against its management thrust to express disaffection is relatively toothless so long as the 'normal' therein is disinvested from consonant and contradistinctive nuances. This is evident in the bitterness with which, following 9/11, moves contradicting rule-of-law principles were regarded as the 'new normal', or, after the 2007–2008 financial crisis, austerity and exacerbating inequality were pegged as the 'new normal', or, with growing unease after 2010, freakish weather events related to climate change were dubbed the 'new normal'. This kind of turning of the catchphrase against its management temper suggests, unmistakably, an unmanageable juncture from which there is no return, redolent either with

despair or irony. In the very usage of the catchphrase, with contradistinctive and consonant nuances muted, the possibility of a horizon or point for resistance or opposition seems forbiddingly remote or abstract. The only appeal that is possible appears to be within the sphere of existing management and authority, which has prior possession of the 'new normal' already. There are obviously, as the previous chapters have found, numerous appeals which dislocate the catchphrase from its brash managerial presentism to imbue it with a futuristic idealism. However, that ultimately takes the form of calling upon the same authorities and management functionaries that have possession of the 'new normal' now to push the catchphrase into future realization, demanding that those very elites should declare emergencies or enact better policies and simply become universally beneficent. The juncture of spiraling disaffection that was 2020 amidst the pandemic thus saw a contestation of catchphrases that diversified appeals to the elites and were quickly adopted by them: for the immediate management of pandemic measures as a 'new normal'; for the management of larger disaffections with the more future-gazing 'next normal' and its variants, like 'build back better', all heartily taken up to bolster the authority of, for instance, Boris Johnson's government or Joe Biden's candidature. The other side of that appeal simmers at the same time in the populist right-wing 'return to normal'—with its Harding-like echo—where 'normal' doesn't have contradistinctive or consonant nuance either, but simply replaces presentism and progressive future-gazing with a regressive nod to a past that is now per se the 'normal' and, in any case, it is an imagined past.

From the area of everyday and popular usage where catchphrases have ascendancy, then, a curious gap is introduced in relation to specialist and academic areas apropos of conceptualizing normality. In these areas, as I have noted, well-defined usage of the 'normal' continues, but their rationales seem to work across a chasm from popular and everyday usage where 'normal' is captured in 'new normal' or 'next normal'. Arguably, these catchphrases alongside others play a part, however unthinkingly, in attitudes of uncomprehending hostility or sacralized deference to 'science' or 'experts'—terms which acquire a monolithic remoteness from everyday life. The undefined 'normal' has habitually been associated with consonant or contradistinctive terms which emerged from scientific investigation, as an accrual around the term in everyday usage, and thereby also as having a continuous relationship with everyday usage. 'Normal' contained in 'new normal', now its own consonant and contradistinctive term, loses that continuity; in catchphrase circulation it offers no more than devout acceptance of expertise/science or arbitrary refusal thereof with managerial or authority-bearing assertion.

I have put these arguments impressionistically and perhaps I have made too much of something as blithe and light as catchphrases. These observations are no more than speculations to consider and test. They do, at any rate, offer a bridge towards considering the advent of the catchphrase 'new normal' in academic studies and the continuing career of the term 'normal' alongside.

I have suggested that in historicizing the term 'normal', academic effort, especially since the 1980s, has largely been in line with Foucault's project of elucidating normalization as a structure of power. That usually meant assuming Foucault's historiographical burden of elucidation, whereby tracking the career of the term entails questioning and possibly resisting existing power structures. In its bare bones, the argument was that normalization involves concealing how power, as a social force (political, economic, cultural, institutional, interpersonal, etc. in a cohesive totality), works through institutionalized concepts of normality. Tracking the history of normalization then, woven through the term 'normal', reveals how power has been embedded from the top to the bottom in society. Such a revelation through doing history makes it possible to clarify where the structure of power is not-quite-right (iniquitous, coercive, oppressive) and accordingly conceive resistance to such power structures. Foucault gave little substance to what such resistance might involve, but it could reasonably be inferred that critique and resistance would engage with the linked-up totality of the institutional and discursive structures through which power is exercised. Put otherwise, the power that is grounded through the undefined everyday usage of the term 'normal', carrying the complex accrual of contradistinctive and consonant terms from specialist usage, can only be countered by carefully reckoning with those accruals. In that sense, Foucault's project involved addressing normalization itself, as an autonomous processing of power with its own principles.

From the 1980s onwards, the spirit of Foucault's project was seemingly taken forward, anchored to the term 'normal', from a limited standpoint. This may be broadly dubbed the standpoint of *embodied identity politics*—that is, from the political perspective of, particularly, disability, sexuality, and race, where politics is an expression of collective identities, principally by those who can individually claim those identities for themselves. I have in mind, especially, Lennard Davis's *Enforcing Normalcy* (1995), Michael Warner's *The Trouble with Normal* (1999), and Julian Carter's *The Heart of Whiteness* (2007). Several similar arguments were made from such standpoints. First, these noted some of the accruals of contradistinctive and consonant terms through biomedical and statistical definitions of the term 'normal', and observed that in everyday and popular usage a range of associations underpin it in a kind of blur

(Davis gave a fairly detailed history of the term). These arguments then took this aggregate blur of the connotations in 'normal' as actualizing a dominant *normal culture*. Second, these arguments stressed that they were themselves extended from non-dominant cultural positions and were accordingly named by particular contradistinctive terms, such as 'disabled' (or, eschewing its own contradistinctive placement, 'differently abled') or 'queer' or 'black'. In doing that, it might have appeared that the term 'normal' and the concept of normality were being narrowly defined after all, in terms of specific contradistinctive terms. But, third, these arguments maintained that this was not the case because their specific non-dominant perspectives were not narrow but themselves rounded social positions, themselves cultures that confront the totality of the dominant normal culture. Thus, Lennard (1995) held that dominant culture normalizes able bodies in all dimensions of social life and thereby conceals its power dynamics; from the disabled perspective, this normal dominant culture was revealed as a prejudiced and iniquitous 'ableist culture'. Roughly the same structure of argument was followed by Warner (1999), here revealing that normal dominant culture was really 'straight culture', and by Carter (2007), where normal dominant culture was revealed as 'White'. Such arguments putatively removed shrouds from normal cultures with marginal embodied vision. The point was most lucidly made by Carter:

> Normality seems both immense and blank, ubiquitous and insubstantial, so that it is difficult to get a critical purchase on it except by catching at its ragged edges. In the effort to focus on its center, I have found it helpful to think of normality's apparent blankness as deriving from the power-evasiveness of its component parts, heterosexuality and whiteness. [...] If normality is a slippery subject, then, it is because whiteness and heterosexuality share a certain unwillingness to acknowledge their own power and the many forms of coercion and violence that uphold their own coercion and violence. (26–7)

Fourth, the thrust of such arguments was that the impetus for resisting normal dominant culture comes from the embodied non-dominant culture which allows the undesirable dominant power to be characterized as ableist culture, straight culture, White culture. Notably, unlike received terms like 'Black' or 'disabled', the very appointment of the term 'queer'—itself a catchword—was a resistant strategy that worked at the level of terminology itself, generally designating lifestyles that are not exclusively and institutionally heterosexual. 'Queer' was thus enunciated with metaphoric directness against the term 'normal' as an agglomeration of normalized senses. As Warner (1999) put it: 'One

of the reasons why so many people have started using the term "queer" is that it is a way of saying: "We're not pathological, but don't think for that reason that we want to be normal"' (59).

The explicit turn towards putting the onus of resisting the normalized power of dominant culture on specific embodied identity positions seems to put these arguments in line with Foucault's project. Moreover, this turn appears to move that project from academic work into social activism, so that it comes closer to life in everyday and popular usage. However, it is doubtful whether this is indeed a development on Foucault's project; in some respects it seems to depart decisively from the rounded and comprehensive character of Foucault's project. Whereas Foucault homed in on normalization itself and in all its dimensions as grounding power, the arguments of embodied identity politics do ultimately seem to apprehend normalization in a reduced and conditional way. It has always been debatable whether embodied non-dominant identity can be claimed by those who are unable to individually own to such identities, such as those who are apt to be themselves perceived as of the dominant normal culture. If the latter are de facto secondary in or excluded altogether from resistance to the iniquities of normalization, then it is not really normalization that is being resisted. The logic of embodiment seems to lead into sectoral, and often self-interested, activism which seems smaller than the critical awareness sought in Foucault's project on normalization. Nevertheless, this argument, anchored squarely to the term 'normal', has a strong and continuing currency in academic usage as in everyday and popular usage, despite and alongside the rise of the catchphrase 'new normal'. In its complex play of consonant and contradistinctive moves, it does enable a critical academic as well as popular politics to be voiced. The recruitment of the catchphrase 'new normal' in academic discourse has had a contrary effect. I turn to that next.

By and large, 'new normal' has been used in academic publications as a catchphrase but without delving into its character as such or defining the phrase. That is to say, academic usage has perpetuated its vogue as a catchphrase, much as in commercial/governmental or news reports (as in the sentences in Chapter 1). The most common academic usage takes the catchphrase as denoting a particular issue or juncture already, often in quotation marks to indicate its popular currency, so that it is recognized as such without further ado. There are numerous examples of such academic usage, many cited in the previous chapters, where simply saying 'new normal' refers to emerging conditions or instituted regimes after 9/11, the 2007–2008 financial crisis, China's economic policy, and the Covid-19 outbreak. Similar denotative usage also occurs for issues with which the catchphrase has become strongly

associated outside academia: flexible working, digital technology adaptations, new investment environments, austerity and inequality, weather events symptomatizing climate change, etc. Also in line with catchphrase usage, categorical statements of the form 'such-and-such is the new normal' are variously found in academic publications, by way of striking an informal note or chiming with the idiomatic context. To this extent, nothing specifically academic is discernible except, perhaps, in suggesting an inclination in scholarly circles to nod deferentially or condescendingly to popular usage.

Somewhat more searching academic usage of the catchphrase is occasionally found, and says a great deal about the spirit in which the catchphrase circulates. These are of two broad sorts: those that reflect on the catchphrase's sociopolitical effect and those that seek to give it a substantial and, better yet, measurable content. Both directions attest, in different ways, to the 'new normal' having the effect of neutralizing both contradistinctive and consonant terms for the 'normal' in relevance-determination, with the kind of ideological effect impressionistically described earlier. The former sort, which considers the sociopolitical effect of the catchphrase, does so by holding the catchphrase alongside a particular contradistinctive nuance of 'normal' in a specific context. Those following this line then argue that the catchphrase has served to deliberately obfuscate or gloss over that undesirable nuance, effectively normalizing it. Thus, Susan Ruddick (2006), in describing deleterious changes to Anglo-American (post-9/11) legal and institutional regimes for protecting children's rights, placed the catchphrase alongside Foucault's concept of the 'abnormal'. Ruddick demonstrated that where legal normalization in Foucault's view worked in contradistinction from some concept of the unacceptably abnormal, in the proclaimed 'new normal' the abnormal is deliberately absorbed into what is acceptable. No space is left for excessive punitiveness and unreasonable attribution of culpability to be considered unacceptable. In this regime, the 'grotesque' is part of the 'new normal' rather than presenting a counterpoint to the 'normal':

> In schools, the grotesque has taken the form of the adoption of a quasi-legal discourse that constructs young people who misbehave in the form of criminals and constricts their rights almost to the point of erasure, limited to codes of conduct that elaborate their rights toward each other. But these codes afford them no legal recourse. (76–7)

Similarly, contemplating US education policies to 'do more with less' after the 2006–2007 financial crisis, Rebecca Goldstein et al. (2011) found that the

catchphrase conflated the desirable and the undesirable with rhetorical glib-ness: '[for some] the *new normal* is supposedly a welcome outcome of engaging in school reform during an economic crisis. For others, the *new normal* signals a dangerous turn in the social contract between the state and the people' (122). Another interesting analysis along these lines appears in a study of changing work regimes by Edward Granter and Leo McCann (2015). Here, the term 'extreme' was somewhat unusually employed in contradistinction to 'normal', as in extreme work (intensive, long hours, distressing, etc.) in opposition to normal work practices. Their careful argument was succinctly stated thus: 'Extreme has become the new normal' (447).

Where attempts are made to give the catchphrase a substantive and mea-surable definition, akin to defining 'normal' with carefully chosen contradis-tinctive and consonant terms, it might be expected that the phrase would thereby be taken away from catchphrase circulation, extracted from popular and ordinary usage and recruited to specialist usage. But that is not quite what happens. In the few academic publications where this has been attempted, the catchphrase was taken as substantializing public perception, and measuring it meant measuring public perception. Thus, in a paper entitled with the catch-phrase and referring to conditions following the 2007–2008 financial crisis, Amitai Etzioni (2011) merely described changes indicated in public attitude surveys and made some optimistic inferences from those. The most imagi-native and rigorous attempts at giving some measurable account of the 'new normal' have appeared with reference to climate change. Most directly, Sophie Lewis et al. (2017) explicitly tried to recruit the catchphrase away from media framing and 'instead propose the more precise concept of the time of emer-gence of a new normal (ToENN)' (1141). This involved setting a particular year as a standard (not a norm, more a convenient axis to refer to), in terms of which the frequency of anomalous weather events, understood in terms of magnitude or intensity, could be tracked. The immediate point of such a mea-sure was arguably less of meteorological interest, where understanding causes of variations in weather events is of paramount importance, and more for the purpose of making a general perception of climate change evident where it might not be otherwise. Having a 'new normal' time tracking of this sort is es-pecially useful because climate change might otherwise not register in 'normal' perception of weather events. That 'normal' perception of weather variations adapts quickly so that change is constantly normalized and climate change seems imperceptible and is apt to be treated with scepticism was argued per-suasively by Francis Moore et al. (2019). Their paper proposed a method for measuring adaptations in normal perceptions of variable weather events by

analysing data from Twitter comments. Such researches, we may say, do not define the 'new normal' but erect a conceptual apparatus to measure relativizing perceptions of the 'normal' in the sphere of everyday communications and attitudes. This kind of argument effectively underlines the sense of relativized normality that the catchphrase suggests, and generally goes along with the notion that the 'normal' in 'new normal' is both its own consonant and contradistinctive term. The 'new normal' remains grounded in everyday and popular usage even when seemingly subjected to content analysis and measurement. In this regard, the Covid-19 context has not offered any significant advance in academic engagement with the catchphrase. In fact, as the previous chapter shows, the catchphrase was interrogated to some degree within the sphere of the popular and the everyday itself, especially in commercial and political circuits.

By way of bringing this chapter towards a close, I finally consider a specialist turn given to the term 'normal' which has some affinity with the catchphrase 'new normal', especially in the Covid-19 context: 'post-normal science'. The formulation of 'post-normal science' was offered by Silvio Funtowicz and Jerome Ravetz (1993), drawing upon two academic catchphrases: Thomas Kuhn's 'normal science' and 'postmodernism', or, more precisely, an academic vogue for the prefix 'post-' (which continues to have currency, see Sinclair and Hayes 2019, Callus and Herbrechter, eds. 2004). Insofar as 'post-normal science' referred to Kuhn's concept of 'normal science', it came with several missteps which are of interest here, and call for a brief digression into that concept. Kuhn's *The Structure of Scientific Revolutions* (1962, 2nd edn. 1970) had described the practice of 'normal science' with reference to a specific understanding of *paradigms*, which could be thought of, in imperfect summary, as fundamental principles that hold together a rational system for describing and explaining the natural world (as opposed to the social world) at a given juncture of knowledge acquisition. Kuhn made an important distinction in using the term 'paradigm' from its standard usage:

> In this standard application, the paradigm functions by permitting the replication of examples any one of which could in principle serve to replace it. In a science, on the other hand, a paradigm is rarely an object for replication. Instead, like an accepted judicial decision in the common law, it is an object for further articulation and specification under new or more stringent conditions.
>
> (Kuhn 1970: 23)

This distinction is important for understanding both what Kuhn meant by 'normal' and by 'science', and therefore the phrase 'normal science'. This sense

of 'paradigm' holds for the purpose of describing and explaining the natural world in a rational system, whereas the standard application is relevant to the social world and sociological analysis. Given this scientific sense of 'paradigm', which is constantly being further articulated and specified in scientific practice, the idea of 'normal' appears—as indeed the term usually did in well-defined usage—in relation to some contradistinctive terms. Kuhn offered, in fact, several terms with different degrees of contradistinction to the 'normal' in 'normal science'. Two of these were within the broad area of normal scientific practice, but put increasing pressure upon its paradigms by testing the limits of description and explanation on their basis. Thus, there is the term 'anomaly', which refers, for instance, to observations which seem not to fit into the descriptions and explanations offered by existing scientific paradigms. These call for intensive analysis in terms of the existing paradigms and may lead to some adjustment therein, but still within the precincts of 'normal science'. Somewhat more forcefully, there is the term 'crisis'. This suggests, for instance, a growing number of observations which seem to be out of synch with the paradigms of the prevailing rational system. These are still addressed insofar as possible through the prevailing paradigms, so are still within 'normal science', but it is felt that these paradigms are now not quite sufficient or equal to describing and explaining adequately. Nevertheless, feeling that insufficiency, Kuhn observed, is not enough to give up on 'normal science'—the latter is still the basis of ongoing practice even though its limitations are admitted. The prevailing scientific paradigms of a rational system are only abandoned when they can be replaced by another set of paradigms erecting a distinct rational system, which has superior descriptive and explanatory powers and can overcome the growing 'crisis'. This then becomes the basis of an updated 'normal science'. This replacement is designated by the principal contradistinctive term for 'normal science': 'revolutionary science' or 'extraordinary science' (Kuhn used both).

The contradistinctive terms 'normal science' and 'extraordinary/revolutionary science' excited considerable interest on being proposed by Kuhn. Notably, it led to a sort of debate with those subscribing to Karl Popper's account of scientific practice in *The Logic of Scientific Discovery* (1934, in English 1959). In a colloquium in 1965, Kuhn and Popper addressed their differences from each other, and these were debated by others (proceedings published by Lakatos and Musgrave, eds. 1970). In the event, it appeared that they did not consider their differences to be quite as significant as has often been made out since. Kuhn suggested that Popper's account, centred on falsifiability, overly emphasized 'revolutionary science'; Popper objected that Kuhn had made too much of his notion of paradigms in 'normal science', since

several competing or uncertain paradigms were not uncommon in ordinary scientific work. However, Kuhn's concept of 'paradigm' in relation to 'normal science' passed into frequent, albeit occasionally misdirected, usage across disciplines as a specialist catchphrase, especially in social and philosophical investigations. It was in the spirit of a catchphrase that Funtowicz and Ravetz (1993) referred to it in their formulation of 'post-normal science'.

Funtowicz and Ravetz's formulation was offered from the perspective of policymakers and managers. The argument was that for certain pressing social issues which are identified in and derive from scientific research, scientists are unable to offer decisive guidance for policy directions and management decision-making. Examples of such issues could be the evidence for climate change in the 1990s so as to legitimize a decision to decommit from fossil fuels, or, of particular moment in early 2020, to make a decision on lockdown given the available evidence of the effects of a pandemic. Such issues could be contested within scientific practice, or scientific methods may well be insufficiently developed to allow conclusive results. However, the social consequences of not acting in policy and management terms could be so momentous that decisions cannot wait for the uncertain or slow processing of rigorous scientific conclusions. Further, at the same time such decisions may have immediate social effects which would cause significant discord and therefore need clear scientific validation. Under these circumstances, Funtowicz and Ravel argued, it is necessary for scientific practice to offer more than uncertain advice based on rigorous methods—to do more than, as they thought, 'normal science'. It is incumbent on scientists then, they argued, to also actively help management and policymaking by validating their decisions for broad publics. That would involve scientists taking an active part in public persuasion, and involving interested parties with no scientific background ('stakeholders' in industry, communities, etc.) in the process of assessing scientific research and findings. Thus, they proposed having extended 'peer review communities' including those non-scientific interested parties, having scientists designing policies with broad publics like 'professional consultants', and the like. A great many catchphrases and buzzwords from scientific and management circles were tacked together to present this argument.

A significant tacking together took place in the formulation of the would-be catchphrase 'post-normal science' itself, as if it is to be understood in contradistinction from Kuhn's 'normal science':

> For [Kuhn], 'normal science' referred to the unexciting, indeed anti-intellectual routine puzzle solving by which science advances steadily between its conceptual revolutions. In this 'normal' state of science,

uncertainties are managed automatically, values are unspoken, and founda-
tional problems unheard of. The post-modern phenomenon can be seen in
one sense as a response to the collapse of such 'normality' as the norm for
science and culture. As an alternative to post-modernity, we show that a new,
enriched awareness of the functions and methods of science is being devel-
oped. In this sense, the appropriate science for this epoch is 'post-normal'.
 (Funtowicz and Ravetz 1993: 740)

Kuhn was to pass away three years after this appeared and possibly did not hear
of it, otherwise he would have been profoundly shocked by this characteriza-
tion of 'normal science'. The sales-pitch cadences which put 'normal science'
down in normative terms as 'unexciting', 'anti-intellectual', 'routine', and its
'normal' practice as 'collapsed', and the idea of 'post-normal science' as 'enrich-
ing' and 'appropriate for this epoch' made negligible academic sense. At any
rate, this 'post-normal science' had nothing to do with Kuhn's contradistinc-
tive 'extraordinary/revolutionary science'. More importantly, the would-be
catchphrase 'post-normal science', approached thus, courted some dangerous
consequences. Simply by tagging 'post-normal' to 'science' and thereby re-
ferring to Kuhn's 'normal science' in a hostile tone, Funtowicz and Ravetz
suggested that what they proposed had something to do with the scientific
practice that Kuhn (and Popper) was theorizing. In fact, the latter, as noted
already, had to do with a rational system for describing and explaining the
natural world, as opposed to the social world, at a given juncture of knowledge
acquisition. Funtowicz and Ravetz were concerned, as they noted in their pa-
per, with *applied* science, that is, with what to do with those descriptions and
explanations to serve a social purpose, which is usually distinguished from the
term 'science' itself as 'technology' or 'engineering'. Kuhn's 'normal science'
is not about application, technology, or engineering, or social purposes; his
understanding of paradigms that enable 'normal science' were pertinent in-
sofar as description and explanation go. Had Funtowicz and Ravetz spoken
of 'post-normal technology/ engineering', that might have made better sense,
subject to suitable definitions. But being lured by the Kuhnian catchphrase
'normal science' simply invited confusion. Such confusion could well have
deleterious consequences for the practice of science generally, whether nor-
mal or extraordinary, and therefore for application/technology/engineering,
which are dependent on rigorous 'normal science'. If managers and policy-
makers wished to be absolved of justifying their decision-making at difficult
times by pressurising scientists to concede to or court the opinions of politi-
cal, commercial, and community interests—by enforcing diverse 'peer review

communities' and 'professional consultancy' diktats and the like—then the temptation to massage descriptions and explanations in doing science according to political and popular demand would be strong. The integrity and usefulness of scientific practice could well be fundamentally undermined.

Funtowicz and Ravetz kept up a steady production of papers on 'post-normal science' thereafter, and others joined in over subsequent decades. Though this phrase did not quite seep out of specialist circuits, and certainly not with the purchase of 'normal science', it has had not insignificant success. A Google Scholar search in early 2021 with the phrase came up with over 6,600 distinct academic texts which used it—often as title or keyword—for 2010–2020. Several journal special issues have been devoted to it; it features in management curricula in a number of tertiary education institutions worldwide. In a way, as a catchphrase it appears to have had an effect in specialist and professional circles which is analogous to that of 'new normal' in everyday and popular usage. 'Post-normal science' muddies the waters of Kuhnian 'normal science' in much the way that 'new normal' has muddied the waters of the popular conception of 'normal': the contradistinctive and consonant qualifications seem to disappear in the interests of serving elite interests. My impressionistic observations earlier about the 'new normal' might equally be repeated here with reference to specialist and professional circles: 'post-normal science' is used as a means of moderating the relationship between elites and citizens, leaders and followers, managers and the managed, sellers and buyers, employers and employees, governors and the governed. In this case, that moderation is done by elites passing the buck of their responsibility for taking tough decisions to an interim layer of workers—scientific researchers—at some risk to the integrity and effectiveness of doing science. Not unsurprisingly, the two catchphrases have been put side by side at times, especially amidst the obviously challenging conditions of the Covid-19 outbreak. Jerome Ravetz (2020[1], 2020[2]) had himself weighed in on a couple of occasions, mainly to suggest that the catchphrase 'post-normal science' should not only replace 'normal science' but up its reach to the level of the wildly popular 'new normal' under Covid-19 conditions.

Other catchy terms

By way of examining the conceptual underpinnings of the 'new normal' as traced in the previous three chapters, this chapter has first taken recourse to existing historical accounts of the term 'normal', principally from Canguilhem

to Cryle and Stevens. These offered some insights into the steps through which the term 'normal' has moved from well-defined scientific and specialist usage into popular and everyday usage. Scientific usage involved definitions in terms of contradistinctive and consonant terms; everyday usage involved context-specific relevance-determinations from accruals of contradistinctive and consonant terms. The distinctions in usage from well-defined to undefined usage have been considered in this chapter, as have the rule-of-thumb and subjective dimensions of 'normal' in some specialist usage, and the role played by institutions. Returning then to the currency of the catchphrase 'new normal', firmly grounded in everyday and popular communication, I have argued that it has tended to elide even the relevance-determination of contradistinctive and consonant terms in everyday usage of 'normal'. Instead, the phrase, somewhat paradoxically, seems to contain its own contradistinction from and consonance with 'normal'. This turn, I have argued, seems to have the advantage of serving elite political and cultural interests. The passage of the catchphrase 'new normal' from everyday and popular usage into specialist and scientific usage—a kind of reversal of the pathway of 'normal'—was taken up thereafter. Academic studies in which the concept of 'normal' continues to be significant were considered. So were studies which use the catchphrase as a catchphrase, and others which unpack how it serves management and governance, and yet others which try to give it a measured and well-defined character. Finally, the nuances of the specialist catchphrase 'post-normal science' were considered. I have argued that this phrase has had, within a narrow professional remit, a similar management orientation as the 'new normal' has in popular and everyday usage.

These observations draw a tentative line under the contemporary historical tracking of the catchphrase 'new normal' which occupied the previous two chapters and this one. My account thus far has been, evidently, somewhat unevenly weighed by the currency of the catchphrase amidst and after the Covid-19 outbreak in 2020, so that the picture of the previous two decades, 2000–2019, in Chapter 2 now seems relatively sketchy. To fill in some lacunae in that picture, I turn next in Chapter 5 to two catchwords, 'austerity' and 'resilience', which I have already mentioned in relation to 'new normal'. I have not yet mentioned the catchphrase/slogan I explore in Chapter 6—'the 99% and the 1%'—but its relevance to the account in Chapter 2 will become evident. These have distinctive histories and institutional trajectories which complement observations presented so far.

5

Policy Catchwords

'Austerity' and 'Resilience'

Filling gaps

Two related political catchwords, 'austerity' and 'resilience', are the theme of
this chapter. Both have been strongly associated with the 'new normal' fol-
lowing the 2007–2008 financial crisis, as outlined in Chapter 2. Here they are
considered in terms of usage within narrower domains.

The term 'austerity' has featured in Chapters 2 and 3 already, but mainly as
referring to certain economic policy measures rather than as a catchword it-
self. The relationship between concepts and catchphrases/words is germane
to this study, exemplified earlier by considering the concept of normality
in terms of the catchphrase 'new normal'. 'Austerity' offers another instance
of such a relationship. At the same time, closer attention to 'austerity' as a
catchword complicates the picture of the 2007–2008 financial crisis woven
through the 'new normal'. That is to say, both the analysis of catchphrases
and the contemporary historical narrative of that juncture gain in depth. The
previous chapters have dwelt somewhat single-mindedly on a single catch-
phrase, but such catchphrases obviously work concurrently with, alongside
and through other catchphrases/words. The adaptations and slippages in
contextual usage are both concentrated in specific catchphrases/words and
distributed over a network of catchphrases/words bearing variously upon each
other. The catchword-character of 'austerity' thus adds a further dimension
to the catchphrase-character of the 'new normal' and indeed to other catch-
phrases/words at the time. Moreover, whereas in Chapter 2 I gave a sketchy
overview of various areas dubbed the 'new normal' over a protracted pe-
riod, my observations in this chapter on 'austerity' focus on a limited domain:
British political discourse in, mainly, 2008–2010. This presents, so to speak, a
focal point within the larger sweep of the account in Chapter 2.

The term 'resilience' is considered after 'austerity' in the following, mainly
for the period 2010–2017, but within an even more limited domain of usage:

Political Catchphrases and Contemporary History. Suman Gupta, Oxford University Press.
© Suman Gupta (2022). DOI: 10.1093/oso/9780192863690.003.0005

anchored to a specific British policy-setting body, the Arts Council England. The somewhat different purchases of the two catchwords guide my choice of appropriate domains to focus upon. In fact, as terms redolent of economic policy measures following the 2007–2008 financial crisis, 'austerity' and 'resilience' had linked but, in some respects, contrary resonances. They have seemed obviously linked—'austerity' measures test the 'resilience' of organizations—and yet, in terms of usage, they resisted each other. 'Austerity' mainly came to be associated with critical perspectives of the measures in question, used by those who were troubled by them. For a brief period, 2008–2010, it appeared in uncharacteristically positive tones in Britain and elsewhere, and that is therefore the period of particular interest in this chapter. But even as such, it was rarely adopted within policy speak. No significant policy measure was officially promoted as an 'austerity' measure, actually using the term, by legislators and managers. In fact, 'austerity' became a catchword—whether with positive or negative cadences—in media, academic and activist documents, and further afield. However, over the same period and subsequently, 'resilience' was principally a catchword within policymaking, at home in legislative and management circles. Outside that domain its resonances were weak. 'Resilience' is a useful example of a policy catchword which is best traced through governmental documents and official records.

Words and phrases usually call for somewhat distinct methods in discourse analysis, which is evident in some of the observations later in the chapter. However, I do not make a strong conceptual distinction between the catchiness of the words and of the phrases examined here. My approach to the 'catchwordness' of 'austerity' and 'resilience' in this chapter is aligned with my approach to the 'catchphraseness' of the 'new normal' in the previous chapters. Their catchiness has to do with the intensity and extensiveness of repeated usage, adaptations, and recontextualizations in diverse settings, shifting and accruing nuances, and their becoming grounded amidst and serving to ground current or emerging practices. On a related note, both 'austerity' and 'resilience' have occasionally been dissected as 'keywords' in the sense popularized by Raymond Williams (1983). It seems to me that in many respects keywords and catchwords are indistinguishable, but equally, in some important ways, calling a term a 'keyword' or a 'catchword' announces different analytical approaches. In the final chapter, I give more detailed consideration to the concept of catchphrases, and there the distinctions between catchwords and keywords are also addressed.

'Austerity'

That 'austerity' had become a catchword very soon after the 2007–2008 financial crisis is indicated by the analytical attention subsequently devoted to the policies it designated. Such attention has largely ranged from sceptical to hostile towards those policies. Insofar as the term's catchiness goes, how the relationship between the concept of austerity (realized in policy) and the word 'austerity' was understood is significant. Economist Mark Blyth's *Austerity: The History of a Dangerous Idea* (2013) has proved to be a useful, indeed obvious, source in this regard, and his succinct definition oft cited:

> Austerity is a form of voluntary deflation in which the economy adjusts through the reduction of wages, prices, and public spending to restore competitiveness, which is (supposedly) best achieved by cutting the state's budget, debts, and deficits. Doing so, its advocates believe, will inspire 'business confidence' since the government will neither be 'crowding-out' the market for investment by sucking up all the available capital through the issuance of debt, nor adding to the nation's already 'too big' debt. (2)

Blyth's history of this concept appeared while such policies were being enacted on large scale in response to the financial crisis, particularly in the UK and other EU member states. It was written to highlight the contradictions in, and inadequacies of the concept and the policies entailed, both in terms of economic reasoning and of past experience of implementing such policies. Importantly, Blyth argued, as an economic concept it misrepresented where responsibility for the deficit lay—principally the private sector—and consequently penalized those who were not responsible for it—the public sector and therefore the public at large, especially the less affluent and precariously employed. The attractiveness of the concept, Blyth observed, was engrained in the development of liberal political economy from the eighteenth century onwards (he started with John Locke), with its determination to limit state powers while preserving market freedoms, often more as a matter of conviction than logic. Blyth's criticism of austerity as a concept was especially meaningful when the book appeared. Other economists with notable public voices—such as Paul Krugman, Thomas Piketty, and Tony Atkinson—were making substantially similar arguments at the time (more on this in the next chapter). However, just a bit earlier, as the financial crisis broke over 2007–2010, the concept had enjoyed a not insignificant degree of popular support, especially in Britain. This

is a curious circumstance which possibly contributed to 'austerity' becoming a catchword. I turn to that soon, but let me stay with analytical retrospection on the financial-crisis concept and word a bit longer.

Blyth did not consider why the particular word 'austerity' was being used thus, when it had started being used, and with what connotations. He took it for granted that 'austerity' simply stands for such economic policies, defined the term accordingly, and reconfirmed its usage as such by using it. His history therefore traced those policies and the concept back to contexts when the word was not used thus, though the word itself was in use. Effectively, Blyth's history of austerity fixed the word to the idea as if that was necessarily received usage, as indeed it had become. In fact, economists at the time very seldom paused on the aptness of the term for the idea, or the rhetorical appeal it carried. Even those who found that the term was misunderstood or understood in contradictory ways, tended to sharpen the economic idea rather than meddle with the use of the term (Anderson and Minnerman 2014 a case in point). Naturally, scholars employing quantitative methods to gauge the currency and implications of 'austerity' over the financial-crisis period, mainly media and discourse analysts, paid more attention to the word itself than Blyth and other economists—and with the same political thrust. This was a methodological matter. Quantitative methods to gauge political or cultural tendencies often depend upon tracking the frequency and contexts of usage for specific words, where contexts are demarcated by time periods and categories of source documents (of different genres, with analysis ranging from lexical and syntactical to various post-sentential levels). Thus, to examine the idea of austerity through a corpus of political documents produced by British thinktanks in 2003–2013, Nick Anstead (2018) coded his corpus according to the incidence of the word 'austerity'. The word then became the key anchor for the idea, which was understood as both 'technical and normative' (289–90). Similarly, to study the 'the process by which a term ["austerity"] turns into a catchword that becomes used in ever-new contexts, reframing and reorganizing political discourses and actual policies', Laia Ferrer and Pertti Alasuutari (2019: 1041) focused on the incidence of the word 'austerity' in Spanish and Portuguese parliamentary papers. Reiner Grundman et al. (2018) took a more complex path to analyse the idea of austerity as featured in a corpus of British mainstream news texts in 2007–2015. They decided not to take the word as the sole anchor for the idea, but to devise a 'parsing routine that includes articles about austerity (even if the word does not appear) and to exclude articles that are not about austerity (even if the word appears)' (100). This involved associating the idea with a cluster of connected words rather than singularly with 'austerity'. Interestingly,

where Blyth and other economists tacitly fixed the word ('austerity') to the idea (deficit-reduction policies) by using it without reflecting on its received usage, these quantitative discourse analysts did much the same by negotiating laboriously with the word itself in their research methods. Therefore, in such quantitative analyses, between the period limitations of the corpora and the methodological attention to words, the economic concept of austerity seemed to get fixed to the term 'austerity' again, much as in Blyth's book. As little careful attention was given to the history of the word's usage across contexts, its varied connotations and accruing resonances. While such quantitative analyses made for valuable assessments of how the term was used in this period, they did not explain why 'austerity', particularly, became a catchword and how and why catchwords catch.

Rather more helpful for the latter purpose were studies which delved into the longer history and wider resonances of the term. While economists and reporters were using and settling the term prolifically to refer to deficit-reduction policies, it took a while for broader reflections on the term itself to emerge after the 2007–2008 financial crisis. I mean, reflections which were not simply about checking incidence of usage and fixing the term to the idea, but exploring why this particular term was being used and catching on at this time. These recalled the ethical and religious connotations of the term, of considerably older provenance, and pondered their bearing on current usage. An intriguing article on the idea of and the term 'austerity' in eighteenth- century Georgian England by Helen Berry (2014) wondered whether the present conception of austerity throws any light on that history, which also meant, of course, that the history could throw light on the present. Placing the eighteenth-century idea amidst an emerging culture of bourgeois consumption and denominational Christian principles, Berry noted several nuances. For elite men, austerity was a kind of ethical self-denial; for women, it was considered laudable domestic economy; immoderate self-denial was regarded with suspicion, as misanthropic or extremist; and in moderation it was taken as a sign of piety, where the denial of consuming pleasures was also an indulgence of the 'pleasures of conspicuous abstention' (276). That 'austerity' suggested a complex set of religious and ethical associations, veering between genteel piety and rigid extremism, moderation and immoderation, pleasant male self-denial and laudable female thrift, could well have been a dimension of the term's catchiness after the 2007–2008 financial crisis, for deficit-reduction by cutting public spending—and indeed earlier. That argument was made forcefully by Martijn Konings (in his 2015 book and 2016 paper). Konings argued that despite appearances, economic concepts (such as the idea of money) have evolved with and continue

to be infused with religious and emotional significances, which play their part in how economic terms—and the policies couched in them—are received. Insofar as 'austerity' goes, I had noted Blyth's complaint that austerity policies penalize the public for the culpability of the private sector. Konings observed that this unreasonable thrust is precisely what the term 'austerity' presents as a positive nuance, given its erstwhile religious and moral associations:

> Neoliberal capitalism's ethos facilitates disavowal of our complicity in the production of suffering, while allowing us to claim responsibility for our fortune; it urges us to feel responsible for things that we have little influence on while letting us off the hook when it comes to things we are responsible for. [...] The subject assumes responsibility for its own powerlessness and is assured that it is doing the right thing in exercising power. Any guilt we might feel should quickly be converted into the outwardly directed aggression that secures our wealth, and not to do so would jeopardize our self-realization. Neoliberal austerity is redemptive, holding out the promise of limitless wealth and assuaging the anxiety we might feel about the disagreeable alliances we have to forge in our pursuit of money. Any reluctance to own our desire for money and any hesitations we might experience in wielding our powers jeopardize our future salvation. (111)

Arguably, both the infrequent approbatory usage and the frequent denunciative usage of the term 'austerity' to refer to economic policy after the financial crisis—contributing to its spread as a catchword—were grounded in the accrual and juxtaposition of nuances over its long career.

With these retrospective analyses of the rise of 'austerity' as a catchword after the 2007–2008 financial crisis, I turn to some notes on its career in Britain as such.

In 2010 'austerity' was already firmly a catchword, not just in Anglophone circuits but well beyond, especially in EU member states. The Merriam-Webster Dictionary named 'austerity' its Word of the Year in December 2010, that is, the most searched term on its digital platform (Sanburn 2010). That year in Britain the Conservatives won the general election with a promise of stiff austerity measures to reduce the 'sovereign debt', formed a coalition government with the Liberal Democrats, and duly began implementing them. The severity of those measures became evident within the year. And yet, in that year particularly, the balance of attitudes to the term was ambiguous. Anstead's (2018) survey of usage of the term in British think-tank documents 2003–2013, divided them into left-leaning (critical of austerity) and right-leaning

(supportive of austerity) and found that such usage had gone up steadily year-by-year from 2008 onwards, pre-dominantly driven by left-leaning think tanks. However:

> Only in 2010, the year of a general election, did references to austerity come close to parity (1.595 mentions per 100k words on the left, 1.209 on the right). This might suggest that, at that point in our sample period at least, discussion of austerity was seen to serve some useful purposes for the political right, particularly to claim that the incumbent Labour government had engaged in excessive spending. In contrast, in the years after the election, discussion of austerity on the political left increases much more rapidly. (294–95)

In fact, the unusually high approbatory support that 'austerity' had in 2010 briefly gave it an ambiguous cast as a catchword, but that did not last beyond the year. Thereafter, it became ever more firmly weighed with negative normative associations and has remained so. How this brief flash of positive normativity appeared is of interest in these notes. Possibly, it is that, more than the negative associations which propelled the term into catchword status, which was thereafter capitalized on by the disapproving voices.

Though the popularity of the term and concept of 'austerity' is associated with the Conservative campaign and victory in 2010, and the advent of David Cameron as prime minister and George Osborne as chancellor of the exchequer, the background tells another story. That Cameron and the Tories became the flagbearers of tough austerity from 2009 onwards was somewhat ironic. As Blyth (2013) observed:

> Britain's [Labour] prime minister, Gordon Brown, who as chancellor of the exchequer presided over the biggest boom and bust in British history while promising financial 'prudence for a purpose', spent, lent, or otherwise guaranteed about 40 percent of British GDP to save the banks and even more to stimulate the economy. When the Brown government lost the election to Conservative David Cameron in May 2010, Cameron's party had spent the last two years trying to convince voters that it would not slash social spending and would actually be better than New Labour at providing public services. These were, as the Chinese proverb has it, interesting times. Given this odd mixture of political positions and ideological priors, spring 2010 produced the curious spectacle of the Americans arguing for global Keynesianism while the Germans, cheered on by the new British Conservative government under David Cameron, demanded regional austerity. (59)

In fact, the vogue for 'austerity' as a *potential* catchword appeared under the New Labour governments of Tony Blair and Gordon Brown. Through the period 2003–2010 the term rarely appeared in UK government policy documents, and then mainly to refer to economic measures in other countries or to look back to post-World War II austerity in the 1940s. However, the term did appear intermittently in newspapers in relation to the Labour government's economic policies and budgeting. The think-tank usage tracked by Anstead (2018), cited earlier, showed that though not of catchword scale, a steady drip of usage appeared before 2008, and in this drip both left-leaning and right-leaning sources had a more or less equal part. Over that period it is not at all obvious that right-leaning and left-leaning usage mapped straightforwardly to being, respectively, supportive and critical of austerity. In fact, particularly in Britain prior to 2009, 'austerity' as a word and concept tended to be associated strongly with the post-World War II Labour government's economic policies, which were seen as both necessary and successful, and had not a little of the ethical and religious senses of self-denial and moderation imbued in it. To trace how 'austerity' became set to be a catchword after the 2007–2008 financial crisis in Britain, its earlier career and its intermittent place in Tony Blair's and Gordon Brown's New Labour governments need to be factored in. That necessarily takes us back to the memory of the patriotic self-denial and success that was wartime and post-war austerity in Britain.

World War II rationing and budgeting were where the term 'austerity' made a step towards the transition from its dominantly religious and moral connotations, as traced from the eighteenth century by Berry (2014), to the economic sense taken for granted by Blyth (2013). In fact, wartime austerity was not so much a transition as a sliding of the moral and religious connotations into the economic policy needs; the latter were equally a matter of economic pragmatism and patriotic fortitude and moral fibre. It was even a clarion-call for attack in the war effort: a light war locomotive designed by British and American engineers in 1943 was aggressively named *Austerity*. Post-war austerity gave the word its squarely economic sense, but still with those positive norms attached. The word was already being used as such by Maynard Keynes and his followers during the war, and when the post-war economic recovery was planned, 'austerity' was firmly pegged as an economic term. So, somewhat after the Beveridge Report of 1942 (regarded as the foundational document of the British welfare state), and shortly after the Bretton Woods conference in July 1944 (establishing the post-war international economic order), at a Chatham House lecture in October 1944, A.R. Guinness had full command of this sense of the word:

I suggest that this period [a three- or four-year period of implementing the monetary plan in Britain discussed at Bretton Woods] should definitely be looked upon as one of austerity, when we shall have to do without many of the things we were accustomed to before the war, and conform to a much stricter regime. We shall have to continue eating Woolton Pie and ration our expenditure both internally and externally. Only in this way shall we be able to regain our economic position and make up part of what we have lost, but if we set a limit to this period and have the clear goal of freedom before us and a better standard of living, our people will agree to this self-discipline and our foreign friends will put up with the inconveniences.

(Guinness 1944: 497)

With the formation of the Labour government in 1945, under Prime Minister Clement Attlee, post-war austerity policies were gradually implemented. In particular, Stafford Cripps, first as president of the Board of Trade and then chancellor of the exchequer, came to embody the spirit of austerity with religious and ethical senses tacked on—puritanical, vegetarian (no doubt well-acquainted with Woolton Pie), and socialist. Keynesians wondered at times whether continuing austerity was necessary: Roy Harrod (1947) wrote a passionate diatribe against it. However, post-war austerity was always meant to be temporary and did end by 1951. Under the Labour government from 1945, it meant the consolidation of the modern welfare state in Britain, a series of Acts ensuring social protections and workers' rights, the formation of the National Health Service, and the nationalization of major industries and public utilities. After post-war austerity, the economic sense of the word dominated, but the positive normative inflection remained and became firmly associated with the economic sense in Britain. Austerity had been a good and necessary phase, a morally justified economic transition.

So, it is ironic that after the 2007–2008 financial crisis, especially as a catchword from 2010 and onwards, 'austerity' has come to stand for exactly the opposite of what it meant for post-war Britain. 'Austerity' now seemed a permanent rather than temporary condition. It represented a taking down of, rather than the settling of the welfare state: cuts from and privatizations of public services, dismantling of welfare mechanisms, and minimizing government in favour of business. Or perhaps it is not ironic: perhaps it was not fortuitous but more or less by design. In the first instance, 'austerity' reappeared as a kind of political and media strategy to extrapolate the righteous necessity of wartime and post-war 'austerity' and associate it with economic policies which were their opposite so as to sell them. Perhaps the use of 'austerity', especially

from the 2007–2008 financial crisis onwards, was designed to fool everyone by suggesting a salutary continuity with post-war austerity, whereas this 'austerity' actually represented a determined drive to do away with what was achieved through post-war austerity. But that association helped the term 'austerity' to catch on, first with vaguely welcoming confusion which was then propelled into more verbose irony and bitterness.

When I say the misleading transfer of 'austerity' from the post-war regime to the present-day regime happened by design, I do not mean politicians and financial pundits called a boardroom meeting and decided to make it happen. It happened rather through a series of opportunistic linkages made by persons with an interest in courting the public eye, through the news media. Occasionally, the term 'austerity' was associated with Gordon Brown in news reports, through his career as Chancellor of the Exchequer of the Blair government (1997–2007) and then as prime minister (2007–2010) with Alistair Darling as Chancellor. As Chancellor, Brown's budgetary decisions after the dot-com crash in 2002, to counter slowing growth and plummeting stocks in 2003, were pegged as being 'austerity' measures in financial columns (e.g. Stewart 2003; Hawkins 2003). In subsequent phases of recoveries and downturns, further balances of 'austerity' cuts and targeted investments in budget statements were periodically reported (e.g. Elliot and Seager 2005; White 2006). These mentions often came with a nod towards post-war Labour austerity years, and, more interestingly, seemed to become attached to Brown's own austere character, comparable to Stafford Cripps's. One report observed, 'the Calvinistic implication behind his austerity of tone (common to most Brown speeches)' (White 2006). When he became prime minister in 2007, 'austerity' was associated with Brown's own record as Chancellor and the tradition of Labour post-war austerity, and, at the same time, as a feature of his personality, rather like post-war Chancellor Cripps—often in a sarcastic vein:

> I want to write this week about Mr Brown and the cult of austerity. Austere people, which I thought I believed Mr Brown was, tend not to go in much for smiling. This might, of course, be for dental reasons. The only picture I have ever seen of the godfather of 1940s Labour austerity, Sir Stafford Cripps, smiling reveals a set of gnashers that the Almighty appears to have allocated almost at random.
>
> (Heffer 2007)

With the 2007–2008 financial crisis and the bank bailouts by Brown and Darling, he was more frequently pegged as the 'austerity PM' in news media:

'The austerity Prime Minister endorsed closing curtains at dusk, turning down thermostats, switching off lights and blocking draughts' (Murphy and Waugh 2008). Through 2008, even as Cameron started his campaign for the 2010 elections, those associations of 'austerity' seemed mostly up Brown's street: '[T]he current austerity suits Labour. Cameron and his colleagues may accuse Brown and his ministers of being reckless, profligate, high-rollers. The trouble is, they seem so ordinary, dour, normal and unreckless as people' (Ashley 2008). In fact, as far as news media went, it was Labour economic policies and Brown's personality that got pegged as an 'austerity'-led response to the 2007–2008 financial crisis, with the upbeat memory of post-war Labour-led austerity ever in the background. Indeed, and this is the juncture of interest, 'austerity' had quite a lot of good press through 2008.

Popular historians played their part in invoking post-war austerity amidst the financial crisis. In 2007, David Kynaston's history of post-war austerity in Britain appeared to the general approval of reviewers. So, when it became apparent that cutbacks would follow the bank bailouts from 2008, Kynaston allowed himself to be called upon as an austerity guru and remind the public that this was no bad thing, quite the contrary—remember post-war austerity. Kynaston did his bit in an introduction for *The Independent*'s special November 2008 'Austerity Issue', sub-headed thus:

> Amid the bewildering complexities of the global financial crisis, one simple fact stands out: the little we have left needs to go a lot further. Fear not! We'll show you how to endure the forthcoming recession with a bit of grit, some nous and the wise advice of our post-war forebears.
>
> (Kynaston 2008)

Similarly, and also in 2007, broadcaster Andrew Marr had presented a BBC2 series *A History of Modern Britain* (the first part of which was devoted to post-war austerity), attended by the publication of a book. Marr did his bit too as an austerity guru, in a Christmas *Daily Mail* feature, entitled 'Austerity be damned! We're all cutting back, but Andrew Marr says that's the reason to make this Christmas special.' As an expert, Marr marked out a series of parallels between post-war austerity and present-day austerity: 'No historical era can really be revisited. But [...] I've found it intriguing to spot the parallels between then and now' (Marr 2008). In fact, in 2008 others courting the public eye also got in on the act, making virtuous-sounding comparisons between austerity then and now, evoking a bit of wartime and post-war patriotism and backbone. Various public health gurus, including celebrity chef Jamie

Oliver, called for a return to wartime cooking (Wickham and Winterman 2008). Designer Stephen Bayley was quoted as observing:

> 'Recession could be healthy, interesting', he says. 'Austerity is a good thing – an inspiration, not an impediment to genius. It forces more expressiveness and more interesting choices. The tighter the discipline, the more creativity flourishes. I adore Norman Lewis's observation on encountering some Spanish village in the Alpujarras that beauty is best maintained under a reign of poverty. Now the same village would have an EU grant and they'd all have 4x4s and satellite dishes. Restraints – economic, philosophical or religious – tend to ensure beauty. When anything goes, nothing does.'
>
> (Betts 2008)

So far then, the term was mostly with Labour and Brown, gradually becoming popularized as a tough but necessary matter, with post-war austerity and moral and ethical nuances in mind.

These opportunistic links between post-war and present-day 'austerity' in 2008 were curiously colonized by David Cameron and the Conservatives. Brown's whimper was stolen and turned into Cameron's thunder, famously in his speech of 26 April 2009 at the Conservative Party Conference in the run-up to the 2010 general election:

> There are deep, dark clouds over our economy, our society, and our whole political system. Steering our country through this storm; reaching the sunshine on the far side cannot mean sticking to the same, wrong course. We need a complete change of direction. I'm not just talking about changing one group of Ministers for another. Or one set of policies, plans and proposals for another. I'm talking about a whole new, never-been-done-before approach to the way this country is run. Why? Because the world has completely changed. In this new world comes the reckoning for Labour's economic incompetence. The age of irresponsibility is giving way to the age of austerity.
>
> First, 'the age of austerity' demands responsible politics. Over the next few years, we will have to take some incredibly tough decisions on taxation, spending, borrowing—things that really affect people's lives. Getting through those difficult decisions will mean sticking together as a country—government and people. That relationship, just as any other, is strengthened by honesty; undermined by dishonesty. [...] Does the age of austerity force us to abandon our ambitions? No. We are not here just to balance the books. There's more to our mission than coming in like a bunch of flint-faced

accountants and sorting out the finances. [...] The question is: how does government help achieve these wider aims in the age of austerity? And the answer is: by delivering more for less. (Cameron 2009)

To some degree, this was a rhetorical matter: where 'austerity' chimed as moderate and careful from Brown and New Labour, it rang as radical and brash from Cameron and the Conservatives. In fact, for a brief period after that, Cameron's speech produced a catchphrase: 'age of austerity'. There was no beating about the bush there: an 'age of austerity' was announced, not three or four years of post-war-like austerity but an 'age', without war and yet without closure. A careful line-by-line analysis of Cameron's speech by Matthew Evans and Brian Walker (2020) noted that he used the word without qualification, as if 'the meaning of *austerity* is transparent: it is taken for granted that readers and listeners will know what the word means when used in this context' (175). That lack of definition allowed Cameron to give the term an implicitly but emphatically positive turn, as the opposite of the 'age of irresponsibility'. By the end of 2009, Brown had little choice but to protest against this new forceful occupation of the term 'austerity': 'The biggest risk for Britain is a decade of austerity—of limited growth, limited employment and limited opportunity' (Brown 2009).

After winning the elections and forming the government with the Liberal Democrats in May 2010, Cameron and his chancellor of the exchequer, George Osborne, got down to implementing their promised radical austerity measures. The harsh reality of those measures left very little space for any upbeat note, redolent of religious self-denial, ethical moderation, and post-war success, and indeed Cameron's administration had little use for those associations or the term 'austerity' itself thereafter. In the course of 2010, in fact, whatever of those resonances remained were gradually shed from the term and it became principally a catchword for opposition to those policies, with growing bitterness. If not enunciated with bitterness, disapprobation, or irony, it remained for the following two or three years a neutral designative term: 'in this age of austerity'; 'in this time of austerity'. Otherwise, talking of 'austerity' became coterminous with assuming an 'anti-austerity' stance; 'anti-austerity' itself became a catchword in activist and academic circles. Bitterness in 'austerity' was possibly all the more sharp because its usage had to emphatically extirpate the erstwhile moral and religious associations, the pride in post-war austerity, from the term. Arguably, its burgeoning, catchphrase character after 2010 in Britain was, to some degree, a frequent and loud dispelling of those erstwhile associations to repossess the term as representing deleterious

economic consequences despite—indeed directly against—those done-with associations.

From Cameron's April 2009 speech, 'doing more with less' remained firmly in governmental policy vocabulary after May 2010, but 'austerity' more or less disappeared, except as an occasional designative term. The more policies and directives for cutting public spending and deficit reduction were promulgated, the less 'austerity' appeared within their statements and guidance. Apart from Cameron, chancellor-to-be George Osborne used the term a few times in 2009, but not once he took office and began to enact those deficit-cutting measures (see Grundman et al. 2018: 116–17). As a catchword, 'austerity' did not make it to any significant extent within legislative and bureaucratic circuits, but its usage grew and grew among the critics and opponents of policies referred to by the term.

'Resilience' (co-authored with Ayan-Yue Gupta)

While 'austerity' as a catchword came into its own outside legislative and management circles to refer critically to deficit-reduction policies, 'resilience' became a catchword within legislative and management circles to undergird those policies.

The earliest usages of the term 'resilience' cited in the Oxford English Dictionary (OED), from the early to mid-nineteenth century, either have it as equivalent to 'elasticity' in scientific usage (in studying materials, in physics), or, more pertinently here, as an individual or collective (national or communal) character trait—in the sense of 'the quality or fact of being able to recover quickly or easily from, or resist being affected by, a misfortune, shock, illness, etc.; robustness; adaptability'. In the 1980s, 'resilience' became, alongside and often interchangeably with 'sustainability' (another catchword), a standard academic term in ecological studies (Holling 1973 is credited with introducing it), a field with which it has been strongly associated. Ecology is the pathway through which 'resilience' entered sociology and thereby the domain of policy. For the latter, more nuanced histories of the term have been offered by those who were interrogative or critical of its policy implications, as for 'austerity'. Such historicist accounts cited consecutive definitions from representative scholarly publications, according to discipline, and tried to discern their ideological import (in this vein Adger 2000: 349–52 was mildly interrogative; Walker and Cooper 2011, and MacKinnon and Derickson 2012: 255–58 straightforwardly critical—the latter offered a table of definitions, 256). Through this career, 'resilience' evidently moved from being a definable

quality of materials (in scientific usage) and a normative quality of character (in ordinary language) via ecological studies to becoming a dislocated normative qualifier for almost any 'system' (an overarching catchword). As such, the term was variously defined by area (such as environmental, social, political, economic, cultural) or according to social formation (such as governmental or non-governmental, business, academic, community, charitable, local, and global).

Two connections between 'resilience' and other catchwords made in the previous paragraph are worth pausing on to sharpen its nuances. 'Systems' is so much a grounding catchword in policy discourse, so continuously taken for granted to describe various other terms, that it is difficult to discuss as one itself. It is now used as such in specialist and particularly policy circles in more or less well-defined ways, frequently in terms of 'systems theory' or 'systems thinking' (Jervis 1997: 5–10, tried tackling this head on; Siskin 2016 in an ongoing and detailed way). The other term mentioned earlier is 'sustainability', in fact established earlier as a policy catchword (see Palmer et al. 1997; Scoones 2010), and now often used alongside and interchangeably with 'resilience'. This term appears to have made its way from legal usage (in relation to arguments) into economics (in relation to financial health) and then to ecology, with which it has been as strongly associated as 'resilience'. Lee Talbot (1980: 260–61) influentially introduced 'sustainability' into ecology, though he was more focused on 'conservation'. There are ordinary language nuances to the three terms—'conservation', 'sustainability', 'resilience'—which arguably bear upon their distinct purchases in policy usage. In brief, ordinarily, 'conservation' is coterminous with preservation and suggests maintaining something in a stable state; 'sustainability' suggests giving something (like nourishment) to that which is to be kept alive or active; and 'resilience' suggests an endemic quality of withstanding deterioration or erosion. Put otherwise, 'conservation' and 'sustainability' gesture toward active principles, and involve doing something in an ongoing way; 'resilience' suggests a passive and lasting condition, an inbuilt or constitutive strength.

The driver for 'resilience' as a policy catchword was more at the behest of institutional interests than well-defined conceptual usage or ordinary language adaptation from an early stage. The catchy possibilities of the term were opened by the establishment of 'ecological economics' as a discipline (the ground set in Constanza, ed. 1991 and Constanza et al., eds. 1992). Ecological economics centred on the management of natural resources, from where it was a short step to 'resilience management' for any social formation and therefore of 'resilience' as a cornerstone of policymaking in general. Usefully, 'resilience' seemed umbilically connected to ecology and yet releasable into all areas of

social action irrespective of a direct ecological investment. In fact, the term 'ecology' itself was loosened from its scientific moorings and started being used as a catchy metaphor for all kinds of social systems (more on this later). The potential of 'resilience' as a policy catchword was pushed from the institutional contexts where the discipline of ecological economics initially settled. That was, first, particularly in the restructured Beijer Institute of Ecological Economics in 1991 (established in 1977), with funding from the Beijer Foundation and under the Royal Swedish Academy of Sciences; and, second, by the establishment of the Resilience Alliance in 1999, with an interdisciplinary and international academic membership, supported by various scientific bodies and drawing upon a range of funding sources, particularly foundations. The linkages between social and ecological systems, and thereby of policy overlaps foregrounding 'resilience' emerged from a series of publications through these bodies. Notably, a Beijer Discussion Paper by Berkes and Folke (1994) outlined a project for 'linking social and ecological systems for resilience and sustainability', which led eventually to publications arising from conferences held at the Beijer Institute and supported by the Resilience Alliance (Berkes and Folke, eds. 1998; Berkes et al., eds. 2003). The massaging of 'resilience' into a general policy term originated here.

 In brief, at this juncture, 'resilience' became a notable word at precisely the intersection of ecological economics—ecology and economics: connoting, on the one hand, the powerful moral impetus of ecological concern (saving nature/life/the world itself) and denoting, on the other, the conviction that this could be done by 'management', ergo social policymaking rationalized by economic accounting. Tacitly, the passive sense of 'resilience' noted earlier (as against 'conserving' or 'sustaining') meant that the onus of responsibility for policy seemed removed from the managers and put on the subjects or objects of management. The latter had to be 'resilient', though only the former could determine whether they were so. Perhaps that is one of the reasons why it has proved so catchy in policy circles. Another oft-noted reason is that the term, in ordinary language, suggested withstanding some threat (withstanding or recovering from some 'misfortune, shock, illness, etc.', according to the OED definition). The recourse to 'resilience' in ecological studies in the 1980s was due to a sense of growing environmental crisis; the generalization of 'resilience' as a policy term extended that into the growing ambit of crises in the 2000s: a security crisis and terrorist threat after 9/11, overlaid by the 2007–2008 financial crisis, and later a perceived 'migration crisis' from 2014 onwards, and then the 2020 Covid-19 crisis, alongside unfolding crises of democracy and of climate change. 'Crisis' became another overarching catchword, like 'systems', with its meaning regarded as self-evident and its relevance

increasingly ubiquitous in media and especially policy circles. As Janet Roit-man (2014: 39) observed: '[C]risis is not a condition to be observed (loss of meaning, alienation, faulty knowledge); it is an observation that produces meaning.' Critical disentangling of the economic rationale from the ecological norm of 'resilience' understandably came as its significance grew in the late noughties. An extensive debate on this unfolded within the circles of ecological ethics (a brief critical piece in *Nature*, McCauley 2006, marked an impetus); a broader political critique of 'resilience' as coeval with neoliberal management developed alongside critiques of 'austerity' (e.g. Walker and Cooper 2011; MacKinnon and Derickson 2012).

In British government circles there was a marked rise of 'resilience' dis-course after 2001 (following 9/11) and then a veritable explosion of usage after the 2007–2008 financial crisis, particularly 2010 onwards, when the Conser-vatives under David Cameron took over and started implementing stringent 'austerity' measures. Since, over this period, 'resilience' became a catchword principally within institutional spaces, in legislative and management circles, the rest of this section focuses on a particular area of British policymaking and a key policy-determining body: art and culture policy and the Arts Coun-cil England (ACE). Sources from the latter are examined as a case study of how the catchword worked within institutional contexts, mainly after 2010. It worked similarly in numerous other sectors. In a speech in November 2011, Alan Davey, chief executive of the ACE, gave an account of the dramatic policy changes in the arts and culture sector that an 'instant austerity budget' had ne-cessitated (Davey 2012: 16). Tracking the career of 'resilience' in ACE policy speak gives a reasonable sense of what those changes were and how they were managed.

Before proceeding with this, a brief note on the status and function of ACE is expedient. ACE is a non-departmental government body at 'arm's length', by its own description, from the UK government's Department for Culture, Media and Sports, or, from 2017, Department for Digital, Culture, Media and Sports (DCMS). This means ACE is entitled to make decisions independently of DCMS but is ultimately accountable to the DCMS. ACE receives much of its funding from DCMS (in 2015–18, that was £1.1 billion), with addi-tional funds coming from the National Lottery (in 2015–18, £700 million) and private donations (DCMS 2017: 15-6). The UK Lottery is operated by the Camelot Group with a franchise from the government. ACE's budget is spent on National Portfolio Organizations (NPOs), Major Partner Museums (MPMs) and Grants for the Arts and Strategic Funding. NPOs and MPMs concern large-scale museums, galleries, theatres, and so on; other grants are directed to smaller-scale organizations, and individual and group projects.

The regions covered are London, Midlands, North, South East, and South West. The governance structure is complex, hierarchical, and generally representative of all regions and sub-sectors—further detail is irrelevant here. Insofar as funding is directed towards the 'arts', the remit is evident in thematic categorizations of recipients: dance, literature, music, theatre, visual arts, combined arts (which includes arts festivals and centres), museums, and libraries. In disbursing funding, the ACE follows certain principles of 'public value'—another policy catchword which was subject to consultation and debate in 2006 (see Bunting 2006, and for a critical assessment Gray 2008). For the period in question here, the ACE was much in the news for being subject to stringent budget cuts. From 2010 the government grant to ACE was cut by 30 per cent in real terms over four years, and further, all culture bodies were asked to reduce administration costs by 50 per cent (Davey 2012: 16). After a sharp funding dip, in 2015–16 it was reported that the government's grant had decreased by −1.5 per cent and real-terms arts expenditure by −3.6 per cent compared to 2010–11 (Dempsey 2016). The immediate effects on arts institutions and projects were severe. This then was the 'austerity' context in which the term 'resilience' found its policy purchase.

A year-by-year keyword search of 'resilience' and 'sustainability' in the National Archives for UK government records from 2002–2017 tells the story of these catchwords effectively. Table 5.1 gives the results of items (webpages and

Table 5.1 Usage of 'resilience' in British governmental and ACE documents

Year	Items in domain nationalarchives.gov.uk		Items in domain artscouncil.org.uk	
	'resilience'	'sustainability'	'resilience'	'sustainability'
2002	84	1143		
2003	2120	14501		
2004	68741	29278		
2005	262446	29893		
2006	478499	43377		1
2007	110637	20349		
2008	75051	142863	9	225
2009	2970406	870398	18	539
2010	3444020	2267314	33	544
2011	517818	1023278	29	25720
2012	249677	1245310	127	279
2013	101682	796041	2927	940
2014	168690	618145	3709	9873
2015	375390	815488	268	303
2016	173356	1124975	233	210
2017	188108	1182979	5744	5493

publications) from the general government domain and the ACE domain and needs little commentary:

Evidently, 'sustainability' has been the more common and older term in British policy circuits, and 'resilience' a relatively late entry. However, 'resilience' had caught on and at times overtaken the other term with extraordinary expedition, especially in the ACE. The points at which the usage of either term peaked before tapering may be points at which policy drives were afoot. For reasons discussed later, 'resilience' can be considered the more weighty policy catchword, especially in ACE's remit—partly because of the speed with which it was foregrounded, and more because of the distinctive ways in which it was deployed.

'Resilience' entered into ACE's policy circuit emphatically in 2010, with a strategic focus and definition. The term was more circumstantially used earlier: for instance, in a report on how the arts may benefit young offenders (Hughes 2008) 'resilience' appeared principally in its received sense, as a desirable (individual) character trait. In the main, 'sustainability'/'sustainable' was used circumstantially throughout in ACE documents, premised on its received meanings, though with increased frequency as austerity measures bit; its strategic focus came as related to 'resilience' in 2010.

'Resilience' appeared alongside 'sustainability' as a key policy thrust in a ten-year strategic plan released by ACE in November 2010, *Great Art for Everyone* (ACE 2010). This announced five 'long-term goals' (the quotation below gives only the headlines):

> Goal 1: *Talent and artistic excellence are thriving and celebrated*
> Goal 2: *More people experience and are inspired by the arts*
> Goal 3: *The arts are sustainable, resilient, and innovative*
> Goal 4: *The arts leadership and workforce are diverse and highly skilled*
> Goal 5: *Every child and young person has the opportunity to experience the richness of the arts.* (11, italics in original)

The headlines in themselves wove a net of policy catchwords ('excellence', 'leadership', 'opportunity', 'innovative') which could be usefully analysed, but that is not to the purpose here. Also notably, the glue for such policy statements was a superlatively upbeat register: 'excellence' itself is a normative extreme; it is not enough to be 'skilled' but to be '*highly* skilled'; one does not merely 'experience' art but such that art is *inspiring* and *rich* and *excellent*. Such hyperboles (a classical rhetorical trope) commonly characterize or qualify policy catchwords, obviously geared for public persuasion or advocacy. Goal 3 is

to the theme here. 'Resilience' and 'sustainability' were not quite defined but elaborated thus in the strategic statement:

> It is clear that the future resilience of the UK arts sector is dependent on a sustainable mixed economy of increasingly varied income sources. However a model that relies on public subsidy as a catalyst for securing self-generated and private sector income may come under considerable strain in the short term. The need to reduce the UK public spending deficit over the lifetime of our strategic framework will have a major impact on the arts economy as a whole. (18)

And further:

> *Why this Goal [3]?* [...] With public investment in the arts reducing, it is also about developing resilience, as arts organisations extend their roles and responsibilities within the wider cultural landscape and civil and national life, including how they adapt and respond to climate change.
> *What will we do?*
>
> - we will invest in the sustainable growth of the arts ecology—encouraging networking, collaboration and partnerships
> - we will broker partnerships with other major public and private funders to secure greater impact from our shared investment in the arts
> - we will work with partners, including government, to encourage and enable a higher level of private giving to support the arts
> - we will encourage innovation through recognising the value of research and development in the production, presentation and distribution of art
> (33)

Instead of a *definition*, then, this significant ACE policy document introduced 'resilience' (alongside 'sustainability') as a policy issue with two *associations,* precisely at the juncture of 'ecological economics'. On one hand, 'resilience' proposed an austerity-driven financial management policy: using 'public subsidy as a catalyst for securing self-generated and private sector income'. Interestingly, the proposal was not simply pushing to replace reduced public funding by increased private funding, but to exhort the sector to actively use reduced public funding itself as a means of raising more private funding. In a way then, the public funding was made conditional on private enterprise, for which responsibility was passed on to arts organizations (and artists). The latter had to demonstrate their 'resilience' and thereby remain 'sustainable'. The

'we' that is ACE adopted a financial middleman position: 'encouraging', 'brokering', 'enabling', and in the metaphor of working as 'catalyst'. On the other hand, the moral impetus of 'resilience' was pushed by maintaining an association with its ecological provenance: directly, by enjoining attention to 'climate change' on arts organizations, and indirectly, by using ecology as a metaphor for arts organizations themselves—the 'arts ecology' and 'cultural landscape'. It is unlikely that many would have regarded 'climate change' as a particular concern of arts organizations at this juncture, to be singled out from the many social concerns that such organizations might address. By simply naming it particularly, the received moral weight of 'resilience' as pinned on ecological ethics was given full rein.

This significant ACE document then mined the possibilities of the term 'resilience' by using rhetorical ploys (in the sense most carefully unpacked in McCloskey 1998 [1985]): locating it within a hyperbolic register, fitting it into an existing network of catchwords, making associations rather than defining, by selective exemplification (e.g. 'climate change'), by using loaded metaphors (e.g. 'arts ecology', 'catalyst'). These had the effect of massaging a direction out of the ambiguity of 'resilience' while shrouding the intent it signalled insofar as that might be resisted—a characteristic feature of policy catchwords. Once the direction was set and connected to the word, the word was set to catch on. It could then be reiterated ad nauseam in further policy documents which concern implementation on the ground, region-by-region, subsector-by-subsector, institution-by-institution, area-by-area. The nuances of 'resilience' negotiated through those rhetorical ploys settled and became habitual as the ACE (2010) strategy passed into practice across the arts sector. However, for that to happen, definition is usually considered more effective than loose associations; definitions massage a direction as catchwords are repeated, adapted, and grounded within organizations. In policy discourse, definitions appear to bring clarity amidst ambiguity without quite dispelling the opportune manipulation of ambiguity. Defining 'resilience' for the purposes of ACE policy posed some distinctive challenges, of particular interest here.

Though it was not evident in the November 2010 strategy paper, ACE had already commissioned a report, released four months earlier (Robinson 2010, July), proposing a relevant definition of 'resilience'. This was by Mark Robinson, executive director of ACE from 2005 to April 2010 and thereafter director of a private consultancy, Thinking Practice. This had offered a definition and recommendations for the ACE (2010) strategy statement. Neither were substantively adopted, possibly because some points in it caused some unease.

Its definition and discussion of 'resilience' revealed potential tensions for the arts field, though it fleshed out the associations of 'resilience' with financial management and scientific ecology sufficiently to underpin the strategy statement.

For this sector, meaningful definition of 'resilience', with its passive sense and grounding in systems theory, tends to go against the grain of received conceptions of 'the arts'. The relevant understanding of the noun 'art' here is as in the OED (sense 8a under definition I, 'skill; its display, application, or expression'): 'The expression or application of creative skill and imagination'. It is powerfully associated with norms of artistic independence and freedom, popularly regarded as best pursued without being constrained by convention, censorship, or other extrinsic control (e.g. political, commercial). These norms are often personified in 'the artist': an embodiment of creativity, originality, genius, and so on. Placing the arts, with these connotations, within systems (*social*, not to speak of *institutional, economic*, or *ecological*) perceptually undermines its received value, which liberal policy discourse can scarcely promote without causing unease. (Luhmann's 2004 attempt carefully put art as an *autopoietic* system, and not wholly successfully at that). Robinson (2010), therefore, had a challenging job, and his efforts were as revealing of the difficulty as of his determination to overcome it by various subterfuges.

Insofar as a definition went, Robinson chose a qualifier to go with 'resilience' by way of fitting it to arts policy: 'adaptive resilience'. His own definition went thus: 'Adaptive resilience is the capacity to remain productive and true to core purpose and identity whilst absorbing disturbance and adapting with integrity in response to changing circumstances' (p. 14). This emphasis was borrowed from ecological economic studies, and could be traced back to Berkes et al., eds (2003, cited earlier). In their concluding synthesis of the contributions to this volume, the editors decided that:

> The focus of the volume is the study of the adaptability of social-ecological systems to meet change and novel challenges in navigating ecosystem dynamics without compromising long-term sustainability. Throughout this volume, we argue that resilience is a key property of sustainability; that loss of resilience leads to reduced capacity to deal with change.
>
> (Folke et al. 2003: 354).

It also offered some prescriptions, usefully summarized in a table, for 'Building resilience and adaptive capacity in social-ecological systems' (355). Robinson found his way to 'adaptive resilience' in precisely this register and echoing the

prescriptions (principally via Walker and Salt 2008, with no reference to the just-quoted volume), but with some important nudges in keeping with its arts focus. The definition elided any reference to what such 'adaptive resilience' applies to, making no mention of social-ecological systems or even systems as such; it seemed a generalization which could apply anywhere. Instead of gesturing towards a referent, the definition threw in three abstract nouns which were likely to resonate in arts circles: 'core purpose', 'identity', 'integrity'. Thus, the management of 'adaptive resilience' in 'changing circumstances', it was suggested, would not disturb that which makes the arts such. The question, however, remained: what would this definition apply to? To answer it, Robinson resorted to fleshing out what the phrase 'arts ecology' might mean (in a tentative section entitled 'Towards an Art Ecology?', Robinson 2010: 23–6):

> The term 'arts ecology' has been heard much more frequently in recent years. In part, this may be down to fashion: an awareness of climate change, systems thinking and the interrelatedness of things. It has, to a certain extent, replaced the phrase 'arts economy', which has fallen into some ill-defined ill repute, particularly since Sir Brian McMaster's report on excellence placed greater emphasis on the intrinsic values of the arts, and on innovation, diversity and access whilst urging avoidance of top-down targets. (23)

McMaster's (2008) report notwithstanding, Robinson ploughed on to give some flesh to the notion of an 'arts ecology', principally through a figurative representation: a series of concentric circles with 'individual artists' in the centre', 'arts organization' and 'arts institution' in the two rungs immediately surrounding it, and then across several further rungs up to 'economy' and finally 'society' containing all the others (25). Having done this, however, Robinson paused on the core of this schema, that embodiment of independence, creativity, originality, etc.—the artist:

> the centre of this schematic version of an arts ecology is the individual, in particular the artist. Without that centre system – what artists are doing, how they are innovating and evolving – little change will occur elsewhere. Without either romanticising or patronising individual artists, it is important that policies to increase organisational resilience do not marginalise the creativity at the heart of the arts ecology. (The place of artists is interesting when considered through the frontline/back office lens: how do we properly acknowledge the roles of a playwright and a literary manager within most drama, for instance? Is either frontline?) (24–5)

There is an obvious double-take here. Seemingly, this suggested that 'adaptive resilience' can be managed into this entirety of the 'arts ecology' without significantly affecting the core, 'how artists are innovating and evolving', without 'marginalising the creativity at the heart of the arts ecology'. Then, in a parenthetical volte-face, Robinson appeared to make out that the artist (synecdoche 'playwright') is perhaps not all that central to the 'arts ecology' after all, no more at any rate than 'resilience' managers (synecdoche 'literary manager'). Effectively, patronizing lip service was paid to the romanticized artist while parenthetically undermining the artist's centrality to the 'arts ecology'.

Robinson's (2010) definition of 'adaptive resilience', while solidly to the purpose of 'austerity' cuts with ecologically inspired moral verve, was also uncomfortably placed in the arts. Instead of going with the qualified phrase 'adaptive resilience' or the definition, in a modified version of the strategy statement, *Great Art and Culture for Everyone* (ACE 2013), a definition appeared, different from and yet echoing something of Robinson's:

> By resilience we mean the vision and capacity of organisations to anticipate and adapt to economic, environmental and social change by seizing opportunities, identifying and mitigating risks, and deploying resources effectively in order to continue delivering quality work in line with their mission. (31)

This maintained the generalizing register of Robinson's definition but gave it a referent—'organisations'—which effectively removed the complexity of 'arts ecology' and the 'individual artist'). The definition seemingly qualified the kind of change which 'resilience' would denote (and there was no arts focus here, simply 'economic, environmental and social'), and did not court an arts vocabulary at all (leaving that to the vague 'quality work in line with their mission'). This was the definition that then became set for policy purposes: 'resilience' became the ACE policy catchword with this definition reiterated at every sub-sector level. It appeared numerously in further sub-sector strategy statements, project guidelines, minutes, and records.

The ACE (2013) strategy statement also rephrased Goal 3: whereas in ACE (2010) that read, 'The arts are sustainable, resilient, innovative', in ACE (2013) it read, 'The arts, museums and libraries are resilient and environmentally sustainable'. In contrast to the four bullet points under 'What will we do?' re Goal 3 in ACE (2010), the same section in ACE (2013) had thirteen bulleted action points (51–2) with quite specific directions. These adjustments concretized the implementation of Goal 3 as being unambiguously about actively using

and reducing public funding to increase private and non-governmental funding, with a special focus on 'environmental sustainability'. Six of the thirteen points concerned financing, including: 'encourage and enable more private giving'; 'incentivise organisations to reduce costs', 'build new markets and explore new sources of income', 'explore alternative sources of non-grant income', 'development of new and emerging business models for library services', and 'develop new markets through international touring'. Five points put performance targets on arts organizations to undergird the funding considerations, and to ensure that responsibility for 'resilience' will always rest with the organizations which would need to demonstrate that they are resilient. One point addressed direct public funding, 'invest in the arts sector's buildings and infrastructure through capital investment'; and one the environmental aspect of the goal, 'support arts and cultural organisations to understand and reduce their environmental impact'. By the last point, the unnamed 'arts ecology' was no longer a metaphor but a field for actual environmental activism through arts institutions, though the metaphoric use was to resurface later. That the environmental concern occupied but one of thirteen points showed that it was mainly there to continue to associate 'resilience' with ecological ethics. By ACE (2013), 'resilience' explicitly signalled an agenda of withdrawing public funding and thereby privatizing the arts. The career of definitions of 'resilience' had massaged that agenda into increasing degrees of clarity and pinned down its policy-catchword thrust.

Between ACE (2010) and ACE (2013), in fact, an implementation process had taken place across the arts sector, accounting for modifications made in the latter. According to the table above, 2012–2014 showed particularly intensive use of the term 'resilience' in the ACE circuit. Through this period, another characteristic feature of policy catchwords came into play: it became a word for *naming* and *branding*. This circumstance in fact differentiated 'resilience' as the weightier policy term compared to the more widely used 'sustainability'. There is a thin line between naming and branding: here, we take *naming* as simply a consensual and succinct way of referring to something (a person, product, project, organization, etc.), and *branding* as a succinct way of referring to something to promote or market it. Naming may or may not lead into branding. In both cases, the word assigned to refer to something (name or brand) is to some degree dislocated from its intrinsic meaning. The assigned word seemingly comes to be possessed by that which is named/branded, either relevantly (which a brand aspires to) or irrespective of such relevance (as in simple naming). Thus, a person who is named 'resilient' will be referred as

such irrespective of the meaning of 'resilient'; and a product being branded 're-silient' would be expected to have some particular or aspirational association with the meaning of 'resilient'.

From 2011 onwards, 'resilience' was used as the name and/or brand at numerous levels within the remit of ACE. This occurred in two ways: ei-ther by simply giving certain initiatives and schemes names with the word 'resilience' in them, or by associating 'resilience' as a descriptor for existing brands. 'Resilience' was used thus principally for ACE's funding initiatives, and in every case it served to use (reduced) public funding as a spring-board for private or non-governmental funding. So, ACE's Building Resilience funding programme for organizations began from 2012, on themes anchored to 'entrepreneurship', 'philanthropy', 'change management', and 'intellectual property' (ACE 2016a). The Museum Resilience Fund was launched in 2015, for activity 'demonstrably linked to increased resilience and/or diversity' (ACE 2016b). A series of Catalyst funding programmes from 2014 were all anchored to the 'resilience' goal of the ACE (2013) strategy. Catalyst Arts funding from 2012 to 2015 was in synch with the Building Resilience scheme (ACE 2015: 1); Catalyst: Evolve from 2014 was to enable organizations to 'attract more private giving'; Catalyst Small Grants 'to build fundraising capacity and en-courage more private giving to arts and culture resulting in improved financial resilience support' (ACE 2017a); and Catalyst: Evolve grants 'offering match funding to incentivise new philanthropic giving' (ACE 2016c). Under this rubric, organizations with a diversity agenda were offered Elevate grants to help them 'increase levels of contributed and earned income' (ACE 2016d). Projects foregrounding—and grounding—'resilience' across the arts sector were thus funded by ACE, such as: the Retail Resilience project through the Association of Cultural Enterprises, 2015–2016; and the Boosting Resilience: Survival Skills for the New Normal project led by City University London, 2016–2018. The ACE also launched its own programmes, notably the De-veloping Cultural Sector Resilience (DCSR) programme, 2014–15 (CidaCo 2015); and Museums and Resilient Leadership (MRL) programme from 2015. Further, the ACE commissioned reports to examine the case for 'resilience' funding subsector-by-subsector, such as: for local authority museums (TBR 2015); on the UK museum workforce (BOP Consulting 2016); on libraries (in phases from 2012, reports at ACE website, Envisioning the Library of the Future); on theatre funding (Hetherington 2015); and on the livelihoods of writers of literary fiction (see ACE website 'Artist Resilience'). Each of these involved the appointment of managers bearing 'resilience' in their formal affiliations, beginning with ACE's Director of Resilience appointed in 2013.

In the course of these policy implementations of the ACE (2013) strategy statement under 'resilience and sustainability' (Goal 3), the term 'resilience' seemed to gradually drift predominantly into financial management, while 'sustainability' became more the preserve of environmental action without losing touch with 'resilience'. Under the latter, ACE mandated all its funded organizations to do environmental reporting for their programmes, and partnered with the non-profit organization Julie's Bicycle to support arts organizations in reducing their 'carbon footprint'. Accordingly, a report for the period 2012–2015 (Julie's Bicycle 2015) gave measurements of the carbon footprint of ACE funded organizations in a section on 'Building Resilience' (23–4), and observed that energy savings could both achieve lower detrimental environmental impact and cost savings (25–7). Thus the 'austerity' financial rationale of 'resilience' neatly dovetailed into the ecological ethics of 'resilience'. A couple of years later, ACE (2017b) was able to give a figure for financial savings from environmental initiatives in its sphere of funding, announcing: 'The sector is more resilient: The reporting portfolio has managed to save £11 million since the beginning of the programme' (6). The figure was obtained by supposing what the greater costs might have been had energy-saving measures not been taken.

In stock-taking exercises of ACE's 'resilience' policies through this period, the associations made with the word in strategy statements (ACE 2010 and 2013) were variously and continuously evoked. It became a catchword for disinvestment and privatization moves, with a virtuous echo of ecological concern. Thus, a stock-taking 2014 report was entitled: *This England: how Arts Council England uses its investment to shape a national cultural ecology* (ACE 2014). This self-consciously used 'ecology' as a metaphor was to make its case for using reduced public funding to stimulate more private income for the sector: 'To return to that metaphor of the ecology, we must invest carefully, ensuring that this investment has a beneficial effect across the whole ecology, in ways that will be experienced by the public' (33). The implementation of this strategy was accounted in a section on 'resilience' (24–8). Another stock-taking exercise came in 2017, in DCMS's *Tailored Review of Arts Council England* (2017). The emphasis here was strongly on 'financial resilience' (to which a section was devoted, 29–31), with 'environmental sustainability' (31–2) being kept somewhat apart. Of the twenty-five times that the term 'resilience' appeared in the review, it was as 'financial resilience' sixteen times, as naming a 'resilience' programme four times, and in 'resilience and sustainability' twice.

Building or supporting '-resilience' had become a kind of euphemistic management term for imposing and dealing with the consequence of 'austerity' policies.

Wider contexts

This account of the political catchwords 'austerity' and 'resilience' gives only a very partial account of their reach and penetration. The focus on the British context, and that too within specific junctures and domains, conveys little of catchwords that are current in numerous countries. In each country 'austerity' and 'resilience' ring with somewhat different nuances, inflected by other languages and histories, while carrying a set of like connotations. Conceptually too, the account leaves out much. The scope of the catchwords has occasionally been sharpened or given new turns with qualifiers. In Britain, before the December 2019 general election both Labour and Conservatives removed their deficit-reduction goals from manifestos and promised higher public spending along with secession from the European Union (Brexit). These moves were received as harbinger of a 'post-austerity' period (Eaton 2019; Islam 2019). The end of 'austerity' policies was declared in various countries according to political expediency, though with little discernible effect. A growing body of research papers and reports have therefore contemplated 'post-austerity' policies, especially after the Covid-19 outbreak, usually in future-gazing and aspirational tones. In the contrary direction, Vivien Lowndes and Alison Gardner (2016) coined the term 'super-austerity' as a further step over the hefty austerity measures adopted at national level in Britain from 2010 onwards. Their paper analysed regional and city-level devolution of budgetary responsibilities after centralized austerity measures were implemented. Through devolution, they argued, austerity was decentralized and grounded at local or ground level, while seemingly allowing for greater degrees of local autonomy—pushing towards pervasive 'super-austerity'.

Having settled firmly as a policy catchword, 'resilience' is now used with distinctive nuances in diverse knowledge areas for numerous pressing social issues. Official and institutional sanction is useful for perpetuating a catchword: 'resilience' studies centres have cropped up around the world, several journals entitled with the term are out there, and numerous publications try to substantiate its possibilities. Amidst the Covid-19 outbreak, as noted in Chapter 3, 'resilience' was particularly foregrounded in almost all economic policy reports, whether commercial or governmental. It was underlined as

the essential quality needed for businesses to survive in the 'new normal' or recuperate in the 'next normal'. At the same time, the catchword 'resilience', like 'austerity', has not infrequently been received with disquiet and disapprobation in academic and activist usage. As already noted, it has played an important part in the language which promotes deleterious 'austerity' policies and neoliberal governance. Some researchers have consequently tried to rescue the term from neoliberal, austerity-promoting clutches. 'Critical resilience' has appeared as a kind of academic counter-catchword in that spirit, arguing that at ground level (e.g. in community action and volunteering) an emancipatory or at least bottom-up 'resilience' may be bolstered by being interrogative and developing resistance to top-down austerity and neoliberal governance (DeVerteuil and Golubchikov 2016; Grove 2018: especially Chapter 8; Monforte 2020; Smirnova et al. 2020; Olsson 2020). 'Disruptive resilience' is another phrase which may come to have a larger purchase (Bahadur and Dodman 2020). With the constantly growing incidence of social and natural disruptions, this phrase suggests the need for more responsive and adaptable planning for and management of 'resilience' than is available. In other words, the currently instituted structures for instilling 'resilience' themselves need to be disrupted to deal effectively with disruptions.

So far, this study has explored contemporary political catchphrases/words which evoke, in the main, establishment strategies and policies. They have at times been turned against the latter, but usually after appearing as such. In the next chapter I turn to a political catchphrase which caught on from, and remains associated with anti-establishment advocacy, usually enunciated in a spirit of registering protest.

6

Anti-Establishment Catchphrases

'We Are The 99%'

Protests

Starting in September 2011, the Occupy Wall Street protests in Zuccotti Park, New York City, produced the resonant political catchphrases 'the 1%' or '1 percenters' to designate the super-rich, and 'the 99%' to characterize the rest. Given the form of a political slogan, 'We are the 99%' became the rallying call of the protesters, appointing 'the 1%' as the targets of the protest or as the agents of inequity. The slogan was widely taken up as the movement spread globally (Pickerill et al., eds. 2015 offered an overview across various contexts, taking in the USA, Canada, Spain, Britain, Israel, and Chile; in 2020 the Wikipedia entry for 'Occupy Movement' listed thirty countries). These calls were a direct response against austerity measures following the 2007–2008 financial crisis.

The catchphrases and catchwords discussed so far ('new normal', 'austerity', 'resilience') were introduced and largely promoted from above, by political and commercial authorities and organizations. Catchphrases and slogans emerging from the Occupy movement were meant to mobilize against and counter those—appearing, as it were, from below. Examining their purchase as catchphrases, therefore, takes this study into the distinct, though obviously related, territory of anti-establishment political expression.

The use of statistical figures as slogans has seemed an obvious rhetorical move since the Occupy protests, though nothing similar appeared in their immediate precursors, such as the *Movimento 15-M* anti-austerity protests in Spain and the so-called 'Arab Spring' uprisings in North Africa and the Middle East. In fact, no such earlier usage is found in compendiums of political catchphrases and words (compendiums are discussed in the next chapter). Idiomatic expressions using statistical notations to make pat rule-of-thumb estimations have enjoyed some popular currency. Pertinently here, for instance, the oft-reiterated statement 'Genius is one per cent inspiration, ninety-nine per cent perspiration' (attributed to Thomas Edison, see Rosanoff 1932: 406)

Political Catchphrases and Contemporary History. Suman Gupta, Oxford University Press.
© Suman Gupta (2022). DOI: 10.1093/oso/9780192863690.003.0006

comes to mind. As an idiomatic turn, presenting rule-of-thumb estimations as if they are statistically precise is an emphasizing tactic. That makes the reckoning (a loose estimation of what is overwhelmingly weighty) seem like what it is not (a statistical figure indicating precisely how much weightier). This could be regarded as using statistical notation in a metaphoric way. That sort of metaphoric usage was obviously called upon in 'the 1%', 'the 99%', and 'We are the 99%', but, at the same time, there was something more to it here than in the kind of idiomatic usage cited. In fact, there *were* statistics behind those catchphrases even if the latter were not statistical expressions in themselves. The catchphrases capitalized upon and were pushed according to statistical investigations and methods underpinning the protests, to do with measuring inequality. In this respect, alongside the metaphoric usage of statistical notations there was also a gesture towards actual statistical work. For this study, therefore, these catchphrases offer an opportunity to consider both the language of protest at a specific juncture (the Occupy protests) and, at the same time, to exemplify how statistics bear generally upon political discourse at present.

The following observations are given in three sections: 'statistics as metaphor', 'statistics as basis', and 'aftermath'.

Statistics as metaphor

In the service of political mobilization, 'the 99%' and 'the 1%' and the slogan 'We are the 99%' had two obvious metaphorical aspects: *scale* (large/small, strong/weak) and *capacity* (inclusive/exclusive).

The metaphor of scale could suggest both the force undertaking protest (big) and the justness of the cause (strong), and thus encourage and reassure those who are mobilized. Correspondingly, the force and agenda of that which is opposed is diminished. Naomi Klein's 6 October 2011 speech to Occupy Wall Street protesters exemplified this well:

> If there is one thing I know, it is that the 1 percent loves a crisis. When people are panicked and desperate and no one seems to know what to do, that is the ideal time to push through their wish list of pro-corporate policies: privatizing education and social security, slashing public services, getting rid of the last constraints on corporate power. Amidst the economic crisis, this is happening the world over.

And there is only one thing that can block this tactic, and fortunately, it's a very big thing: the 99 percent. And that 99 percent is taking to the streets from Madison to Madrid to say 'No. We will not pay for your crisis'.

'The 99%' is metaphorically 'a very big thing', at a scale which reassures, counters 'panic and desperation', and builds optimism. The metaphor of the 'very big thing', signified as 'the 99%', fills in the otherwise uncharacterizable presence of the protesters, which is to say, otherwise the protestors are only available as what they are not, they are not 'the 1%'. 'The 1%' was understood in more substantial terms. 'The 1%' stood for a set of abstract principles and interests ('pro-corporate policies' producing 'crisis') rather than a collective of persons. However, once those principles and interests were named as 'the 1%', that could be treated as a person or group, addressed with third-person pronouns ('*their* wish list') and attributed feelings ('the 1 percent *loves* a crisis'). 'The 1%' was thus, in an immediate way, a personification, somewhat like an allegorical persona of the rich and powerful. Correspondingly, 'the 99%' was a negative-personification ('not-the-1%') which was also akin to an allegorical figure, not dissimilar to the medieval mystery-play personae 'Everyman' and 'Mankind'. This negative personification did not need to be substantiated because, after all, it spoke as 'the 99%' and about the '1%', 'the 99%' was the voice that announced itself for the purpose of describing and holding to account 'the 1%'. 'The 99%' substantiated itself by announcing itself and speaking as such, and did not need to be described; in the self-same moment 'the 1%' was foregrounded and could be substantively described by 'the 99%'. Shortly after Klein's speech, these nuances of the metaphor of scale and concomitant allegorical personifications were evident in *The 99% declaration* (The 99 Percent Working Group, Ltd. 2011) issued on 15 October 2011, albeit without the sanction of the Occupy Wall Street organizers. This was announced as issuing from 'we, the ninety-nine percent of the people of the United States of America'. Without naming 'the 1%', this sought 'redressal' for 'grievances' from putatively 'the 1%'. But the culpable party, implicitly 'the 1%', were not characterized as actual persons, and redressal consisted of demands for instituting equitable financial and political arrangements. The closest it came to identifying a core culpable party was in terms of the established legal personhood of corporations:

We, the 99% of the American People, categorically REJECT the concepts that corporations are persons and that money is equivalent to free speech because if that were so, then only the wealthiest people, corporations and entities possessing concentrated wealth would have a meaningful voice in our society.

This is interesting because 'the corporation' is a kind of juridically substantiated allegorical figure with all-too-material agency (see Orts 2013; Kelsen 2006 [1946]: Chapter 9). In a way, the allegorical persona 'the 99%' itself assumed a kind of legal personhood at times: for instance, 'Writers for the 99%' (2011) appeared as the author of a published volume, thereby both making a collective intellectual property claim and simultaneously eschewing property claims.

As metaphor of capacity (inclusiveness/exclusiveness), 'the 99%' and 'the 1%' evinced further complexities. 'The 99%' suggested not only large scale but an alignment of maximum inclusiveness. However, that also potentially meant downplaying differences, effectively defocusing constituencies which had been powerfully centred in similar protests earlier, such as the working class, minority ethnicities and, especially, the impoverished. In a 24 November article, Paul Krugman (2011) not only suggested scaling up the 'the very big thing' (the article was entitled 'We Are the 99.9%'), but also observed:

'We are the 99 percent' is a great slogan. It correctly defines the issue as being the middle class versus the elite (as opposed to the middle class versus the poor). And it also gets past the common but wrong establishment notion that rising inequality is mainly about the well educated doing better than the less educated; the big winners in this new Gilded Age have been a handful of very wealthy people, not college graduates in general.

In this reading, the thrust of the slogan is that the 'middle class' and 'well educated' are included, needless to say so are 'the poor' (the 'versus' is removed from between 'middle class' and 'poor'), and only a 'handful of very wealthy people' are excluded ('the 1%' or even '0.1%'). Such inclusiveness had the effect of removing the common expectation that protestors mainly represent their own experiences and grievances, are affected by the conditions they protest against—so to speak, embody their allegiances (e.g. workers protest against pensions cuts, women protest against gender violence). As included in 'the 99%', these protesters claimed rather than embodied their allegiance, either as individuals or as a whole, with only blurred or erased differentiations between individuality and near-totality. In fact, the dominant image of 'the 99%' was of individuals with stories which gel with the overarching story of exacerbating inequality. Numerous such images—of a person holding a sheet stating something of her or his circumstances and the slogan 'We are the 99%' or 'I am the 99%'—were posted on the 'We are the 99%' Tumblr site (now in the Archive page) and collectively stood in as 'the 99%' personified. This was set up in August 2011 by Chris (surname withheld) with the help of Priscilla Grim,

credited since with being key organizers of the Occupy Wall Street protests (Weinstein 2011). Instructions were issued to ensure that the images could be visually collectivized easily (see Milner 2013: 2372). With these images in sight, Mathijs van de Sande (2020) was later to discern a synecdochical logic at work, where each image is a part which represents the whole:

> On this website, thousands of people, mostly from the US, posted pictures of themselves, accompanied by a brief statement that described their individual situation: giving testimonies of debt, unemployment or systematic under-employment, poverty, chronic illness, and war trauma. Their testimonies were all undersigned by the slogan 'I am the 99%'. Although these were all individual accounts of many different situations and experiences, the slogan suggested that all these stories had something important in common. It seemed that, in a way, every single personal story could embody or encompass all the others—they all represented the entire 99%. Whereas this idea of the 99% suggests that they together constituted a majority, the I in 'I am the 99%' also suggested a synecdochal, representative claim: my story is representative for what we all are going through (in spite of the obvious differences between us). (407)

That different metaphorical nuances could lead into allegorical personification and synecdochical representation respectively, speaks to the complexity of the tacit work that analogies do in such catchphrases. The catchiness of these phrases may well be grounded in that analogical richness. In any case, being of 'the 99%' was evidently more a matter of declaring allegiance and less a matter of having shared and experienced grievances. Literally, of course, high-profile media intellectuals like Paul Krugman, Joseph Stiglitz, Naomi Klein, and others, who seemed to become public mediators of 'the 99%', may not have been too far from 'the 1%', probably squarely within the top decile by income (not irrelevantly, Klein featured in Robbins 2017: Chapter 5, as a 'well-intentioned beneficiary'). But that did not make their claim as mediators any the less cogent; their articulacy strengthened their claim. The possibilities of claiming allegiance were negotiated in interesting ways thereafter. Some actively blurred the boundary between conviction and embodiment by positioning themselves as belonging to 'the 1%' but supporting 'the 99%' (see Flock 2011).

With his observations as a participant and ethnographic researcher in view, Jamie Matthews (2019) was later to see the two metaphorical directions cobbled together in 'the 99%' as presenting a troublesome schism for the Occupy protests:

The idea of 'the 99%' was the locus of a profound tension between contradictory political modes. It articulated a populist orientation, centring on the idea of 'the 99%' as the great collective of 'the people'. However, this tendency, with its dynamics of representation and identity, ran against a contrary orientation for which such dynamics were anathema. Within this anti-identitarian orientation, 'the 99%' did not refer to a collectivity at all, but instead named the fact of inequality, seeking not the gathering of a collective subject, but the dispersal of mobilisation along lines of difference. (1019)

The schism radiated fissures and tensions as the protests proceeded, Matthews observed, but nevertheless the catchphrase has held a potential for unifying. However, focusing too intently on the catchphrases and slogan in themselves, as texts, may lead to overlooking important dimensions of their effect in the Occupy protests. The Tumblr site images turned the slogan into multimodal texts, which circulated and proliferated as such on an immense scale through digital networks. At the level of internet circulation, then, the uptake of the slogan was arguably more usefully considered as following the pattern of a 'We-are-the-99%' internet meme (see Milner 2013; Shifman 2014: 129–38; Hristova 2014). Meme circulations in the digital sphere could be regarded as analogous to the more diverse and wider circulations of catchphrases in the social and everyday sphere, and in some respects a particular mechanism for disseminating catchphrases among other mechanisms.

The easiest takedown of the catchy metaphorical nuances of 'the 99%' and 'the 1%' and 'We are the 99%' was by taking the statistical notations literally, by playing the metaphorical against the literal. In news commentaries the point was made thus by David Brooks (2011):

Unfortunately, almost no problem can be productively conceived in this way. A group that divides the world between the pure 99 percent and the evil 1 percent will have nothing to say about education reform, Medicare reform, tax reform, wage stagnation or polarization. They will have nothing to say about the way Americans have overconsumed and overborrowed. These are problems that implicate a much broader swath of society than the top 1 percent.

And, with a slightly different emphasis, Jonah Goldberg (2011):

The top 1 percent is a funny thing. If you got rid of all the 1 percenters tomorrow, a new top 1 percent would take its place. There will always be a top 1 percent. [...] That's why the sloganeering about the top 1 percent is

simultaneously brilliant and daft. It dehumanizes the villains of the tale by turning them into a permanent mathematical abstraction. No reform will ever go far enough because there, on the horizon, like a moon you can sail toward for all eternity without ever getting any closer to, will remain the 1 percent looking down on the lumpen-ninetyniners with cold disdain.

Though these comments seemed to play out the absurdity of the catchphrases by taking the statistical notations literally, they did little more than reveal the metaphoric bent of the slogans. These were made in a spirit of opposing the Occupy protests and their agenda, to diminish their rousing effect and discourage mobilization. More substantially, such conservative commentators variously argued that inequality is a necessary condition for economic growth. And, moreover, that the very rich contribute disproportionately already to existing redistributive mechanisms (e.g. pay enough taxes), and are particularly socially productive (e.g. are 'employers') and deserve their vast incomes. The linguistic sleights and statistical ploys involved in these arguments are not my immediate focus here. From the other side, for instance, there was Alain Badiou (2017 [2016]) addressing 'the young' about 'why it is absolutely necessary to change the world' (1), with a lifetime of espousing emancipative political commitments behind him:

Today, 10% of the world population own 86% of the available capital. 1% own 46% of that capital. And 50% of the world population own exactly nothing, 0%. It is easy to see why the 10% who own practically everything don't want to be lumped together with those who have nothing, or even with the less prosperous of those who share between them the scant remaining 14%. What's more, many of those who share that 14% are very roughly split between passive resentment and a ferocious desire to hold on to what they've got, in particular by the support they give, with racism and nationalism playing their parts, to the countless repressive barriers against the terrible 'threat' they perceive in the 50% who have nothing.

All this, incidentally, means that the supposedly unifying slogan of the Occupy Wall Street movement, 'We are the 99%', was totally meaningless. The participants in the movement, full of good will that they should be commended for, were probably for the most part young people from families somewhere 'in the middle', neither truly poor nor really rich—the middle class, in a word, which is hyped as loving democracy, as being a pillar of democracy. But the truth is, the affluent West is full of people from that 'middle', that middle class, who, even though they're not in the 1% of the

wealthy elite or in the 10% of well-off property owners, nevertheless fear the 50% of complete have-nots, and, clinging to the tiny 14% of resources that they share among themselves, provide globalized capitalism with the petit-bourgeois troop of supporters without which the 'democratic' oasis would have no chance of surviving (31–2).

This took the statistical notation so seriously that the metaphoric nuances of using that as a slogan were entirely erased ('totally meaningless'). There was no perfunctory regret here about the misconceived metaphorical promises. For Badiou, there were no metaphorical promises there, only uncomprehending misconception and possibly culpable misconception. Badiou's approach points to two preconceptions. First, that statistical notations predominantly signify descriptive truth, allowing precise description of a given field. They are difficult to dislocate from that function, even as signifiers. This is so despite the fact, as is well known, that such expressions are often used idiomatically for rule-of-thumb estimations or to actively manipulate. Second, in identifying protesters, the rationale of embodiment is more material and relevant than claims of commitment. For Badiou, who the protesters are makes sense of the act of protest.

In catchphrases and slogans then, statistical notations could work in para-doxical ways: shifting back and forth according to contextual emphasis between precision and rule-of-thumb estimation, description and appeal, truth claim and suggestion, abstraction and reality, summation and breakdown, literally and metaphorically. Amidst the Occupy protests, the connotations of the catchphrases and slogan were severally tested. A conservative move was to propose the statistical counter-slogan 'We are the 53%' on Tumblr and Twitter sites, which was fleetingly reported (Khimm 2011; Memmott 2011) and flared briefly as a contestation of memes in digital forums (Milner 2013: 2373–75). The counter-slogan purported to represent the proportion of the population paying income tax, 53 per cent, against the protestors claiming to represent the 99 per cent, suggesting that by paying taxes and contributing to redistributive measures this 53 per cent occupy a higher moral ground. As a slogan it had less of the persuasive advantages of 'We are the 99%', with neither a corresponding suggestion of scale or capacity. Of course, paying taxes is not a matter of conviction but of being within a tax-collecting agency's jurisdiction and abiding by establishment rules. But as a counter-slogan it was reasonably effective: its effect was *conditional* to the catchiness of 'We are the 99%', both in appearing responsively moderate and temperate and in numerically appearing to falsify 'the 99%'.

Notably, some advocates of the Occupy protests tried to build bridges be-
tween the contrary pulls of statistical notations as catchphrases by giving the
metaphorical statistical expression a literal turn: that is, by seeking to con-
vert the loosely estimated appeal into a material description. 'The 1%' as a
catchphrase, seemingly designating those culpable for the grievances of 'the
99%', naturally aroused a desire to give flesh to the top '1%', to identify its con-
stituents as specific persons with visualizable features, to locate them as agents
with trackable interests and behaviours who actually do something iniquitous.
In the course of the Occupy New York protests, the question of who *they* are
appeared occasionally in the news media (e.g. Luhby 2011; Cox 2011), but the
grounds for mulling this question had been laid before the protests. In fact, it
may be argued that the possibility of imagining 'the 1%' as concrete persons
and agents, with describable lifestyles and backgrounds, was already imbued
in the catchphrases and slogans. The more the phrase '1%' caught on, the more
material its substance seemed to subsequently become, but equally the phrase
caught on because there was a sense of substance in it already. In this regard, a
May 2011 feature by Joseph Stiglitz (2011), which appeared somewhat earlier
than the protests, is often cited as the point where the catchphrase emerged—
that is, as a catchphrase. It was entitled 'Of the 1%, by the 1%, for the 1%'. While
drawing attention to the evidence for spiralling inequality in the USA and its
deleterious consequences, Stiglitz tried to give some flesh to the top '1%' as
wilful agents of inequity:

> The top 1 percent may complain about the kind of government we have in
> America, but in truth they like it just fine: too gridlocked to re-distribute, too
> divided to do anything but lower taxes. [...] But one big part of the reason we
> have so much inequality is that the top 1 percent want it that way. [...] The
> personal and the political are today in perfect alignment. Virtually all U.S.
> senators, and most of the representatives in the House, are members of the
> top 1 percent when they arrive, are kept in office by money from the top 1 per-
> cent, and know that if they serve the top 1 percent well they will be rewarded
> by the top 1 percent when they leave office. By and large, the key executive-
> branch policymakers on trade and economic policy also come from the top 1
> percent. [...] The top 1 percent have the best houses, the best educations, the
> best doctors, and the best lifestyles, but there is one thing that money doesn't
> seem to have bought: an understanding that their fate is bound up with how
> the other 99 percent live.

In this, Stiglitz's characterization of the top '1%' as a group of specific persons depended more on assertive syntax than considered argument. Elaborate statistical exercises in concretizing the constituency of the '1%' appeared afterwards, in terms of occupation, education, race, religion, conjugal relationships, possessions, and consuming habits (Keister 2014 discussed and gave figures for these in the USA; Breau 2014 for Canada). Sophisticated statistical analysis unsurprisingly suggested that concentration of wealth in the top '1%' came at the cost of deprivation lower down, and that active exploitation is the mechanism of concentration. In the concluding words of Thomas Lambert and Edward Kwon's (2015) paper:

> [This] paper finds strong statistical support for radical contentions that income share gains to the top one percent are extracted from workers and that the marginal product of capital theory or concept does not hold much validity, especially in trying to justify greater income going to the top strata of U.S. society. The findings herein also make a contribution to the literature by using different measurements of exploitation to predict successfully the gains and losses of the top one percent and put radical concepts and measurements on an equal footing with the mainstream ones in a statistical sense. (473)

Such arguments were variously valid, but insofar as 'the 1%' were thereby presented as a characterizable group, material persons, there was good reason to be sceptical. Such claims seemed to describe the '1%' as if it were a body being observed, whereas it was more the case that if it were assumed that there is such a body then those were some of the things that could be said about it. But whatever could be said about it after assuming that it was materially there, could also be said about others outside the top 1 per cent by income. By income it could be stated that such-and-such persons were definitely in the top 1 per cent, but insofar as occupation, education, consuming habits, exploitative actions, ideological proclivities, culpabilities, etc. went there was no combination of these that could be considered as peculiar to or definitive of those persons that were 'the 1%'.

So, such attempts to concretize and give flesh to the top '1%' with seemingly sound statistical expertise nevertheless appeared as being little more than an accentuation of the metaphorical use of statistical notations in catchphrases. These appeared as statistically informed persuasive devices which work irrespective of statistics. But it is interesting that strong statistical ability was invested in this. This recalls one of the oldest pitfalls of statistical reasoning: an

inclination to give any point or range (not much difference between point and range) in a scale of social statistics a normative emphasis, as presenting a particularly significant and rounded human/social reality. It was the path through which Adolphe Quetelet's early nineteenth-century researches into the 'average man' came to misdirectedly construe this average as a normatively real person, with lasting sociopolitical consequences even after becoming irrelevant as statistics (Desrosières 1998 [1993]: Chapter 3; Cole 2000: Chapter 2; Mosselmans 2007: Chapter 3; Donnelly 2016). Analogously, since its appearance as a political catchphrase, 'the 1%' and 'the 99%' have offered a resonant normative point with seeming statistical weight and have imbued statistical notations with normative connotations.

Statistics as basis

Though the Occupy protest catchphrases, with their normative bent, have had some after-the-fact bearing upon statistical analysis, it was statistical analysis which propelled the catchphrases in the first place. The statistical reckonings of inequality which led towards and then undergirded the catchphrases are the focus of this section. Those reckonings grounded and foregrounded an analytical shift in academic circles where rhetorical calculations were not obvious. That is to say, the rhetorical ploy was implicated in the statistical analysis rather than obtrusively inserted there. The shift also involved downplaying statistical reckonings which had been centred in anti-establishment and protest discourses earlier, especially with regard to measures of poverty.

With the wide spread of the Occupy protests, their statistical basis—in concert with the now familiar catchphrases 'the 1%' and 'the 99%'—surfaced out of academic circles into the public sphere. The catchphrases thus fed the remarkable market and media success of publications by economists whose statistical analyses had been the impetus for the catchphrases to begin with, effectively keeping the catchphrases alive and relevant for the remainder of the decade. With the resonances of 'the 1%' and 'the 99%' backing them, such publications included: Thomas Piketty's *Capital in the Twenty-First Century* (2014 [2013]); Joseph Stiglitz's *The Price of Inequality* (2012), which began with the chapter 'America's 1 Percent Problem'; Paul Krugman's *End This Depression Now!* (2012), especially Chapter 5, 'The Second Gilded Age'; and Anthony B. Atkinson's *Inequality: What Can Be Done?* (2015). A couple of years earlier Atkinson had collaborated with Facundo Alvaredo, Thomas Piketty, and Emmanuel Saez (Alvaredo et al 2013) on a scholarly paper entitled 'The Top 1

Percent in International and Historical Perspective', which came with friendly circumspection about the Occupy catchphrases while substantiating them:

> We should start by emphasizing the factual importance of the top 1 percent. It is tempting to dismiss the study of this group as a passing political fad due to the slogans of the Occupy movement or as the academic equivalent of reality TV. But the magnitudes are truly substantial.
>
> (Alvaredo et al 2013: 4).

Atkinson's contribution was noteworthy because his earlier work on measuring inequality had a somewhat different normative approach.

Jiggar Bhatt (2012) made a reasonable attempt to track the immediate spur for the catchphrases 'the 99%' against 'the 1%' before Stiglitz (2011) gave those proportions their catchy turn. There are notable older instances of such usage which were not mentioned during the Occupation protests, such as in the *Black Liberation Month News* (1984: 6) and the documentary film *The One Percent* (dir. Jamie Johnson 2006). More immediately inspiring, Bhatt found, were the scholarly work of Piketty and Saez—citing two of their papers (2003 and 2006)—and Edward Wolff—nothing by him was cited—which presented the basis for highlighting these proportions. He also tracked their passage into popular forums via Senator of Vermont Bernie Sanders's eight-hour speech in the US Senate on 10 December 2010 objecting to continuing tax cuts under President Barack Obama's administration:

> We cannot give tax breaks to the rich when we already have the most unequal distribution of income of any major country on Earth. [...] The percentage of income going to the top 1 percent nearly tripled since the 1970s. [...] The top 1 percent now owns more wealth than the bottom 90 percent. That is not the foundation of a democratic society. [...] The fact is, 80 percent of all new income earned from 1980 to 2005 has gone to the top 1 percent.
>
> (Quoted in Bhatt 2012)

Thereafter, it was eye-catchingly highlighted in Stiglitz's (2011) *Vanity Fair* article before finding its way as the logo of the Tumblr site 'We are the 99%'.

The two papers by Piketty and Saez (2003 and 2006) just mentioned were relevant to the catchphrases in question insofar as addressed predominantly to the situation in the USA. They presented long runs of data on income (with breakdown into capital income and labour income tracked)—for 1913–1998 in the 2003 paper and 1913–2002 in the 2006 paper—based on individual income tax returns in the USA. This data was tabulated according to deciles and

centiles of the population by individual income, thus offering a measured view of unequal distribution of wealth. The explanatory focus in these papers was put on the top 10 per cent and the top 1 per cent, so as to answer the question: what factors explain the patterns of income across time evidenced thus at the top of the table? The 2003 paper focused exclusively on the USA, and the 2006 paper provided comparative figures (with similar income tabulations from Canada, United Kingdom, France, Switzerland, and Japan) with the USA centred. In short, these tabulations showed an accelerating concentration of income—both capital and labour—in the top decile and especially in the top centile, mainly from 1970 onwards, and particularly in the USA (and later the UK) compared to other countries, though also generally in all countries studied. Where available, corresponding tabulations of other data with shorter runs (such as household income and consumption) seemed to fit the pattern shown by income. Explanations for such concentration were partly based on statistical corroboration from other data tabulations, and often based on 'instinctive' connections. Here 'instinctive' meant that the explanations were not inferred from the data but plausibly suggested by comparing data shifts with the timings of policy changes, historical events, etc. or by connecting geopolitical differences in income data to differences in regimes and environments. The foregrounding of these two papers was relevant insofar as the slogans of the Occupy Wall Street programme went, but these were part of a larger project following the same methods of income tabulation and analysis in different contexts which appeared concurrently (such as, Piketty 2003 for France, Saez and Veall 2005 for Canada), and which continued to appear in and after 2011 (those with Piketty and Saez in authorial roles included Atkinson et al. 2011; Piketty and Saez 2013; Alvaredo et al. 2013; Piketty et al. 2016). The explanations offered in all these took in the deleterious social consequences of income concentration in the top decile and centile, and consistently recommended redistribution by increased taxation of the wealthy—not just in scholarly papers but also in journalistic writings (some of Piketty's appeared in a 2017 volume). Piketty's *Capital in the Twenty-First Century* (2014 [2013]) gave full scope to the methods of income tabulation, and analysis sketchily outlined here by synthesizing the longest data runs that could be plausibly harnessed (eighteenth century onwards), across geopolitical contexts on a continental or global scale.

There were several notable elements in this mode of delineating and approaching inequality measurements compared to those centred prior to that.

First, there was the nature of this data, drawn mainly from individual income tax returns. Inequality gauging prior to that had been predominantly concerned with household income and consumption based on household

surveys, on the assumption that neither individual incomes nor individual contributions to redistributive mechanisms sufficiently conveyed a sense of a condition of life, which is what measuring inequality should be concerned with. Piketty, Saez, and their collaborators' tabulations seemingly directed the lens squarely on individuals and taxes. The 'individual' in these terms is actually an abstract entity. Noting that household surveys in the USA were not available before the 1950s whereas income tax returns were available from the beginning of the twentieth century, the method of placing the individual in the new database was described thus by Piketty and Saez (2006: 200):

> Those [tax] statistics generally report the corresponding number of taxpayers for a large number of income brackets, as well as their total income and tax liability. The statistics usually provide the breakdown by income source: capital income, wage income, business income, etc. Using population census data, one can estimate the total number of tax units, had everybody been required to file a tax return, and determine the number of returns in top fractile groups such as the top 10 percent, 1 percent, etc.

The collation with population census data and the assumption of total returns (by everybody) rendered this individual more a mathematical reference point than a person. But, of course, behind all the mathematical reference points there *were* persons—and if even with these assumptions the income concentration at the top proved heavy, in practice it would probably be heavier. Similarly, tax returns are (as the publications that have been cited noted variously) notoriously limited since much may not be declared (be legally withheld or illegally hidden). However, if even the returned tax data shows such concentration, the reality was probably of even higher income concentration at the top. Those who mooted the 'We are the 53%' slogan in response to 'We are the 99%' might have suggested that the problem of concealment of income was more at the bottom, the 47 per cent that pays no tax, but, as Khimm (2011) observed:

> Altogether, about 23 percent of Americans don't pay federal income taxes because their incomes are too low [...]. The other 23 percent of Americans don't pay federal income taxes mostly because of tax breaks given to the elderly, low-income working families, government welfare recipients, and students.

At any rate, the point is that this mode of sourcing data for tabulation invited a normative emphasis on individuals and taxes rather than on households and conditions of life.

Second, there were the advantages of the scale of income-based data with which inequality of distributions were charted thus, compared to previously dominant studies of inequality distributions. It is a general axiom of statistical research that the larger the scale of data tabulated and analysed, the more robust the inferences are likely to be. In principle, the horizon to be aimed for is comprehensive data collection on whatever is being examined. In practice, since that is rarely possible, especially in social tabulation, adjustments need to be made in reading tabulations of limited scales of data so as to approximate comprehensive data—that is, by removing biases and errors that may arise from limitations (e.g. by randomizing data sources, adjusting by weightings and for calculable error margins). From this perspective, the scale of data with which Piketty, Saez, and collaborators could populate their income-centred database had several advantages. Since income tax returns are legally enjoined on all with an income (like census declarations, but more frequent), data drawn from this source have a reasonable claim to being close to comprehensive, and render meaningful shifts trackable. Further, as observed already, there were longer runs of such data than, for instance, data based on household surveys, so that the database could offer a picture which was chronologically extensive. It seemed possible to track changes with a historical perspective and obtain more persuasive charting of tendencies and instinctive explanations of causes. Moreover, since such data can be found in a significant number of international contexts, with comparable differences, the database could also offer a picture that was spatially extensive, enabling explanations referring to different political and economic regimes.

Third, and of some importance in contemplating catchphrases, there was a shift of analytical focus here to the top of the income scale, whereas previously the focus had been predominantly on the bottom. As economist Charles I. Jones (2015: 44) put it: 'Piketty and Saez and their co-authors have shifted our understanding of inequality in an important way. To a much greater extent than we've appreciated before, the dynamics of top income and wealth inequality are crucial.' Correspondingly, we may say that Piketty, Saez, and their collaborators have defocused poverty—bottom income—in understanding inequality, where the focus used to predominantly rest earlier. This defocusing was amply evident in the political catchphrases of interest here. Krugman (2011) was not mistaken in observing that the slogan 'We are the 99%' 'correctly defines the issue as being the middle class versus the elite (as opposed to the middle class versus the poor)'. The defocusing resulted from putting aside the dynamics of 'the middle class versus the poor' and locating the conflict at 'the middle class versus the elite'. Or, since 'the middle class' has ever been a bit

vaguely articulated in inequality research and analysis, the perspective shifted from 'the poor versus the rest' to 'the super-rich versus the rest'. That may be understood in different ways: possibly poverty thereby became a blurred bottom line of the rest, or perhaps features of poverty were understood as diffuse and seeping upwards into the rest. The implications of this shift of analytical focus—which was effectively a shift in the understanding of inequality—calls for a considered pause here; it lay at the heart of the catchiness of 'the 1%' and 'the 99%'.

Let me attempt a pared-down account of the shift in question: a shift from what to what? Prior to the post-2000 work of Piketty, Saez, and collaborators, very little investment in inequality measurement had taken place without some cognisance of poverty measurement alongside. These two kinds of measurement are obviously different and not immediately relatable. In a given population, measuring inequality involves putting the distribution of wealth on a relative scale. For a given population, poverty measurement mainly involves setting markers in terms of access to wealth beneath which the condition of life is unsatisfactory in the extreme. Measures of inequality and of poverty, separately or concurrently, have generally been undertaken with some conviction in progressive egalitarianism through redistribution. Such conviction has been espoused on both sides of the shift in approaching inequality of interest here: that is, those considering inequality and poverty alongside each other (such as, Amartya Sen, James Foster, Martin Ravallion, Sabina Alkire) and those focusing on income inequality with the top decile and centile in focus (Thomas Piketty, Emmanuel Saez, Facundo Alvaredo, and others; Anthony Atkinson seemed to move more or less seamlessly between). The egalitarian conviction could be based on an ethical idea of reasonable equality being a good in itself (in the nature of equality in law, equality in opportunity, etc.), or, negatively, because reasonable equality is necessary to avoid conflict. Interestingly, in their early self-locating overviews of inequality analysis, Amartya Sen (1973 [1997]), a strong advocate of focusing on the bottom, and Thomas Piketty (2015 [1997]), key popularizer of focusing on the top, began with the causal connection between economic inequality and political conflict. Thus, on both sides of the shift, egalitarian conviction which conceptualizes redistributive measures accordingly has had a motivating role. However, the former and older approach had a particular interest in poverty and its measurement while the latter and increasingly dominant with the Occupy protests did not.

Considering inequality measurement and poverty measurement side by side, with a commitment to reasonable redistributive measures, has been regarded as welfare driven ('welfarist'). That is what an analytical focus on the

bottom entailed in inequality measurement. There were two important considerations here: first, the mechanics and principles of redistribution; and second, the manner in which the bottom could be targeted to reasonable egalitarian ends, that is, for poverty alleviation. Thus, Atkinson's earlier work on inequality measurement (especially Atkinson 1970) effectively worked in a proportional welfare coefficient in inequality measurement with effect on the lower rungs of distribution, and considered the different ways in which redistribution could factor in poverty measurement with or without a commitment to social change (particularly Atkinson 1987). These were, in the main, clarifications of the manner in which inequality measurements could bear upon redistribution such that the bottom rungs—the low income—may be benefitted with more or less disturbance in the upper. Atkinson's was a cautious welfarist modelling approach in this respect, and primarily addressed to the first consideration, the mechanics of redistribution. Sen's understanding of inequality measurement was similarly welfarist and attentive to the mechanics of redistribution, but with a stronger interest in the second consideration, how the bottom can be targeted for poverty alleviation. That naturally involved a firm focus on understanding what the needs of the bottom are, that is, what poverty consists in. Poverty thus needed searching exploration. To consider how to target the poor in welfare terms, it was not enough to simply know what their income was. A cluster of factors needed to be grasped as the *content* of poverty, and then measured to the extent of being rendered targetable in economic terms (from basic needs to being equipped to participate in society, to being content with circumstances). So, the condition of life in poverty needed to be understood in all its complexity and given an economically targetable character. Sen's stronger investment in this meant a more complex understanding of inequality measurement itself (laid out in Sen 1973 [1997]); the development of a 'capabilities approach' to social development (Sen 1979, and numerously thereafter); endorsement of realistic poverty-line measurements (remarkably in an abrasive exchange with Peter Townsend—Sen 1983; Townsend 1985; Sen 1985); and contribution towards conceiving the Human Poverty Index (UNDP 1997) and Multidimensional Poverty Index (UNDP 2010: 94–100; Alkire and Santos 2010).

In understanding inequality, when the analytical focus was firmly put on the top fractiles of wealth distribution by individual income, quite a lot of this complexity could be put aside and a relatively simplified picture appeared. Since targeting of welfare was out of focus, the complexities of conditions of life could be disregarded (we do not need to ask what it means to be poor and how to alleviate that condition). The rich could be described by the one factor of income,

and every other dimension of their life could be assumed to be conditional to that one factor (we already know that the rich can set any condition of life they wish to for themselves). If abnormal patterns of wealth concentration at the top became evident, the key question then was: what features of the existing economic regime enables wealth to gravitate and accumulate upwards? Corollary to that, there is another question: what effects are evident downwards? But this became *generally* downwards, not particularly at the *bottom*. In focusing on the upper rungs there was no immediate need to go to the bottom, the upper rungs came into focus in terms of a generality of other rungs beneath them. If those effects downwards proved deleterious, and were aggregated, the overall picture settled somewhere in the middle and not at the level of poverty. No specific measurement of poverty seemed necessary any longer to understand deleterious effects of maldistribution. The redistributive mechanism also appeared correspondingly simplified from this perspective. It was now not so much a matter of targeting a social stratum or a certain range of social strata: it became a matter of taking away from the top to alleviate the deleterious effects beneath the top in a general way, at the level of aggregates. It was not the least well-off who needed to be especially targeted any longer; in that sense, John Rawls's (1971 [1999]: 65–73) 'difference principle' ('maximin'), which provided a horizon within progressive liberal economics, became largely irrelevant. Now it was mainly a matter of pulling wealth downwards such that the deleterious consequences of excessive wealth concentration at the top could be addressed. As observed already, Atkinson, whose welfarist approach to inequality measurement had a circumspect interest in poverty measurement, made the shift to focusing on the top income rungs effortlessly. Some of the fifteen proposals he offered at the end of his book *Inequality* (2015: 303–4) gave a reasonable summary of the targets that need to be met to alleviate deleterious consequences of income concentration at the top: guaranteed employment, minimum wage, positive interest on savings and maximum holding per person, universal child benefit, renewal of social insurance, and a minimum target in aid from rich countries. These had little to do specifically with poverty; the poverty-stricken would benefit from such measures as much as other strata. From this perspective, the mechanics of redistribution also became simplified: it comes down to taxing the rich more (for a scholarly treatment, see Diamond and Saez 2011; Saez and Zucman 2019; for a lucid summary of the instruments through which redistributive revenue can be obtained, managed and targeted, see Piketty 2015 [1997]: Chapter 4). There were, of course, complexities in the mechanics of taxation and redistribution from this perspective. Larger shares of tax, after all, do not come from individuals but from firms—so

fiscal rather than direct redistribution is arguably more effective—but those details, it was felt, could be modelled once the progressive direction is set. Effectively, though, poverty was defocused. Seen thus, *the catchphrases 'the 1%' and 'the 99%', and the slogan 'We are the 99%', were popular crystallizations of the statistical defocusing of poverty in inequality measurement.*

In saying poverty was defocused, I do not mean to suggest that poverty disappeared from all reckonings. Though a degree of consecutiveness is suggested here in describing the shift as taking place from focusing on the bottom to focusing on the top, the former approach to inequality analysis did not get replaced. It was more the case that the top-focused approach appeared later, and thereafter both kinds of analytical foci have been pursued. However, the popular uptake of the top-focused approach through the Occupy protests following the 2007–2008 financial crisis, through crystallization and easy adaptability via the statistical catchphrases 'the 1%' and 'the 99%', through the complexities of how statistical notations are received, through the means and interests with which advocacy was undertaken ... through all that, arguably, a general defocusing of poverty in the wider sociopolitical sphere occurred.

While Piketty and Saez (2003 and 2006) were presenting their analysis of income distributions in the USA for the period between 1913 and 2002 (a long run of data) with an eye on the top rungs, Edward Wolff (mentioned earlier) and co-authors were also focusing on income distributions in the USA for shorter periods (1984–1999 in Caner and Wolff 2004; from the 1940s to 1970s and 1970s to 2000 in Wolff 2004) with an eye on the bottom rungs and a firm interest in poverty. Insofar as poverty was focused, that involved more than simply taking account of income. In one of the papers, measures were drawn from various sources to obtain an understanding of 'asset poverty' for households (rather than individuals): 'a household is considered to be "asset-poor" if its access to "wealth-type resources" is insufficient to enable the household to meet its "basic needs" for some limited "period of time"' (Caner and Wolff 2004: 496)—obviously, terms designed to capture an impoverished condition of life. However, this research evidently had a weaker purchase in popular discourses, whereas Piketty, Saez, and their collaborators' perspective had a considerably stronger appeal, to the extent of feeding into and legitimizing the Occupy protest catchphrases and slogan.

No doubt the wider defocusing of poverty was helped by energetic conservative arguments in favour of abandoning the existing poverty line based on income, and poverty lines generally, on the grounds that it misrepresents material progress (such as, Eberstadt 2008). But those arguments are countered by poverty measures such as the Multidimensional Poverty Index adopted by

UNDP (2010), replacing the earlier Human Poverty Index, and also including inequality adjustments in the Human Development Index. Evidently, in institutional reckonings, poverty measurement and its association with inequality measurement have not only stayed strong, but have been honed in their sensitivity to real circumstances. It is possible that such fine-grained poverty measurement may speak in some new way to top-focused approaches to inequality measurements based on income. In any case, that such defocusing of poverty has taken place is also suggested in some research which attends to academic linguistic usage rather than the minutiae of measurement. For instance, examining definitions of poverty in 578 documents from the 1970s to the 2000s in decadal segments, Misturelli and Heffernan (2008: 260) found:

> Not surprisingly, during the 1970s, the focus was on physical and material needs. [...] By the 1990s, economic and institutional factors rose to match those relating to physical and material needs, which had dominated the themes since the 1970s. The $1 a day cut-off point was introduced to the definitions during this time, as was the UN's notion of 'human poverty'. Thus, during this time, two of the most powerful players produced two opposing notions of development, both of which competed for legitimacy. Indeed, the UN's notion of human poverty was largely based upon Sen's capability approach and directly acknowledged the social dimension of poverty. Conversely, the World Bank offered a purely quantitative, money metric measure that was easily translatable across cultures, actors and communities.

However, during the 2000s, the division became somewhat blurred. Indeed, definitions tended to list criteria that included both social and more quantitative factors. Further, the focus of the definitions became the poor rather than poverty in general. The heavy use of juxtaposition, however, revealed that listing the features of poverty were more important than detailing the causes. Thus, by the 2000s the definitions had returned to the descriptive and largely unproblematic concepts of the 1970s.

Definitions in themselves do not say much about the measurements and their analysis, and yet definitions do indicate what is ostensibly measured and may prefigure how the results would be analysed.

The shift in approaches to analysing inequality reflected in popular attitudes and expressions has had obvious implications for contemporary anti-establishment political mobilizations. The liberal welfarist approach to analysing inequality with a strong sense of the bottom, targeting redistribution accordingly, has often become aligned with establishment interests.

It could blur the part played by the upper rungs of income in social organization and suggest that if only the bottom were targeted properly all would be well, and the bottom can be targeted by well-measured policies and criteria determined from above. Understandably, this offers little encouragement for political mobilization with a view to large-scale or wide-ranging change. Mobilization may only be encouraged to the extent that it is confined within and confirms stable establishment arrangements: for instance, it occurs within the structures of multiparty electoral contests, takes the form of single-issue policy activism, engages in temporary protest-as-performance/spectacle style events, and seeks change in institutional directions/leadership rather than of institutions themselves. The approach to analysing inequality with a focus on the top, foregrounding taxation as the core for redistribution downwards, has rather more to offer for political mobilization seeking large-scale and wide-ranging change. Insofar as establishment structures are perceptibly controlled by elites, this mode of challenging their dominance could portend a desire for restructuring establishment arrangements such that the elites are decentred and perhaps de-elitized—the very systems that produce elites could be targeted. That potentially implies a comprehensive ideological transformation.

However, to see the top-focused approach thus courts overestimating its potential. Despite the possibility of large-scale mobilization, this approach has built within it several mechanisms which ultimately also render it confirmatory of liberal establishment structures. On the one hand, it conceives of the elites as individuals in income terms, at the least as abstract individuals within a statistical demarcation. On the other, the arrangements which gravitate and concentrate wealth towards the top are largely institutional, themselves embedded in political and financial systems underpinned by 'rule of law'. The foregrounding of abstract individuals tends to downgrade attention to the institutional and systemic underpinnings, or to render them after-the-fact. Further, the strong focus on taxation for redistribution effectively reiterates the position of the elites and the legitimacy of the establishment authorities charged with tax collection, policing, and redistribution.

Insofar as the conditions of impoverished life go, little is promised in mobilizations with the top-focused approach. Where a loose apprehension of poverty was implicated in the Occupy protests, that involved associating certain terms with the statistical catchphrases and slogan—such as, 'precarity' or 'precarization', 'crisis', 'unemployment' and 'employment insecurity', 'casualization', 'depreciating standards of living', 'privatized welfare', 'indebtedness', and 'low credit access'. These terms worked as linked or conditional

catchphrases and words in the midst of anti-establishment mobilization and protests. These suggest that, insofar as poverty is considered, that is not as a condition of life but a seepage of variegated experiences from the lower rungs upwards. A kind of osmosis of drops and drips of impoverished experiences across the quantiles of the chart from the bottom upwards appears to be at work, through systems at the behest of elites. It is probably fair to think of the impetus of such political mobilization as more to do with *fear of poverty* than with actually existing poverty (on this point, Gupta 2019: 206–8). There are several possible reasons why this impetus may seem stronger now than it has been in the past. That may be because of the actual reduction of existing poverty, or because of the reduced significance of existing poverty, or perhaps due to the near monopoly of the middle rungs in anti-establishment political mobilization (as Badiou argued in the quotation earlier). In this regard, the effectiveness of mobilization on the back of catchphrases like 'the 1%' and 'the 99%' or slogans like 'We are the 99%' is likely to be contextually variable, depending on the extent of actual poverty. It is likely to be quite different, for instance, in the USA or UK compared to India or Nigeria.

Aftermath

By 2015 the worldwide Occupy protests had largely fizzled out. The circulation of the catchphrases 'the 1%' and 'the 99%' and the slogan 'We are the 99%' also diminished, but not entirely. They remained associated with activism against extreme inequality, centred on the metaphorical suggestiveness of the statistical notation. Retrospection on the Occupy protests examined the catchphrases at regular intervals, as has been noted. They also continued to appear as catchy anchors for ongoing investigation into growing inequality and ways of addressing its effects (e.g. Hardoon 2017; Adler 2019; Azmanova 2020: Chapter 6). A manifesto, *Feminism for the 99%* (Arruzza et al. 2019), called for the alignment of feminist commitments with an anti-neoliberal agenda, foregrounding the interwovenness of identity-based prejudices and the exploitation of workers: 'This feminism does not limit itself to "women's issues" as they are traditionally defined. Standing for all who are exploited, dominated, and oppressed, it aims to become a source of hope for the whole of humanity. That is why we call it *a feminism of the 99%*' (14). A collection of essays on what studying Shakespeare means amidst precarious employment prospects and underfunded educational provision, brought 'the 99%' into the somewhat rarefied space of literary scholarship (O'Dair and Francisco, eds. 2019). Needless

to say, the catchphrases and slogan entered everyday exchanges, featuring seriously, playfully, and ironically in conversations.

After the Occupy protests, the slogan 'We are the 99%' also engendered a kind of slogan-template for other contexts. The potential for this was demonstrated by the 'We are the 53%' counter-slogan during the Occupy protests mentioned earlier. After the Brexit referendum of June 2016 confirmed by a majority of 51.9 per cent that the UK would withdraw from membership of the EU, a 'We are the 48%' slogan, putatively representing those who opposed that result, gathered momentum for a while in digital forums (Change.org, Twitter, Facebook; for an admonitory article on this, see Katwala 2016). When the far-right nationalist Alternative für Deutschland party received 12.6 per cent of the popular vote in the September 2017 Bundestag elections, the slogan 'Wir sind 87 Prozent' was raised and flared for a brief period, mainly in social networking forums (Bell 2017).

With the Covid-19 outbreak in 2020, 'the 99%' and 'We are the 99%' saw a decisive downturn in usage, at least in the spirit of the Occupy protests. The pandemic sharpened the visibility of the bottom and undermined the unifying appeal of 'the 99%'. The impoverished condition of life surfaced again in this 'new normal', drawing attention to the challenge of containing the contagion in congested localities and housing, the devastating consequences of losing employment amidst straitened circumstances, the difficulty of accessing online education on the wrong side of the digital divide, and so on. The undertaking of vaccination programmes in 2021 quickly divided the world into rich and poor countries, and demonstrated the advantages of the former. As investigations into the effects of the pandemic on poverty and inequality proliferated (too numerously to offer citations meaningfully), the optimism of 'the 99%' seemed misplaced. Accusatory attention to the advantages of being among 'the 1%' amidst the pandemic appeared occasionally instead; there was some talk (with little follow through) of taxing 'the 1%' more to pay for the costs of the outbreak; it was variously noted that 'the 1%' had become relatively wealthier in the course of the pandemic (Stebbins and Suneson 2020; Al Jazeera Staff 2021; Collins 2021). It was left to the anti-restriction or anti-hygiene protestors in Britain and elsewhere, associated with libertarian and nationalist right-wing organizations promoting 'conspiracy theories', to chant 'We are the 99%' in some of their public gatherings (Murphy and Weston 2020; Langfitt 2020), ringing more as a mockery of the slogan than as a rallying call.

7

Conclusion

Loose Ends

Concepts

I introduced this study with brief outlines of its guiding concepts—'political catchphrase' and 'contemporary history'—before eagerly taking up the case studies to substantiate them. It seemed to me that there is enough of a received understanding of these concepts out there to set the observations and arguments rolling. A considered elaboration of the concepts *as concepts*, as generalized and rationally extendable ideas, was postponed in the Introduction and promised in this final chapter. The case studies, I figured, would demonstrate how those received concepts bear upon and are woven into the analysis of particular catchphrases in recent times. Concurrently, in the process of working through those, the received understanding of these concepts would gradually become sharper, perhaps even come to be articulated beyond their received understanding.

In pausing finally on 'political catchphrases' and 'contemporary history' as general concepts, I find myself caught in some uncertainty. It is now not clear to me how far the conceptual formulations later in this chapter guided this study and to what extent these are actually inferences made from the study. Perhaps, in fact, these have become somewhat more than inferences, more in the nature of general hypotheses to inform further investigations. I am inclined to think so. I did begin exploring the specific catchphrases/words discussed earlier—'new normal', 'austerity', 'resilience', 'the 99%' and 'the 1%', 'we are the 99%'—with some general precepts (rather than concepts), based roughly on considerations such as those laid out in the following. And yet, as I progressed, those precepts were stretched and gradually seemed more like general concepts. However, these elaborations are only extended to some degree by the preceding chapters. Observations about a few catchphrases/words are not a sufficient basis for the following generalizations. Further case studies are needed and further sharpening of concepts.

Political Catchphrases and Contemporary History. Suman Gupta, Oxford University Press.
© Suman Gupta (2022). DOI: 10.1093/oso/9780192863690.003.0007

What follows, then, is not a conclusion in the sense of summarizing the main findings in the preceding chapters and charting some ways forward. Instead, the following offers conceptual elaborations and generalizations which have underpinned or have developed through the case studies, but are of larger import. These are presented in three sections. The first mulls the ever-slippery pursuit of 'contemporary history' and proposes a notion of the 'contemporary' which coheres with this book's. The second considers the 'political' in 'political catchphrases', with political dictionaries in view. The third section focuses on how to describe the catchiness of catchphrases/words by considering them alongside keywords.

The 'contemporary' in contemporary history

Chapters 2 and 3 on the 'new normal' above covered a period from 2001 to 2020; Chapter 4 reached back to the nineteenth and twentieth centuries to explore concepts of the 'normal'; and the other chapters addressed more concentrated periods within the range 2001–2020. This range is not, in itself, indicative of what makes this a study of 'contemporary history'. 2001 should not be regarded as the boundary of contemporariness here. It was the year, I argued, when the catchphrase 'new normal' became a catchphrase, that is all.

My brief remarks on 'contemporary history' in the Introduction had referred it to a 'recent period', but left the period range to common-sense approximations. In his influential introduction to the study of 'contemporary history', Geoffrey Barraclough (1967 [1964]) observed that 'The word "contemporary" inevitably means different things to different people' (13); the term 'recent' is similarly vague. Occasionally, a dated boundary is affixed to demarcate a contemporary period, usually when historians of the contemporary find yet another institutionally expedient space: for example, for teaching programmes, professional bodies, serial publications, or repositories. Thus, at present, for the *Journal of Contemporary History* that boundary is after 1930, for the journal *European Contemporary History* it is after 1918, for *British Contemporary History* after 1945. Conceptually too, periodization is powerfully embedded in historiography, so it seems natural that the 'contemporary' refers to a period. As Barraclough had it: '[C]ontemporary history should be considered as a distinct period of time, with characteristics of its own which mark it off from a preceding period' (12). Let me start this section by saying that the idea of 'contemporary history' relevant to this study is not based on a delimited period.

My introductory remarks also pointed to the practicalities of calling upon sources which are yet to be consolidated in existing historical narratives. With regard to contemporary history, the most productive debates have been about methods for tapping into 'living memory', particularly in oral history. Some of the sources called upon earlier do draw upon interviews, testimonies, reminiscences, and the like to elicit an analysable record. These sources present that unique encounter between the historian and the informing subject which underpins oral history (outlined well in Abrams 2016: Chapter 2). However, this study has not taken recourse to such methods itself. It has depended entirely on texts already in the public domain. No obvious methodological negotiation with living memory was undertaken.

In planning this study, I was attentive to the challenges of negotiating between past and present with consistent historiographical principles, a subject of much philosophical reflection. Let's leave aside Benedetto Croce's (1921: 12) argument, quoted in the Introduction, that 'every true history is contemporary history'. That deliberately conjoined past and present such that little scope was left for conceptualizing a distinctive space for contemporary history. Insofar as a meaningful practice of contemporary history has been considered, there are two influential ways of relating the past to the present. On the one hand, contemporary history involves establishing the presentness of the present in relation to some idea of where the past became firmly such. This approach could be considered via the metaphor of strata (like geological strata). If a historical period is considered as a stratum where previous and subsequent periods are strata formed beneath or on top, then the present is the surface the historian is on, founded upon the latest acknowledged stratum. This is roughly the view that, for instance, Frederick W. Pick (1946) took in observing, 'The writer of Contemporary History [...] having analysed the society of the present, can subtract from his vision of the past just those features which he found to be peculiar to the world in which he lives' (27). That is, the past is found by scraping away the surface of the present. And, similarly, the metaphor of strata is implicit in Barraclough's (1967 [1964]) declaration: '*Contemporary history begins when the problems which are actual in the world today first take visible shape*' (20, italicized in the original). The present *appears* like structures built upon the surface of the past. On the other hand, in contemporary history the relationship of present and past could be considered a continuous process. Instead of strata, metaphors of ongoing movement may be foregrounded: the present is the moving tip, the vanguard, of a process that extends backwards as the past. Some of the discussions of Michel Foucault's various statements on his method after *The Archaeology of Knowledge* (1972 [1969]), especially

of his phrase 'history of the present' (Roth 1981; Auxier 2002; Garland 2014; Revel 2015; Poster 2019: Chapter 4), delve into such metaphors. His use of the terms 'archaeology' and 'genealogy' for subsequent phases of his approach are suggestive in this regard (see Garland 2014). 'Archaeology' metaphorically digs into geological strata as historical periods; and 'genealogy' is a process metaphor in Foucault's later and more politically charged work, where the traces of the past are always in the present.

Such historiographical metaphors to sharpen the 'contemporary' have had a bearing on this study, but unevenly. To some extent, for instance, the surface of the present appears in the case studies that have been presented, where a phrase or word catches on—usually at some transitional juncture of usage. The 'new normal' could thus be thought of as taking off from the surface of the stratum where concepts of normality have become, in some sense, static and seem insufficient. Similarly, 'austerity' acquires its current resonance at the end of a chain of adjustments and modifications in usage, following a kind of genealogy or, rather, its linguistic equivalent, etymology. On the whole, however, neither of those metaphors for conceiving the 'contemporary' works satisfactorily for this study. The case studies suggest that the particular connotations and resonances of a catchphrase at a given juncture work in relation to a great many other catchphrases, slogans, references, associations, and so on. They catch on in different ways as catchphrases, and take off or rise and fall and sometimes disappear irrespective of anything as cohesive as a surface or boundary from where the present is gauged, or as coherent as a continuous process. The sense of contemporaneity in this study has a different basis.

With regard to the historiographical implications of the 'present', this study's methods benefitted from Henry Rousso's *The Latest Catastrophe* (2016 [2012]). Rousso's was a careful investigation into the impulse to engage with the 'present' in the practice of history as that developed through history; therefore, a history of that impulse itself, mediated by accounts of various received periods. It effectively tracked the reckonings of scholars and learned bodies at subsequent junctures, which often involved denying the possibility of contemporary history and yet always returned to the need for and undertaking of it. Rousso presented, thus, a process whereby historiographical preconceptions were sharpened, so that by the later twentieth century contemporary history occupied a dominant place in the discipline. With such hindsight, Rousso found a periodic push for the reiteration of contemporary history, which he called 'the latest catastrophe'. This push also posts the boundary at any given time from where the contemporary, the character of the present, is derived. In his introductory summary:

Interest in the near past thus seems ineluctably connected to a sudden erup-
tion of violence and even more to its aftereffects, to a time following the
explosive event, a time necessary for understanding it, becoming cognizant
of it, but a time marked as well by trauma and by strong tensions between
the need to remember and the temptation to forget. That, in any case, is the
hypothesis I develop here, relying on the lapidary and compelling definition
that all contemporary history begins with 'the latest catastrophe', or in any
case with the latest that seems most telling, if not the closest in time. (9)

Rousso mainly had in mind such 'explosive events' as world wars, revolutions
and genocides; 'eruptions of violence' that call urgently for explanations and
coming to terms. To some degree, the 'latest catastrophe' therefore puts pres-
sure on the pursuit and principles of doing history itself. Historiography needs
to be reconsidered in a fundamental way, so that the present can both be un-
derstood in terms of, and calls for, a renewed understanding of the past. The
historian assumes a position somewhat greater than that of a specialist or aca-
demic in the narrow sense, and becomes a kind of arbitrator for the settlement
of trauma and tensions:

> [H]istorians of the contemporary, in the face of the short- or medium-term
> legacy of a great catastrophe or major upheaval, must confront issues that go
> far beyond a mere intellectual and academic exercise. At stake is the quest for
> truth, the taking into account of all the suffering endured, the avid need to
> distinguish between good and evil, the often urgent and anguished necessity
> of a narration, even imperfect, that will make sense in the event's aftermath.
> (41)

Naturally, the practice of contemporary history constantly constitutes itself
along the moving boundaries set by periodic outbreaks of 'catastrophe'.

Obviously, such a sense of contemporary history in relation to the 'latest
catastrophe' is relevant to the tracking of catchphrases/words like the 'new
normal', or 'austerity', or 'the 99%' and 'the 1%'. Rousso's use of 'catastrophe' is
similar to what are dubbed as 'crises' in the junctures covered here: the 9/11
terrorist attacks, financial crisis of 2007–2008, the Covid-19 outbreak, climate
change. However, 'crisis' has a somewhat different emphasis than 'catastrophe',
more of a sense of being on a precipitous edge than being in the aftermath of
disaster, more intricately woven into the ongoing process of under-pressure ex-
changes and social life than leading into consequent trauma and tensions. As
Janet Roitman (2014: 39) put it, '[C]risis is not a condition to be observed (loss

of meaning, alienation, faulty knowledge); it is an observation that produces meaning'. A 'crisis' could be an 'eruption of violence' (like 9/11), or a realization of being at an edge of an abyss (like climate change), that variously appears and peaks and recedes and remains latent, or slides seamlessly into another crisis. A crisis, we may say, portends an imminent catastrophe or seems like a slide towards catastrophe without quite being a catastrophe itself. A catastrophe is an explosive event that ends but has an aftermath, which contemporary history then engages in a cathartic spirit. Crises unfold, recede, and shift without clear culminations. Tracking the usage of catchphrases like the 'new normal', therefore, seems to follow the passages, the expansions and contractions of crises, rather than focalize the catastrophic event. Insofar as such tracking materializes an account of contemporary history, that bears some resemblance to Rousso's conception of contemporary history, but with a significant difference. Rousso's 'latest catastrophe' puts a putative boundary for doing history, from where the 'contemporary' is articulated. The tracking of catchphrases amidst and through the passage of crises does not do that. The contemporary here, for this study, seems more indefinitely or intractably initiated; the drive of doing contemporary history appears more enmeshed in an unfolding process of crises upon crises than a reckoning with the latest catastrophe behind us. Rousso's understanding of contemporary history is relevant to what this study does, but offers no handle for grasping its focus on political catchphrases.

A somewhat different formulation of the 'contemporary' in contemporary history is called for, consistent with the historiography of this study. I propose this: *the contemporary is understood in terms of the prevalence of a structure of idiomatic usage across multiple or extensive domains of communication; the practice of contemporary history involves working within and with attention to the prevailing structure of idiomatic usage.* I am aware that this is an unusual approach to engaging with contemporary history; clarifications are in order. A 'structure of idiomatic usage' refers to a network of idioms which is current at a given time or over a stretch of time. The relevant sense (3) in the Oxford English Dictionary (OED) defines an 'idiom' as:

> A form of expression, grammatical construction, phrase, etc., used in a distinctive way in a particular language, dialect, or language variety; *spec.* a group of words established by usage as having a meaning not deducible from the meanings of the individual words.

The specification points to the non-logical construction of idioms, and is taken as definitive of idioms in scholarly accounts. Sam Glucksberg's (2001) helpful

overview of idioms, among other kinds of figurative expressions, gave the standard definition as: 'a construction [of words, a phrase] whose meaning cannot be derived from the meanings of its constituents' (67). Much of Glucksberg's account charted the enormous variety and fluidity of idioms, and of scholarly approaches to studying them. For the latter, he summarized the main issues thus:

> The first issue concerns compositionality. To what extent are idioms compositional, that is, to what extent can the meaning of an idiom be derived from the meanings of its constituents? As we shall see, degree of compositionality varies greatly among idioms, with some idioms being fully compositional and others not at all. The second issue concerns the syntactic properties of idioms. To what extent does an idiom's meaning depend on its syntactic form, and to what extent can an idiom be open to syntactic analysis and transformation? This issue of syntactic flexibility [where the components of an idiom can be moved around while continuing to carry its meaning], like that of compositionality, relates directly to the standard definition of idioms as non logical. If an idiom's constituents have no meaning at all, then the idiom should be incapable of syntactic flexibility. However, idioms can vary from being fully syntactically flexible to not at all. (68)

Linguists studying idioms have tended to focus on describing categories of idioms and analysing specific idioms in context, and at times describing 'idiomaticity' as a set of practices inferred from large collections of idioms (using a corpus, e.g., in Wulff 2008). The kind of idioms that are foregrounded in analysis are usually *received idioms*, that is, identified as such through sustained and varied histories of usage. Catchphrases, I suggest, are not quite received idioms. Rather, catchphrases are constructions which, in bursts of intensive and extensive usage, by catching on, become idiomatic—perhaps temporarily or for a short time and sometimes gradually becoming received idioms. Through their constant usage in different contexts, through continuous adaptation and accruing associations, they become non logical and are used in non-logical ways at least for a while, that is, they come to mean more than their constituents. Some catchphrases may persist in being used thus to gradually become received idioms, others may fall out of the catchphrase circuit and melt into ordinary logical usage. Catchphrases like the 'new normal' or 'the 99%' and 'the 1%', within their circuits of extensive and intensive usage, acquire meanings which cannot be inferred from their constituents. A catchword, in a similar way, confers more meaning to a phrase

in which it features than its dictionary definition or logical implication would suggest—within its catchword circuit and whilst a catchword. Catchwords like 'austerity' or 'resilience' mean more than they are defined to whilst used as catchwords. Catchphrases/words could thus be thought of as idioms-in-the-making or short-term idioms, relatively unstable compared to received idioms. But within their catchphrase/word circuits they behave idiomatically, and just as variably, with a similar range of compositionality and syntactical flexibility, as received idioms do. The case studies in this study could be regarded as demonstrations of how and in what ways catchphrases/words acquire their idiomatic character. Their catchiness makes them idiomatic, their idiomaticity escalates their catchiness.

The linguistic approach to idioms, largely focused on categories of idioms and specific idioms in context, has been less attentive to their bearing upon each other at a given juncture, or to their networked or interconnected prevalence in communication systems. Idioms of a given language formation have a collective effect on how that language is used to constitute the world. That is in much the same way as in the junctures examined in preceding chapters, where the catchphrase-connotations of 'new normal', 'austerity', 'resilience', 'We are the 99%', etc. were intricately connected. Such catchphrases/words are used in relation to each other and with reference to prevailing social circumstances; at the same time, together they render those social circumstances coherent. Unsurprisingly then, idiomaticity has usually been taken as conferring a character on everyday language, giving language the life of its time. Such is, in fact, the leading sense (1) of the word 'idiom' given in the OED, albeit marked as anachronistic or rare: 'The specific character or individuality of a language; the manner of expression considered natural to or distinctive of a language; a language's distinctive phraseology'. Glucksberg's study considers the significant part idioms play in language acquisition, to conclude:

> People talk not only to communicate propositional content but also to reflect upon and express attitudes and emotions. Idioms, metaphors, and many fixed expressions reflect social norms and beliefs. To learn a culture's idioms and other fixed expressions is to immerse oneself in that culture. (89).

Since catchphrases/words are idioms which are intensively and extensively used over specific periods, their usage signifies not only what Glucksberg calls 'immersion in that culture' but also having the pulse of that culture or being attune to that zeitgeist. For this study, the catchphrases/words refer predominantly to the cultures of British and American communication circuits

(somewhat more widely, Anglophone circuits), but also carry the reverberations of the global or global cultural circuits of our world, in our time (to echo Hegel).

This temporality of catchphrases as idioms makes them particularly serviceable for doing contemporary history. Whilst a catchphrase is idiomatic, it is of the present. The present is, to some significant degree, held together by a network of catchphrases in use. Tracking the passages of catchphrases in use is therefore, in a material sense, tracking the passage of presentness as it unfolds, from within, in at least some of its dimensions. As a method, this approach is necessarily different from that which begins from some putative boundary of the present, such as Rousso's 'the latest catastrophe' or Barraclough's period-line where 'the problems which are actual in the world today first take visible shape'. Catchphrases that are currently in circulation, all bearing variously upon each other, obviously do not all become catchphrases at any one juncture or even within any compressed phase. Each enters into and falls out of catchy eminence at different times, but while it is used concurrently with other catchphrases/words, they all bear upon each other and link up different dimensions of the social world. This sense of the 'contemporary', which can be obtained by tracking catchphrases, then, does not fall in readily with the convention of historical periodization. In this context, the idea of a historical period seems too neat and categorical. The 'contemporary' that is apprehended via catchphrases—for that matter, any juncture in history that could be apprehended via the catchphrases of the time—appears without the convenience of periodization. This does not, or should not, trouble the practice of history particularly. Historians have generally been cognisant of the artifice and problems of periodization for a while now (see Blackbourn 2012; Le Goff 2015[2014]), and the concept of historical time, especially 'modern time', has been helpfully complicated (especially in Kosellek 2004 [1979]; Kosellek 2002: Chapters 6 and 7). Nevertheless, if the contemporary is not approached as a period, or at least some kind of time-formation, it is perhaps difficult to grasp its place in history. We may ask: in what sense is the contemporary, tracked thus though catchphrases, then historicized? Where is the history in this mode of analysing the contemporary?

Arguably, an historicizing 'distance' appears in critically analysing catchphrases while those catchphrases are widely in use. There is, for instance, an obvious slippage in my reading of sources featuring the catchphrase 'new normal' in Chapters 2 and 3. I refer to publications which used 'new normal' to refer to, for example, conditions arising from the Covid-19 outbreak. In

these publications, the catchphrase was used because it was already considered meaningful and did not need elucidation; using it established immediate relevance between authors and readers, simply by being used. However, my discussion of the catchphrase in these publications goes against the spirit in which it was used. I deliberately try to elucidate the particular instance of usage in a given publication in relation to previous and forthcoming instances of usage. In doing this, I dislocate the presumption of immediate relevance and expect to throw some light on the publication itself. Instead of, so to speak, going along with the usage of 'new normal' as a catchphrase of our time, as a transparent expressive device, I disjunctively draw attention to it as a catchphrase, and look at the catchphrase as if it were opaque. And I do this repeatedly for sources where 'new normal' was transparently used, in texts along a timeline, presenting the catchphrase's shifting opacity as an expression of passing time.

Because the catchphrase is pervasively in use, pausing on it as if it were a historical construct and, then, demonstrating its historical constructedness becomes a constant—constantly performed—negotiation between past and present. Brashly, I am inclined to suggest that historically tracking current catchphrases is par excellence a method for contemporary history. At any rate, it is a methodological ploy which concretizes an abstract aspect of contemporary history that has occasionally been noted. It is akin, for instance, to Michael Roth's (1981) understanding of what Foucault's 'history of the present' entailed:

> Writing a history *of* the present means writing a history *in* the present; self-consciously writing in a field of power relations and political struggle. [...] Foucault, in all the [later] works discussed in this paper, is writing a history of the present in order to make the present into a past. Writing from the brink of a dramatic shift in the structures of our experience is essential to Foucault's task because this enables him to conceive of the present as that which is almost history. (43)

Where Roth saw Foucault's project as disrupting the political present, Rousso focused on the historian's effort. Historicizing the contemporary is, in Rousso's view, a disruption of the historian's present:

> Historians of the present time, like all historians, thus experience a structural tension between proximity, distance, and alterity, but they do so with a different polarity: *it is more difficult for them to be far away*. Their practice consists

not of moving closer to what is a priori remote, like an anthropologist considering a Caduveo Indian or a historian a medieval peasant woman. On the contrary, it consists of moving away from what appears close by, such as a resistance fighter or a survivor who is the same age as the historian's father or grandfather, who speaks the same language, who may live in the same neighbourhood, and, often, who regularly attends or attended the seminars at which the historian speaks.

<div align="right">(Rousso 2016: 158)</div>

To restate that nice stew of metaphors: the contemporary historian is not like one who speaks about a remote idiom, but like one who speaks about the idiom within which they live *as if it were remote and can be spoken about*. Narrating contemporary history via current catchphrases is a direct way of doing that.

The 'political' in political catchphrases

In the Introduction I distinguished the sort of catchphrases of interest here, *political* catchphrases, from *commercial* catchphrases. This way of distinguishing catchphrases is, in fact, based on contemporary circumstances. It is taken as understood now that the term 'catchphrase' is predominantly associated with advertisements and showmanship. The Oxford English Dictionary (OED) definition (updated in 2018) confirms this:

> A frequently used or well-known phrase or slogan, typically associated with a particular group or person and serving to attract public attention or interest; *esp. (a)* a signature or stock phrase of an entertainer or character in a play, film, etc.; *(b)* a memorable or striking phrase used in an advertisement; an advertising slogan.

However, of the seven examples of usage given in the OED, two—including the earliest from 1834—are from political rather than advertisement or entertainment contexts. Despite the precedence given to commercial usage now, catchphrases continue to be associated with political communication. So, it seems natural to embark on any investigation of catchphrases by distinguishing between the commercial and the political.

The first dictionary devoted exclusively to catchphrases was Eric Partridge's *A Dictionary of Catch Phrases* (1977 [1985]), covering a long period from the sixteenth century to the present. This had 'catch phrases' as overlapping with proverbial sayings, clichés, and famous quotations; according to Partridge,

'catch phrases' are distinguishable from those not by definition but by 'the context, the nuance, the tone' (viii). Dictionaries of catchphrases since, (such as Craig 1990; Rees 1997; Farkas 2002), mainly dwelling upon current usage, have tended to play up commercial contexts. Like Partridge, later lexicographers have found it easier to recognize catchphrases than to define the term 'catchphrase'. Also like Partridge, in their selections, these dictionaries have included almost any construction which could be considered idiomatic at a given juncture, taking in what would have been called 'war-cries', 'slogans', 'sayings', 'idioms', 'quotations', 'clichés', and so on earlier.

The rationale for focusing particularly on contemporary *political* catchphrases in this study can be sharpened by considering general idiomatic usage which has been tagged 'political' in various historical contexts. Dictionaries of *political* terms and usage from different historical junctures offer a useful resource in this regard. Their selections, definitions, and exemplifications of words and phrases, and the cross-connections made between them, reveal much about political discourses in historical contexts.

All dictionaries are necessarily of their time, of course. Amidst constantly evolving contexts and verbiage, dictionaries draw the line where and when they appear, while political usage moves on. Certain terms inevitably become archaic thereafter while others become current—and updated editions follow. Some dictionaries construct their presentness with careful cognizance of the past record, by following historical linguistic principles. Hans Sperber and Travis Trittschuh's *American Political Terms* (1962) presented a model for this approach, trying to find the common ground between philological and historical scholarship (v). Dictionaries are sometimes designed especially for scholarly usage: thus, Iain McLean's *Concise Oxford Dictionary of Politics* (1996) covers 'the concepts, people and institutions most commonly referred in academic and scholarly writing about politics' (x). More common, though, have been dictionaries of political terms meant for consultation by anyone interested in the politics of their time—for general readers. These offer snapshots of political idiomaticity in specific historical junctures, a vivid sense of both politics and political communication current then. In approaching contemporary history via political catchphrases, I had in mind the awareness of politics in the present that such dictionaries reflect.

A few well-spaced examples may serve to illustrate the differences in subsequent phases of political awareness found in these dictionaries. The earliest political dictionaries of the late eighteenth century in Britain bear little resemblance to their later counterparts. Despite ideological differences, dictionaries such as Joseph Pearson's (1792) and Charles Pigott's (1795) shared some

common ground (for the background to these, see Jang 2016; Mee 2016: Chapter 4). They were obviously addressed to (and were about) an inner circle of the political elite, largely distant from what they called 'the people'. Readers with an interest in political terms and communication at the time were mostly men of the literate gentry. Their choice of words and phrases represented a jargon shared by this elite circle, and the explanations alongside usually came with coterie snipes and diatribes. Insofar as communication with a larger public was concerned, the only relevant entry in both was, fittingly, 'proclamation'; and their elaborations spoke clearly of the spirit in which, and audience for which, they were written:

> PROCLAMATION.—A piece of paper pafted on walls, to frighten the people out of their rights; the fame as idle cautions againft p—-g pofts, and of juft the fame ufe. People will always know *where* they have the right to p-fs, and will p-fs *when* they pleafe.
>
> (Pearson 1792: 43)

and

> *Proclamation.* A fuppofed letter from the king to his People, in which they are informed when they are happy, and by which they learn an increafe of taxes to be an accumulation of comfort.
>
> (Pigott 1795: 125)

Around a hundred years later and in the USA, where the focus of political exchanges had shifted to civil conflict, election campaigns and mass media reportage, a wider circuit—albeit confined to White men—was evident in Charles Norton's *Political Americanisms* (1896). This was meant, according to Norton, to record 'the current argot of the period, [...] often as vigorously expressive as the most picturesque slang of the streets' (v). Placing a collection of political terms as an 'argot' (in the OED: 'The jargon, slang, or peculiar phraseology of a class, *originally* that of thieves and rogues'), similar to 'slang of the streets', took the discourse tagged as 'political' well out of the elite circles and coteries where eighteenth century dictionaries had centred it. Instead of 'proclamation' then, as a mode of political communication, Norton's selection highlighted 'war-cries' every now and then. He used that term in preference to the synonymous 'slogans', and defined it thus:

> War-Cries – The presidential campaign of 1884 saw the introduction of a species of political war-cry not previously in vogue. It was based on the

well-known habit of drill-sergeants in marking time for a squad of recruits, to teach them to march in step. (120)

With the military metaphor, the command structures and campaigns of party politics rather than the tensions between gentlemen parliamentarians and monarch were now evidently centre-stage. Four decades later, the emphasis had shifted again for what a dictionary charts of political usage. On the one hand, it had come to serve the purpose of a name index, listing terms used as common reference points for political debates in the public sphere. Walter Theimer's *The Penguin Political Dictionary* (1939), covering a list of concepts, proper names, and names of parties, movements, and policies exemplifies this. Its choices were grounded in the evolving geopolitics of its time, just on the eve of World War II. It could be considered a mapping of two political registers, the German, and the British or American. In conception, Theimer's dictionary seemed now to gesture forward to the more scholarly tracking and mapping to come in Sperber and Trittschuh's (1962) and then McLean's (1996) political dictionaries. On the other hand, and as a direct development upon Norton's approach, there was George Shankle's *American Mottoes and Slang* (1941). Where Norton saw such terms as expressing a political ground level, fluid and alive as an 'argot' or 'slang', Shankle's 'mottoes' and 'slogans' seemed redolent of responsible citizenship:

> In American usage a motto is a word, a phrase, or an expression which tersely, concisely, clearly, and fittingly expresses some moral, religious, social, ethi-cal, educational, or political truth upon which one builds his philosophy of life or upon which he founds his life's activities. A slogan is some pointed term, phrase or expression, fittingly worded, which suggests action, loyalty, or which causes people to decide upon and to fight for the realization of some principle or decisive issue. (7)

For Shankle, evidently, political terms and usage were less rooted in campaigns on the streets and more in staid drawing-room discussion or formal debate. The class locus of political communication now appeared to be neither with the elites nor with the commons, but somewhere between (there is an unmis-takable air of middle-class earnestness). A couple of decades later, with William Safire's *The New Language of Politics: An Anecdotal Dictionary of Catchwords, Slogans, and Political Usage* (1968) the lexicographical approach to political communication took a new turn. In this study's Introduction, my initial notion of 'catchphrase', 'catchword', and 'slogan' were referred to Safire's dictionary.

Insofar as political dictionaries for general reference go, those preceding Safire's seemed to be conceived according to where political discourse is centred, or where political terms predominantly circulate: among the elites, in the streets, amidst responsible citizens. Naturally, political communication continued—and continues—to be variously socially stratified, but Safire's approach to his dictionary seemed relatively uninterested in that. Instead, he focused on what makes words and phrases appealing in political usage, wherever that might be. Accordingly, his choices were especially attentive to the catchiness of 'catchwords', 'catchphrases', and 'slogans' in political usage, more so than earlier political dictionaries. He also performed a kind of lexicographical catchiness on his own behalf, by garnishing explanations with witty and humorous anecdotes—his was an 'anecdotal dictionary'. For Safire, political communication was clearly more about the form of appeal rather than which social stratum is represented or catered for. He said as much in the Introduction:

> This is a dictionary of words and phrases that have misled millions, blackened reputations, held out false hope, oversimplified ideas to appeal to the lowest common denominator, shouted down inquiry, and replaced searching debate with stereotypes that trigger approval or hatred.
> This is also a dictionary that shows how the choice of a word or metaphor can reveal sensitivity and genius, crystallize a mood or turn it into action; some political language captures the essence of an abstraction and makes it understandable to millions (vii).

The modality and effect of communication was the key to political usage here. Unsurprisingly, 'catchwords', 'catchphrases', and 'slogans' in those terms were centred, and each defined according to that which makes them appealing. Thus, 'a catchword' 'crystallizes an issue, sparks a response' (68); 'catch phrases used as slogans summarize and dramatize a genuine appeal' (68); a 'slogan' is 'a brief message that crystallizes an idea, defines an issue, the best of which thrill, exhort, and inspire' (403). Political usage and therefore politics itself, Safire suggested, is primarily about appeals and only secondarily about the characteristics of the polity and the ideologies of political actors.

Leaving aside scholarly and academic dictionaries, Safire's turn seems to mark a general drift in political lexicography and general usage that has only grown since. Politics remain grounded, as always, in the power structures that reify or modify social stratifications, but political communication has increasingly been—is now dominantly—perceived as a different matter: consisting in making appeals, having messages that catch or do not catch, that provoke

or revoke actions and subscriptions. I am inclined to think of this shift as being political itself, engendering the mainstream politics of the present as well as describing the contemporary thrust of political communication. In this respect, in fact, political communication acquires cadences which are largely indistinguishable from commercial communication. That is to say, contemporary politics and business bear upon and penetrate into each other. When I started this study by making a threefold distinction between political catchphrases and commercial catchphrases, I was, as observed already, tacitly acknowledging that the latter are inescapable in our time. More than the distinctions made, it is arguably the enmeshing of political and commercial catchphrases, of politics and business, that characterizes the contemporary idiom. That is one of the reasons why it seems to me that the circulations and networks of political catchphrases offer a helpful grid for doing contemporary history. Catchphrases/words capture more than any narrow or conventional conception of politics and much of the contemporary as a historical (or historicizable) juncture. The catchphrases/words examined in this study have repeatedly shown that political and business interests, ideological principles and commercial calculations, coalesce seamlessly in the current idiom.

The catchiness of catchphrases

Raymond Williams's *Keywords* (1976) also has the appearance of a political dictionary, but his introduction steadfastly refused any such association and described it thus instead:

> It is [...] a record of an inquiry into a *vocabulary*: a shared body of words and meanings in our most general discussions, in English, of the practices and institutions which we group as *culture* and *society*. Every word which I have included has at some time, in the course of some argument, virtually forced itself on my attention because the problems of its meanings seemed to me inextricably bound up with the problems it was being used to discuss. [... The notes on words address] a problem of *vocabulary*, in two senses: the available and developing meanings of known words, which needed to be set down; and the explicit but as often implicit connections which people were making, in what seemed to me, again and again, particular formations of meaning – ways not only of discussing but at another level of seeing many of our central experiences.
>
> (Williams 2015 [1976]: xxvii)

Williams's approach to his chosen terms focused on their shifting connotations and interconnections, and their epistemological significance. They are used, he said, both to refer to and to structure experiences and offer pathways into 'practices and institutions which we group as *culture* and *society*'. That the chosen terms were designated as 'keywords' put the immediate emphasis on their epistemological significance; the notes on them substantiated that designation. Despite Williams's equivocation about their academic basis and insistence on their ordinary currency, collectively they do seem inclined towards the academic. At the least, his choices were redolent of an intellectual register. His notes on 'intellectual' (122–23) usefully gestured towards the scope of this register, and the ambiguous regard in which those au fait with it are held. As Stephen Heath (2013) observed, '[M]ost of the *Keywords* words are abstract nouns of Latin rather than Anglo-Saxon provenance, representative of what Williams would call "the vocabulary of learning and power"' (6–7). Unsurprisingly, much admiring discussion has been devoted to *Keywords* in scholarly publications: by following his example when analysing later or other 'keywords'; by elaborating on Williams's view of culture and society; and occasionally by distinguishing 'keywords' from, for instance, 'catchwords' or 'buzzwords' (an American synonym).

A touch of mystique attaches to the epistemological significance that Williams discerned in his chosen *Keyword* words. That significance is better recognized than defined, easier to demonstrate than theorize about. The significance of these terms, it seems, surfaces through observing culture and society carefully; the perspicacity of the observer is confirmed by being able to understand their significance. Metaphorically, those observers have the 'keys' to culture and society. The mystique of Williams's 'keywords' has inspired a significant number of volumes emulating his book: with a focus on culture (e.g. Bennett, Grossberg, and Morris, eds. 2005; Burgett and Hendler, eds. 2007; MacCabe and Yanachek, eds. 2018), and numerously for specific themes and disciplines. Studies in linguistic semantics and argumentation have occasionally sharpened the rationale of how such keywords work in usage (Wierzbicka 1997: Chapter 1; Bigi and Morasso 2012). These do not divest 'keywords' of that mystique; they show how certain terms, invested with such significance, find their place in the structure and strategies of communication acts. Occasionally, understanding this quality of significance in 'keywords' is also a matter of understanding other words which may seem similar but are not as significant: 'catchwords' or 'buzzwords' are mooted as such at times. The mundaneness of the latter offsets the significance of the former and vice versa. That

the latter are designated 'catchwords' emphasizes their catchiness—their pop-
ularity and frequent usage—but that emphasis is itself taken as showing that
they are not quite 'keywords', that catchiness and significance are contrary
thrusts. Thus, Annabel Patterson (2004: 77) observed: 'When is a potential
keyword not a keyword? When it is merely a catchword'. Taking Safire's dictio-
nary of political catchwords as the source, Patterson felt that keywords have a
'dignity and difficulty' (78) that 'catchwords' do not, though in a few instances
'catchwords' may become 'keywords'. In considering 'nature' as a keyword,
Noel Castree (2014) observed:

> 'Nature' is a keyword rather than a buzzword. Keywords, as Raymond
> Williams (1976) argued in his famous book of this name, have three charac-
> teristics. First, they are 'ordinary', which is to say used widely and frequently
> by all manner of people in all manner of contexts. Second, they are enduring
> rather than ephemeral – they do not come-and-go in a way that buzzwords
> like 'globalisation' or 'post-modernism' do. Finally, keywords possess what
> cultural critic Tony Bennett and colleagues, in their update of Williams's
> book, call 'social force'. (8–9)

Actually, it is doubtful whether Williams regarded keywords as enduring. His
introduction mentioned choosing keywords which show both 'continuity and
discontinuity' (2015 [1976]: xxxiv), and it is questionable whether some of
his keywords (like 'dialectic' and 'reactionary') have quite endured. It is of
course similarly questionable whether 'globalization' is a 'come-and-go' buz-
zword. The key to 'keywords' as differentiated from 'buzzwords' here is in
the perceived deep significance, the 'social force'. Accepting Castree's distinc-
tions, Thomas Skou Grindsted (2018: 57–8) felt that nevertheless a term like
'sustainability' lies somewhere between being a keyword and a catchword.

I have given this brief account of Williams's notion of 'keywords' mainly
to distance the remainder of this argument from its powerful influence. In
this final section, I explore the issue of the catchiness of 'catchwords' and
'catchphrases', without assuming that catchiness is contrary to significance.
How significant the catchphrases/words taken up in the previous chapters
are, and by what criteria, is evident in the discussions and do not involve
the sort of epistemological weight attached to keywords à la Williams. Inso-
far as understanding the catchiness of catchphrases/words goes, I feel that
can be productively considered via keywords, but not in the sense Williams
used the term, indeed in quite another sense. But before taking that up, let
me be clear about the purpose with which the notion of catchiness is raised

here. Attention to the catchiness of words, phrases, slogans, idioms, etc. has conventionally tended to focus on their content and context: what catches, where, and when? Safire's (1968) notes on catchphrases/words and slogans focused on their catchy content-in-context, which included factors such as ambiguity, word-play and wit, aural effects like alliteration and rhyming, and crystallization of an issue, etc. With regard to political catchphrases/words, a voluminous body of publications in research areas like 'political marketing' and 'campaign advertising' have explored such factors, mainly with applied interests, sometimes in terms of consumer and social psychology or as a matter of historical richness. That is not the dimension of catchiness I consider here; that dimension has cropped up to the extent needed in the case studies. A significant body of research has also investigated the processes through which catchphrases/words, slogans, etc. spread: how do they catch? In the main, such research takes recourse to quantitative methods: for example, tracking frequency of usage, modelling proliferation, and factor analysis of targeting and uptake. These methods have been especially profitably employed, with capitalizable outcomes, for and in the digital environment. That too is not the direction I pursue here.

By way of drawing this study towards a close, I turn to a question which is neither about the content of catchiness and nor about the measures of catchiness, but which bears upon both. This is a question of articulating the concept: what is *catchiness* in relation to a catchphrase/word? How can it be described? What sort of condition does it manifest? A concept of catchiness such as the following had, at any rate, led me into this project, and may retrospectively clarify some corners of the case studies that I have examined..

Let me go back to keywords, but not in Williams's sense. The OED gives the following senses of the term 'keyword':

1a. A word that serves as the key to a cipher or code;
1b. A word or idea that serves as a solution or explanation for something; a word, expression, or concept of particular importance or significance;
2. A word (usually one of several) chosen to indicate or represent the content of a larger document, text, record, etc., in an index, catalogue, or database. Later also: any word entered as a search term in a database or search engine.

Williams's use of the term was in sense 1b, which is related to 1a (both under sense 1). In terms of sense 1a, Williams's keywords could be thought of as keys

to crack the code of culture and society. Sense 2 puts keywords as practical de-
vices for structuring information about texts and accessing information from
texts. Here 'text' has a broad sense, including written documents, recordings,
linguistic corpora, datasets, and collections of any or all of those. Insofar as
the search terms featuring in a book index or library catalogue are regarded as
keywords, these are chosen and arranged so that readers can find what they are
looking for in the book or library. Similarly, if the most frequently used words
featuring in a linguistic corpus are taken as keywords, researchers can use list-
ings of these to explore the corpus for various purposes. These are examples
of sense-2 keywords.

To hone this argument, let us consider sense-2 keywords in books (in codex
form). Some sense-2 keywords appear and guide reading from the beginning:
terms in the title, contents listing, and chapter headings and sub-headings.
These could be considered *text-describing-keywords*. They map the overall
structure and sequential order of the book. Other sense-2 keywords are listed
in alphabetical (or some such) order at the end, the *indexed-keywords*. Readers
use indexed-keywords to locate particular themes or names which are dis-
cussed in the book. These indexed-keywords are listed by the book's indexer
because they expect readers to look for them; that is to say, these keywords
have some significance beyond the book, which readers are likely to bring
to their search. That is why the indexer chooses and lists them in anticipa-
tion: let us call this their *received-significance*. At the same time, a reader looks
for a particular keyword in the index not simply because it has a received-
significance but because it has some specific significance for that reader, is
somehow relevant to their purpose: let us call this *attributed-significance*. The
attributed-significance is likely to lead into 'about'-questions that a reader asks:
for example, 'let me see what this book says *about* this concept, person, event,
phenomenon, etc. (which are named as keywords)?' In consulting the index to
find a keyword, the reader hopes that its received-significance and attributed-
significance coincide. The keyness of these indexed keywords rests in the
frequent concurrence of received-significance and attributed-significance. In
other words, the keyness is in these words having some general significance al-
ready and in being conferred some particular significance for a search. In the
case of a book, the indexed-keywords are understood as conditional to the
text-describing-keywords. The received-significance is delimited according
to the discursive remit of the text-describing-keywords; and the attributed-
significance is sought with reference to that remit. A book's keywords, then,
are structuring devices of the book as well as devices to structure reading.

Somewhat more complex considerations arise for sense-2 keywords with that afterthought in the OED definition: 'any word entered as a search term in a database or search engine'. Let's call these *search-keywords*, used for accessing digital resources. These are akin to indexed-keywords (both are in OED's sense 2), and yet these are obviously different. Let me focus on the basic functions of a search engine where search-keywords are used to look for information and material in the World Wide Web (Web hereafter). To some extent, search-keywords are used for the Web in similar ways as indexed-keywords for books. But the differences are germane, arising from the fact that the Web and the book are very different kinds of texts. Consequently, the keyness of indexed-keywords and search-keywords operate in different ways. The Web could be thought of as a very large text—the largest there is—and extremely fluid: a super-text. As such, the Web incorporates within its super-textual structure all kinds of texts, in numerous forms and modalities, variously accessible from widely distributed portals; moreover, incorporated texts are variously interconnected (hyperlinked); and further, texts are in an ongoing process of incorporation, accruing second by second, while a great many texts are also continuously removed from the Web. The only unifying feature of these texts within the Web's super-textual structure is that they are incorporated through machine code. This machine code has no meaningful relationship with the textual codes that are prolifically displayed, that is to say, to the substantive content of the texts incorporated in the Web. Therefore, unlike a book, as a super-text, the Web can have no text-describing-keywords. It is simply too prolific and fluid to be grasped *in toto* or sequentially. For the same reason, the Web as a super-text, can have no meaningful listing of indexed-keywords; only relatively small and coherent bits of the Web can be indexed. Search-keywords for the Web are a means of replacing the functions that both text-describing-keywords and indexed-keywords serve for a book.

Nevertheless, search-keywords for the Web have an affinity to indexed-keywords in a book. Where the reader searches for an indexed-keyword of interest to them amongst those listed in a book, a Web search engine allows the searcher to input their own keyword and then locate where in the Web it appears. The engine's search-results then appear as a listing of texts within the Web where that keyword appears. For any one search-keyword there are usually many results listed. That plethora is managed in two ways. On the one hand, the results listing could have some criteria of ordering, for example by date, length, or relevance (frequency of the keyword's occurrence in a text). On the other hand, the searcher can narrow down the search by combining several search-keywords and phrases.

As with searching through indexed-keywords for a book, in choosing
search-keywords for the Web the starting question is likely to be an 'about'
question: for example, 'let me see what information can be found on the Web
about this concept, person, event, etc. (named by the keyword)?' The main
difference between indexed-keywords for books and search-keywords for the
Web is in how their attributed-significance and received-significance are ne-
gotiated by the searcher. For indexed-keywords of a book, inclusion in the
index acknowledges received-significance, the searcher brings the attributed-
significance, and both are conditional to and delimited by the scope of
the text-describing-keywords. In choosing search-keywords for the Web, the
searcher's attributed-significance is very much determinative and the received-
significance seems relatively indeterminate. It could perhaps be estimated by
the searcher from general usage outside the digital environment of the Web,
which in any case would be implicit in the attributed-significance. Since the
Web offers no text-defining-keywords, no other direction about received-
significance is available to the searcher in appointing search-keywords. How-
ever, as the search is undertaken and develops, the received-significance of the
search-keyword is anticipated, estimated, and sharpened by degrees with the
attributed-significance in mind. In the process of using the search engine with
search-keywords—after they are keyed in and results consulted and search
narrowed by combining search-keywords and so on—the searcher gradu-
ally gauges the received-significance and accordingly adjusts the attributed-
significance of search-keywords. Thus, search-keywords for the Web are
inevitably opened to negotiations of both attributed-significance and received-
significance *within the process of searching. Search-keywords, we may say,
are implicitly processive.* The processing continues till the searcher feels con-
tent that the 'about'-question has been answered sufficiently or has become
irrelevant.

A Web searcher working through search-keywords typically does two other
kinds of activities alongside which are intricately woven through the search
process. The infrastructure of the Web and the facilities built into search en-
gines encourage such enmeshing of activities. First, searching could give way
to surfing or surfing could become a form of open-ended searching. This ef-
fectively removes the focus on an 'about'-question and leads into unplanned
encounters with texts in the Web. That could be a matter of finding some un-
related but interesting text appearing from a keyword search, or following a
chain of hyperlinks between texts. Second, in the process of searching and
surfing, the searcher-surfer could become a contributor to the Web, or, in other
words, become a participative reader and writer. They could add texts to the

Web by putting comments on existing texts or, more elaborately, by generating (posting) their own texts. Searching via keywords could slide in and out of surfing and contributing in a continuous process, where the negotiations of attributed- and received-meanings of keywords flicker and blur, are matched and mismatched, and meet and depart from each other; keywords may be forgotten, switched, and acquire unexpected associations and connotations. Instead of searchers simply using search-keywords in search engines, we really have searcher-surfer-contributors following a search-surf-contribute process. Though search-keywords vis-à-vis the Web have some affinity with indexed-keywords for a book, their usage is considerably more multifaceted. This is so much so that the OED could well put in a sense 3 of the term 'keyword' for Web searching, separated from sense 2.

Thus far, I have been describing what a searcher-surfer-contributor (for brevity, let's call this person SSC) does with search-keywords and search engines on the Web. Now, let's consider how this picture looks from the perspective of tracking the activities of such SSCs on the Web. Over a given period, an SSC's activities may show some such behaviour as the following. As a searcher, the SSC's habitual or preferred search-keywords lead to results listings in which those keywords are frequently associated with a small number of words or phrases. For example, if the SSC searches 'football fixtures', they find that many of the results listed are of texts which are headlined or otherwise associated with the phrase 'new normal'. Further, combining such words and phrases (as search-keywords themselves) with other search-keywords, such as 'new normal' combined with 'shopping' instead of 'football fixtures', brings up result listings of similar scale and density. As a surfer, the SSC finds that following hyperlinks starting from any search-keyword leads to various texts where that small number of words and phrases features. Thus, if the SSC starts with a text on 'football fixtures' and then surfs through hyperlinks and further searches to texts on travel, food, schools, etc., they find that 'new normal' seems to come up one way or another in a great many of them. As a contributor, the SSC then starts using those words and phrases themselves, in their comments, messages, etc. The search-keywords which structure the SSC's entry and activities into the Web, amidst its ever-growing multitude of texts, thus throw up some words and phrases which are used with particularly high frequency and in diverse contexts in the period in question. These are catchphrases and catchwords.

If search-keywords enable the SSC to find their way in the Web, catchphrases/words allow them to acclimatize themselves with the super-text that is the Web and share the idiom of other SSCs there. An SSC's choice

of a search-keyword is made in terms of its attributed-significance, which opens the searching-surfing-contributing process in the Web. That process constitutes the SSC's presence in the Web, and along the way the SSC apprehends something of the search-keyword's received-significance. Gauging the received-significance of the search-keywords is mainly a matter of locating them according to the prevailing idiom in use in the Web, a kind of aggregate of characteristic linguistic habits of all SSCs in a given period on the Web. The catchphrases/words that the SSC latches on to while searching-surfing-contributing provide the idiomatic grid in terms of which the received-significance of any keyword—all keywords—is placed. They could be thought of as similar to text-defining-keywords in a book, but instead of being given first they are discovered gradually. The process of starting with a chosen search-keyword and searching-surfing-contributing could be regarded as a process of becoming acclimatized to catchphrases/words which give the SSC some command over the super-text that is the Web.

If, over that period, the online activities of all the SSCs who use English were tracked, some such picture as the following would appear. It would be evident that certain search-keywords are more frequently employed than others, some texts are more often hit upon than others, some SSCs surf more texts than others, and some SSCs make more contributions than others. These could be represented in different distribution charts. If the bearing of catchphrases/words were factored into these distribution charts, they would be tagged to the dense areas of distribution. That is to say, the catchphrases/words would appear most frequently in search-keyword results listings and as keywords themselves; the catchphrases/words would provide the most frequent pathways in surfing; the catchphrases/words would be employed most often in contributions. That describes the catchiness of catchphrases and catchwords.

In beginning my researches into the case studies for this book, that was the description of catchiness I had in mind. I figured that visualizing catchiness thus, in terms of search-keywords and Web search engines, has a larger import. The mechanics of communicative actions and interactions on the Web are analogous to and overlap with other modes and spaces of communication. The Web is both a part of the social world and reflects practices prevalent across the social world. Habitual oral and written, unthinkingly performed and thinkingly staged, interpersonal and collective communications in various areas of social life are difficult to visualize because they are habitual and transient and we are immersed in them. However, they become more tractable when considered in terms of the mechanics of the Web, where every aspect of the habitual

has to be engineered and becomes retraceable. So, the description of catch-phrases/words which applies in the digital environment is indicative, if not directly revealing, for understanding catchphrases/words in word-of-mouth exchanges or print and broadcast circulations.

However, this description of the catchiness of catchphrases/words says little about the political and commercial interests that play in them and the social forces that bear upon them. The description merely tells us what catchiness is and what makes catchphrases/words recognizable as such. It gives few clues about how catchiness starts being generated, when and why catchphrases ap-pear as such, when they change connotations or cease to be catchy, to what extent they are voluntarily designed, and to what extent they emerge sponta-neously. Such questions implicate too many variables to allow for satisfactory anticipatory generalization; these questions are best considered on a case-by-case basis. The case studies offered in the preceding chapters were devoted to answering these questions. This book has thus analysed the political and commercial forces and interests that go into the production and career of a small number of, specifically, political catchphrases: 'new normal', 'austerity' and 'resilience', 'the 99%' and 'the 1%' and 'We are the 99%'. I hope that in the course of analysing these, the mechanics of catchiness has been clarified to a certain extent and some of the contours of contemporary history have been mapped.

Bibliography

Abrams, Lynn (2016), *Oral History Theory*. 2nd edn. (Abingdon: Routledge).

ACE (2013), 'Great Arts and Culture for Everyone: 10-Year Strategic Framework, 2010–2020', Manchester: ACE, https://www.artscouncil.org.uk/sites/default/files/download-file/Great_art_and_culture_for_everyone.pdf (accessed 2 February 2020).

ACE (2014), 'This England: How Arts Council England Uses its Investment to Shape a National Cultural Ecology', Manchester: ACE, https://www.artscouncil.org.uk/publication/this-england (accessed 2 February 2020).

ACE (2016a), 'Building Resilience Programme: Guidance for Applicants', https://www.artscouncil.org.uk/sites/default/files/download-file/Building_Resilience_guidance_applicants__0.pdf (accessed 2 February 2020).

ACE (2016b), 'Museum Resilience Fund: Guidance for Applicants', https://www.artscouncil.org.uk/sites/default/files/download-file/Museum_resilience_fund_round_2_guidance.pdf (accessed 2 February 2020).

ACE (2016c), 'Catalyst: Evolve, Guidance for Applicants', https://www.artscouncil.org.uk/sites/default/files/download-file/Catalyst_Evolve_guidance.pdf (accessed 2 February 2020).

ACE (2016d), 'Elevate Fund: Guidance for Applicants', https://www.artscouncil.org.uk/sites/default/files/download-file/Elevate_Fund_Guidance_for_applicants.pdf (accessed 2 February 2020).

ACE (2017a), 'Catalyst Small Grants Programme: Guidance for Applicants', https://www.artscouncil.org.uk/sites/default/files/download'(accessed 2 February 2020) file/Catalyst%20Small%20Grants%20Guidance%20-%20FINAL%20April%202017.pdf (accessed 2 February 2020).

ACE (2017b), 'Sustaining Great Art', Manchester: ACE, https://www.artscouncil.org.uk/publication/sustaining-great-art-1617 (accessed 2 February 2020).

ACE (website), 'Envisioning the Library of the Future', https://www.artscouncil.org.uk/sector-resilience/envisioning-library-future#section-6 (accessed 2 February 2020).

ACE with BOP Consulting (2015), 'Catalyst Evaluation Year 1', Manchester: ACE, https://www.artscouncil.org.uk/catalyst-evaluation-year-one-final-report (accessed 2 February 2020).

Adger, W. Neil (2000), 'Social and Ecological Resilience: Are they Related?' *Progress in Human Geography* 24/3, 347–64. https://doi.org/10.1191%2F030913200701540465 (accessed 2 February 2020).

Adler, Paul S. (2019), *The 99 Percent Economy: How Democratic Socialism Can Overcome the Crises of Capitalism* (Oxford: Oxford University Press).

Al Jazeera Staff (2021), 'Wealthy Americans Fare Better in the Pandemic, New Survey Shows', *Al Jazeera*, 5 March, https://www.aljazeera.com/economy/2021/3/5/wealthy-americans-fare-better-in-the-pandemic-new-survey-shows (accessed 22/3/2021).

Alkire, Sabina, and Santos, Maria Emma (2010), *Acute Multidimensional Poverty: A New Index for Developing Countries* (Human Development Research Paper 2010/11) (New York: United Nations Development Programme).

Alvaredo, Facundo, Atkinson, Anthony B., Piketty Thomas, and Saez, Emmanuel (2013), 'The Top 1 Percent in International and Historical Perspective', *The Journal of Economic Perspectives*, 27/3, 3–20.

Amnesty International (2020), 'COVID-19, Surveillance and the Threat to your Rights', *Amnesty International*, 3 April, https://www.amnesty.org/en/latest/news/2020/04/covid-19-surveillance-threat-to-your-rights/ (accessed 2 January 2021).

Anderson, Barry, and Minnerman, Elizabeth (2014), 'The Abuse and Misuse of the Term "Austerity": Implications for OECD Countries', *OECD Journal of Budgeting*, 14/1, 109–22, https://doi.org/10.1787/budget-14-5jxrmdxc6sq1.

Andoh, Efua (2020), 'How Psychologists are Helping America Cope with the New Normal', *Amercian Psychological Association*, 18 May, https://www.apa.org/topics/covid-19/helping-america (accessed 2 January 2021).

Anstead, Nick (2018), 'The Idea of Austerity in British Politics, 2003–2013', *Political Studies* 66/2, 287–305. doi: 10.1177/0032321717720376.

Arruzza, Cinzia, Bhattacharya, Tithi, and Fraser, Nancy (2019), *Feminism for the 99%* (London: Verso).

Arter, Melanie (2020), 'Cuomo: "We're Going to a Different Place, Which Is a New Normal"'. *CNS*, 15 April, https://www.cnsnews.com/article/national/melanie-arter/cuomo-were-going-different-place-which-new-normal (accessed 2 January 2021).

Arts Council England (ACE) (2010), 'Achieving Great Arts for Everyone: A Strategic Framework for the Arts', London: ACE, https://webarchive.nationalarchives.gov.uk/2010121519944/http://www.artscouncil.org.uk/publication_archive/strategic-framework-arts/ (accessed 2 February 2020).

Ashley, Jackie (2008), 'Comment & debate: Austerity is in, class is back, and Labour can win again', *The Guardian*, 15 December. 33.

Association of Cultural Enterprises (website), 'Retail Resilience (2015–16)', https://acenterprises.org.uk/retail-resilience-programme (accessed 2 February 2020).

Atkinson, Anthony B. (1970), 'On the Measurement of Inequality', *Journal of Economic Theory*, 2/3, 244–63.

Atkinson, Anthony B. (1987), 'On the Measurement of Poverty', *Econometrica*, 55/4, 749–64.

Atkinson, Anthony B. (2015), *Inequality: What Can Be Done?* (Cambridge MA: Harvard University Press).

Atkinson, Anthony B., Piketty, Thomas, and Saez, Emmanuel (2011), 'Top Incomes in the Long Run of History', *Journal of Economic Literature*, 49/1, 3–71.

Auxier, Randall E. (2002), 'Foucault, Dewey, and the History of the Present', *The Journal of Speculative Philosophy*, 16/2, 75–102, http://dx.doi.org/10.1353/jsp.2002.0009.

Azmanova, Albena (2020), *Capitalism on Edge: How Fighting Precarity Can Achieve Radical Change Without Crisis or Utopia* (New York: Columbia University Press).

Badiou, Alain (2017 [2016]), *The True Life*. Trans. Susan Spitzer. (Cambridge: Polity).

Bagby, Wesley M. (1962), *The Road to Normalcy: The Presidential Campaign and the Election of 1920* (Baltimore: Johns Hopkins University Press).

Bahadur, Aditya V., and Dodman, David (2020), 'Disruptive Resilience: An Agenda for the New Normal in Cities of the Global South', *IIED Briefing*, September, https://pubs.iied.org/sites/default/files/pdfs/migrate/17766IIED.pdf (accessed 17 February 2021).

Bambra, Clare, Riordan, Ryan, Ford, John, and Matthews, Fiona (2020), 'The COVID-19 Pandemic and Health Inequalities', *Journal of Epidemiology and Community Health*, 74, 964–68, doi:10.1136/jech-2020-214401. https://jech.bmj.com/content/74/11/964 (accessed 5 January 2021).

Barraclough, Geoffrey (1967 [1964]), *An Introduction to Contemporary History* (Harmondsworth: Penguin).

Bawden, Tom (2013), 'Extreme Heatwaves Are Predicted as the New Normal for British Summers by 2040', *The Independent*, 15 August, https://www.independent.co.uk/environment/climate-change/extreme-heatwaves-are-predicted-new-normal-british-summers-2040-8762336.html (accessed 7 December 2020).

Beagle, Jan (2020), 'Statement of the Director General of IDLO: A Rule of Law Based Response to the COVID-19 Pandemic', IDLO [International Development Law Organization], 27 March, https://www.idlo.int/news/policy-statements/statement-director-general-idlo-jan-beagle-rule-law-based-response-covid-19 (accessed 5 January 2021).

Beaumont, Peter (2020), 'Reopening Schools: How Different Countries are Tackling Covid Dilemma', *The Guardian*, 28 August. https://www.theguardian.com/education/2020/aug/28/reopening-schools-different-countries-tackle-education-conundrum-coronavirus (accessed 2 January 2021).

Beijer Institute (website), http://www.beijer.kva.se/sida.php?id=1 (accessed 2 February 2020).

Bell, Chris (2017), 'German Election: "We Are the 87%", Say AfD Opponents', *BBC*, 25 September, https://www.bbc.co.uk/news/blogs-trending-41384799 (accessed 22/3/2021).

Bennett, Tony, Grossberg, Lawrence, and Morris, Meaghan (eds.) (2005), *New Keywords: A Revised Vocabulary of Culture and Society* (Oxford: Blackwell).

Berkes, Fikret, Colding, Johan, and Folke, Carl (eds.) (2003), *Navigating Social-Ecological Systems: Building Resilience for Complexity and Change* (Cambridge: Cambridge University Press).

Berkes, Fikret, and Folke, Carl (1994), *Linking Social and Ecological Systems for Resilience and Sustainability* (Beijer Discussion Paper Series No.52). Stockholm : Beijer International Institute of Ecological Economics.

Berkes, Fikret, and Folke, Carl (eds.) (1998), *Linking Social and Ecological Systems: Management Practices and Social Mechanisms for Building Resilience* (Cambridge: Cambridge University Press).

Berry, Helen (2014), 'The Pleasures of Austerity'. *Journal for Eighteenth-Century Studies*, 37/2, 261–77. doi:10.1111/1754-0208.12137.

Betts, Hannah (2008), 'Taste during the Recession: "Economic Restraints Ensure Beauty"', *The Telegraph*, 9 July, https://www.telegraph.co.uk/news/features/3637234/Taste-during-the-recession-Economic-restraints-ensure-beauty.html (accessed 2 February 2020).

Bhatt, Jiggar (2012), '"We Are the 99 Percent" – The Unlikely Journey of a Revolutionary Slogan', *Huffington Post*, 19 March, https://www.huffpost.com/entry/we-are-the-99-percent_b_1362141 (accessed 22/3/2021).

Bick, Raphael, Chang, Michael, Wang, Kevin Wei, and Yu, Tianwen (2020), 'A Blueprint for Remote Working: Lessons from China', *McKinsey Digital*, 23 March, https://www.mckinsey.com/business-functions/mckinsey-digital/our-insights/a-blueprint-for-remote-working-lessons-from-china (accessed 2 January 2021).

Biello, David (2010), 'The New Normal? Average Global Temperatures Continue to Rise', *Scientific American*, 22 July, https://www.scientificamerican.com/article/average-global-temperature-rise-creates-new-normal/ (accessed 7 December 2020).

Bigi and Morasso (2012), 'Keywords, Frames and the Reconstruction of Material Starting Points in Argumentation', *Journal of Pragmatics*, 44/10, 1135–49, https://doi.org/10.1016/j.pragma.2012.04.011.

Black Liberation Month News (1984), "The USA: Who Owns It? Who Runs It?". Chicago, February. 6.

Blackbourn, David (2012), "'The Horologe of Time": Periodization in History', *PMLA/Publications of the Modern Language Association of America*, 127/2, 301–07. doi 10.1632/pmla.2012.127.2.301.

Bloom, Peter (2017), *The Ethics of Neoliberalism: The Business of Making Capitalism Moral* (New York: Routledge).

Blyth, Mark (2013), *Austerity: The History of a Dangerous Idea* (Oxford: Oxford University Press).

Boosting Resilience (website) (2016–18), https://www.boostingresilience.net/ (accessed 2 February 2020).

BOP Consulting (2016), 'Character Matters: Attitudes, Behaviours and Skills in the UK Museum Workforce', https://www.artscouncil.org.uk/sites/default/files/download-file/Character_Matters_UK_Museum_Workforce_full_report.pdf (accessed 2 February 2020).

Breau, Sébastien (2014), 'The Occupy Movement and the Top 1% in Canada', *Antipode*, 46/1, 13–33.

Brooks, David (2011), 'The Milquetoast Radicals', *New York Times*, 10 October, http://www.nytimes.com/2011/10/11/opinion/the-milquetoast-radicals.html (accessed 22/3/2021).

Brown, Gordon (2009), 'PM's Message on the Pre-Budget Report', Number10.gov.uk, 9 December, https://webarchive.nationalarchives.gov.uk/20100304193937/http://www.number10.gov.uk/Page21681 (accessed 10 February 2021).

Bruininks, Robert H., Keeney, Brianne, and Thorp, Jim (2010), 'Transforming America's Universities to Compete in the "New Normal"', *Innovative Higher Education*, 35, 113–25, https://doi.org/10.1007/s10755-009-9135-y (accessed 4 January 2021).

Bunting, Catherine (2006), 'Public Engagement with the Arts: Art Council England's Strategic Challenges', London: Arts Council England, https://webarchive.nationalarchives.gov.uk/20160204123102/http://www.artscouncil.org.uk/advice-and-guidance/browse-advice-and-guidance/public-engagement-with-the-arts-arts-council-englands-strategic-challenges (accessed 2 February 2020).

Burgett, Bruce, and Hendler, Glenn (eds.) (2007), *Keywords for American Cultural Studies* (New York: New York University Press).

Bush, George W. (2001), 'Address to a Joint Session of Congress and the American People, Washington D.C', *The White House,* 20 September, https://georgewbush-whitehouse.archives.gov/news/releases/2001/09/20010920-8.html (accessed 2 January 2021).

Cai Feng ed. (2020), *China's Economic New Normal: Growth, Structure and Momentum* (Singapore: Springer).

Callus, Ivan, and Herbrechter, Stephan (eds.) (2004). *Post-Theory, Culture, Criticism* (Amsterdam: Rodopi).

Cameron, David (2009), 'The Age of Austerity'. 26 April. *Conservative Party Speeches, SayIt.* https://conservative-speeches.sayit.mysociety.org/speech/601367 (accessed 23 November 2020).

Caner, Asena, and Wolff, Edward N. (2004), 'Asset Poverty in the United States, 1984-99: Evidence from the Panel Study of Income Dynamics', *Review of Income and Wealth*, 50/4, 493–518.

Canguilhem, Georges (1989 [Fr. 1966]), *The Normal and the Pathological.* Trans. Caroline R. Fawcett with Robert S. Cohen. (New York: Zone).

Carter, Julian B. (2007), *The Heart of Whiteness: Normal Race and Sexuality in America, 1886-1940* (Durham NC: Duke University Press).

Caso, Federica (2020), 'Are We at War? The Rhetoric of War in the Coronavirus Pandemic', *The Disorder of Things*, 10 April, https://thedisorderofthings.com/2020/04/10/are-we-at-war-the-rhetoric-of-war-in-the-coronavirus-pandemic/ (accessed 2 January 2020).

Castree, Noel (2014), *Making Sense of Nature: Representation, Politics and Democracy* (Abingdon: Routledge).

CDC [Centers for Disease Control and Prevention] USA Government (2020), 'Health Equity Considerations and Racial and Ethnic Minority Groups', CDC, 24 July, https://www.cdc.gov/coronavirus/2019-ncov/community/health-equity/race-ethnicity.html (accessed 2 January 2021).

Cellan-Jones, Rory (2001), *Dot.Bomb: The Strange Death of Dot.com Britain* (London: Aurum).

Cheney, Dick (2001), 'Vice President Cheney Delivers Remarks to the Republican Governors Association', 25 October, *The White House: President George W. Bush*, https://georgewbush-whitehouse.archives.gov/vicepresident/news-speeches/speeches/vp20011025.html (accessed 23 November 2020).

Christensen, Kathleen (2013), 'Launching the Workplace Flexibility Movement: Work Family Research and a Program of Social Change'. *Community, Work & Family*, 16/3, 261–84. doi: 10.1080/13668803.2013.820092.

Christiansen, Thomas (2020), 'The EU's New Normal: Consolidating European Integration in an Era of Populism and Geo-Economics', *Journal of Common Market Studies*, 58/S1, 13–27, https://doi.org/10.1111/jcms.13106 (accessed 4 January 2021).

CidaCo (2015), 'Evaluation of the Developing Cultural Sector Resilience Programme', https://www.artscouncil.org.uk/sites/default/files/download-file/Evaluation%20of%20the%20Developing%20Cultural%20Sector%20Resilience%20Programme.pdf (accessed 2 February 2020).

Cole, Joshua (2000), *The Power of Large Numbers: Population, Politics and Gender in Nineteenth-Century France* (Ithaca: Cornell University Press).

Coleman, Victoria (2021), *Digital Divide in UK Education During COVID-19 Pandemic: Literature Review* (Cambridge Assessment Research Report) (Cambridge, UK: Cambridge Assessment).

Collins, Chuck (2021), 'COVID-19 Has Made the Super-Rich Richer: It's Time for a Billionaire Wealth Tax', *Open Democracy*, 1 March, https://www.opendemocracy.net/en/oureconomy/covid-19-has-made-the-super-rich-richer-its-time-for-a-billionaire-wealth-tax/ (accessed 22/3/2021).

Connor, Michael with Olson, Marisa, and Shirky, Clay (2008), *The New Normal* (New York: Independent Curators International and Artists Space).

Costanza, Robert (ed.) (1991), *Ecological Economics: The Science and Management of Sustainability* (New York: Columbia University Press).

Costanza, Robert, Norton, Bryan G., and Haskell, Benjamin D. (eds.) (1992), *Ecosystem Health: New Goals for Environmental Management* (Washington DC: Island).

Cox, Jeff (2011), 'Protests Target "One Percent," But Who Exactly Are They?' *CNBC*, 19 October, https://www.cnbc.com/id/44960983 (accessed 22/3/2021).

Cox, Josie (2020), 'COVID-19 and the Corporate Cliché: Why We Need To Stop Talking About "The New Normal"', *Forbes*, 22 April, https://www.forbes.com/sites/josiecox/2020/04/22/covid-19-corporate-cliche-why-we-need-to-stop-talking-about-the-new-normal/?sh=6395f7fd159e (accessed 2 January 2021).

Craig, David (2020), 'Pandemic and its Metaphors: Sontag Revisited in the COVID-19 Era', *European Journal of Cultural Studies*, 23/6, 1025–32. doi:10.1177/1367549420938403 (accessed 5 January 2021).

Craig, Doris (1990), *Catch Phrases, Clichés and Idioms: A Dictionary of Familiar Expressions* (Jefferson NC: McFarland).

Creadick, Anna G. (2010), *Perfectly Average: The Pursuit of Normality in Postwar America* (Amherst MA: University of Massachusetts Press).

Croce, Benedetto (1921), *Theory of History and Historiography* . Trans. Douglas Ainslie. (London: George G. Harrap).

Crouch, Colin (2011), *The Strange Non-Death of Neoliberalism* (Cambridge: Polity).

Cryle, Peter, and Stephens, Elizabeth (2017), *Normality: A Critical Genealogy* (Chicago: University of Chicago Press).

D'Orville, Hans (2020), 'COVID-19 Causes Unprecedented Educational Disruption: Is There a Road Towards a New Normal?' *Prospects*, 49, 11–15, https://dx.doi.org/10.1007%2Fs11125-020-09475-0 (accessed 2 January 2021)

Danner, Chas (2020), 'Read What Presidents Obama, Bush, Carter, and Clinton Have Said About George Floyd', *New York Magazine*, 3 June. https://nymag.com/intelligencer/2020/06/obama-bush-carter-george-floyd-protests.html (accessed 2 January 2021)

Dardot, Pierre, and Laval, Christian (2019 [2016]), *Never-Ending Nightmare: The Neoliberal Assault on Democracy*. Trans. Gregory Elliot. (London: Verso).

Davey, Alan (2012), 'Arts Funding in a Cold Financial Climate' (transcript of address delivered 16 November 2011). *Vital Speeches International* 4:1, January, 13–20.

Davis, Ian (2009), 'The New Normal', *McKinsey Quarterly*, 1 March, https://www.mckinsey.com/business-functions/strategy-and-corporate-finance/our-insights/the-new-normal# (accessed 23 November 2020).

Davis, Lennard J. (1995), *Enforcing Normalcy: Disability, Deafness, and the Body* (London: Verso).

De Paolo, Charles (2006), *Epidemic Disease and Human Understanding: A Historical Analysis of Scientific and Other Writings* (Jefferson NC: McFarland).

Dempsey, Noel (2016), *Arts Funding: Statistics* (Briefing Paper, Number CBP 7655). (London: House of Commons Library), https://researchbriefings.parliament.uk/ResearchBriefing/Summary/CBP-7655#fullreport (accessed 2 February 2020).

Department of Digital, Culture and Sport (DCMS) (2017), 'Tailored Review of Arts Council England', https://www.gov.uk/government/publications/tailored-review-of-arts-council-england (accessed 2 February 2020).

DePierro, Jonathan, Lowe, Sandra, and Katz, Craig (2020), 'Lessons Learned from 9/11: Mental Health Perspectives on the COVID-19 Pandemic', *Psychiatry Research*, 288, June, 113024. https://doi.org/10.1016/j.psychres.2020.113024 (accessed 2 January 2021)

Desrosières, Alain (1998 [1993]), *The Politics of Large Numbers: A History of Statistical Reasoning*. Trans. Camille Nash. (Cambridge MA: Harvard University Press).

DeVerteuil, Geoff, and Golubchikov, Oleg (2016), 'Can Resilience be Redeemed? Resilience as a Metaphor for Change, not against Change', *City*, 20:1, 143–51, doi:10.1080/13604813.2015.1125714.

Diamond, Peter, and Saez, Emmanuel (2011), 'The Case for a Progressive Tax: From Basic Research to Policy Recommendations', *Journal of Economic Perspectives*, 25/4, 165–90.

Donnelly, Kevin (2016), *Adolphe Quetelet, Social Physics and the Average Man, 1796-1874* (Pittsburgh: University of Pittsburgh Press).

Duncan, Arne (2010), 'The New Normal: Doing More with Less – Secretary Arne Duncan's Remarks at the American Enterprise Institute', 17 November, *US Department of Education*, https://www.ed.gov/news/speeches/new-normal-doing-more-less-secretary-arne-duncans-remarks-american-enterprise-institut (accessed 23 November 2020).

Duplaga, Mariusz (2020), The Determinants of Conspiracy Beliefs Related to the COVID-19 Pandemic in a Nationally Representative Sample of Internet Users', *International Journal of Environmental Research and Public Health* 17, 7818, http://dx.doi.org/10.3390/ijerph17217818 (accessed 4 January 2021)

Dziuban, Charles D., Graham, Charles R., Moskal Patsy D., Norberg, Anders, and Sicilia, Nicole (2018), 'Blended Learning: The New Normal and Emerging Technologies', *International Journal of Educational Technology in Higher Education*, 15/3, https://doi.org/10.1186/s41239-017-0087-5 (accessed 4 January 2021).

Dziuban, Charles D., Hartman, Joel L., and Moskal, Patsy D. (2004), 'Blended Learning. Educause Center for Applied Research: Research Bulletin 2:7', March, https://library.educause.edu/resources/2004/3/blended-learning (accessed 4 January 2021).

Eaton, George (2019), 'The Age of Post-Austerity – Why Labour and the Tories Have Embraced Big Government', *New Statesman*, 4 November, https://www.newstatesman.com/politics/economy/2019/11/age-post-austerity-why-labour-and-tories-have-embraced-big-government (accessed 4 February 2021).

Eberstadt, Nicholas (2008), *The Poverty of 'The Poverty Rate': Measure and Mismeasure of Want in Modern America* (Washington DC: American Enterprise Institute Press).

El-Erian, Mohamed A. (2010), *Navigating the New Normal in Industrial Countries* (Washington DC: Per Jakobsson Foundation), http://www.perjacobsson.org/lectures/101010.pdf (accessed 23 November 2020).

El-Erian, Mohamed A. (2016), 'The End of the New Normal?' *Project Syndicate*, 2 February, https://www.project-syndicate.org/commentary/the-end-of-the-new-normal-by-mohamed-a—el-erian-2016-02 (accessed 24 November 2020).

El Erian, Mohamed (2020), 'The New Normal 2.0', *Journal of Portfolio Management*, 46/7, July, 1–4. doi: https://doi.org/10.3905/jpm.2020.1.164 (accessed 2 January 2021).

El-Erian, Mohamed with Carver, Tom (2020), 'The New Normal: Mohamed El-Erian's Predictions for the Global Economy', *Brink News*, 25 May, https://www.brinknews.com/this-is-the-new-normal-mohamed-el-erians-predictions-for-the-global-economy/ (accessed 2 January 2021).

Elliot, Larry and Seager, Ashley (2005), 'Economics: Brown planning return to austerity, say experts', *The Guardian*, 7 December. 27.

Elliott, Lucinda, and Robinson, Matthew (2020), 'Bolsonaro Threat to Take Brazil out of WHO as Coronavirus Deaths Soar', *The Times*, 6 June, https://www.thetimes.co.uk/article/coronavirus-deaths-soar-but-brazil-has-to-lift-lockdowns-says-president-bolsonaro-lrn67xhk2 (accessed 2 January 2021).

Enhancing Education Through Technology Act of 2001, revised (2015), https://www.congress.gov/bill/114th-congress/house-bill/4021/text (accessed 2 January 2021).

Etzioni, Amitai (2011), 'The New Normal'. *Sociological Forum*, 26/4, December, 779–89.

Eurodad [European Network on Debt and Development] (2020), 'Civil Society Organisations' Statement against Continued IMF Austerity', *Eurodad*, 6 October, https://www.eurodad.org/civil_society_organisations_open_letter_to_imf_austerity (accessed 2 January 2021).

Evans, Matthew and Walker, Brian (2020), 'The Beginning of "the Age of Austerity": A Critical Stylistic Analysis of David Cameron's 2009 Spring Conference Speech', *Critical Approaches to Discourse Analysis across Disciplines*, 11/2, 169–86, https://www.lancaster.ac.uk/fass/journals/cadaad/wp-content/uploads/2020/02/Vol11.2-8-Evans-and-Walker.pdf (accessed 2 February 2021)

Farkas, Anna (2002), *The Oxford Dictionary of Catchphrases* (Oxford: Oxford University Press).

Ferrer, Laia Pi and Alasuutari, Pertti (2019), 'The Spread and Domestication of the Term "Austerity:" Evidence from the Portuguese and Spanish Parliaments', *Politics and Policy* 47/6, 1039–65, https://doi.org/10.1111/polp.12331.

Flock, Elizabeth (2011), 'Occupy Wall Street Protests Get Support of the One Percent', *Washington Post*, 13 October, https://www.washingtonpost.com/blogs/blogpost/post/occupy-wall-street-protests-newest-blog-we-are-the-1-percent-we-stand-with-the-99-percent/2011/10/13/gIQA7Yx1hL_blog.html?utm_term=.e126f435f267 (accessed 22/3/2021).

Folke, Carl, Colding, Johan, and Berkes, Fikret (2003), 'Synthesis: Building Resilience and Adaptive Capacity in Social-Ecological Systems', in Berkes, Colding, and Folke, eds., *Navigating Social-Ecological Systems: Building Resilience for Complexity and Change* (Cambridge: Cambridge University Press, 2003), 352–87.

Forbes (2010), 'Pimco's New Normal', *Forbes.com*, 21 January, https://www.forbes.com/forbes/2010/0208/investing-mutual-funds-stocks-pimco-new-normal.html?sh=64a0c6a57fdf (accessed 23 November 2020).

Forrest, Adam (2020), 'Build Back Better: Who Said it First — Joe Biden or Boris Johnson?' *The Independent*, 5 November, https://www.independent.co.uk/news/uk/politics/biden-boris-johnson-build-back-better-b1613419.html (accessed 2 January 2021).

Foucault, Michel (1972 [1969]), *The Archaeology of Knowledge* (London: Tavistock).

Foucault, Michel (1973 [Fr. 1963]), *The Birth of the Clinic: An Archaeology of Medical Perception*. Trans. A.M. Sheridan. (London: Tavistock).

Foucault, Michel (2003), *Abnormal: Lectures at the Collège de France, 1974-1975*. Trans. Graham Burchell. (London: Verso).

Freeden, Michael (2019), 'The Coming Realignment of Ideology Studies', *Journal of Political Ideologies*, 24/1, 1–10, https://doi.org/10.1080/13569317.2019.1555899 (accessed 4 January 2021).

Frizelle, Dorothy (2020), 'Coronavirus Pandemic and War Talk: Considerations for Clinical Psychologists', Association of Clinical Psychologists, UK, April, https://acpuk.org.uk/war_talk/ (accessed 2 January 2020).

Funtowicz, Silvio O., and Ravetz, Jerome R. (1993), 'Science for the Post-Normal Age', *Futures*, 25/7, 739–55, https://doi.org/10.1016/0016-3287(93)90022-L

Garland, David (2014), 'What is a "History of the Present"? On Foucault's Genealogies and their Critical Preconditions', *Punishment and Society*, 16/4, 365–84. doi: 10.1177/1462474514541711

Georgetown University Law Centre (2009), *Public Policy Platform on Flexible Work Arrangements* (Washington DC: Georgetown University Law Centre).

Gillis, Matilda (2020), 'Ventilators, Missiles, Doctors, Troops … The Justification of Legislative Responses to COVID-19 through Military Metaphors', *Law and Humanities*, 14/2, 135–59. doi: 10.1080/17521483.2020.1801950.

Glucksberg, Sam (2001), *Understanding Figurative Language: From Metaphors to Idioms* (Oxford: Oxford University Press).

Goldberg, Jonah (2011), 'Percentage Play', *National Review*, 63/22, November 28, https://www.nationalreview.com/nrd/articles/295026/week (accessed 22/3/2021).

Goldberg, Lesley (2012), 'NBC's "The New Normal" Draws Ire of One Million Mums Group', *Hollywood Reporter*, 20 July, https://www.hollywoodreporter.com/live-feed/nbc-new-normal-boycott-one-million-moms-352676 (accessed 24 November 2020).

Goldberg, Steven (2013), 'What "New Normal?" El-Erian's Pimco Fund Falls Flat', *Kiplinger*, 20 November, https://www.kiplinger.com/article/investing/t041-c007-s001-what-new-normal-el-erian-s-pimco-fund-falls-flat.html (accessed 23 November 2020).

Goldmacher, Shane, and Tankersley, Jim (2020), 'In "Buy American" Speech, Biden Challenges Trump on the Economy', *New York Times*, 9 July, https://www.nytimes.com/2020/07/09/us/politics/biden-buy-american.html (accessed 2 January 2021).

Goldstein, Rebecca, Macrine, Sheila, and Chesky, Nataly Z. (2011), 'Welcome to the "New Normal": The News Media and Neoliberal Reforming Education', *Journal of Inquiry & Action in Education*, 4/1, https://digitalcommons.buffalostate.edu/jiae/vol4/iss1/6 (accessed 4 January 2021).

Granter, Edward and McCann, Leo (2015), 'Extreme Work/Normal Work: Intensification, Storytelling and Hypermediation in the (Re)construction of "the New Normal"', *Organization*, 22/4, 443–56. doi: 10.1177/1350508415573881.

Gray, Clive (2008), 'Arts Council England and Public Value: A Critical Review', *International Journal of Cultural Policy*, 14/2, May, 209–14, https://doi.org/10.1080/10286630802106383 (accessed 2 February 2020).

Grindsted, Thomas Skou (2018), 'Geoscience and Sustainability – In between Keywords and Buzzwords', *Geoforum*, 91, May, 57–60, https://doi.org/10.1016/j.geoforum.2018.02.029.

Gross, William H. (2009), 'On the "Course" to a New Normal', Pimco, 1 September, https://www.pimco.co.uk/en-gb/insights/economic-and-market-commentary/investment-outlook/on-the-course-to-a-new-normal/ (accessed 23 November 2020).

Grove, Kevin (2018), *Resilience* (London: Routledge).

Grundman, Reiner, Kreischer, Kim-Sue, and Scott, Mike (2018), 'The Discourse of Austerity in the British Press', in Roland Sturm, Tim Griebel, and Thorstein Winkelmann, eds., *Austerity: A Journey to an Unknown Territory: Discourses, Economics and Politics. Zeitschrift für Politik* (nomos-elibrary, 2018), 92–198. doi:10.5771/9783845281728-92.

GT (Global Times staff) (2020), 'New Normal Life in Outbreak', *Global Times*, 12 February, https://www.globaltimes.cn/content/1179369.shtml (accessed 2 January 2021).

Guinness, A.R. (1944), 'International Trade and the Making of the Peace', *International Affairs*, 20/4, 495–508, https://doi.org/10.2307/3017130.

Gupta, Suman (2002), *The Replication of Violence: Thoughts on International Terrorism after 11 September 2001* (London: Pluto).

Gupta, Suman (2019), 'On the Cusp of Mediating Poverty: Phenomenal Experience and Fear', *ALEA: Neo-Latin Studies*, 21/3, September-December, 1–13, https://dx.doi.org/10.1590/1517-106X/203113.

Gupta, Suman, Allen, Richard, Basu, Maitrayee, Durão, Fabio Akcelrud, Gupta, Ayan-Yue, Katsarska, Milena et al. (2020), *Social Analysis and the COVID-19 Crisis: A Collective Journal* (London: Routledge).

Gupta, Suman, and Virdee, Satnam (eds.) (2019), *Race and Crisis* (London: Routledge).

Hacque, Zubaida, Becares, Laia, and Treloar, Nick (2020), *Over-Exposed and Under-Protected: The Devastating Impact of COVID-19 on Black and Minority Ethnic Communities in Great Britain* (London: Runnymede Trust), http://www.runnymedetrust.org/uploads/Runnymede%20Covid19%20Survey%20report%20v3.pdf (accessed 4 January 2021).

Halimi, Serge (2020), 'From Santiago to Paris to Beirut, Protest is the New Normal', *Le Monde diplomatique*, 1 January, https://mondediplo.com/2020/01/01world-protest (accessed 2 January 2021).

Hardoon, Deborah (2017), *An Economy for the 99%: It's Time to Build a Human Economy that Benefits Everyone, Not Just the Privileged Few* (Briefing paper). (Oxfam GB for Oxfam International). https://www-cdn.oxfam.org/s3fs-public/file_attachments/bp-economy-for-99-percent-160117-en.pdf (accessed 22/3/2021).

Harrod, Roy (1947), *Are these Hardships Necessary?* (London: Hart-Davis).

Hawkins, Paula (2003), 'Austerity rules if you are living with prudence'. *The Times*, 10 April. 42 (Business).

Heath, Stephen (2013), 'Keywords: Abstract, Abstraction', *Critical Quarterly*, 55/3, 1–10, https://doi.org/10.1111/criq.12065

Hedegaard, Connie (2012), 'Get Used to "Extreme" Weather, It's the New Normal', *The Guardian*, 19 September. https://www.theguardian.com/environment/2012/sep/19/extreme-weather-new-normal-climate-change (accessed 7 December 2020).

Heffer, Simon (2007), 'Brown's austerity extends only to the English middle classes'. *Daily Telegraph*, 16 May. 22.

Hegel, G.W.F. (1956), *The Philosophy of History*. Trans. J. Sibree.(New York: Dover).

Hetherington, Stephen (2015), 'The Interdependence of Public and Private Finance in British Theatre', Manchester: ACE, https://www.artscouncil.org.uk/publication/interdependence-public-and-private-finance-british-theatre (accessed 2 February 2020).

Hinkley, Sara, 'Austerity as the New Normal: The Fiscal Politics of Retrenchment in San Jose, California', in Mark Davidson and Kevin Ward, eds., *Cities under Austerity: Restructuring the US Metropolis* (Albany, NY: SUNY Press, 2018), 59–76.

Hinshaw, Drew, and Armour, Stephanie (2020), 'Trump Moves to Pull U.S. Out of World Health Organization in Midst of Covid-19 Pandemic', *Wall Street Journal*, 7 July, https://www.wsj.com/articles/white-house-says-u-s-has-pulled-out-of-the-world-health-organization-11594150928 (accessed 2 January 2021).

Hodges, Paul, and Richardson, John (2011), *Boom, Gloom and the New Normal: How Western Baby Boomers are Changing Global Demand Patterns, Again* (London: ICIS).

Holling, C.S. (1973), 'Resilience and Stability of Ecological Systems', *Annual Review of Ecology and Systematics*, Vol 4, 1–23, https://doi.org/10.1146/annurev.es.04.110173.000245 (accessed 2 February 2020)

Hristova, Stefka (2014), 'Visual Memes as Neutralizers of Political Dissent', *triple*, 12/1, 265–76, https://doi.org/10.31269/triplec.v12i1.507

Hughes, Jenny (2008), 'Doing the Arts Justice: A Review of Research Literature, Practice and Theory', Cambridge: Unit for Arts and Offenders, https://webarchive.nationalarchives.gov.uk/+/http:/www.culture.gov.uk/NR/rdonlyres/D4B445EE-4BCC-4F6C-A87A-C55A0D45D205/0/Doingartsjusticefinal.pdf (accessed 2 February 2020).

Huntington, Samuel (1996), *The Clash of Civilizations and the Remaking of the World Order* (New York: Simon and Schuster).

IDLO [International Development Law Organization] (2020), 'COVID-19 and Rule of Law: Policy Brief', IDLO, September, https://www.idlo.int/sites/default/files/pdfs/publications/idlo-rule_of_law_and_covid19-policy_brief-final.pdf (accessed 5 January 2021).

Igo, Sarah E. (2007), *The Averaged American: Surveys, Citizens, and the Making of a Mass Public* (Cambridge MA: Harvard University Press).

iiMedia (2020), '艾媒报告|2020年中国新春远程办公行业热点专题报告', iiMedia.cn, 11 February, https://www.iimedia.cn/c400/68850.html (accessed 2 January 2021).

Islam, Faisal (2019), 'Labour and Tories Plan for a Post-Austerity Future', BBC, 7 November, https://www.bbc.co.uk/news/business-your-money-50329893 (accessed 3 February 2021).

Jang, Sunghyun (2016), '"The Overturning of an Arbitrary Government": Pigott's Radical Challenge to Standard Lexicography', *Texas Studies in Literature and Language*, 58/3, 251–77. doi: 10.7560/TSLL58301

Jervis, Robert (1997), *System Effects: Complexity in Political and Social Life* (Princeton NJ: Princeton University Press).

Johnson, Jamie (dir.) (2006), *The One Percent* (documentary film). Written by Nick Kurzon. Produced by Wise and Good Films LLC.

Jones, Charles I. (2015), 'Pareto and Piketty: The Macroeconomics of Top Income and Wealth Inequality', *Journal of Economic Perspectives*, 29/1, 29–46.

Julie's Bicycle (2015), 'Sustaining Great Art Environmental Report 2012–2015: Results and Highlights', Manchester: ACE, https://www.artscouncil.org.uk/publication/sustaining-great-art-environmental-report (accessed 2 February 2020).

Katsampekis, Giorgos, and Stavrakakis, Yannis (eds.) (2020), *Populism and the Pandemic: A Collaborative Report* (Loughborough: Loughborough University), http://populismus.gr/wp-content/uploads/2020/06/interventions-7-populism-pandemic-UPLOAD.pdf (accessed 2 January 2021).

Katwala, Sunder (2016), 'It's Time to Disband the "Tribe of the 48%"', *Open Democracy*, 28 July, https://www.opendemocracy.net/en/opendemocracyuk/its-time-to-disband-tribe-of-48/ (accessed 22/3/2021).

Keister, Lisa A. (2014), 'The One Percent', *Annual Review of Sociology*, 40, 347–67.

Kelsen, Hans (2006 [1946]), *General Theory of Law and State* (New Brunswick NJ: Transaction).

Khimm, Suzy (2011), 'Conservatives Launch "We are the 53 Percent" to Criticize 99 Percenters', *Washington Post*, October 10, https://www.washingtonpost.com/blogs/ezra-klein/post/conservatives-launch-we-are-the-53-percent-to-criticize-99-percenters/2011/10/10/gIQA70omaL_blog.html?utm_term=.f62348d45243 (accessed 22/3/2021).

Kirby, Tony (2020), 'Evidence Mounts on the Disproportionate Effect of COVID-19 on Ethnic Minorities', *Lancet*, 8/6, 547–48. doi: https://doi.org/10.1016/S2213-2600(20)30228-9 (accessed 2 January 2021).

Klein, Naomi (2011), 'Occupy Wall Street: The Most Important Thing in the World Now', *The Nation*, October 6, https://www.thenation.com/article/occupy-wall-street-most-important-thing-world-now/ (accessed 22/3/2021).

Konings, Martijn (2015), *The Emotional Logic of Capitalism* (Stanford: Stanford University Press).

Konings, Martijn (2016), 'The Spirit of Austerity', *Journal of Cultural Economy*, 9/1, 86–100. doi: 10.1080/17530350.2015.1054415.

Kosellek, Reinhart (2002), *The Practice of Conceptual History: Timing, History, Spacing Concepts*. Trans. Todd Samuel Presner and others. (Stanford CA: Stanford University Press).

Kosellek, Reinhart (2004 [1979]), *Futures Past: On the Semantics of Historical Time*. Trans. Keith Tribe. (New York: Columbia University Press).

Krugman, Paul (2011), 'We Are the 99.9%', *New York Times*, 24 November, http://www.nytimes.com/2011/11/25/opinion/we-are-the-99-9.html (accessed 22/3/2021).

Krugman, Paul (2012), *End This Depression Now!* (New York: W.W. Norton).

Krugman, Paul (2020), 'Apocalypse Becomes the New Normal', *New York Times*, 2 January, https://www.nytimes.com/2020/01/02/opinion/climate-change-australia.html (accessed 2 January 2021).

Krzyżanowski, Michał (ed.) (2020), 'Special Issue: Strategies of Normalization in Public Discourse: Paradoxes of Populism, Neoliberalism and the Politics of Exclusion', *Social Semiotics*, 30/4, https://www.tandfonline.com/toc/csos20/30/4?nav=tocList (accessed 4 January 2021).

Kuhn, Thomas S. (1970 2nd edn. [1st edn. 1962]), *The Structure of Scientific Revolutions* (Chicago: University of Chicago Press).

Kynaston, David (2007), *Austerity Britain, 1945-1951* (London: Bloomsbury).

Kynaston, David (2008), 'The Austerity Issue: Don't Panic', *The Independent*, 2 November, https://www.independent.co.uk/news/uk/this-britain/the-austerity-issue-don-t-panic-984034.html (accessed 2 February 2020).

Lakatos, Imre, and Musgrave, Alan (eds.) (1970), *Criticism and the Growth of Knowledge* (Cambridge: Cambridge University Press).

Lambert, Thomas E., and Kwon, Edward (2015), 'The Top One Percent and Exploitation Measures', *Review of Radical Political Economics*, 47/3, 465–76.

Langfitt, Frank (2020), 'Conspiracy Theories, Such as QAnon, Appear to Gain Ground in Britain', *NPR*, 8 October, https://www.npr.org/2020/10/08/921506695/conspiracy-theories-such-as-qanon-appear-to-gain-ground-in-britain?t=1615039168303 (accessed 22/3/2021).

Lawyers Committee for Human Rights (2003), 'Assessing the New Normal: Liberty and Security for the Post-September 11 United States', New York: Lawyers Committee for Human Rights, https://www.humanrightsfirst.org/resource/assessing-new-normal-liberty-and-security-post-september-11-united-states (accessed 23 November 2020).

Lazaridis, Gabriella, and Campani, Giovanna (eds.) (2017), *Understanding the Populist Shift: Othering in a Europe in Crisis* (Abingdon: Routledge).

Lazarus, Liora (ed.) (2020), *A Preliminary Human Rights Assessment of Legislative and Regulatory Responses to the COVID-19 Pandemic across 11 Jurisdictions* (Bonavero Report No. 3/2020) (Oxford: Bonavero Institute of Human Rights), https://www.law.ox.ac.uk/sites/files/oxlaw/v3_bonavero_reports_series_human_rights_and_covid_19_20203.pdf (accessed 4 January 2020).

Lazzarato, Maurizio (2017 [2009]), *Experimental Politics: Work, Welfare, and Creativity in the Neoliberal Age* (Cambridge MA: MIT Press).

Le Goff (2015[2014]), *Must We Divide History into Periods?* Trans. Malcolm DeBevoise. (New York: Columbia University Press).

Lemov, Doug (ed.) (2020), *Teaching in the Online Classroom: Surviving and Thriving in the New Normal* (Hoboken NJ: Wiley).

Lemov, Doug, and Woolway, Erica (2020), 'Remote Teaching and the New Normal'. In Lemov ed. 1–14.

Lewis, Sophie C., King, Andrew D., and Perkins-Kirkpatrick, Sarah E. (2017), 'Defining a New Normal for Extremes in a Warming World', *Bulletin of the American Meteorological Society*, 98/6, 1139–51, https://doi.org/10.1175/BAMS-D-16-0183.1

Lex-Atlas (2021), 'Lex-Atlas: COVID-19: A Global Academic Project Mapping Legal Responses to Covid-19', https://lexatlas-c19.org/ (accessed 5 January 2021).

Lloyd, Elisabeth A. (2008), 'Normality and Variation: the Human Genome Project and the Ideal Human Type', in *Science, Politics and Evolution* (Cambridge: Cambridge University Press), 133–47.

Lowndes, Vivien, and Gardner, Alison (2016), 'Local Governance under the Conservatives: Super-Austerity, Devolution and the 'Smarter State', *Local Government Studies*, 42/3, 357–75. doi: 10.1080/03003930.2016.1150837.

Luhby, Tami (2011), 'Who Are the 1 Percent?' *CNN Money*, October 29, http://money.cnn.com/2011/10/20/news/economy/occupy_wall_street_income/index.htm (accessed 22 March/2021).

Luhmann, Niklas (2004), *Art as a Social System*. Trans. Eva M. Knodt. (Stanford CA: Stanford University Press).

Lusiani, Nicholas, and Chaparro, Sergio (2018), *Assessing Austerity: Monitoring the Human Rights Impacts of Fiscal Consolidation* (New York: Center for Economic and Social Rights), http://dx.doi.org/10.2139/ssrn.3218609 (accessed 7 December 2020).

Ma Chi (2020), 'Remote Work a New Normal for Beijing Employees', *China Daily*, 11 February, https://global.chinadaily.com.cn/a/202002/11/WS5e4247e8a310128217276ac1.html (accessed 2 January 2021).

McBride, Stephen (2016), 'Constitutionalizing Austerity: Taking the Public out of Public Policy', *Global Policy*, 7/1, 5–14. doi: 10.1111/1758-5899.12271.

MacCabe, Colin, and Holly Yanachek eds. (2018). *Keywords for Today: A 21st Century Vocabulary*. Oxford: Oxford University Press.

McCauley, Douglas (2006), 'Selling Out on Nature', *Nature*, 443, October, 27–28. doi: 10.1038/443027a.

McCloskey, Deirdre (1998 [1985]), *The Rhetoric of Economics* (Madison WI: University of Wisconsin Press).

MacKinnon, Danny and Derickson, Kate Driscoll (2012), 'From Resilience to Resourcefulness: A Critique of Resilience Policy and Activism', *Progress in Human Geography*, 37/2, 253–70. doi: 10.1177/0309132512454775.

McLean, Iain (1996), *Concise Oxford Dictionary of Politics* (Oxford: Oxford University Press).

McMaster, Brian (2008), 'Supporting Excellence in the Arts: From Measurement to Judgement', London: DCMS, https://webarchive.nationalarchives.gov.uk/+/http:/www.culture.gov.uk/images/publications/supportingexcellenceinthearts.pdf (accessed 2 February 2020).

McNamee, Roger (2004), *The New Normal: Great Opportunities in a Time of Great Risk* (London: Portfolio).

McNamee, Roger, and Labarre, Polly (2003), 'The New Normal', *Fast Company*, 30 April, https://www.fastcompany.com/46387/new-normal (accessed 23 November 2020).

Malmsten, Ernst, Portanger, Erik, and Drazin, Charles (2002), *BooHoo: The Dot.com Story from Concept to Catastrophe* (London: Arrow).

Mangia, Karen (2020), *Working From Home: Making the New Normal Work for You* (Hoboken NJ: Wiley).

Mangu-Ward, Katherine (2020), 'The New Normal and the Prospects for a Post-Political Future', *Reason*, 51/9, February, https://reason.com/2020/01/06/the-new-normal-and-the-prospects-for-a-post-political-future/.

Marr, Andrew (2007), *A History of Modern Britain* (Basingstoke: Macmillan).

Marr, Andrew (2008), 'Austerity Be Damned! We're All Cutting Back, but Andrew Marr Says That's the Reason to Make this Christmas Special', *Daily Mail*, 24 December, https://www.dailymail.co.uk/debate/article-1101108/Austerity-damned-Were-cutting-ANDREW-MARR-says-thats-reason-make-Christmas-special.html (accessed 2 February 2020).

Massetti, Emanuele, Mazzoleni, Oscar, and Heinisch, Reinhard (eds.) (2020), *The People and the Nation: Populism and Ethno-Territorial Politics in Europe* (Abingdon: Routledge).

Matthews, Jamie (2019), 'Populism, Inequality and Representation: Negotiating "the 99%" with Occupy London', *The Sociological Review*, 67/5, 1018–33, https://doi.org/10.1177/0038026119851648.

Mee, Jon (2016), *Print, Publicity, and Popular Radicalism in the 1790s: The Laurel of Liberty* (Cambridge: Cambridge University Press).

Memmott, Mark (2011), 'For Those Who Aren't Fans of the "99 Percent," There's The "53 Percent"', *NPR*, October 11, https://www.npr.org/sections/thetwo-way/2011/10/11/141239358/for-those-who-arent-fans-of-the-99-percent-theres-the-53-percent (accessed 22/3/2021).

Millett, Gregorio A., Jones, Austin T., Benkeser, David, Baral, Stafan et al. (2020), 'Assessing Differential Impacts of COVID-19 on Black Communities', *Annals of Epidemiology*, 47, July, 37–44, https://www.sciencedirect.com/science/article/pii/S1047279720301769?via%3Dihub (accessed 4 January 2021)

Milner, Ryan (2013), 'Pop Polyvocality: Internet Memes, Public Participation, and the Occupy Wall Street Movement', *International Journal of Communication*, 7/34, 2357–90.

Mirowski, Philip (2013), *Never Let a Serious Crisis Go to Waste: How Neoliberalism Survived the Financial Meltdown* (London: Verso).

Misturelli, Federica and Heffernan, Claire (2008), 'What is Poverty? A Diachronic Exploration of the Discourse on Poverty from the 1970s to the 2000s', *The European Journal of Development Research*, 20/4, 666–84.

Monforte, Pierre (2020), 'From Compassion to Critical Resilience: Volunteering in the Context of Austerity', *The Sociological Review*, 68/1, 110–26. doi:10.1177/0038026119858220.

Mooney, Chris (2015). 'Study Sees a "New Normal" for How Climate Change is Affecting Weather Extremes', *Washington Post*, 22 July, https://www.washingtonpost.com/news/energy-environment/wp/2015/06/22/study-sees-a-new-normal-for-how-climate-affects-weather-events/ (accessed 7 December 2020).

Moore, Frances C., Obradovich, Nick, Lehner, Flavio, and Baylis, Patrick (2019), 'Rapidly Declining Remarkability of Temperature Anomalies May Obscure Public Perception of Climate Change', *Proceedings of the National Association of Sciences (PNAS)*, 116/11, 4905–10, https://doi.org/10.1073/pnas.1816541116

Moore, Francis C. (2019). 'Climate Change is the New Normal but We Don't Seem to Notice', *New Scientist*, 2 March, https://www.newscientist.com/article/2195471-climate-change-is-the-new-normal-but-we-dont-seem-to-notice/ (accessed 7 December 2020).

Mosselmans, Bert (2007), *William Stanley Jevons and the Cutting Edge of Economics* (Abingdon: Routledge).

Murphy, Joe, and Waugh, Paul (2008), 'Turn out the lights, close the curtains: As "austerity" PM unveils £910m package'. *Evening Standard*, 11 September. 1.

Murphy, Neil, and Weston, Alan (2020), 'Maskless Protesters Descend on City Centre Days after New Tier 3 Rules Take Effect', *The Daily Mirror*, 17 October, https://www.mirror.co.uk/news/uk-news/maskless-protesters-descend-city-centre-22862647 (accessed 22/3/2021).

Museums and Resilient Leadership (MRL) (website), http://www.museumresilience.com/ (accessed 2 February 2020).

National Archives (website), 'UK Government Web Archive'. http://www.nationalarchives.gov.uk/webarchive/ (accessed 2 February 2020).

NCIA (National Communication and Information Administration) and Economics and Statistics Administration (2002), *A Nation Online: How Americans Are Expanding Their Use of the Internet* (Washington DC: NTIA), https://www.ntia.doc.gov/legacy/ntiahome/dn/nationonline_020502.htm (accessed 24 November 2020).

New Normal, The (US TV sitcom) (2012–13). Created by Ryan Murphy and Ali Adler. NBC.

Noble, David F. (1998), 'Digital Diploma Mills, Part 2: The Coming Battle Over Online Instruction', *October* 86. doi:10.2307/779111.

Noesselt, Nele ed. (2017), 'Special Issue on *China's New Normal: Change and Continu-ity*', *Journal of Chinese Political Science*, 22/3, https://link.springer.com/journal/11366/volumes-and-issues/22-3 (accessed 24 November 2020).

Nolland, Lisa Severine, Moseley, Carys, and others (2018), *The New Normal: The Trans-gender Agenda* (London: Wilberforce).

Norton, Charles Ledyard (1896), *Political Americanisms: A Glossary of Terms and Phrases at Different Periods of American Politics* (London: Longmans, Green and Co).

NPR Programme Transcript (2001), *The Infinite Mind: A New Normal?* (Washington DC: NPR).

O'Dair, Sharon, and Francisco, Timothy (eds.) (2019), *Shakespeare and the 99%: Literary Studies, the Profession, and the Production of Inequality* (Cham: Palgrave Macmillan).

Obama, Barack, with Kroft, Steve (2010), 'Transcript: President Barack Obama, Part 1', *CBS News*, 7 November, https://www.cbsnews.com/news/transcript-president-barack-obama-part-1-07-11-2010/5/ (accessed 23 November 2020).

OECD (2020), 'Testing for COVID-19: A Way to Lift Confinement Restrictions', OECD, 4 May, https://www.oecd.org/coronavirus/policy-responses/testing-for-covid-19-a-way-to-lift-confinement-restrictions-89756248/ (accessed 4 January 2021).

Olsson, David (2020), 'The Transformative Potential of Resilience Thinking: How It Could Transform Unsustainable Economic Rationalities', *Alternatives: Global, Local, Political*, 45/2, 102–20. doi: 10.1177/0304375420938284.

Ortiz, Isabel, and Cummins, Matthew (2019), *Austerity: The New Normal, A Renewed Washington Consensus 2010–2024* (New York: Initiative for Policy Dialogue; In-ternational Confederation of Trade Unions (ITUC); Public Services International (PSI); European Network on Debt and Development (EURODAD); The Bretton Woods Project (BWP)). http://policydialogue.org/files/publications/papers/Austerity-the-New-Normal-Ortiz-Cummins-6-Oct-2019.pdf (accessed 7 December 2020).

Orts, Eric W. (2013), *Business Persons: A Legal Theory of the Firm* (Oxford: Oxford University Press).

Oxford English Dictionary (OED 2019) (website), http://www.oed.com/ (accessed 2 February 2020).

Oxford English Dictionary Online (2020, September), 'Normal', https://www-oed-com.libezproxy.open.ac.uk/view/Entry/128269?redirectedFrom=norma (accessed October 16, 2020).

Pacheco, José Augusto (2020), 'The "New Normal" in Education', *Prospects*, https://doi.org/10.1007/s11125-020-09521-x (accessed 4 January 2021).

Palmer, Jason, Cooper, Ian, and van der Vorst, Rita (1997), 'Mapping Out Fuzzy Buzzwords – Who Sits Where on Sustainability and Sustainable Development', *Sustainable Develop-ment*, 5/2, 87–93, https://EconPapers.repec.org/RePEc:wly:sustdv:v:5:y:1997:i:2:p:87-93 (accessed 2 February 2021).

Pareek, Manish, Bangash, Mansoor N., Pareek, Nilesh, Pan, Daniel, Sze, Shirley, Min-has, Jatinder S. et al. (2020), 'Ethnicity and COVID-19: An Urgent Public Health Research Priority', *Lancet*, 395/ 10234, 1421–22. doi: https://doi.org/10.1016/S0140-6736(20)30922-3 (accessed 2 January 2021.

Partridge, Eric (1977 [1985]), *A Dictionary of Catch Phrases from the Sixteenth Century to the Present Day* (New York: Stein and Day).

Patterson, Annabel (2004), 'Keywords: Raymond Williams and Others', *ESC: English Stud-ies in Canada*, 30/4, 66–80.

Pearson, Joseph (1792), *Pearson's Political Dictionary; Containing Remarks, Definitions, Explanations, and Customs, Political and Parliamentary* (London: Chapman and Co).

Penna, Dominic (2020), 'This is How Other Countries Are Gradually Reopening Schools', *The Telegraph*, 24 June, https://www.telegraph.co.uk/education/2020/04/20/coronavirus-lockdowns-ease-countries-gradually-reopening-schools/ (accessed 2 January 2021).

Perkins, Anthony B., and Perkins, Michael C. (2001), *The Internet Bubble: The Inside Story on Why It Burst – and What You Can Do to Profit Now* (New York: Harper Business).

Pick, Frederick W. (1946), 'Contemporary History: Method and Men', *History*, 31, March, 26–55.

Pickerill, Jenny, Krinsky, John, Hayes, Graeme, and Gillian, Kevin (eds.) (2015), *Occupy! A Global Movement* (Abingdon: Routledge).

Pierce, Scott D. (2012), 'KSL Won't Air Gay-Themed NBC Sitcom "New Normal"', *Salt Lake Tribune*, 27 August t, https://archive.sltrib.com/article.php?id=54759750&itype=CMSID (accessed 24 November 2020).

Pigott, Charles (1795), *A Political Dictionary Explaining the True Meaning of Words* (New York: Thomas Greenleaf).

Piketty, Thomas (2003), 'Income Inequality in France, 1901–1998', *Journal of Political Economy*, 111/5, 1004–42.

Piketty, Thomas (2014 [2013]), *Capital in the Twenty-First Century*. Trans. Arthur Goldhammer (Cambridge MA: Harvard University Press).

Piketty, Thomas (2015 [1997]), *The Economics of Inequality*. Trans. Arthur Goldhammer. (Cambridge MA: Harvard University Press).

Piketty, Thomas (2017), *Chronicles on Our Troubled Times*. Trans. Seth Ackerman. (London: Penguin).

Piketty, Thomas, and Saez, Emmanuel (2003), 'Income Inequality in the United States, 1913-1998', *The Quarterly Journal of Economics*, 118/1, February, 1–39.

Piketty, Thomas, and Saez, Emmanuel (2006), 'The Evolution of Top Incomes: A Historical and International Perspective', *American Economic Review: Papers and Proceedings*, 96/2, May, 200–05.

Piketty, Thomas, and Saez, Emmanuel (2013), 'Top Incomes and the Great Recession: Recent Evolutions and Policy Implications', *IMF Economic Review*, 61/3, 456–78.

Piketty, Thomas, Saez, Emmanuel, and Zucman, Gabriel (2016), *Distributional National Accounts: Methods and Estimates for the United States* (Working paper 22945). (Cambridge MA: National Bureau of Economic Research).

Polizzi, Craig, Lynn, Steven Jay, and Perry, Andrew (2020), 'Stress and Coping in the Time of COVID-19: Pathways to Resilience and Recovery', *Clinical Neuropsychiatry*, 17/2, 59–62, https://doi.org/10.36131/ (accessed 4 January 2021).

Popper, Karl (1959 [Ger. 1934]), *The Logic of Scientific Discovery* (London: Hutchinson).

Poster, Mark (2019), *Critical Theory and Poststructuralism* (Ithaca NY: Cornell University Press).

Putzier, John (2004), *Weirdos in the Workplace: The New Normal ... Thriving in the Age of the Individual* (Upper Saddle River NJ: Prentice-Hall).

Quilter-Pinner, Harry, and Ambrose, Anna (2020), *The 'New Normal': The Future of Education after COVID-19* (London: Institute of Public Policy Research, October). https://www.ippr.org/research/publications/the-new-normal (accessed 4 January 2021).

Race Disparity Unit, UK Government (2020), *Quarterly Report on Progress to Address COVID-19 Health Inequalities* (UK Government, October), https://www.gov.uk/government/publications/quarterly-report-on-progress-to-address-covid-19-health-inequalities (accessed 4 January 2021).

Ram, Natalie, and Gray, David (2020), 'Mass Surveillance in the Age of COVID-19', *Journal of Law and the Biosciences*, 7/1, 1–17, https://doi.org/10.1093/jlb/lsaa023 (accessed 4 January 2021).

Ravetz, Jerome (2020[1]), 'Science for a Proper Recovery: Post-Normal, not New Normal', *Issues in Science and Technology*, 13 June, https://issues.org/post-normal-science-for-pandemic-recovery/ (accessed 2 February 2021).

Ravetz, Jerome with Finch, Matt (2020[2]), 'Post-Normal Science in the Time of COVID-19: Discussion with Jerome Ravetz', *Mechanical Dolphin* (blog), July 13, https://mechanicaldolphin.com/2020/07/13/post-normal-science-in-the-time-of-covid-19-discussion-with-jerome-ravetz/ (accessed 2 February 2021).

Rawls, John (1971 [1999]), *A Theory of Justice* (Cambridge MA: Belknap Press of Harvard University Press).

Rawls, John (1999), *The Law of Peoples* (Cambridge MA: Harvard University Press).

Rees, Nigel (1997), *Cassell's Dictionary of Catchphrases* (London: Weidenfeld and Nicholson).

Resilience Alliance (website), https://www.resalliance.org/about (accessed 2 February 2020).

Reuters (2014), 'Xi Jinping's "New Normal" with Chinese Characteristics', *South China Morning Post*, 14 May, https://www.scmp.com/business/global-economy/article/1511855/xi-jinpings-new-normal-chinese-characteristics (accessed 23 November 2020).

Revel, Judith (2015), '"What Are We At the Present Time?" Foucault and the Question of the Present', in Martina Tazzioli, Sophie Fuggle, and Yari Lanci, eds., *Foucault and the History of Our Present* (Basingstoke: Palgrave Macmillan), 13–25.

Robbins, Bruce (2017), *The Beneficiary* (Durham NC: Duke University Press).

Robinson, Mark (2010), 'Making Adaptive Resilience Real', London: ACE, https://webarchive.nationalarchives.gov.uk/20160204122146/http://www.artscouncil.org.uk/advice-and-guidance/browse-advice-and-guidance/making-adaptive-resilience-real (accessed 2 February 2020).

Roitman, Janet (2014), *Anti-Crisis* (Durham NC: Duke University Press).

Rosanoff, M.A. (1932), 'Edison in His Laboratory', Harper's Magazine, I June, 165.

Rose-Redwood, Reuben, Kitchin, Rob, Apostolopoulou, Elia, Rickards, Lauren, Blackman, Tyler, Crampton, Jeremy et al. (2020), 'Geographies of the VOVID-19 Pandemic', *Dialogues in Human Geography*, 10/2, 97–106, https://doi.org/10.1177%2F2043820620936050 (accessed 4 January 2021)

Roth, Michael S. (1981), 'Foucault's "History of the Present"', *History and Theory*, 20/1, 32–46.

Rousso, Henry (2016 [2012]), *The Latest Catastrophe: History, the Present, the Contemporary*. Trans. Jane Marie Todd. (Chicago: University of Chicago Press).

Ruddick, Susan (2006), 'Abnormal, the "New Normal", and Destabilizing Discourses of Rights', *Public Culture*, 18/1, 53–77.

Sa'adah, Annie (2017), 'After the Party: Trump, Le Pen, and the New Normal', *French Politics, Culture and Society*, 35/2, http://dx.doi.org/10.3167/fpcs.2017.350205 (accessed 4 January 2021).

Saad, Lydia (2005), 'Americans Sense a "New Normal" After 9/11', *Gallup*, 9 September, https://news.gallup.com/poll/18448/americans-sense-new-normal-after-911.aspx (accessed 23 November 2020).

Saez, Emmanuel, and Veall, Michael R. (2005), 'The Evolution of High Incomes in Northern America: Lessons from Canadian Evidence', *American Economic Review*, 95/3, 831–49.

Saez, Emmanuel, and Zucman, Gabriel (2019), *The Triumph of Injustice: How the Rich Dodge Taxes and How to Make Them Pay* (New York: W.W. Norton).

Safire, William (1968), *The New Language of Politics: An Anecdotal History of Catchwords, Slogans and Political Usage* (New York: Random House).

Sanburn, Josh (2010), 'What is the Definition of Austerity?' *Time Magazine*, 20 December, https://newsfeed.time.com/2010/12/20/what-is-the-definition-of-austerity/ (accessed 2 February 2021).

Sande, Mathijs van de (2020), 'They Don't Represent Us? Synecdochal Representation and the Politics of Occupy Movements', *Constellations*, 27, 397–411. doi: 10.1111/1467-8675.12462.

Schuhmann, Antje (2018), 'German Rightwingization as the New Normal? Tales of Becoming', *International Journal of Critical Diversity Studies*, 1/2, 72–81, https://doi.org/10.13169/intecritdivestud.1.2.0072 (accessed 2 January 2021).

Schwartz, Kevin L. , and Gölz, Olmo (2020), 'Going to War with the Coronavirus and Maintaining the State of Resistance in Iran', *Middle East Research and Information Project*, 1 September, https://merip.org/2020/09/going-to-war-with-the-coronavirus-and-maintaining-the-state-of-resistance-in-iran/ (accessed 2 January 2021).

Scoones, Ian (2010), 'Sustainability'. in Andrea Cornwall and Deborah Eade. eds., *Deconstructing Development Discourse Buzzwords and Fuzzwords* (Oxford: Practical Action and Oxfam), 153–62.

Seib, Gerald F. (2020), 'Trump, Biden Offer Dramatically Different Visions of "Normal" in America', *Wall Street Journal*, 6 July, https://www.wsj.com/articles/trump-biden-offer-dramatically-different-visions-of-normal-in-america-11594045222 (accessed 2 January 2021).

Sellnow, Thomas L., Seeger, Matthew W., and Ulmer, Robert. R. (2005), 'Constructing the "New Normal" through Post-Crisis Discourse', in H. Dan O'Hair, Robert L. Heath, and Gerald R. Ledlow, eds., *Community Preparedness and Response to Terrorism: III, Communication and Media* (Westport CT: Praeger), 167–90.

Semino, Elena (2020), '"Not Soldiers but Fire-Fighters" – Metaphors and Covid-19', *Health Communication,* 36/1, 50–58. doi: 10.1080/10410236.2020.1844989.

Sen, Amartya (1979), 'Equality of What?' The Tanner Lecture on Human Values, May 22, Stanford University, https://tannerlectures.utah.edu/_documents/a-to-z/s/sen80.pdf (accessed 22/3/2021).

Sen, Amartya (1983), 'Poor, Relatively Speaking', *Oxford Economic Papers*, 35/2, 153–69.

Sen, Amartya (1985), 'A Sociological Approach to the Measurement of Poverty: A Reply to Professor Peter Townsend', *Oxford Economic Papers*, 37/4, 669–76.

Sen, Amartya (1997 [1973]), *On Economic Inequality (with an Annexe by James E. Foster and Amartya Sen)* (Oxford: Clarendon).

Shackleton, Lucy, and Mann, Rosanna (2021), 'COVID-19 and the Digital Divide in Higher Education: A Commonwealth Perspective', in David Baker and Lucy Ellis, eds., *Libraries, Digital Information, and COVID: Practical Applications and Approaches to Challenge and Change* (Hull: Chandos), 149–58.

Shadmi, Efrat, Chen, Yingyao, Dourado, Inês, Faran-Perach, Inbal et al. (2020), 'Health Equity and COVID-19: Global Perspectives', *International Journal for Equity in Health*, 19/104, https://doi.org/10.1186/s12939-020-01218-z (accessed 4 January 2021).

Shahsavari, Shadi, Holur, Pavan, Wang, Tianyi, Tangherlini, Timothy R. , Roychowdhury, Vwani (2020), 'Conspiracy in the Time of Corona: Automatic Detection of Emerging COVID-19 Conspiracy Theories in Social Media and the News’', *Journal of*

Computational Social Science, 3, 279–317, https://doi.org/10.1007/s42001-020-00086-5 (accessed 4 January 2021).

Shankle, George Earlie (1941), *American Mottoes and Slang: Political, Patriotic, Personal* (New York: H.W. Wilson).

Sharon, Tamar (2020), 'Blind-Sided by Privacy? Digital Contact Tracing, the Apple/Google API and Big Tech's Newfound Role as Global Health Policy Makers', *Ethics and Information Technology*, https://doi.org/10.1007/s10676-020-09547-x (accessed 4 January 2021).

Shifman, Limor (2014), *Memes in Digital Culture* (Cambridge MA: MIT Press).

Shriftgiesser, Karl (1948), *This was Normalcy: An Account of Party Politics During Twelve Republican Years 1920-1932* (Boston: Little, Brown and Co).

Sinclair, Christine, and Hayes, Sarah (2019), 'Between the Post and the Com-Post: Examining the Postdigital "Work" of a Prefix', *Postdigital Science and Education*, 1, 119–31, https://doi.org/10.1007/s42438-018-0017-4 (accessed 2 February 2021).

Siskin, Clifford (2016), *System: The Shaping of Modern Knowledge* (Cambridge MA: MIT Press).

Smirnova, Vera, Lawrence, Jennifer L., and Bohland, James (2020), 'The Critical Turn of Resilience: Mapping Thematic Communities and Modes of Critical Scholarship', *The Geographical Journal*, https://doi.org/10.1111/geoj.12370.

Smith, Wesley J. (2020), 'Trump Rejects the "New Normal"', *National Review*, 17 April, https://www.nationalreview.com/corner/trump-rejects-the-new-normal/ (accessed 2 January 2021).

Sneader, Kevin, and Singhal, Shubham (2020)[1], 'Beyond Coronavirus: The Path to the Next Normal', McKinsey and Co., 23 March, https://www.mckinsey.com/industries/healthcare-systems-and-services/our-insights/beyond-coronavirus-the-path-to-the-next-normal (accessed 2 January 2021).

Sneader, Kevin, and Singhal, Shubham (2020)[2], 'The Future is Not What It Used to Be: Thoughts on the Shape of the Next Normal', McKinsey and Co., 14 April, https://www.mckinsey.com/featured-insights/leadership/the-future-is-not-what-it-used-to-be-thoughts-on-the-shape-of-the-next-normal (accessed 4 January 2021).

Sneader, Kevin, and Singhal, Shubham 2020[3], '3 Changes Businesses Will Need to Adapt to Post-Coronavirus', *Fortune*, 1 May, https://fortune.com/2020/05/01/business-reopen-economy-coronavirus-new-normal/ (accessed 2 January 2021).

Sontag, Susan (1990), *Illness as Metaphor and AIDS and Its Metaphors* (New York: Doubleday).

Sperber, Hans, and Trittschuh, Travis (1962), *American Political Terms: An Historical Dictionary* (Detroit: Wayne State University Press).

Stebbins, Samuel, and Suneson, Grant (2020), 'Jeff Bezos, Elon Musk among US Billionaires Getting Richer during Coronavirus Pandemic', *USA Today*, 1 December, https://eu.usatoday.com/story/money/2020/12/01/american-billionaires-that-got-richer-during-covid/43205617/ (accessed 22/3/2021).

Stevens, Elizabeth (2020), 'Post-Normal: Crisis and the End of the Ordinary', *Media International Australia*, 177/1, 92–102. doi: 10.1177/1329878X20958151.

Stewart, Heather (2003), 'Brown ends spending spree: Whitehall is put on austerity diet in run-up to election', *The Guardian*, 1 September. 24.

Stiglitz, Joseph (2011), 'Of the 1%, by the 1%, for the 1%', *Vanity Fair*, May, https://www.vanityfair.com/news/2011/05/top-one-percent-201105 (accessed 22/3/2021).

Stiglitz, Joseph (2012), *The Price of Inequality* (New York: W.W. Norton).

Stover, Dawn (2014), 'Climate: The New Abnormal', *Bulletin of the Atomic Scientists*, 26 August, https://thebulletin.org/2014/08/climate-the-new-abnormal/ (accessed 7 December 2020).

Sturm, Tristan, and Albrecht, Tom (2020), 'Constituent Covid-19 Apocalypses: Contagious Conspiracism, 5G, and Viral Vaccinations', *Anthropology & Medicine*, https://doi.org/10.1080/13648470.2020.1833684 (accessed 4 January 2021).

Sullivan, Andrew (1995), *Virtually Normal: An Argument About Homosexuality* (New York: Vintage).

Talbot, Lee M. (1980), 'The World's Conservation Strategy', *Environmental Conservation*, 7/4, Winter, 259–68, https://doi.org/10.1017/S0376892900007955 (accessed 2 February 2020).

Tamanaha, Brian Z. (2004), *On the Rule of Law: History, Politics, Theory* (Cambridge: Cambridge University Press).

Taylor, Stephanie, and Luckman, Susan (eds.) (2018), *The New Normal of Working Lives: Critical Studies in Contemporary Work and Employment. Dynamics of Virtual Work* (Basingstoke: Palgrave Macmillan).

TBR (2015), 'Research to Understand the Resilience, and Challenges to This, of Local Authority Museums: For Arts Council England', Newcastle upon Tyne: TBR, https://www.artscouncil.org.uk/publication/research-understand-resilience-and-challenges-local-authority-museums (accessed 2 February 2020).

Theimer, Walter (1939), *The Penguin Political Dictionary* (Harmondsworth: Penguin).

The 99 Percent Working Group, Ltd. (2012), '99 Percent Declaration', 7 October 2011, https://sites.google.com/site/the99percentdeclaration/ (accessed 22/3/2021).

Time Magazine (1949), 'New Normal?' *Time* 0040781X, 54/5, 1 August. http://content.time.com/time/subscriber/article/0,33009,794943,00.html

Tong, Sara Y., and Ling, Wan (2017), *China's Economy in Transformation Under the New Normal* (Singapore: World Scientific).

Townsend, Peter (1985), 'A Sociological Approach to the Measurement of Poverty: A Rejoinder to Professor Amartya Sen', *Oxford Economic Papers*, 37/4, 659–68.

Trenberth, Kevin E., Fasullo, John T., and Shepherd, Theodore G. (2015), 'Attribution of Climate Extreme Events', *Nature Climate Change*, 5/7, 725–30, https://doi.org/10.1038/nclimate2657.

UN [United Nations] (2020), *World Economic Situation and Prospects as of mid-2020* (United Nations, Department of Economic and Social Affairs), https://www.un.org/development/desa/dpad/wp-content/uploads/sites/45/publication/WESP2020_MYU_Report.pdf (accessed 4 January 2021).

UNCTAD [United Nations Conference on Trade and Development] (2020), *Trade and Development Report 2020: From Global Pandemic to Prosperity for All: Avoiding another Lost Decade* (Geneva: UNCTAD), https://unctad.org/webflyer/trade-and-development-report-2020 (accessed 4 January 2021)

UNDP (1997), *Human Development Report 1997* (New York: United Nations Development Programme and Oxford University Press).

UNDP (2010), *The Real Wealth of Nations: Pathways to Human Development* (Human Development Report 2010) (New York: United Nations Development Programme).

UNESCO 2020[2], 'Global Education Coalition: #LearningNeverStops : COVID-19 Education Response', UNESCO, https://en.unesco.org/covid19/educationresponse/globalcoalition (accessed 2 January 2021).

UNESCO 2020[3], 'Global Education Coalition: Members', UNESCO, https://globaleducationcoalition.unesco.org/members (accessed 2 January 2021).

UNESCO [The United Nations Educational, Scientific and Cultural Organization] 2020[1], The Next Normal Campaign (video), released 25 June 2020. https://en.unesco.org/news/unescos-next-normal-campaign (accessed 2 January 2021).

UNICEF [United Nations Children's Fund] and ITU [International Telecommunication Union] (2020), *How Many Children and Young People Have Internet Access at Home? Estimating Digital Connectivity during the COVID-19 Pandemic* (New York: UNICEF).

UNISDR [United Nations Office for Disaster Risk Reduction] (2017), *Build Back Better in Recovery, Rehabilitation and Reconstruction* (UNISDR), https://www.unisdr.org/files/53213_bbb.pdf (accessed 4 January 2021).

US Department of Education (2010), *Smart Ideas to Increase Educational Productivity and Student Achievement* (US Department of Education, 15 June), https://www2.ed.gov/policy/gen/guid/secletter/productivity.doc (accessed 4 January 2021).

van Kolfschooten, Hannah, and de Ruijter, Anniek (2020), 'COVID-19 and Privacy in the European Union: A Legal Perspective on Contact Tracing', *Contemporary Security Policy*, 41/3, 478–91. doi: 10.1080/13523260.2020.1771509.

Verisk Maplecroft (2020), *Political Risk Outlook 2020* (Verisk Analytics Official Public Information, 16 January), https://www.maplecroft.com/insights/analysis/download-the-political-risk-outlook-2020-executive-summary/#embedform (accessed 4 January 2021).

Vieten, Ulrike M. (2020), 'The "New Normal" and "Pandemic Populism": The COVID-19 Crisis and Anti-Hygienic Mobilisation of the Far-Right', *Social Sciences*, 9/9. doi:10.3390/socsci9090165.

Walker, Brian, and Salt, David (2008), *Resilience Thinking: Sustaining Ecosystems and People in a Changing World* (Washington DC: Island).

Walker, Jeremy, and Cooper, Melinda (2011), 'Genealogies of Resilience: From Systems Ecology to the Political Economy of Crisis Adaptation', *Security Dialogue*, 42/2, 143–60. doi: 10.1177/0967010611399616.

Walker, Martin (2009), 'The New Normal', *Wilson Quarterly* 33/3, Summer, https://www.wilsonquarterly.com/quarterly/summer-2009-thrift-the-double-edged-virtue/the-new-normal/ (accessed 24 November 2020).

Wan, Haiyuan, and Li, Shi (2019), *Income Distribution and China's Economic 'New Normal'* (Singapore: World Scientific).

Warner, Michael (1999), *The Trouble with Normal: Sex, Politics, and the Ethics of Queer Life* (New York: Free Press).

Weinstein, Adam (2011), '"We Are the 99 Percent" Creators Revealed', *Mother Jones*, 7 October, http://www.motherjones.com/politics/2011/10/we-are-the-99-percent-creators/# (accessed 22/3/2021).

White, Michael (2006), 'Financial: Budget report 2006: Politics: Budget briefing: A little more austerity, fewer details please', *The Guardian*, 23 March. 11 (Supplement).

WHO 2020[1], 'New COVID-19 Law Lab to Provide Vital Legal Information and Support for the Global COVID-19 Response', *World Health Organization*, 22 July, https://www.who.int/news/item/22-07-2020-new-covid-19-law-lab-to-provide-vital-legal-information-and-support-for-the-global-covid-19-response (accessed 2 January 2021).

WHO 2020[2], 'From the "New Normal" to a "New Future": A Sustainable Response to COVID-19', *World Health Organization*, 13 October, https://www.who.int/westernpacific/news/commentaries/detail-hq/from-the-new-normal-to-a-new-future-a-sustainable-response-to-covid-19 (accessed 2 January 2021).

Wickham, Fiona, and Winterman, Denise (2008), 'Wartime Lessons for the Credit Crunch', BBC, 31 March, http://news.bbc.co.uk/1/hi/magazine/7306451.stm (accessed 2 February 2020).

Wierzbicka, Anna (1997), *Understanding Cultures Through Their Key Words: English, Russian, Polish, German, and Japanese* (Oxford: Oxford University Press).

Williams, Raymond (1976), *Keywords: A Vocabulary of Culture and Society* (Oxford: Oxford University Press).

Williams, Raymond (1983/1st edn. 1979), *Keywords: A Vocabulary of Culture and Society, 2nd edn.* (Glasgow: Flamingo).

Williams, Raymond (2015 [1976]), *Keywords: A Vocabulary of Culture and Society* (Oxford: Oxford University Press).

Wodak, Ruth (2015), *The Politics of Fear: What Right-Wing Populist Discourses Mean* (London: Sage).

Wodak, Ruth, KhosraviNik, Majid, and Mral, Brigitte (eds.) (2013), *Right-Wing Populism in Europe: Politics and Discourse* (London: Bloomsbury Academic).

Wolff, Edward N. (2004), 'Recent Trends in Living Standards in the United States'; in *What Has Happened to the Quality of Life in the Advanced Industrialized Nations?* (Cheltenham: Edward Elgar), 3–26.

World Bank (2020), *The COVID-19 Pandemic: Shocks to Education and Policy Responses* (World Bank Group, May), https://www.worldbank.org/en/topic/education/publication/the-covid19-pandemic-shocks-to-education-and-policy-responses (accessed 4 January 2021).

Writers for the 99% (2011), *Occupying Wall Street: The Inside Story of an Action that Changed America* (New York: OR Books).

Wulff, Stephanie (2008), *Rethinking Idiomaticity: A Usage-based Approach* (London: Continuum).

Wysong, Earl, and Perrucci, Robert (2018), *Deep Inequality: Understanding the New Normal and How to Challenge It* (Lanham MA: Rowman and Littlefield).

Xi, Jinping (2014), Speech at the Opening Ceremony of the APEC CEO Summit, Beijing, 9 November, http://www.silkroadfund.com.cn/enweb/23809/23814/27094/index.html (accessed 24 November 2020).

Xi, Jinping (2017), *The Governance of China, Vol. 2* (Beijing: Foreign Languages Press).

Xin, Xie, Siau, Keng, and Nah, Fiona Fui-Hoon (2020), 'COVID-19 Pandemic – Online Education in the New Normal and the Next Normal', *Journal of Information Technology Case and Application Research*, 22/3, 175–87, https://doi.org/10.1080/15228053.2020.1824884 (accessed 4 January 2021).

Index

9/11 (terrorist attacks 2001) 8, 24–30, 48–52, 91–92, 97
The 99% declaration (2011) 136–137

Alfred P. Sloane Foundation 39
Amnesty International 51
Arts Council England (ACE) 9, 121–131
Atkinson, Anthony B. 144, 149–150
Atlee, Clement 113

Badiou, Alain 140–141
Beijer Institute 119
Beveridge Report (1942) 112
Biden, Joe 74–76, 92
Black Lives Matter 68–70
Blair, Tony 112
Blyth, Mark 107–108
Bolsonaro, Jair 51, 71
Bretton Woods Conference 1944 112
Brexit 71, 132
Brown, Gordon 111–112, 114, 117
'build back better' 76, 92
Bush, George W. 26, 48–49

Cameron, David 32, 111, 114, 116–118, 121
Canguilhem, Georges 78, 81, 84–85, 87
catchphrase/catchword
 dictionaries of 167–171
 idiomaticity of 163–167
 and keywords 10, 172–181
 meaning of 2, 25
 political and commercial 2, 10, 167
 Safire on 2, 25, 170–171
Cheney, Dick 24, 26, 30, 34, 91
China, People's Republic of
 economic policy 8, 38–39, 45
 flexible working in 59–60
climate change 42–44, 45, 46, 92, 98
Connor, Michael 30

Conservative Party (UK) 9, 110, 111, 116–118, 132
Covid-19 pandemic 8, 11–22, 63, 48–76, 91–92, 103, 132, 156
Cripps, Stafford 113, 114
Croce, Benedetto 4, 45
Cryle, Peter
 and Stephens 78–84, 88, 91
Cuomo, Andrew 74–75

Darling, Alastair 114
Democratic Party (USA) 74–76
disability 94–96
Dodd-Frank Act (2010) 35
dot-com crash (2002) 8, 31–32, 45, 54, 57, 91
Duncan, Arne 33, 64

ecological economics 119–120
education 61–65
 in schools 61, 97
 universities 62–65
El-Erian, Mohamed 33–34, 35, 55, 57
Erdoğan, Recep Tayyip 71
Extinction Rebellion 46

financial crisis 2007-2008 8, 31, 32–35, 54, 57, 66, 67, 91–92, 98, 105, 110, 113, 121
flexible working/working from home 8, 39–41, 45, 59–65
 in China 59–60
 and education 61–65
Floyd, George 68
Foucault, Michel 87–89, 94, 96, 97, 159, 166
Freud, Sigmund 83
Fridays for Future movement 46
Funtowicz, Silvio
 and Ravetz 44, 99–103

Galton, Francis 83
gender and sexuality 37, 94–96
Gross, William H. 33–34

Harding, Warren G. 2, 25, 34, 75
Hegel, G.W.F. 4
history
 contemporary (theory and method) 4–5,
 10, 158–167
 Barraclough on 158, 159
 Croce on 4, 159
 Foucault on 159, 166
 Hegel on 4
 and idiomaticity 162–167
 Rousso on 4, 160–161, 166
 of ideas 1
 material 1
Hodges, Paul 36
Human Genome Project (HGP) 85
Human Rights First (NGO) 27–28

IMF (International Monetary
 Fund) 36–37, 67
Infinite Jest, The (radio programme)
 26–27
internet meme 139

Johnson, Boris 71, 76, 92

keywords 10, 106, 172–181
 Williams on 10, 106, 172–174, 175
Kinsey, Alfred 83
Klein, Naomi 135–136, 138
Konings, Martijn 109–110
Krafft-Ebing, Richard von 83
Krugman, Paul 46, 137, 138, 144, 148
Kuhn, Thomas 35–39
Kynaston, David 115

Labour Party (UK) 9, 111–112, 113, 114,
 116, 117, 132
Liberal Democrats (political party,
 UK) 110, 117
Lloyd, Elisabeth 85
Lombroso, Cesare 82–83

Marr, Andrew 115
McNamee, Roger 31–32, 45

McKinsey and Company 33, 56–57
Modi, Narendra 71

New Normal, The (TV series) 37
'next normal' 57–58

Obama, Barack 26, 32, 68–70, 145
Occupy Wall Street movement 6, 7, 9,
 134–141, 155–156
OECD (Organization for Eco-
 nomic Co-operation and
 Development) 52
Osborne, George 111, 117–118

Piketty, Thomas 144–149, 152
Popper, Karl 100
populism, right-wing 71–73
'post-normal science' 44, 99–103
poverty and inequality
 measurement 149–154

race (and ethnicity) 68–70, 94–96
Ravetz, Jerome 103
 and Funtowicz 44, 99–103
Rawls, John 150
Republican Party (USA) 25–26, 74–76
Resilience Alliance 119
Robinson, Mark 125–128
Rousso, Henry 4, 160–161, 166

Saez, Emmanuel 144–149, 152
Safire, William 2, 25, 170–171
Sanders, Bernie 145
Sen, Amartya 149
slogan 2, 25, 38, 75–76, 139, 169
Sontag, Susan 50
Stephens, Elizabeth
 and Cryle 78–84, 88, 91
Stiglitz, Joseph 138, 141–142, 144, 145
'sustainability' 118–119, 122–123, 130

Technology Act (2001, USA) 62
Trump, Donald 52, 71, 74–76

UNCTAD (United Nations Conference on
 Trade and Development) 68
UNESCO (United Nations Educa-
 tional, Scientific and Cultural
 Organization) 57–58, 65

United Nations (UN) 54–55
United States Presidential election
 of 1920, 2, 25–26
 of 2008, 26
 of 2016, 71
 of 2020, 74–76

'war on terror' 26, 48–49
Williams, Raymond 10, 106, 172–174, 175
Wolff, Edward 145, 152
World Health Organization (WHO) 11,
 51, 52, 59

Xi Jinping 38–39